Sex and Film

Sex and Film

The Erotic in British, American and World Cinema

Barry Forshaw

palgrave
macmillan

First published 2015 by
PALGRAVE MACMILLAN

Palgrave Macmillan in the UK is an imprint of Macmillan Publishers Limited, registered in England, company number 785998, of Houndmills, Basingstoke, Hampshire RG21 6XS.

Palgrave Macmillan in the US is a division of St Martin's Press LLC, 175 Fifth Avenue, New York, NY 10010.

Palgrave is the global academic imprint of the above companies and has companies and representatives throughout the world.

Palgrave® and Macmillan® are registered trademarks in the United States, the United Kingdom, Europe and other countries.

ISBN 978–1–137–39004–2 hardback
ISBN 978–1–137–39005–9 paperback

This book is printed on paper suitable for recycling and made from fully managed and sustained forest sources. Logging, pulping and manufacturing processes are expected to conform to the environmental regulations of the country of origin.

A catalogue record for this book is available from the British Library.

Library of Congress Cataloging-in-Publication Data

Forshaw, Barry.
Sex and film : the erotic in British, American and world cinema / Barry Forshaw, independent writer and journalist, UK.
pages cm
Includes bibliographical references.
ISBN 978–1–137–39005–9 (paperback)
1. Sex in motion pictures. 2. Erotic films—History and criticism. 3. Motion pictures—Great Britain—History and criticism. 4. Motion pictures—United States—History and criticism. I. Title.
PN1995.9.S45F68 2015
791.43′6538—dc23 2014047898

Typeset by MPS Limited, Chennai, India.

Contents

Acknowledgements

My thanks to Judith Forshaw for her diligent copyediting, fact-checking and proofreading – and her (sometimes reluctant) readiness to watch films ranging from the classic to the meretricious.

And to the unknown manager of the northern cinema who programmed Bergman's *Summer with Monika* and Fellini's *La Dolce Vita* for just a handful of patrons; in my early teens, I was lucky enough to be one of them.

Introduction

A fairly sober warning should be given to any potential readers of this book. If notions of political correctness are important to you, it might perhaps be best to steer clear of what follows. Sexuality and the treatment of sex on film has long been a minefield for a variety of reasons, but it has perhaps become even more so now that it is essential for any writer to parade his or her ideological credentials or attitudes; even the sentence you have just read had to be non-gender specific. One might say that the Damoclean sword of 'avoidance of offence' in the sexual arena fell in the 1980s with the surprising and unlikely marriage between the morality campaigner Mary Whitehouse and anti-pornography feminists. While the former was famous for her 'Clean-up TV' campaign and battles with such dramatists as Dennis Potter, the latter concurred with her view that the female body had become objectified in popular and even serious culture. Personally, I argued in vain with feminists of my acquaintance who supported her censorship initiatives, believing that they (my friends and colleagues) had far more in common with someone like myself, who had no objection to either female or male nudity. Their fragile alliance was with a woman who, for instance, objected to such feminist shibboleths as abortion and felt that her own sex was best served by a devotion to family, church and conservative values – the German mantra 'Kinder, Küche und Kirche', in fact. But while Mrs Whitehouse herself has not had a notable successor (although, at the time of writing, the government is once more attempting to push through a variety of censorship legislation), attitudes to female nudity and graphic expressions of sexuality remain highly contentious. This book would have to be twice as long if I made an apology for each unblushing treatment of these themes – or, for that matter, if I repeatedly laid out my own position. I would simply suggest that

those offended by any discussion of sexuality that does not immediately freight in a 'politically correct' opinion (one that laments the calculated exposure of Brigitte Bardot's naked body in most of her films, for example) should accept that I am unlikely to be observing these strictures. Of course, it might be argued that a reader possessed of such squeamish sensibilities would be unlikely to pick up a book entitled *Sex and Film* in any case.

Any book that purports to be a study of sex in the cinema – from the earliest days of the medium up to the present and beyond, and taking in the films of every nation – has to set out its stall in one particular: what is the attitude of the author to sexual activity on the screen? Utterly objective? Dispassionate? Mildly stimulated? And how objective must a commentator be on a subject that gets so many people hot under the collar, not to mention other regions of the body? One might accept that a critical examination of, say, the orchestral tone poems of Richard Strauss or the Dutch interiors of Pieter de Hooch might be written in an utterly detached fashion, with the reader completely unconcerned about the individual tastes of the critic, but a discussion of sex will have even the most casual reader examining – consciously or otherwise – the attitude taken by whoever is writing or talking about the subject. What is their own take on the treatment of sex on film? Surely the writer's views must influence the objectivity of any statements? One would not want a commentator with a rigorously celibate frame of mind to make value judgements about the sensual content of films. Adherents of the Catholic Church are prepared for (supposedly) celibate priests to make pronouncements on the sex lives of worshippers, but it is hardly a view shared universally. The best one might hope for is a commentator who tries their damnedest to be objective, but accepts that their personal mindset will influence their views; the intelligent reader can accordingly decide whether or not they wish to agree.

Speaking personally, I have absolutely no problem with a film, or a sequence in a film, that is designed to effect sexual arousal – but the definition of 'film' can extend from mainstream and arthouse filmmaking to utilitarian pornography. And as this book is largely concerned with the former – that is to say, linear narrative cinema – it should be pointed out that nearly all the work discussed here, whatever the erotic elements, is generally committed to saying something pertinent about the film's characters, or about society, rather than merely treating us to some photogenic concupiscence. In other instances, the films mentioned in these pages utilise the medium of cinema in some creative

or innovative fashion, or perform the useful function of testing the parameters of taboos in representational art.

However, as Orson Welles once observed, two things can never be filmed in an interesting way: prayer and sexual intercourse. Presumably this is because both are ultimately somewhat boring to watch for the non-participant; there is no doubt that that is often the case with the lovemaking scenes in many films. After a prolonged scene of sweaty, graphic carnal activity – or worse, a languorous series of lap dissolves, seemingly shot through gauze, showing naked limbs being rearranged in uninteresting patterns – viewers may be inclined to mutter, 'OK. They've made love. Now, for God's sake, let's get on with the plot!' I once attended a reading at an erotic bookshop for women (men were permitted only if accompanied by a woman); as I sat there, surrounded by sometimes mystifyingly complex sex toys, I was aware that the frequent and lengthy descriptions of intercourse, fellatio, cunnilingus and other diversions quickly became wearisome. Until, that is, one woman writer read out her story, which involved paid-for sex between a middle-aged woman and a young male prostitute. The sex scenes were humdrum, but the subsequent section of the story – in which the woman attempted to talk to her young hustler, trying to build some kind of relationship with him when he wanted only to be paid and to leave – was infinitely more interesting. But the context of this conversation was the detailed description of the coupling that preceded it, and censors have rarely looked beyond the physical act in such scenarios.

Serious films, such as Ingmar Bergman's *The Silence* – with its controversial scenes of sexual intercourse (in a cinema, in fact) and female masturbation – outraged censors in the 1960s, and those who cut the film were not persuaded by either the Swedish director's impeccable artistic credentials or the fact that he had utilised the joyless sex scenes to make points about the arid emotional lives of his characters. Of *The Silence*, the Legion of Decency (clearly an unimpeachable authority concerning matters of artistic taste) said: 'His [Bergman's] selection of images is sometimes vulgar, insulting to a mature audience, and dangerously close to pornography ... he has seriously violated artistic taste and sensitivity and leaves the film's presentation open to a sensational exploitation by the irresponsible.'

The treatment of sexuality in film can be multifaceted, and, just as in literature, it may function as an index of the zeitgeist, often through a reading of what is permitted or omitted. The Victorian novel, for instance, was not able to touch on the pornography of the period,

but sexuality is undoubtedly present in such highly charged books as Thomas Hardy's *Jude the Obscure* (1895) and Emily Brontë's *Wuthering Heights* (1847). Similarly, the confused sexuality of 1950s America can be read via its films as much as through its popular novels; a comparison here might be made of Grace Metalious's then-shocking novel *Peyton Place*, with its adultery, incest and abortion, and the sanitised film version that followed in 1957 – even in its toned-down form, the film broke a few taboos. America in the late 1950s is the setting in which the outrageous, transgressive act performed by the unlikable hero and his lover in John Updike's *Rabbit, Run* (1960) is, simply, fellatio. In Britain, the frank post-coital discussion in Jack Clayton's film of John Braine's *Room at the Top* (1959) and the sympathetic handling of homosexuality in Basil Dearden's *Victim* (1961) were both events that were as significant in the popular consciousness as the radical and ground-breaking literature of the time. A complaint articulated (although not always by gay viewers) about pioneering films that tackled the subject of homosexuality, such as *Victim*, is that the treatment was never lyrical or life-enhancing; rather, the subject was presented as a societal problem, even though, as in *Victim*, sympathy is extended to the protagonists. But this critique – that films with gay themes should have presented a more positive image – is surely retrospectively expecting too much from the filmmakers of the day. In some ways, such tendentious strictures are similar to the feminist criticism of Freud, suggesting that the psychoanalyst had a faulty understanding of female sexuality; while that might certainly be argued, it is at least true that Freud was discussing the subject of female sexuality when a great many people did not even acknowledge its existence, and condemning Freud for his misunderstanding of female orgasm ignores this rather significant fact. In a similar vein, Basil Dearden and his screenwriters on *Victim* were bravely moving into areas that were unacceptable at the time; the fact that they were doing so at all is surely commendable, whatever their missteps. Ironically, a lyrical exploration of gay themes was present in Roy Ward Baker's enjoyably absurd and camp *The Singer Not the Song* (1961), with black leather trouser-clad bandit Dirk Bogarde inexplicably obsessed with a priest played by John Mills (Mylene Demongeot is the 'beard' included in the scenario to half-heartedly suggest we are not watching a homosexual romance). The two men expiring on the ground, hands clasped, after an exchange of gunshots recalls a similarly Wagnerian Liebestod at the ending of King Vidor's *Duel in the Sun* (1946), with, in that film, a heterosexual couple finding consummation in a death in the dust.

In many films, the erotic impulse – either a direct physical expression or built into the DNA of a given piece – can transform the narrative, both illuminating and energising the films of which it is a part. So, largely speaking, you will find less attention paid within these pages to films that have the excusable but rather unambitious aim of simply arousing the viewer; the focus will be on those movies that use sex to make significant points. But let's not be too po-faced about this – when it is necessary to describe exactly what happens in various films, you will find the details here. And there is much about the human body – speaking of which, the history of sex in the cinema may be traced through its representation of the female body (but see the caveat above about reading such notions as invariably sexist): from the first glimpse of Hedy Lamarr's pubic hair in Gustav Machaty's 1933 *Ekstase* to the unblushing photography of the labia in Lars von Trier's *Nymphomaniac* and Abdellatif Kechiche's *Blue is the Warmest Colour* (both 2013).

Metaphysical sex

Interpretations of the erotic can easily slip into being prosaic descriptions of the mechanics of the sexual act – or they can move into more rarefied poetic realms that transcend the merely physical. It goes without saying that the most conspicuous practitioner of the latter approach was D. H. Lawrence, and his descriptions of sexual activity in such novels as *The Rainbow* and *Women in Love* (both filmed by Ken Russell) so melded and intermingled the physical with the poetic that it was difficult for the reader to figure out precisely what was happening between the lovers. Was that an orgasm we had just encountered? Or a metaphysical merging of psyches? But Lawrence was at least trying to articulate what was previously terra incognita, and more complex and subtle attitudes to the erotic became the concern of various writers and filmmakers. Inevitably, literature, by virtue of its inward nature, is able to convey more enigmatic individual responses to the sexual experience, and writers from James Joyce to J. R. Salamanca have attempted to convey this subtle gradation of the physical and the spiritual. And certainly the cinema, being obliged to show rather than tell, found some difficulty in portraying the essential difference between male and female sexual responses. In film, such contrasts can be conveyed more or less directly in post-coital conversations, although the way in which the richness of individual experiences can be suggested inevitably relies on the articulacy of the protagonists – or, rather, of the screenwriter of après-sex colloquies. Non-communication between the sexes is easy

to convey, as is communication of the most direct kind during the sex act itself (recordable on film with various degrees of frankness or discretion). However, subtler undercurrents prove more elusive. High art, even more than these popular examples, has often dealt with the erotic, and the field of opera would be the poorer for its absence: think of Bizet's Carmen enslaving Don José or the consummation in death of the lovers in Wagner's *Tristan und Isolde* – or the most unabashed and shocking treatment of sexual obsession and even necrophilia in Richard Strauss's setting of Oscar Wilde's play *Salome*. However, Strauss's reputation as one of the greatest of modern operatic composers did not save the work's London premiere, conducted by Thomas Beecham, from some crass interference; the Lord Chamberlain decided that Salome kissing the severed head of Jokanaan (John the Baptist) was completely unacceptable, although it is standard in any production of the opera now. Instead, the murderous nymphet had to be presented with the sword that performed the decapitation – thus replacing a kiss on dead lips with the kiss of a phallic symbol. However, it was not high art that was (for many years) considered to be dangerous: the cinema carried much more of a perceived threat to the social order.

Pre-censorship bacchanalias

If we consider the early, pre-censorship era of silent cinema, we are reminded of a time when filmmakers were essentially given carte blanche, as is evident in the unbuttoned orgiastic sequences of American and Italian films that would be unthinkable two decades later. Perhaps more than films of later eras, those of this period, and from a variety of countries, keenly reflected the societies of their day, not just the sexual attitudes. And the antecedents of these movies were often literary.

Two lovers who can't keep their hands off each other's bodies and who have sex on the floor; an inconvenient and unattractive husband whom it is necessary to get out of the way. James M. Cain's *The Postman Always Rings Twice*? Or one of its many imitators? No, another writer got there earlier ... Émile Zola, with his carnal and edgy *Thérèse Raquin* in 1867. Who can write about sex like Zola these days, with everyone flinching in advance at the ironic but ultimately censorious awards or political correctness? Take this timeless passage as an example:

> Then, in a single violent motion, Laurent stooped and caught the young woman against his chest. He thrust her head back, crushing her lips against his own. She made a fierce, passionate gesture of

revolt, and then, all of a sudden, she surrendered herself, sliding to the floor, on to the tiles. Not a word passed between them. The act was silent and brutal.

This is from the 2013 Vintage Classics translation by Adam Thorpe of *Thérèse Raquin* and perhaps makes the reader realise anew why Zola was so shocking in his day. Writers and filmmakers looking to re-energise their batteries when writing about murder and sex might profitably pick up a novel that was written a hundred and fifty years ago and learn from a master.

Zola's powerful novel of death and adultery was given a (then) modern-day makeover by Marcel Carné in his celebrated 1953 adaptation; Simone Signoret and Raf Vallone are the tormented lovers paying a price for their passion, but there is strong work from Jacques Duby as the sickly, doomed husband. Later versions have not offered any competition to Carné's take on Zola. But the 1950s are for later consideration; this introduction will largely concentrate on the immediate cinematic heirs of Zola's sexual frankness: the filmmakers of silent cinema.

Filling the vacuum

Initial attitudes to the treatment of sex in British cinema reflected a distrust of an earlier entertainment medium, but one that was still current. When opponents discussed the dangerous appeal of films, they drew parallels with the vulgarity of the music hall, which was believed to appeal to the lowest common denominator – and the hoi polloi needed protecting against further moral depredations. Filmic depictions of the erotic were by no means the only target. Crime – and, in particular, drunkenness – were considered thoroughly unedifying spectacles and not suitable for cinematographic representation. Simple titillating subjects, such as the 1905 short film *Lady Undressing*, brought forth a degree of ire, despite their distinctly chaste nature. This particular film was summed up in the Pathé Company catalogue: 'A nice and pretty girl, after having gone to bed, blows the candle out wishing good night to the public (this subject can be used as a finish to a show).' Voices were also raised against another short film of the same year called *The Flea*: 'A young and pretty woman undressed is trying to catch a flea. The grimaces and position she takes up are very suggestive.'

The first major censorship board in the United States was convened in 1909, while British manifestations of the new breed of moral guardian included organisations such as the Manchester Purity League. Inevitably, human nature demonstrated its tendency to fill the vacuum

that the growing forces of censorship were creating, and an ad appeared in the 1908 *Kinematograph Weekly*: 'Venus Films: Special "for gentlemen" performances. Very piquant films and lantern slides; send 6d stamp; 448 pages richly illustrated catalogue.' After complaints from church groups, the ad was withdrawn. Censorship was ineluctably on the march, and an army of petitions was sent to the Home Secretary in 1910 concerning the alleged danger of cinematographic performances; two years later, the British Board of Film Censors was established.

The lure of sex

Theda Bara, with her heavily kohled eyes and hour-glass figure, may look to modern viewers like a parody of the silent-era vamp, but she was undeniably a key figure among screen goddesses of the time, and her delivery (courtesy of the intertitles) in *A Fool There Was* in 1915 of the much-quoted line 'Kiss me, my fool!' passed into the language. There were, however, more sexually graphic films in the silent era, such as *Traffic in Souls* in 1913, which was described in breathless copy as an exposure of white slavery in turn-of-the-century New York; the semi-documentary approach worked well for the film's audiences. Other films treating such issues as prostitution included *The Inside of the White Slave Traffic*, also from 1913, and *The Sex Lure* three years later, with early examples of luridly exploitative marketing ensuring healthy audiences for all these films. Alongside such erotically inclined fare were explicitly pornographic films such as *A Free Ride* in 1915, in which a well-heeled man picks up two women in his car and has sex with them after parking. Such films were seen only in all-male gatherings and not in commercial cinemas, but nudity was beginning to find its way into the mainstream: silent-era swimming star Annette Kellermann was shot sensuously naked under a waterfall in *A Daughter of the Gods*, a fantasy directed by Herbert Brenon in 1916. One of the most famous erotic tableaux of the time could be seen in D. W. Griffith's *Intolerance* (1916), with its half-naked women cavorting amidst classical pillars and disporting themselves against an opulent Babylonian set. Cecil B. DeMille, always a director fully aware of the public's interest in the libidinous, shot a famous sequence of an undressed Gloria Swanson in *Male and Female* in 1919, while at the start of the 1920s the brilliant German expatriate director and actor Erich von Stroheim included orgy scenes in his film *The Merry Widow* (1925) along with regal sexual excesses in *Queen Kelly* (1929).

By all accounts, the first treatment of male homosexuality in early cinema was the German film *Different from the Others* (*Anders als die Andern*),

directed by Richard Oswald in 1919, with gay men described as 'the third sex'. There were several 'firsts' in the film, such as the depiction of a gay bar and of 'butch' gay females. The plot involves two star-crossed lovers, one of whom was played by Conrad Veidt and the other, a young music student, by Fritz Schultz; another motif initiated in this film was the tragic ending of a gay relationship – the more mature partner commits suicide after blackmail and the threat of exposure. Richard Oswald's critical view of the legal strictures facing gay men was ahead of its time.

Sweden, later to be regarded in Britain and America (wrongly, in the view of such native writers as Håkan Nesser) as the font of sexual freedom in the arts and society, established an early vanguard in discarding the shibboleths of the period. *Witchcraft Through the Ages* (*Häxan*, directed by Benjamin Christensen) is a remarkable exploration of the supernatural and religious gullibility that has both shocked and entertained audiences since its premiere in 1922. Christensen's enthusiastic dramatization of the activities of witches and the devil seems quaint and amusing today in some ways, but it is still easy to see how it ruffled the feathers of the easily offended. The director himself provocatively plays a grimacing, semi-nude Satan, twitching his tongue suggestively in genuinely unsettling make-up. But the outrage caused by the film was principally due to the devil's capering entourage of witches enthusiastically engaged in a variety of acts of sacrilege and depravity; these scenes retain the power to shock after many decades, although Christensen's sense of parody has drawn the sting for modern audiences. These diversions are complemented by some charming stop-motion animation scenes (Ray Harryhausen *avant la lettre*). It is instructive to note the way in which certain images that were once considered so extreme were to become humorous with the passing of time. The thronging and colourful visions of hell painted by Hieronymus Bosch may have led to nervous sinners placing a few more coins in the collection box in the painter's day, but the crowded variety of monsters and demons and the imaginatively grotesque torments of the damned appear to modern eyes as eccentric and even charming in their absurd detail. Similarly, modern viewers tend to laugh at the Black Mass sequence in *Witchcraft Through the Ages*, notably at the obscenely waggling tongues of the demons. As so often, the church is portrayed in the film as the repository of obscurantist thinking, and the end of the film suggests that the various victims of religious persecution through the ages – burned at the stake – were merely mentally disturbed individuals who may have been helped by therapy. *Witchcraft Through the Ages* was banned for many years, not

least because of its flashes of nudity, but has been available in a variety of forms since then – and it was something of a hit when a William Burroughs narration was added in the 1960s. However, its most faithful presentation remains the original.

Going back even further, audiences were titillated in 1896 by a film that was barely more than a sideshow attraction: William Heise's *The Kiss* (also known as *The Widow Jones*), with a distinctly unappealing middle-aged couple, May Irwin and John C. Rice, kissing at length. The less-than-impressive appearance of the plump stars hardly mattered to viewers of the day, such was the novelty of the experience. And as the kiss was to be central to the cinema from then onwards, leisurely osculations of this kind were to follow in their hundreds. In a later era, when restrictions were placed on the duration of such sequences for reasons of decency, ingenious directors such as Alfred Hitchcock got around them with subtle interruptions, as in the two-and-a-half-minute kiss between Cary Grant and Ingrid Bergman in *Notorious* (1946); the minor distractions did not take attention away from the principal erotic business on hand.

Call of the exotic

The idea of the film star as the repository of sexual attractiveness was introduced very early in the cinema: the 1920s saw the emergence of such stars as Clara Bow, the rebellious, sexually adventurous 'It girl', and such flapper contemporaries as Joan Crawford (the latter was to have a considerably longer film career than Bow). Established early in the history of the medium was the figure of the exotic temptress, a woman clearly differentiated from the virginal girl-next-door figure. Such stars were often possessed of a distancing 'foreign' quality; they included non-Americans such as Marlene Dietrich, Greta Garbo, Pola Negri and British actress Margaret Lockwood, whose generously displayed cleavage in Leslie Arliss's *The Wicked Lady* (1945) upset several US states, necessitating re-shoots with higher necklines. American actresses, however, could also supply in-your-face sexual appeal: the short-lived Jean Harlow represented a particularly modern kind of sexual freedom, with her much-remarked-upon penchant for going without a bra, as did the aforementioned Joan Crawford in her first films (she had appeared, pre-fame, in a short hard-core film in 1925). And the sardonic Carole Lombard was more able than most to deliver wry and snappy dialogue to finesse her no-nonsense sexual appeal.

Male stars, too, were permitted to express erotic possibilities, although the idealisation of the male physique – and concepts of sculpted male

beauty as found in fine art – was less evident in the cinema, with a few significant exceptions. In the 1920s, Rudolph Valentino's smouldering Latin charisma presented a slightly feminised image of male beauty, but other, more macho versions of this male ideal quickly began to appear, such as the actor Clark Gable, who supplemented his good looks with a muscular, well-toned torso. However, actors quickly learned to conceal the fact that their appearance was finessed in the gym, possibly because even at this early stage such activities were not considered strikingly masculine; this ethos was to have changed considerably by the time when Steve Reeves, among others, displayed his ripped abs and pectorals in Italian musclemen movies as Hercules and other legendary heroes. Other male stars who came to represent a certain kind of muscular masculine appeal soon achieved immense popularity – Burt Lancaster and Kirk Douglas, for example, who both sported athletic physiques – although actors such as the narrow-shouldered Humphrey Bogart were equally able to personify masculinity.

The notion of the female 'vamp' was a mainstay of early silent cinema, epitomised by the actress Theda Bara in such films as Frank Powell's *A Fool There Was* in 1915, in which her character was called, straightforwardly enough, 'The Vampire' (the word 'vamp', of course, derives from 'vampire'). Bara's character offered a pleasurable path to destruction for her male victims, although the actress's artificial appeal is harder to appreciate today. Gloria Swanson presented a not dissimilar image in the opulent films of Cecil B. DeMille, in which sexual indulgence was often counterpointed by a thoroughly phoney puritanical overlay to appease the critics. And decades later, in a more heavily censored era, actresses such as Rita Hayworth came to personify tempting sexual availability, as in Charles Vidor's film *Gilda* (1946), which features a striptease in which only a single silk glove is removed.

The more intelligent image-conscious female stars were well aware that their sensuous appeal could be best served by directors and cinematographers who knew how to photograph them to the best possible advantage; the stellar example here is the perfect working relationship between the actress Marlene Dietrich and the director Josef von Sternberg. What is more, unlike DeMille, von Sternberg has no truck with the conventional trappings of middle-American morality; the famous shot of Dietrich in *The Blue Angel* (1930), with her camiknickers, suspenders and stockings exposed by the skirt pulled away from her waist, is an image that was considered so ineluctably sexual that it was crudely painted over in certain versions of the shot, with the skirt modestly extended. Dietrich and von Sternberg were even prepared to

flirt with suggestions of lesbianism in *Blonde Venus* (1932), while in *The Scarlet Empress* (1934) Catherine the Great's legendary sexual conquests (however far from the historical truth) provided the perfect marriage between the popular image of a well-known historical figure and a cinematic realisation that plays knowingly on audience expectations. A year later, *The Devil is a Woman* dealt specifically with sexual perversity, and the sadism of Dietrich's character suggested a misandry that was a new element in cinema.

Unacceptable fantasies

Now that politically correct, and largely proscriptive, attitudes towards sex have achieved the kind of self-censorship that would have pleased such right-wing figures as the 1970s school teacher-turned-moral reformer Mary Whitehouse mentioned earlier, it is something of a stretch to conceive of an era when what was essentially a cinema rape fantasy held a great deal of the world in thrall. In 1921, in George Melford's *The Sheik*, a spoiled rich woman, Lady Diana (played by Agnes Ayres) is kidnapped by a handsome, charismatic Bedouin sheik and taken to his tent, where she is raped several times. She is subsequently captured by another sheik – this time a deeply unattractive figure – but ends up with her original captor, with whom she has fallen in love. So why was all this offensive fare acceptable – even fascinating – to 1920s audiences? One simple reason: the sheik was played by the most beautiful man on the planet, Rudolph Valentino, whose level of stardom is hard to imagine today – several women committed suicide at the news of his untimely death. One of the reasons why Valentino became such an object of obsessive fixation for so many women was the astonishingly vitriolic campaign mounted against him by a host of male writers, including constant accusations that the actor was gay; the latter appears not to be true, although the story was repeated so often that it eventually passed into common currency.

The original novel, *The Sheik* by E. M. Hull, had already sold 1.2 million copies in the US and the UK before the film was made; it was the 1920s equivalent of E. L. James' modern sexual fantasies of domination and subjugation. The subsequent cinematic adaptation added an equally shocking visual dimension in what appeared to be interracial sex, although Valentino – with his darkened skin – simply looks tanned and Italian in the film. This was an era when, if an actor was adored by one sex only, it was enough to create superstardom; in contrast, actors and actresses of the sound era generally appealed to both sexes, although

in his early days as a willowy crooner, men would not admit to being admirers of Frank Sinatra.

The first act of sexual intercourse in *The Sheik* is not shown, but after some resistance on the part of Lady Diana, a title card suggestively announces 'After a week of sullen obedience ...', during which audiences assume that the inevitable has taken place. His sexual assaults aside, and unlike his character in the novel, Valentino's sheik is otherwise shown to be a man of sensitivity, drawing back from one sexual encounter when he notices his captive weeping. Nonetheless, the notion that such material might be filmed today is unthinkable. But the rioting mobs attempting to get near the dead Valentino's body at his funeral would similarly be – one assumes – unthinkable today.

Opening Pandora's box

Any consideration of the female erotic principle in vintage cinema must always make reference to the brilliant German director G. W. Pabst, whose broader European sophistication concerning sexual subjects shocked but exhilarated American and British audiences. *Diary of a Lost Girl* in 1929 (with American actress Louise Brooks, who was to become Pabst's muse) tells the unvarnished tale of the decline of a young woman into a life of prostitution. But there is no doubt that the director's masterpiece – and one of the cinema's most unyielding pictures of destructive sexuality – was *Pandora's Box* in the same year. The film was also known as *Lulu* after its central character, the sexually omnivorous femme fatale of Wedekind's play, which was also turned into a shocking opera by Alban Berg – its lesbian countess hopelessly in love with the elusive Lulu was something new for opera audiences. Even today, the much imitated bobbed hairstyle of Louise Brooks looks utterly timeless, and her artless modernity, along with her piquant combination of innocence and depravity, means that the film can still talk to audiences in a fashion unimaginable for many of its filmic contemporaries, which now simply look quaint. Brooks, utterly defined by this part, is mesmerising as the completely amoral female libertine, bringing chaos to everyone she encounters as they fall under her erotic spell, before sliding into banal prostitution and dying at the hands of a knife murderer. Brooks' combination of petulant expression and sardonic knowingness is matched by the strange 'animal caught in the headlights' dereliction of will that seems to descend upon her victims. And although the film is shot through with a keen post-Freudian analysis of its characters, Pabst allows his viewers to make their own decisions about what they are witnessing on screen.

Licences for excess

A decade after the silent era, the visions of aristocratic excess lovingly conjured by the directors Ernst Lubitsch and Erich von Stroheim allowed audiences to participate in the sybaritic indulgences on display, while paying lip service to the kind of moral disapproval that would have done justice to the *sans-culottes* of the French Revolution. Another kind of permissible setting for erotic freedom was the African jungle, far from civilisation, as in the Tarzan novels of Edgar Rice Burroughs. However, only one film was allowed to suggest the sexual freedom of Tarzan and Jane, W. S. Van Dyke's *Tarzan the Ape Man* (1932), which – as well as sporting a variety of sexual references courtesy of co-writer Ivor Novello, who knew all about sexual transgression – was enhanced by the near-naked appearances of Maureen O'Sullivan and Johnny Weissmuller as the jungle-dwelling couple, whose cutaway outfits made them appear to be nude from the side (there is a famous censored underwater swimming scene in which a naked actress stands in for Maureen O'Sullivan). But by the very next film in this series, the expurgators had done their worst and had modestly covered Tarzan and Jane in almost comically baggy costumes that removed both their sexual allure and their sense of freedom. The 1930s were to prove seismic in the cinema's approach to sex, with the decade witnessing a change of direction from abandonment to censoriousness.

1

The 1930s: From Mae West to the Legion of Decency

The smart, witty and frank sex comedies of the impudent 1930s – notably the 'bad girls' cycle of the day – are as fondly celebrated today as when they originally delighted audiences. Crackling with untrammelled sexual energy, their freedom to treat such subjects as prostitution was later prohibited, abruptly ended by the introduction of the Hays Code under its folksy but steely progenitor, Will Hays, the voice of the church. The Code's draconian restrictions brought about a new age of enforced innocence for the cinema, which was to last for two decades. But the Hay's Code was not the only opponent of freedom in the cinema, as we shall see. The British establishment, uneasy with the frankness of films, had no ideological arguments with the Code's strictures.

An early sortie in the sex war had been the notorious *Ekstase*, which sported the skinny-dipping, youthful Hedy Lamarr making love in a cottage during a rainstorm and showing the clear effects of orgasm. This Czechoslovak film (directed by Gustav Machaty in 1933) is generally considered to be the first time in which sexual intercourse was shown, although with no details of genital contact, and it was seized by the US customs in 1935 and prosecuted for obscenity. As well as being the first major film to depict the sex act and to show female pubic hair, it became the first to initiate the use of customs laws to stop a film entering the US. The film was also an example of a director seeking to enhance the erotic experience of the viewer by utilising other elements such as nature, with couples making love in sylvan settings, although any sense that there is a kind of pantheistic communication with nature as part of the sex act is rarely attempted after *Ekstase*.

Sex in film would prove to be a battlefield, and America would be where the real conflicts would take place. However, one woman

encapsulated a free-and-easy attitude to sex – and powerful religious organisations knew that she had to be dealt with.

Come up and see me sometime

To modern eyes, Mae West suggests a broad, camp parody of the femme fatale, with her massively exaggerated drawl, jutting false eyelashes (now firmly back in favour in various regions of the UK), skin-tight dresses and, above all, her pronounced hips – the latter, in fact, were padded; West was always a construct, and she was fully aware of this. But, in West's case, the vision of carnality coded for 1930s and 1940s audiences is straightforward: what we see is what we get. West is essentially saying: 'Don't take this slyly ravenous man-eater seriously – I don't.' And while it is not surprising that Mae West is something of a favourite today among gay audiences with her awareness of and enthusiastic celebration of camp (something she virtually invented), the reasons for her following among feminist viewers are also easy to discern. The standard male prerogative of the movies – the sexual advance that overcomes initial feminine resistance – is turned on its head: it is West who makes the running when it comes to getting her conquests into bed, and her frank physical appraisal of her possible paramours is also specifically masculine. It is particularly fun to see her seducing a young Cary Grant in Lowell Sherman's *She Done Him Wrong* (1933), given that the urbane male actor will, from this film onwards, generally be the instigator in scenes of seduction.

Modern viewpoints

West's attitude to sex itself in her films is a surprisingly modern one in an era in which sexual repression was the order of the day. The actress's mastery of the double entendre and her knowing self-caricature initially served her well for the stage and films, and there is no question that she enjoyed something of an *auteur* status, being largely responsible for the screenplays of many of the films she worked on – and frequently voicing dissatisfaction with the contributions of others. After the exuberant stage show *Diamond Lil* in 1928, which established her take-no-prisoners sexual persona, more commercial success was to follow in the 1930s. But the days when she could indulge in risqué material – which was what she had specialised in – were numbered. Having spotted the potential star quality (not to mention the good looks) of a very young Cary Grant doing physical exercises when an unknown in Hollywood, she inaugurated his career by using him as the detective in Salvation

Army disguise in *She Done Him Wrong*, which was the title chosen for the film version of *Diamond Lil*. Although entertaining, their scenes together are rather difficult to watch in some respects: she is already a touch too mature, and Grant already has the sophisticated lineaments of his later screen image; in truth, there is no real sexual chemistry between the two – particularly given that the most important aspect of their scenes together is the delivery by West of the killer wisecrack.

West carefully stage-managed her appearances in films – especially her first scenes. The initial shots of her in *She Done Him Wrong* show her brandishing a parasol and effortlessly attracting the attention of both men and women, prompting such comments as: 'A fine woman!' – to which the reply is: 'One of the finest women that ever walked the streets.' Similarly, in *I'm No Angel* (directed by Wesley Ruggles in 1933), she is seen displaying her ample charms outside a showman's tent, striding, hand on hip, in front of a group of ogling men and making the wry comment to them: 'Penny for your thoughts?' Hilarious though this is – particularly in West's dry delivery – it is also a good example of how West was learning to circumvent censorship restrictions; there is nothing in the line that can be identified as censorable, but, despite that, every savvy viewer of the film knows exactly what thoughts she is referring to. The same film also contains two of her most justifiably famous lines. She asks a further question of her male audience after saucily adjusting her gown: 'Am I making myself clear, boys?' This is followed by her quietly amused verdict on her observers: 'Suckers!' In fact, although we know she is talking about the unsophisticated audience enthralled by her appeal, we too are the 'suckers', reeled in by West and loving every minute of being seduced by her.

To be frank, the individual outings of Mae West are things of shreds and patches, compromised by the necessity for them to be star vehicles for their leading lady with the other characters rarely assuming an importance that matches the name above the title. There is no question of any of her films being a fully integrated comic masterpiece such as Billy Wilder's *Some Like It Hot*, with the various comic elements held in balance against each other. But such a balance was not what Mae West's audiences sought from her work, and the films must be viewed in context. There is a certain honesty in the fact that her roles often demonstrate that sex and Mammon can go hand in hand without any particular problems: West's characters frequently find their use of sex appeal lucrative. In one scene, she is addressing a group of discarded lovers who are recriminating her for her broken promises, and she simply asks whether they feel they have had reasonable value for their

money – it is perfectly clear that we are not expected to see her as being venal in discussing this utterly uncomplicated trading of sex for money.

The curtain descends

West's reign as the queen of the sex comedy lasted only three or four years into the 1930s. It was sadly inevitable that a woman who traded in an unabashed approach to the erotic would become the target of the morality police, and the Motion Picture Production Code, devised in order to whip a debauched Hollywood into line, was brought to bear on her films. For some time, West was immune to their sorties, not least because her films were so financially successful, and she was granted a little leeway in that she was a home-grown temptress, not one of the more dangerous foreign sirens such as Greta Garbo or Marlene Dietrich. *She Done Him Wrong* had largely escaped censorship attention, although some sequences involving white slavery had been removed nervously. But, in April 1934, a powerful collaboration between the Roman Catholic Church and laymen similarly concerned with what they saw as the moral decay of America formed the Legion of Decency. The organisation's Orwellian name may be discredited today, but the Legion wielded considerable power in its heyday and had Hollywood on the ropes. One of the group's first targets was the 'depraved' film output of the actress Mae West, and the motion picture industry, suffering failing box office receipts, was in no mood to take on a powerful religious organisation. Religion may still be utterly woven into the fabric of American life today, but in the 1930s its decision-influencing power at all levels of society was formidable; it was easier by far to kowtow to the Legion of Decency and remove any risky adult content from Hollywood films. West's new film in 1934 was originally to be called *It Ain't No Sin*, but this title was laundered to become the more anodyne *Belle of the Nineties*. Audiences were surprised to see a strangely incongruous pietistic element creeping into Mae West's shamelessly enjoyable and raunchy films, such as a large black choir singing morally uplifting spirituals. But it wasn't just the fact that Mae West was now 'doing God'; her unblushing sexual remarks were no longer to be heard in the films, and she was even obliged to make disapproving moralistic comments on precisely the kind of behaviour in which audiences once would have loved to see her indulging. From this period on, the sexual aspect of her films becomes harmless in these de-fanged versions. The line that perhaps most depressingly encapsulates the new attitude being forced on West is the one she has to utter with unconvincing sincerity when speaking to

a sardonic girl in a dance hall. West says: 'Any time you take religion for a joke, the laugh's on you.' On hearing this at the time, her audiences must have thought: 'Mae, what have they done to you?' It was the kind of hypocritical line that in her earlier films would have been given to the unsympathetic, moralistic characters – precisely the kind of attitude that she herself was there to puncture. The star's days of box office success were numbered, as there was simply no congruence between the po-faced religiosity and a woman who had made no secret of the fact that she liked sex. West, realising that the jig was up, transferred her earlier screen persona back to the stage, where there were fewer restrictions. There were various attempts by directors to lure her back to the cinema, notably from a filmmaker who made no secret of his admiration for large-breasted, broad-hipped women – Federico Fellini – but a Fellini/West film was not to happen. When she was finally tempted back to the cinema in something like her dotage, the result was one of the great cinematic debacles: Mike Sarne's *Myra Breckinridge*, which will be discussed later.

See what the boys in the backroom will have: Marlene Dietrich

Marlene Dietrich was born in Berlin with a variety of possible birth dates posited, 1903 or 1906 being the most likely. Had she conducted her film career only in her native Germany, it still would have been a memorable one, not least for her association with the great German director Josef von Sternberg, her Svengali. The latter, seeing Dietrich's youthful performance in the theatre after her training with Max Reinhardt, was intrigued (even at this nascent stage) by the very element – a rare one – that was to distinguish her film performances: a certain casual coolness and disdain plus a marked sangfroid. This was a woman well aware of her sexuality but uninterested in indulging it in any overt fashion. She was bemused but accepting of her hold over men – and, shockingly for the 1930s, over women, as illustrated by Dietrich's famous kiss planted on the lips of a girl, the former dressed in a man's white tie and tails in von Sternberg's *Morocco* (1930).

The Dietrich/von Sternberg association began in Germany with the legendary femme fatale Lola Lola in *Der Blaue Engel* (*The Blue Angel*) at the start of the decade, with Dietrich's nightclub singer bringing about the disgrace and destruction of her besotted older lover played by Emil Jannings. Hollywood, ever alert to promising foreign talent, particularly of the sexually alluring kind, quickly beckoned for the actress

(and her director). She began to make films in America, but declined an adaptation of Terence Rattigan's play *The Deep Blue Sea* by opining that audiences would not accept her as the kind of woman who would commit suicide over losing her lover. With von Sternberg and other directors, she quickly made a mark with the type of imported European sexuality that was very different from that of indigenous American stars; in *Dishonoured* (directed by her mentor in 1931), she plays the widow of an officer, a woman who has turned to prostitution until spotted by the head of the Austrian Secret Service, who notes her ability to manipulate men. Her favourite director remained the autocratic von Sternberg, who cast her in *The Scarlet Empress* (1934) to play Princess Sophia of Germany. The film industry always relished royals with a reputation for having a voracious sexual appetite (notably Catherine the Great), and in this film Dietrich is able to suggest a transformation of character, which was something she was not often called upon to do. As Sophia, she moves from being a virginal young princess into the all-powerful figure who dresses as a soldier and exercises power in rooms full of men – and who is not averse to sexually enslaving her guards in the privacy of her bedroom.

Domesticating the exotic

Above all else, Marlene Dietrich was well aware that the moulding of her enticing cinematic image owed a great deal to Josef von Sternberg, and she was always unstinting in her praise of him. But like the American Mae West, although in a different way, the kind of eroticism she traded in became too combustible for Hollywood. Near the start of her Hollywood career, the industry expressly forbade the representation of prostitution on the screen; in *Blonde Venus*, directed by von Sternberg in 1932, there is a sleight of hand to suggest that she takes money from men for sexual favours but is not actually 'on the game'. A certain slack was cut for the actress in her representations of such characters by safely distancing them, setting her films in the past or in some exotic foreign locale. Dietrich was nothing if not a survivor, and her delicious comic turn in the Western *Destry Rides Again* (for director George Marshall in 1939) brought an extension to her faltering career. The expedient used in this film was to depict Dietrich's mysterious and exotic sexuality with a more jokey, American flavour. Her foreignness was unavoidable, of course, and was signalled in her character's name: 'Frenchy' – German, French, what did it matter? And setting her against the all-American actor James Stewart – yet to establish the darker aspects of his personality in the Westerns he later made for the director Anthony Mann – worked

as a canny tactic to integrate her into something that was more like a conventional Hollywood product. Directors and producers always knew that it was a good idea to give Dietrich a song, despite the fact that she actually couldn't sing; this makes her later concert career with Burt Bacharach as her musical arranger even more of an achievement. But, as with her acting, Dietrich knew precisely how to parley those things that she could do well into her 'singing': the insouciance, the husky suggestive voice. And the song she was given for *Destry Rides Again*, 'See what the boys in the backroom will have' (the answer, of course, being her), became as much a signature song of her American career as 'Falling in love again' had been in the days of *The Blue Angel*. Like most iconic stars, she could rise above the absurdity of the material she was obliged to work with, such as her unconvincing scenes with Charles Boyer in Richard Boleslawski's *The Garden of Allah* (1936), while Jacques Feyder's *Knight Without Armour* a year later (with Dietrich as a Russian countess whose life is in turmoil because of the Russian Revolution) suggested that the very elements that had made her earlier films so compelling were now only fitfully in evidence. As the years went on, and Dietrich moved into her stately concert platform era, she became not so much a parody of herself as a sort of Madame Tussaud's wax figure – mature, but still retaining the slim and shapely figure of her youth, with dresses slit to the thigh. Audience responses changed from the erotic admiration accorded to her earlier films to a sort of respect for the fact that this ageing woman still – at a distance – looked much as she had in her twenties and could still mesmerise her public. And the element that had been so much a part of her earlier persona – the casual disdain for the way in which she was received, whether manufactured or not – still finessed her long-lasting appeal.

Erotikon: Greta Garbo

To modern audiences, the name 'Greta Garbo' suggests the breathily muttered line 'I vant to be alone!', and the actress's place in the upper firmament of 1930s screen stars is assured. Her legend – and that is not too grandiloquent a term – is inextricably linked with the star's later reclusive lifestyle, when she translated her film persona's desire for solitude into something of a personal obsession. She became deeply resentful of the paparazzi photographs that showed a lank-haired, unglamorous, middle-aged woman in dark glasses who was quite some distance from the glowing screen image audiences had of her. Rumours of her flexible sexuality further piqued the interest of those

who remembered her. But off-screen observations such as this are less important than what remains on celluloid, and what is most striking about Garbo when her films are looked at today is the immense naturalism of her performances, which stand in considerable contrast to the more studied and artificial playing that was largely the norm in her heyday. This naturalistic approach was apparent even in the Swedish actress's earliest films directed by Mauritz Stiller, whose boundary-pushing *Erotikon* from 1920 is fondly remembered. Stiller was undoubtedly something of a Svengali figure for her, and, as well as changing her name from Greta Gustafsson, he married her natural shyness with a subtle but powerful sensuousness. The shyness was apparently evident in early films, in which her directors had to conceal a facial tic that demonstrated Garbo's lack of ease in front of the camera, but Stiller noted, most significantly, that her fresh appeal would prove to be extremely photogenic. Like Marlene Dietrich, Garbo responded to the inevitable summons from Hollywood, and the American industry accommodated her accent, while she worked on her English, by casting her in a series of exotic and foreign roles. The studios quickly realised that her enigmatic quality was something to be stressed both on and off screen, and that it might profitably be played against the mysterious quality of her film characters. The erotic was present in most of her performances, such as that in *Queen Christina* (directed by Rouben Mamoulian in 1933). Garbo's performance as the incognito Swedish queen (travelling abroad disguised as a man) has an almost Strasbergian method-style naturalism.

As with all such films in which a woman masquerades as a man, there is the inevitable unveiling, which happens here when her character is obliged to share a bed in a village inn with the attractive Spanish ambassador (played by John Gilbert). The next morning, inevitably, her gender has been revealed, but her royal status remains concealed – audiences would be more interested in the revelation of the former rather than the latter. There is a suggestion of a sexual awakening leading to a liberation that infuses her entire personality, but the freedom she is to enjoy is bittersweet, as she is fully aware that her royal responsibilities will undermine any possibility of an untrammelled love life with an inappropriate paramour.

Melancholy vamps

MGM and Louis B. Mayer were fully aware of what they had in the unique Garbo, and placed her in a series of intelligently chosen vehicles, which – for the most part – allowed her to utilise the subtle virtues that

were the hallmark of her acting. But, as in such films as *Queen Christina*, her sexual appeal was shot through with a pronounced melancholy, something very different from the self-control and wry attitude to sex demonstrated by Mae West and Dietrich. One might have thought that this attitude to her characters might have pleased her; although they were seductive vamps, they were granted a sad inner life, which would have given the actress sufficient professional challenge, but she chafed at her image as a foreign sex queen. The problem was, of course, that audiences wanted to see her in such roles; they were pleasurably shocked and excited by her understated but potent presentation of sex on screen – one of her innovations was kissing with her mouth open, something hitherto unseen in the cinema. Her most fondly remembered film, promoted with the strapline 'Garbo laughs!', is *Ninotchka*, which was directed by Ernst Lubitsch in 1939 and written by Billy Wilder and Charles Brackett. This razor-sharp comedy cleverly played on the concealed sexuality teased out of Garbo's humourless Russian apparatchik by the sardonic Melvyn Douglas. Audiences were fully aware that the frigid, unyielding exterior would be cracked open by the knowing American hero, and the film remains the actress's most sheerly enjoyable effort. The notion of sexual repression stripped away by the hedonistic pleasures of Western society did service again with another less talented but still charismatic actress, Cyd Charisse. In Cole Porter's musical remake of the same subject, *Silk Stockings* (Rouben Mamoulian, 1957), Charisse was allowed to be more overtly erotic in a sequence danced to the title song, with the actress dressed only in her lacy underwear.

Garbo's performance in George Cukor's *Camille* (in 1936, after Dumas fils) as an upmarket Parisian courtesan showcased the actress's feeling for tragedy, although her skills as a prostitute had to be taken on trust. However, her stellar career ended with the same director's *Two-Faced Woman* (1941), which received some of Garbo's least enthusiastic reviews, mainly because of her miscasting in a role that attempted to imitate those of the American stars with whom she was in competition; the same approach had been much more successful with Dietrich's Americanisation in *Destry Rides Again*. An early print of *Two-Faced Woman* was denounced by the prudish National Legion of Decency for its 'casual attitude towards marriage, impudent suggestive scenes, dialogue and situations', and even its costumes. The first print was cut, and the film was subsequently taken off the 'condemned' list. Garbo, perhaps relieved, abandoned Hollywood and began a lengthy process of growing old in cloistered solitude, her glamour abandoned.

The 't' is silent: Jean Harlow

The much-quoted aphorism (by Margot Asquith) with its cheeky sugges-
tion that a final 't' in Jean Harlow's surname is silent may be unchari-
table, but it seems likely that the insolent and lively actress would have
taken it on the chin – if it were ever said, that is. From her eye-catching
debut in Howard Hughes' *Hell's Angels* in 1930, it was clear that as well
as being an actress of considerable natural skill, Jean Harlow radiated
an unaffected sexuality more indigenously American than that of the
sultry foreign stars discussed above. The actress was cheerfully prepared
to take on the joyless individuals who objected to both her persona
and her films – not least for her frequent, and clearly evident, refusal to
wear a bra; her nipples seen through silk were perhaps the most familiar
objects of scrutiny of any 1930s screen star. Her rebelliousness extended
to her refusal to adhere to the studio's constraining directives and she
was frequently suspended without pay, which did not inhibit her highly
individual instincts any more than it did another actress who similarly
confronted the studio, Bette Davis.

Harlow was the original 'platinum blonde', a role later assumed by
Marilyn Monroe, and both actresses had all too short lives; Harlow's was
the shorter and more tragic, as she died of kidney failure at only 26. Her
famous remark on her successive roles – echoing Garbo's wry observa-
tions on her eternal 'vamp' status – 'What kind of whore am I now?'
demonstrated a humorous and realistic attitude to her physical appeal.
For all the attention paid to her body, her actual statistics (35–23–35)
were modest by contemporary standards, but she exuded a brisk carnal-
ity that was unlike the dark and obsessive brand channelled by earlier
actresses such as Louise Brooks. And the stories about her attitude to
her own provocative sexuality suggested her yearning for something
more than an appraisal based simply on the attraction of her body. Like
Monroe and Bardot after her, she had no problems with nudity, despite
the fact that the film studios of the day were far more circumspect about
such things. Unlike Clara Bow – who complained that the reputation
and persona of a sex symbol were a great burden – Harlow barely had
time to experience that situation.

As so often, Hollywood was well aware that films in which art imi-
tated life titillated audiences; for example, Lana Turner's sexual scandals
and the murder of her gangster lover by her daughter were channelled
into her films. One of Harlow's films, Victor Fleming's *Bombshell* (1933),
seemed particularly to be based on the actress's own life; in the film,
her family is shown as being perfectly prepared to live off her fame

and money, and she becomes a manufactured, manipulated object. Her interactions with male sex symbol Clark Gable in *Red Dust* (also directed by Fleming) in 1932 possessed an eroticism that virtually leapt off the screen, accentuated by lines such as her response to her difficulty in sleeping on hot nights: 'Guess I'm not used to sleeping at night anyway.' This was the kind of dialogue that would squeeze by the censor but that audiences instantly responded to. And unlike many of the stars of her era, her relationship with men appeared to be on an equal footing, with a kind of feminist feistiness built into most of the exchanges. Nevertheless, she was frustrated by the quality of the films she was given, even though George Cukor's *Dinner at Eight* in 1933 made her the humorous recipient of one of the great comic lines in the cinema. Speaking to rough-voiced veteran Marie Dressler, she says 'Machinery is going to take the place of every profession,' to which Dressler replies: 'That's something *you* never need to worry about!'

Harlow's death in her twenties clearly cut short a career that had problems but great potential, but one can speculate that the cinema of her day would never have been interested in exploring much more than the various facets of her sexuality, which it had previously mined so assiduously.

2
Getting it Past the Puritans: The 1940s

Examining the ingenious and entertaining fashion in which clever screenwriters, directors and stars circumvented the crushing censorship demands of the day is a source of pleasure in itself. Those who try to unpick such Machiavellian strategies have often found that it increases their admiration of the ingenuity of the filmmakers of the period. But under the demands of the Mrs Grundys of the day – an insistence on a kind of prelapsarian innocence in which there was no place for adult themes – the concomitant, repressed charge given to material that, on the surface only, conformed to the restrictions of the era made for some electric undercurrents. A good example here might be the discussion of horse racing between Bogart and Bacall in Howard Hawks' *The Big Sleep* (1946) – when Lauren Bacall says her pleasure depends on 'who's in the saddle', audiences understood what she was talking about. Similarly, in the same film, when Bogart opens a book (the contents of which we do not see), his expression makes it clear that he is looking at pornographic material. This sleight of hand was something that powerful newspaper interests in the UK and the US were uneasily aware of; newspaper editors were mostly self-serving supporters of censorship, since shrieks of outage about the immorality of everything – apart from the press itself – has always sold papers.

As an actor, Leslie Arliss has been noted for his mannered but impressive performances, but he created a more lasting impression as a director, and particularly with the trashy but diverting *The Wicked Lady*, a considerable hit in its native UK in 1945. The names of the stars – Margaret Lockwood and James Mason – became almost synonymous with transgressive sexual passion because of the film, which was shot in Islington, London at the Gainsborough Studios. The film was the most commercially successful of all the studio's

overheated melodramas, and arguably the best known. *The Wicked Lady* broke new ground with Margaret Lockwood's feisty portrayal of Lady Barbara Skelton and was considered to be strong stuff; in fact, due to Lockwood's cleavage, it was the very first British film to be cut by Hollywood censors. What was seen even in the Victorian era as the 'excesses' of literature – a storm of condemnation, for instance, greeted the appearance of such novels as Thomas Hardy's *Tess of the d'Urbervilles* and *Jude the Obscure*, both criticised by the church as obscene – would certainly need to be toned down, and any uncomfortable implications ironed out, when the films of such novels were made a century or so later. William Wyler's respectable film adaptation of Emily Brontë's *Wuthering Heights* (1939) downplayed the erotic obsession of Laurence Olivier's Heathcliff with the rather chaste Cathy of Merle Oberon, and the violent sublimation of sexuality that infused the novel was effectively neutered. This was, after all, a film made when censorship in Hollywood had begun to exert a rigid grip. However, a suggestion of flagellation passed by unnoticed some years later, perhaps concealed by the religiose trappings of DeMille's *Samson and Delilah* (1949), when a scantily dressed Delilah (played by Hedy Lamarr) pulls the blinded Samson (Victor Mature) towards the temple pillars he is to pull down with the aid of a bullwhip, a symbol of his sexual enslavement to her. Also, of course, the blinding and cutting of his hair may be read as a symbolic castration.

Lethal ménages

It is ironic that the two best known films of novels by hard-boiled American writer James M. Cain – *Double Indemnity* (1944) and *The Postman Always Rings Twice* (1946) – were made in the buttoned-down, censorship-heavy cinema era of the 1940s. It tested the ingenuity of the filmmakers working within the infantilising constraints of the time to convey to audiences the essence of what these books were about; the two novels were always ineluctably about sex. The fact that they did so without any of the characters divesting themselves of their clothes (*verboten* in the 1940s) was a tribute to the lateral thinking of the filmmakers; by the time of Jack Nicholson and Jessica Lange straddled on a table, her skirt pulled up around her thighs, in the 1981 Bob Rafelson remake of the latter film, much more of Cain's overt eroticism could be channelled. But such luxuries were not accorded to Billy Wilder in *Double Indemnity* or to the director Tay Garnett in the first American version of *The Postman Always Rings Twice*.

The Wilder film is one of his most glitteringly hard-edged and astringent pieces, much enhanced by the fact that Raymond Chandler, no less, worked on the screenplay. Chandler made no secret of the fact that he considered himself a better writer than Cain – a largely unarguable proposition, although the writer was always utterly unsparing regarding rivals such as Cain and Mickey Spillane, whose work he hated. Fred MacMurray, who was best known for light comedy and was to end his career as an ineffectual comic player in Disney movies, gives something of a career-best performance as the manipulated, cynical young hero. He is a classic 'patsy' figure of the Film Noir genre, led to his doom by a duplicitous femme fatale, Barbara Stanwyck's Phyllis Dietrichson. MacMurray's character, Walter Neff, stands for a certain American salesman ethos in the film; while this may lack the despairing and sympathetic note of Arthur Miller's analysis of the profession, its existential emptiness is laid bare. Also built into the screenplay is a commentary on the sexual mores of the era as a counterpoint to the narrative of the lustful couple deciding to rid themselves of the woman's inconvenient husband and to collect his life insurance; this is a scenario arranged by the MacMurray character, Neff, as his profession is the selling of life insurance. A crucial figure in the film is Walter Neff's boss Keyes, played with customary scene-stealing aplomb by the character actor Edward G. Robinson. His experienced claims adjuster quickly suspects that there is something fishy about the death of Mrs Dietrichson's husband, although initially he is unaware that his colleague is involved. However, the senior claims adjuster is not there merely as a plot device; rather, he serves a function regarding the sexual undercurrents in the film, as we shall see in the next paragraph. On the surface, the logic of the narrative unfolds with the inevitable catastrophe after the success of the killing, as the two criminals are discovered by the older, wilier man, a revelation that drives them to try to destroy each other. However, the relationship between the Robinson and MacMurray characters suggests more intriguing things going on beneath that surface.

Undercurrents

In *Double Indemnity*, the insurance salesman Neff is clearly besotted with the alluring Mrs Dietrichson; Billy Wilder and his actress Barbara Stanwyck are able to convey the latter's sexual availability by the simple device of a cheeky ankle bracelet she wears. There is much kidding of Neff by his older colleague, Keyes, about his enslavement to his sexual instincts in a variety of encounters; despite the apparent good humour of the banter, there is an undercurrent suggesting that the older man

disapproves of the debauchery involved in these indulgences. But although the heterosexuality of the principal male/female couple is foregrounded, there is a hint of an unexplored homosexual sympathy between the two men, which is more apparent on the part of the older man. However, the final dying confession of the MacMurray character is made to his colleague via Dictaphone and, although it is delivered in typical hard-boiled fashion, it has a sense of needy desire for exoneration and understanding about it. As so often with Film Noir, viewers are invited to feel a certain sympathy for the luckless hero whose inadequate cynicism conceals a certain naivety – although the sexual politics of such films usually devolve on the fact that the hero is a victim of his hormones and of the seductive *belle dame sans merci* who leads him into crime. An interesting spin or reversal of this sexual formula is to be found in the Wachowski Brothers' modern neo-Noir *Bound*, discussed elsewhere in this volume, where the 'patsy' is a mannish female who is led into crime by another woman – the clearly delineated, high-heel-sporting femme fatale. It might be argued that in the latter case, however, the full implications of this sexual inversion are not seen through to their logical conclusion; there is an upbeat 'kill the nasty male and get away with it' happy ending for the two women that had lesbian audiences stamping their approval at the first showings of the film, despite Jennifer Tilly's manipulative, unsympathetic seducer.

In the case of Barbara Stanwyck's lethal Mrs Dietrichson, there is no ambiguity invited in our response to her. We watch her from the outside, through the eyes of the MacMurray character, but not in his mesmerised state, and calibrate our reactions. Even before such recurrent motifs became clichés, audiences of the 1940s knew how to read the femme fatale – she would be bad news for the ill-fated hero and lead to his death. In fact, the picture of heterosexual relationships in the classic Film Noir field is hardly a healthy one; the few women who do not represent danger – often the to-be-superseded girlfriend or wife of the seduced male – are there to be dispensed with and are not represented as being as sexually enticing as the better accoutred temptresses.

Billy Wilder's heartless cynicism cast an appropriately cold eye on the desperate human behaviour in the film, and the modernity of *Double Indemnity* is emphasised by a dissonant Miklós Rózsa orchestral score, utilised by Wilder in the teeth of studio opposition.

The Postman and *Gilda*

While his filmmaking ability is hardly the equal of Wilder's in terms of authority, Tay Garnett's 1946 version of James M. Cain's *The Postman*

Always Rings Twice still manages to incorporate a fair degree of erotic tension in its unholy trio/lust/murder plot borrowed from Émile Zola, although it lacks the uninhibited eroticism of Visconti's Italian version of the same story, *Ossessione*. In this case, the blonde temptress for whom a murder of an inconvenient husband is once again committed is Lana Turner, an actress most famous for the sweaters that emphasised her breasts – a feature that her earlier film career was at pains to show-case. The film has an icy and uncompromising demeanour, considerably aided by one of American cinema's most persuasively authentic actors of this era, John Garfield, playing the drifter enmeshed in a net of sexual desire and murder. As Garfield is moved towards the removal of Turner's ageing, avuncular husband (played by the chubby Cecil Kellaway), the audience is in no doubt that the only sexual consolations in her life will be with the desperate young man working at the roadside café rather than with her unthreatening asexual husband. There is a sly humour in the film, as evidenced in such details as the Turner character almost always being dressed in white – singularly inappropriate in light of her desires – and the film was able to suggest a certain American malaise that stretches beyond this roadside diner to wider horizons; Thoreau's lives of quiet desperation indeed. Even in the inevitably laundered version that was all that the director and his screenwriters could commit to film in 1946, there is still a powerful sense that the one destabilising factor that might fracture the status quo is sex.

Crime movies, despite – or because of – their draconian supervision, were still able to impart an erotic charge in the 1940s, and another example that has endured is director Charles Vidor's *Gilda* (released, like *Postman*, in 1946), which is remembered for one key erotic sequence, its other virtues apart.

The unpleasant tungsten executive Mundson (played in his customary supercilious fashion by George Macready) who is in charge of the gambling casino represents all tyrants, his facial scarring consonant with his fearful ambitions, which extend far beyond the casino. The casino itself is a stunning piece of production design, rendered with the casual brilliance that was Hollywood's métier in this period, with the upholstered salons, roulette wheels and well-dressed crowds the perfect setting for the squalid drama acted out in private. Mundson's young assistant is Johnny Farrell – played by Glenn Ford – and there is a palpable sexual tension between him and the older man's wife (Rita Hayworth at her most iconic), not least because of the fact that she was previously Farrell's lover. As the characters perform a *danse macabre* around each other, the eternal truths of male and female sexual desire

lead the characters towards their various destinies. But the inevitable bloodshed aside, the most indelible image the film has left on cinemagoers' retinas is the striptease performed by Rita Hayworth, wearing a low-cut, dark, silken sheath, to the song 'Put the blame on Mame'. This being the 1940s, the only garment that Hayworth can actually remove is one of her long gloves, but the actress manages to convey an energetic and open sexuality even within the confines of what the censor would allow in this memorable sequence.

Jane Russell's bra and Basil Hallward's best-known painting

Sex worked its way insidiously into other 1940s movies in a variety of genres, even the customarily celibate Western. Howard Hughes' *The Outlaw* (1943), despite the storm of disapproval it created at the time, now looks a singularly maladroit, poorly acted piece of work. It is best known today for the voluptuous fashion in which Hughes' discovery Jane Russell is provocatively photographed in the film, her breasts given almost parodic presence in both the film and its posters. Audiences of the day were fascinated by the fact that the eccentric producer/director, a designer of planes, had apparently created a cantilevered bra for his eye-catching young discovery, the sultry but flat-voiced Russell – an undergarment that she subsequently claimed she did not wear in the film or even in her public appearances, which Hughes, serially obsessed with his female discoveries, attempted to control. What is perhaps most interesting about the film today are the hints of homoerotic content between the male protagonists, far more pronounced than in virtually any other product of the period. These possibly slipped by the censors because of their concentration on the glittering erotic presence of Jane Russell, cleavage lovingly lit and photographed. The film was the first to defy the Production Code, which proscribed what could and could not be shown on screen – but the Code's objections, which led to several bans in various US states, were to the heavy-breathing sexual encounters between Jane Russell and her handsome but inexpressive co-star Jack Buetel.

Homosexuality was also to be detected – in a variety of fashions – in another celebrated film of the period: director Albert Lewin's 1945 adaptation of Oscar Wilde's scandalous novel *The Picture of Dorian Gray* (the eponymous picture provided by society painter Basil Hallward). The protagonist's name has become a byword for debauchery, although Wilde's original story does not tell us what the eternally youthful, massively depraved Dorian actually gets up to, although homosexual

activity will quickly spring to mind given the author's famous and ignominious disgrace after his liaison with Lord Alfred Douglas, 'Bosie', an affair that was immortalised in the playwright's besotted love letters to the man who eventually brought about his destruction. Modern readers of the story may be surprised by what now appears to be a somewhat cynical overlay of Christian morality, perhaps a sop to the conventionally minded, but one that palpably did not placate Wilde's critics.

However, even if Oscar Wilde had been able to be more specific about Dorian Gray's proclivities and activities – hardly likely in the late nineteenth century – such indulgences would not have found their way into a film made in Hollywood in the 1940s. Nevertheless, the filmmakers are adept at suggesting darker things going on beneath the surface of the fairly conventional bad behaviour we are allowed to witness.

Whether Dorian's sexual interests are directed towards men or women, and inevitably it is a woman in the 1945 film version, the character's real obsession is with himself. Dorian is the ultimate narcissist, with the carefully sculpted and supernaturally maintained image of his own face his greatest pride – as it was for the actor who played him in Albert Lewin's film, the curiously inert, androgynous but somehow charismatic Hurd Hatfield, whose demeanour may now clearly be read as gay. In fact, unlike several of the bisexual actors with whom he had affairs, Hatfield made no pretence of heterosexuality. As much as the depredations of sex, the film is really about image – the image that *all* the characters maintain of themselves, but principally the image of the central character and the supernatural portrait that allows him to retain his youth despite his worst endeavours. Dorian's unequivocal love of himself transcends ordinary sexual fixation and moves into the realms of pagan love, the latter inevitably unacceptable in the hidebound Victorian society that is his domain. But as Dorian's image finally – and hideously – deserts him and he assumes the grotesque, monstrous visage that his portrait has recorded, so too does the image he has blindly maintained of the woman with whom he has fallen in love. He has invested her with all the qualities of an immortal Shakespearean heroine (in the original novel, Wilde's Sybil Vane is an actress, but the character becomes a music hall singer in the film), but ultimately he finds her dull and uninspiring. Wilde's tale had a real-life parallel in the life of the composer Berlioz, who fell in love with and married Harriet Smithson, a Shakespearean actress, who was subsequently unable to live up to the image she had presented onstage as Juliet for him.

While a modern viewer may read Hatfield's performance as gay in a way that the average, and less sophisticated, 1940s audience would not have done – not least for the male adoration he inspires in the film – there is also a hermaphroditic quality to the character. In addition, one might discern in the fascination of such characters as George Sanders' epigrammatic Lord Henry Wotton, effortlessly stealing the film with his impeccable dispensing of bon mots, something more than sexual attraction: a metaphor for the irrational worshipping of the young and the beautiful. This is still as à propos in the image-conscious twenty-first century as it was in Wilde's own time, when his fixation on the handsome, impulsive Lord Alfred Douglas was to prove the instrument of his disgrace. The fact that the beautiful Dorian Gray is also one of the cinema's great monsters may be overlooked in the course of the film, but his iconic status is finally established in the startling Technicolor shot, in this black-and-white movie, of his final decayed visage.

Interestingly, the character of Dorian Gray was only finally addressed in a fashion that might have privately pleased Wilde in the 2014 television series *Penny Dreadful*, written by John Logan. This series allowed Dorian, played by Reeve Carney, to be seen engaged in sadomasochistic sexual practices with both men and women; on television in a more liberated modern age, the gloves are off, and the libido can be explored. In the past, other screen monsters could express their twisted sexual desires in more openly violent displays – as did a succession of Dr Jekylls and Mr Hydes with their abuse of prostitutes, old men and children – but the more enigmatic Dorian is obliged to remain passive, a cool burning flame for the butterflies attracted to him until his own spectacular demise.

Forever Amber

In the 1940s, trashy books that had scandalised readers, such as Kathleen Winsor's *Forever Amber*, could be translated onto the screen (in this case by Otto Preminger in 1947) and retain the vestiges of their lubricious charge. Still, the laundering process was generally pretty thorough, not that it was usually needed – particularly in the case of Winsor's anodyne novel. At this distance in history, it is hard to believe that it ever scandalised anyone. If Preminger's pleasurably gaudy film still works today, it is not so much due to our enjoyment of the amoral eponymous heroine's bed-hopping antics as she climbs the social ladder lover by lover, as played by the attractive but uninteresting Linda Darnell. Rather, if the film still has some life in the twenty-first century,

it is because of the full-blooded engagement of its cynical director (whose career is discussed elsewhere in this study) with the accoutrements of this kitsch costume drama.

The restrictions under which films laboured in the 1940s are perhaps best encapsulated by the famous censorship comments on Michael Curtiz's *Casablanca* (1942), with its brilliantly witty screenplay by the Epstein brothers and its memorable romantic relationship between Humphrey Bogart and Ingrid Bergman. The Hays Code restrictions now seem hilarious: there was to be no suggestion of a 'sex affair' between Bogart and Bergman's characters. So what exactly had the couple got up to in France? 'We'll always have Paris' was the famous exchange, but did they always stay in separate rooms? Similarly, the delicious Claude Rains character, the cheerfully corrupt Captain Renault, was not permitted to grant visas in exchange for sexual favours from young women supplicants. Such prissy mollycoddlings of audience expectations were shortly to come under heavyweight siege from a variety of filmmakers in the 1950s – not least the aforementioned Otto Preminger. The following decade may have been highly conservative in many ways, but a variety of volcanic rumblings in the cinema were about to erupt and change things forever.

3
The Kinsey Era: The 1950s

The 1950s in Hollywood cinema was a decade on the cusp prior to the pending sexual revolution, a staging post between the enforced celibacy and uneasy innocence of 1940s cinema and a new, more liberated decade. Films laboured under the limitations of the outmoded Hays Code before the dynamiting of censorship shibboleths in the 1960s. It was an era in which even musicals were rendered inoffensive by rewriting already innocuous material: a line in Rodgers and Hammerstein's *Oklahoma!*, 'A skinny lipped virgin with blood like water', was obliged to become in the film version 'a skinny lipped lady' – although Otto Preminger bloody-mindedly included this unacceptable noun in *The Moon is Blue* (1953). But just as the American theatre was producing provocative, edgy work with adult themes, shortly to be adapted (and, inevitably, softened) for the cinema, the time was growing ever more ripe for some unruly rebels to take on the censors and once again produce a cinema for grown-up audiences rather than trying desperately to avoid giving offence to church groups. The Catholic Legion of Decency and the formidably right-wing Daughters of the American Revolution were still censorship groups to be reckoned with; however, Freud's notion of the 'return of the repressed' became ever more relevant, as this was also the time of Alfred Kinsey's rigorous examinations of modern sexual behaviour, documents that became stratified through every level of American society. The strictures and inhibitions of the era are intelligently recreated in Bill Condon's unsensational biopic *Kinsey* (2004, with Liam Neeson as the sexologist).

Hello Norma Jean

This national handcuffing of Eros makes the impact of the most celebrated 1950s symbol of sexuality all the more inevitable, given that the actress

Marilyn Monroe was virtually a living refutation of the censor's anti-sex ethos. Her elemental carnality simply refused to be cosseted within the constraints of the day, even though such Monroe vehicles as Billy Wilder's 1955 film version of the play *The Seven Year Itch* tended to be rejigged for the cinema, neutering the sexual imperative. In this example, in the film, the seductive neighbour of the sexually frustrated Tom Ewell character is there to be looked at chastely rather than for having sex with – his counterpart in the original George Axelrod Broadway play is much luckier.

But it is somewhat limiting to consider Monroe as simply a sex symbol; so iconic and all-pervading is her presence that she might be said to represent the medium itself, albeit in a self-parodying form. That knowing burlesquing of her own image is to be seen in such films as Howard Hawks' *Gentlemen Prefer Blondes* (1953). What's more, for modern viewers there are the overtones of the tragic: we think of her in terms of her unhappy life and the monumental professional difficulties of working with her (only Judy Garland, Peter Sellers and Marlon Brando rivalled her in their almost Olympian disregard for the disciplines of making a film with eternally waiting colleagues). And, most poignantly, there is her too-early death under disputed circumstances. Books, memorabilia and a million other representations of the actress continue to appear, and only Audrey Hepburn – whose boyish figure was the absolute antithesis of Monroe's generous curves – has remained as ubiquitous in terms of visual representation. Inevitably, the tragic end mentioned above is all of a part with her posthumous celebrity, but even had Monroe been able to grow old and pile on the weight – as her British opposite number Diana Dors did, the latter becoming a respected character actress – there is little doubt that she would have continued to embody a particular image of female sexuality in the cinema.

Directors such as Billy Wilder and Joshua Logan, who were put under the cosh because of the actress's almost pathological inability to turn up on time and do her job, were fully aware that whatever special measures were needed – and they were considerable – to get just a few feet of film in the camera were worth their weight in gold. Certainly, they were worthwhile in terms of the box office, and even, at times, in an artistic sense; Monroe was a highly accomplished light comedienne in such films as Wilder's *Some Like It Hot* (1959). Wilder noted that Monroe shared with an actress of an earlier generation, the hour-glass-shaped Mae West, a tendency to guy her own image, and the pneumatic sex bomb she presented was always essentially a lampoon – but it was a parody designed to amuse and one that could also function in narrative terms. However, unlike her principal rival in Hollywood, the even

more parodic Jayne Mansfield, there was the quality of vulnerability in Monroe that granted a fragile humanity to her various characters, a quality that gave them a certain dramatic veracity. The actress was an adherent of the Stanislavsky method, as filtered through the portals of the Lee Strasberg Actors Studio, and tried to maintain a truthfulness of character even within the most unrealistic parts; Joshua Logan's *Bus Stop* (1956) is a good example of her skills, with Monroe touching as a modestly talented, insecure singer.

Norma Jean Baker, the illegitimate daughter of an alcoholic mother, spent a great part of her early life in orphanages and underwent an ill-advised child marriage at the age of 14, but, after puberty, her appearance in tight, figure-emphasising apparel attracted the attention of local photographers, and soon both agents and the producer Howard Hughes were showing interest. In one of her early films, she is an object of desire for Groucho Marx in the last (misfiring) Marx Brothers movie, *Love Happy* (1949), but it is her cameo role as the voluptuous mistress of gangster Louis Calhern in John Huston's Noir classic *The Asphalt Jungle* (1950) – along with a similar role in Joseph L. Mankiewicz's *All About Eve* in the same year, in which her older male consort is George Sanders – that made her own above-the-title stardom virtually inevitable.

A nude appearance in the first *Playboy* calendar had the effect of making her the poster girl for a new kind of sexual freedom to be espoused by Hugh Hefner in his magazine, despite subsequent feminist disapproval, and created a congruence with the image presented in her films. That image was notably encapsulated by the shot of Monroe with her skirt blowing up above her waist in *The Seven Year Itch*, one of the most famous photo shoots in film history; however, the white panties, widely familiar from the photo shoot, are not shown in the more circumspect film. Monroe's comic timing in such films as Jean Negulesco's *How to Marry a Millionaire* (1953) was cannily set against the world-weary eroticism of Jane Russell, almost equally famous for the breasts so lovingly showcased by Howard Hughes in the aforementioned *The Outlaw* (1943), and performances in films such as Henry Hathaway's drama *Niagara* (1953) demonstrated that her forte extended beyond the comedic. Inevitably, though, it is her character Sugar in *Some Like it Hot*, wearing a dress into which she appears to have been poured, that remains her career-defining film performance. Ironically, it is a similarly revealing dress that she wears, *sans* bra, when singing at President Kennedy's inauguration; this signalled both the apogee of her breathless female sexual energy and the murky finis of her life after her affair with Kennedy – catnip to conspiracy theorists who think the drug overdose rationale does not

tell the whole story. Age had no chance to wither Marilyn Monroe, and there was not perhaps evidence of infinite variety in her performances, but as a living refutation of the church-led condemnation of all things sexual in 1950s America, she carried a considerable charge in her day, and, amazingly, continues to do so in the twenty-first century.

Girl hunts and gill men

The erotic would appear in a variety of forms in the otherwise censorious 1950s. For instance, the 'Girl Hunt' ballet in Vincente Minnelli's *The Band Wagon* (1953) has a sensuous dance between Fred Astaire and Cyd Charisse, the former parodying a tough Mickey Spillane-type private eye and the latter a femme fatale in a tight red spangled dress. The effect intended by Minnelli is clearly, and successfully, humorous, as Astaire's ludicrously hard-boiled – and nonsensical – voice-over never allows us to forget. However, it is impossible for the viewer not to appreciate the leggy Charisse's deeply sensual flowing movements on a variety of levels: it is a jokey pastiche, yes, but (as both director and dancer are well aware) the dance also has to function on a straightforwardly erotic plane – in fact, it is that raciness that has made the dance iconic over the years rather than the parodic elements.

While the cinema – and certainly the American cinema – may have laboured under a variety of pettifogging constrictions in the mid-1950s, it was still possible to suggest a degree of sensuousness within the context of what was permitted. And it was also possible to suggest that what in other contemporary films would be a representation of romantic love could also be construed as unambiguous sex. Joshua Logan's film of William Inge's *Picnic* from 1955 is remembered for a slow and languorous dance (to the tune 'Moonglow') between the actors William Holden and Kim Novak. There is a certain counter-intuitiveness at work in this scene: while audiences had been conditioned to look at Kim Novak's impressive figure throughout her career, with the actress customarily dressed to show it off to best advantage, the sexual object in this film is in fact the male. It is the tanned and athletic-looking – but none too bright – drifter played by William Holden who inspires frustrated female lust, notably in a character played by Rosalind Russell, who is unwisely encouraged by Joshua Logan to overplay. Logan photographs his male star in quite as appealing and sensuous a fashion as his female star, and their dance during a village community picnic is shot with maximum erotic appeal; there is no doubt that what we are witnessing is a sexual

ritual rather than a romantic one. The most famous image from *Picnic* encapsulates its equal-opportunities sexual appeal: William Holden appears bare-chested, while Kim Novak, cleavage generously on display, kneels below him and pulls the shirt from his glistening torso. The reputation of playwright William Inge went into an early and swift decline and has not recovered, but, like his inspiration Tennessee Williams, his work remains worthy of attention even if Hollywood rarely did it justice. A later Inge film, virtually forgotten (and unseeable) today, is more subtle, with Joanne Woodward as a stripper having a relationship with a younger man played by Richard Beymer. The various title changes suggest the unsubtle imperatives for selling such material to the average film audience: the original play was called *A Loss of Roses*, but Franklin Schaffner's 1963 film was known as *Woman of Summer* in the UK, while a more direct appeal was made to viewers in America, where the film was baldly called *The Stripper*.

The horror film had previously flirted with sexuality in, for instance, *King Kong*'s curious disrobing of the Fay Wray character, but one of its most perfect expressions was to appear in Jack Arnold's *Creature from the Black Lagoon* (1954). In this film, the aquatic beast – a rather elegant and grotesquely beautiful prehistoric relic – captures the heroine, played by the toothsome Julia Adams in a clinging white bathing suit, but not before swimming beneath her without her ever realising that she has a kind of phantom lover echoing her movements beneath the waves. Jack Arnold, the best of the 1950s directors of science fiction, suggests the primeval sexual instinct beneath the surface – in the lower depths of the water, and in the bestiality of the possible coupling about which we are allowed to speculate, principally through the metaphor of the gill man's perfectly synchronised swimming motions mimicking the girl above him. By using an expert swimmer in these scenes in the monster costume, Arnold suggests grace and balletic elegance as much as any sense of threat. The fact that the creature appears to have no visible genitals is a mere detail. Subsequent films in the series, *Revenge of the Creature* (1955) and *The Creature Walks Among Us* (a year later), made little or no further play with the sensuous, although sex itself occasionally resurfaced in such terminally maladroit films as Cy Roth's *Fire Maidens from Outer Space* (1956) with its mini-skirted sexpots.

Genre films aside, 1957 was the year of the film of Grace Metalious's *Peyton Place*. Directed by Mark Robson, the film appeared to dabble in such themes as Oedipal attraction, promiscuous behaviour and even rape within a family, but it did so tentatively. Although the filmmakers

traded to an extent on the notoriety of the book that was being adapted, there was no question that Metalious's scandalous but poorly written bestseller would be anything other than sanitised in the 1950s.

The 'X' cometh

The 1950s represented a turbulent decade for the British cinema trade in terms of what adult audiences were allowed – or forbidden – to see; even an innocuous film such as Claude Autant-Lara's version of Georges Feydeau's farce *Occupe-toi d'Amélie...!* (1949, with Danielle Darrieux, played at a frenetic pace) was refused a certificate completely. This was the period when the British Board of Film Censors (BBFC) laid out its intentions in no uncertain terms, and in 1952 the following statement was released by the organisation regarding its new 'X' certificate:

> The experience gained by the Board in recent years would suggest that some new films may have to be graded 'X' on account of realistic treatment or a sordid theme; but it is not the wish or intention of the Board to open the door to any *undesirable type of film* which is merely designed to attract morbid curiosity. On the contrary, the Board really hopes that the new category will provide an appropriate place for adult films of high quality, serious or light in nature, which though unsuitable for children, make a legitimate appeal to their parents. [my italics]

Despite the paternalism in the above statement – and the blanket dismissal of any film that has less laudable aims than the Board intended ... no 'undesirable' films, please! – there is at least a realistic acknowledgement here of the requirements of an adult audience. This contrasted with the majority of would-be censors of television, who demanded that all television – *all* television, mind you – should be of the unthreatening variety suitable only for 'family' audiences, since the medium is piped into every home.

But despite this liberal-seeming concession by the BBFC, serious films of an adult nature, such as Anatole Litvak's *The Snake Pit* (1948) with its responsible treatment of mental illness, were passed as an 'X' only after several cuts had been made. And conforming to the British perception of France as a land of unbridled sexual licentiousness, the Board paid particular attention to French films, which it felt traded in sex and sensationalism. Such films included 1951's *Caroline Chérie*, directed by Richard Pottier from a screenplay by Jean Anouilh, with its

cheerfully promiscuous heroine played by Martine Carol. The Italians, too, were looked at askance: Luigi Comencini's *Behind Closed Shutters* (*Persiane Chiuse*, also 1951) earned an 'X' for its discreet treatment of prostitution.

The Board may have been secretive in its decisions for nearly a century, but it allowed certain of its philosophies behind its treatment of films to become public knowledge; its principal aim, stated on more than one occasion, was to exclude from public exhibition anything likely to 'impair the moral standards of the public by extenuating vice or crime or by depreciating social standards'. The members of the BBFC prided themselves on the fact that they would make unavailable any material likely to 'cause offence to the majority of reasonable people'. The 'majority of reasonable people' as a concept was inevitably as nebulous in the 1950s as it is today. Cuts were made in the work of such serious directors as Luis Buñuel and Jacques Becker, whose *Casque d'Or* particularly upset the censors in 1952. But any outcry against such strict measures was relatively subdued, as the three main cinema circuits of the day were particularly keen to maintain the much sought-after family audience and tried to avoid more limiting 'X' certificate programmes that excluded children. This attitude has persisted over the years, particularly in regard to the James Bond franchise, and, in the twenty-first century, superhero movies that utilise more adult treatments of violence and are thus certificated in such a way as to exclude younger viewers, hence reducing their earning potential. Inevitably, the 'X' certificate branding acquired a cachet for audiences as something deeply attractive because of its not-for-children nature; a similar syndrome was to be noted when the British television network Channel 4 placed a (theoretically) cautionary red triangle in the corner of films likely to shock the easily offended. The red triangle quickly became identified as a 'come-on' for those seeking out the erotic rather than a warning, and it was abandoned.

4

Pushing the Boundaries: Preminger the Rebel

Important directors such as Otto Preminger took on the all-powerful Production Code with the specific intention of making adult movies; the battles were bloody, but they led to the sudden, swift crumbling of the influence of such organisations as the Catholic Legion of Decency as serious filmmakers' fights with the censors chimed with a new liberalism on the part of audiences. And this short-tempered German expat was the toughest street fighter of all the Hollywood rebels.

Challenging the unacceptable

Artists are sometimes remembered for the wrong things. There is little doubt that the composer Richard Wagner was a distinctly unappetising individual, not least for his anti-Semitism, which was enshrined in his essay 'Jewishness in music', and his ruthless use of those around him. However, few would dispute his genius as one of the greatest of operatic composers, and the reputation of his music is such that even Jewish musicians including Daniel Barenboim are great advocates of his work. But what is his countryman, the German director Otto Preminger – who spent most of his working life in America – best remembered for today? Certainly, he was one of the key directors of the Film Noir movement of the early 1940s, producing such films as the classic *Laura* in 1944, and his later epic films on a variety of heavyweight subjects, *Exodus* (1960) among them, enjoyed great commercial success and a protean critical response that moved from sniffy disdain to a secure enshrining in the canon by the cineaste generation of 1960s film critics. Preminger's later career was marked by a series of spectacular misfires, including the incoherent *Skidoo* in 1968, in which the director's once implacable grip demonstrably deserted him. But if Preminger is personally remembered

for one thing, it is, sadly, for his reputation as a bullying martinet, comfortably of a part with his fierce Germanic appearance and peremptory manner. His repeated (and unsparing) reducing of actors and actresses to tears with his verbal assaults led to a perception among a public that cheerfully embraced a stereotype: this was how a famous old-school German-accented film director in Hollywood was supposed to behave. Preminger took these perceptions on the chin – and even encouraged them – as he was less concerned with the fashion in which he was personally viewed than with the considerable achievements of his film career.

However, there is one aspect of the director's career that is somewhat under-regarded these days, and is certainly the most relevant in terms of a book called *Sex and Film*: Preminger's readiness to undertake savage battles with the censors and move the cinema out of the lengthy period in which it avoided any controversial issues. More than just about any other director working in Hollywood from the 1940s to the 1960s, it was Preminger whose skirmishes with the guardians of morality broke down decades-old barriers and helped forge the realistic modern ethos that is the norm today.

Ironically, Preminger's firing of the first shell in the censorship battles occurred with a relatively innocuous, slight comedy that also marked the director's move into independent production, a preferred method of working that he was to maintain to the end of his life. The director had long chafed at the restrictions of the studio system and was looking for a vehicle with which to launch his independent career. The play *The Moon is Blue* had been successful on Broadway and the kind of light banter in which it dealt, and which was often of a suggestive nature, was to become typical of Hollywood comedies of the 1960s. However, in 1953, certain words were totally unacceptable on the screen – words such as 'virgin'. Preminger intended to set the cat among the pigeons. The director persuaded the playwright F. Hugh Herbert that the latter would have the best commercial prospects for success if he were to allow the director's new production company, Carlyle Productions, to make a film of the play. Preminger also insisted that the production company with which he was working, United Artists, grant him some unprecedented privileges: the right to edit the film in precisely the fashion he wanted, with no interference, and – crucially – the right to a final cut. Hiring nonpareil comic actors David Niven and William Holden for the film was solid insurance, but the director took a chance with a less experienced actress, Maggie McNamara, as the heroine. In the event, this was a not entirely successful gambit, although McNamara is adequate.

It was McNamara who would be obliged to utter the words that had hitherto been unacceptable on the screen. Problems did not arise with most of the banter between the protagonists – a largely forgettable *pas de trois* between two older, experienced men and a feisty female ingénue – but the film was spiced up with a screenplay which, as Preminger was fully aware, utilised language that had previously been completely inappropriate in Hollywood. The Maggie McNamara character voiced remarks such as 'Lots of girls don't mind being seduced' – this was the first time that the word 'seduced' had been used in a major Hollywood film. But the most famous taboo-busting sentence in the film was 'Men are usually so bored with virgins'; and the director was fully prepared for the fights that would ensue over the use of a word that would not raise an eyebrow on prime-time television today. What made the phrase even more confrontational was its combination with a less shocking line spoken by McNamara but one that nevertheless embraced an acceptance of a new realistic morality that had not been presented in film before. The heroine says: 'You are shallow, cynical, selfish and immoral – and I like you.' Such sentiments expressed by a sympathetic female character, who was clearly not troubled by the loss of her virginity, were perceived by the all-powerful Breen Office (the censorship arm of the Motion Picture Association) as an espousal of values that were a direct attack on morality and the family. Preminger was summarily instructed to make cuts, but immediately dug in his heels. Arguments that a cut version of the film would still work as a light comedy cut no ice with him, as this was to be the first major ideological stand he would take against studio interference. Needless to say, the Breen Office was deeply unhappy and made it clear that the film would not be passed for release unless the offending words 'virgin' and 'seduced' were excised. A concerted campaign against the film followed, engineered by Catholic organisations with compliant priests told to attack the film in sermons and to inform their congregations that they would be committing a mortal sin if they were to see it.

The Breen Office seal had long been considered mandatory, but Preminger was the first serious artist to contest – in a very public way – just how necessary it actually was. The director had done his homework and had noted that the Supreme Court has made a ruling that films were entitled to the same protection under the First and Fourteenth Amendments of the Constitution as newspapers. He decided to fight the ban against *The Moon is Blue* in court, and his efforts proved to be ground-breaking, with only a handful of states contesting an uncensored release of the film. The director took a public relish in the battles,

invoking such factors as the use of censorship in totalitarian countries – Preminger was aware that, as a German, this observation would have some force – while still arguing that the Production Code had been created decades ago and that public attitudes had moved on since then. The director also made the point that while Catholics might feel obliged to be told what they could and could not watch by their priests, there was absolutely no reason why the adherents of other religions – or, for that matter, of no religion – should allow their viewing to be dictated by a particular faith group, and a notably illiberal one at that. United Artists was persuaded by Preminger's arguments, and accepted that the film might be distributed without the industry's previously all-important stamp of approval. The worldly British actor David Niven, already noted for his sardonic sense of humour, pointed out that the Catholic Church had provided, free of charge, the best possible public-ity for the film.

The subsequent success of *The Moon is Blue* was prodigious, and swiftly spread through a variety of countries. The more sophisticated French unsurprisingly had no objections, but when the film reached the UK, the BBFC arranged a special showing for this 'problem' film; present at the viewing was the man shortly to take charge of the organisation itself, John Trevelyan. Trevelyan had absolutely no problems with the film, but his attitude was not shared by his more shockable colleagues, who were disturbed by the film's apparent laissez-faire attitude to sexual licence and who insisted on a few small cuts being made. But Trevelyan (who considered himself something of a frustrated filmmaker) recog-nised that Preminger was an artist as much as a controversialist, and was – from that point on – sympathetic to the director's intentions. But another storm was to break over Preminger's head two years later, in 1955, when the director decided to adapt a novel by one of America's foremost writers.

Anatomy of a controversial film

Nelson Algren was an important realist novelist of the era, with books such as *A Walk on the Wild Side* and *Never Come Morning* featuring, respec-tively, a lesbian brothel madam and a graphic gang rape. His novels enjoyed both great critical approval – from, among others, Algren's sometime-lover and fellow writer, Simone de Beauvoir – and commer-cial success, not least because of the frankness of his work in tackling sexual subjects. Preminger had enjoyed success with his film of Oscar Hammerstein's spin on Bizet, *Carmen Jones* (1954), and for his next

project was considering Nelson Algren's novel about drug addiction *The Man with the Golden Arm*. Drug use was another of the great cinema taboos, but Preminger was geared up to tackle it, well aware that his clashes over the use of the word 'virgin' in a soufflé of a comedy would seem the most superficial of skirmishes considering what lay ahead with the Algren adaptation. In the event, the film that resulted remained studio-bound, with its very obvious artificial settings undercutting the reality of the material. It had its virtues, however: Frank Sinatra's powerful performance as the drug-addicted protagonist, Elmer Bernstein's massively influential jazz-inflected symphonic score, and Saul Bass's equally influential angular credits design. On this occasion, the frank sexual descriptions of the novel were not an issue in the conversion to the screen as Preminger soft-pedalled these elements, keeping his powder dry for battles over the unprecedented depictions of drug addiction, notably the harrowing 'cold turkey' sequence as Sinatra's character attempts to kick the habit. The film was subsequently banned in Britain.

The director's next encounter in the sexual arena was to take place over a lengthy and impressive courtroom drama, *Anatomy of a Murder*, from a novel written by Robert Traver, a pseudonym for Supreme Court judge John Voelker. The book utilised the author's own experiences from his early days as a lawyer and attempted to create an objective, unsensational picture of a rape and murder trial; not unexpectedly, in the Hollywood of the period, this was extremely tricky material. A young American lieutenant and his sexy, seductive wife live in a caravan in Michigan. The young woman, Laura Manion, is raped, and it would appear that her short-fused husband murdered the rapist. Handed the defence of the soldier in the subsequent murder trial is a committed young lawyer, and a key figure in the narrative is the distinctly un-pompous and very humane judge presiding over the case.

For the key role of the young wife, Preminger showed great prescience in casting an actress shortly to become a major star, Lee Remick, whom the director had seen a film directed by Elia Kazan (*A Face in the Crowd*, 1957). On Remick's shoulders rested a great deal of the film's more controversial material during her deposition in the courtroom.

Filming in Michigan, Preminger created what is now considered to be one of his signature films: lengthy, intelligent, sporting the now customary Saul Bass titles and another highly impressive score (a particular predilection of the director's), this time by one of the greatest of all jazz musicians, Duke Ellington – he appears in the film in the jazz club attended by the music-loving lawyer, who is played with great authority

by James Stewart. To viewers conditioned by a million subsequent legal dramas on television, just how innovative the frank and no-nonsense approach of the film was may now be hard to appreciate, but it is necessary to remember the extent to which the treatment of sex crimes was mealy-mouthed and circumscribed in films prior to Preminger's. The central question posed by the film is as follows: did an army lieutenant on trial for the killing of an alleged rapist murder in cold blood or was he at the mercy of an irresistible impulse? Preminger, noted for his reluctance to coerce viewers into a particular position, presents the narrative in such a way that we, the audience, are invited to make up our own minds about what we see on the screen. The director does not show the murder happening, and there are no explanatory flashbacks; as in much of his work, Preminger is suggesting that truth is a nebulous commodity, and we are given every side of the argument. The use of James Stewart, instantly a sympathetic figure for cinemagoers, is a way of giving a perspective we can trust on the narrative, particularly when the young wife played by Remick proves to be no innocent figure but worldly and sexy, flirting with Stewart's character. There is also a suggestion that the wife, Laura, did not object so much to her assailant's advances but to their violent nature. It is also clear that her husband is equally violent and possessed of a fiery jealousy. *Anatomy of a Murder* is about surfaces and appearances, specifically in the way in which the defence attempts to finesse the appearance of the witnesses; for example, a young psychiatrist is persuaded to wear a pair of horn-rimmed glasses to accentuate the seriousness of his demeanour, and Laura Manion herself is instructed to wear a girdle to de-emphasise her curvaceous figure. This item of underwear is an area of controversy in later discussions in the film: the Lee Remick character's refusal to wear one is interpreted as a sign of sexual licence. The 'anatomy' of the title can be understood in a variety of ways: the murder itself, the presentation of evidence and the necessity for stage-managing that presentation, and, inevitably, the body of the young woman at the centre of the killing.

The trial judge is played in a non-actorly fashion by a real-life judge, Joseph N. Welch, and he acts as a useful conduit for the audience by organising in cool and authoritative fashion the film's events and testimony. Ultimately, the final resolution of the film is open-ended, leaving us to question all that we have witnessed during its course. It is a classic example of Preminger's objective method laid out in its most unadorned form.

The actress Lee Remick was warned by friends about the director's angry and abusive treatment of actors and was apprehensive, but star

and director worked well together, and between them they made Laura Manion the appropriate fulcrum of the film's argument – and of its controversy.

Preminger's tactics in dealing with the explicit sexual references in the film were canny, particularly in a speech given by the judge, whom we quickly come to respect; he appears to be instructing the audience in the seriousness with which we are to treat what follows. Laura Manion's 'undergarments' (as they are referred to) are frequently discussed, just as they would be in a real rape trial, with a directness that had not previously been seen in Hollywood films. The judge says coolly:

> For the benefit of the jury, but more especially for the spectators, the undergarment referred to in the testimony was, to be exact Mrs Manion's panties. I wanted to get your snickering over and done with. This pair of panties will be mentioned again in the course of this trial and when that happens there will not be one laugh, one snicker, one giggle or even one smirk in my courtroom. There isn't anything comic about a pair of panties which figure in the violent death of one man and the possible incarceration of another.

But while this injunction may have had a salutary effect on audiences watching the film, it was not so much amusement as dismay with which the film's stark descriptions of sexual matters were greeted. Shortly before the Chicago premiere, Preminger was informed that there would be censorship cuts made in five scenes. The offending passages were to be found in the medical expert testimony detailing aspects of the rape; it goes without saying that such details had never been addressed in the cinema before. The Chicago censor was also the police commissioner, and, when Preminger went to meet him, he found him to be a prim individual. The commissioner added that there was to be a further cut in the film along with the initial tally – the use of the word 'contraceptive' – as he pointed out that he would not wish his daughter (who was nearly 20) to hear the word uttered in a film. Realising that reasoned discussion was out of the question, Preminger decided to take the city of Chicago to court and sued for the issuance of a licence for the film, arguing that the cutting of such lines would destroy its integrity. Other unacceptable elements that upset the Chicago censors were references to the words and phrases 'sperm', 'sexual climax' and 'penetration'; the director was persuaded to substitute the word 'violation' in the last case. However, the ultimate victory was to be Preminger's: the film was released with a hard-won Motion Picture Association seal that signalled a fatal blow to

the strictures of the Production Code. Audiences were slowly becoming accustomed to an adult treatment of adult themes, and the genie could not be put back in the bottle. But Preminger had not finished with controversial material, as a subsequent film was to prove.

Skeletons in closets

Preminger had enjoyed considerable success with his version of Leon Uris's novel *Exodus* in 1960, but two years later the director decided to tackle Allen Drury's Pulitzer Prize-winning political novel *Advise and Consent*, which had become famous for its laying bare of political lives in Washington. The novel is about a conflict between the President of the United States and the Senate concerning the appointment of a controversial Secretary of State, and in an era when clashes between the President and the Senate are now ever more bitter, Drury's novel seems particularly prescient. One of the things that led to *Advise and Consent*'s prime position on the bestseller lists for month after month was its unveiling of a variety of secrets in the closets of the politicians who were the dramatis personae, and the sexual revelations – particularly those with a non-heterosexual basis – were to offer Preminger the kind of challenge that he had grown to relish, although the slightly more liberal climate of 1962 meant that the forthcoming fights over censorship would not be as brutal as those the director had encountered earlier. Preminger packed his ambitious film with a remarkable 'A' list cast: Henry Fonda as the controversial senator whose appointment was the basis of the drama; the veterans Walter Pidgeon, Lew Ayres and Burgess Meredith; a comeback role for Gene Tierney, who had played the title role in Preminger's earlier success, *Laura*; Franchot Tone as a weak president; and – most satisfyingly – the English actor Charles Laughton, whose performance as a wily Southern senator was one of the finest of his late career. Also in the stellar cast was another English actor, Peter Lawford, whose familial relationship with John F. Kennedy (brother-in-law), Preminger calculated, would give the film a certain cachet. But – crucially – the young actor Don Murray was to play a character who was the litmus paper for the film's more controversial aspects.

Early suggestions that Preminger should show a favourable image of Americans and their political systems to the rest of the world were met with total disdain by the director, who talked, as he had before, about the importance of freedom of expression on the screen. And *Advise & Consent* is undoubtedly one of the director's most considerable achievements,

presenting a multifaceted picture of American political life with a brilliantly argued series of *crises de conscience* for its large cast of characters as a collection of skeletons are dragged out of closets in various attempts to discredit the politicians. These skeletons include an early flirtation with communism by the Henry Fonda character, but it is the young, married senator played by Don Murray, Brig Anderson, whose personal story allows Preminger to enter dispassionately an area he had not dealt with before. Anderson is being blackmailed, with a letter and a photograph the instruments of his possible destruction; despite now living a heterosexual life, Anderson has a gay past. His visit to a gay nightclub is presented in a non-stereotypical fashion; although the injunction to Murray's character to stay is delivered in a high tenor voice by a feminine-looking gay man, and although Anderson's reaction is to run in disgust from the club, there is nothing homophobic about the way in which the scene is filmed. A close reading of this sequence demonstrates that Preminger is clearly not making the kind of moral judgement that would usually be conferred on gay characters in films of the period (and would be again); Anderson's disgusted reaction comes from a refusal to acknowledge the truth about himself, and, of course, from his knowledge that any sexual revelations would destroy his career and his marriage. Objectivity is always the most precious commodity in the universe that Preminger presents for us. The nightclub we are shown is not sordid, but it does represent an underworld – an underworld rendered clandestine by society's disapproval. The subsequent suicide of Brig Anderson has great emotional force, and we are invited both to feel sorrow for the death of a man we have come to like and sympathise with, and to make a judgement (by a director not given to asking for such things) on a society that would create the climate in which this tragedy could happen. There has been a suggestion in discussions between Anderson and his wife that the sexual side of their marriage has not been to the satisfaction of either; Anderson's wife says, sadly, 'We haven't had an exciting marriage,' but Anderson finds himself unable to tell her the reason for this.

The fact that the scenes involving Anderson's homosexuality created less of a stir than had previous such honesty in Preminger's films may perhaps have been due to the fact that Allen Drury's novel was already familiar to readers. However, it might also have been because alternatives to heterosexual sex, which had once been regarded with horror by previous generations, were becoming more acceptable, even though repressed homosexuality on the part of men leading ordinary

married lives was still a useful dramatic device – it even led to murder in the Gordon Douglas/Frank Sinatra film *The Detective* (1968). *Advise & Consent* was the director's last fully realised film and one that still appears both balanced and persuasive today in its treatment of a controversial theme.

5

This Property is Condemned: Tennessee Williams

If one writer may be said to be a barometer for the boundaries of presenting sex on the screen, it is one who rarely wrote directly for the medium, but whose plays – when adapted for the movies – were wildly successful, not least for their inflammatory depiction of sexual matters. However, most of these adaptations had to be softened and bowdlerised in order to be shown to cinema audiences, who were considered less sophisticated – and thus more open to moral corruption – than the more cultivated theatre audiences who first encountered Tennessee Williams' work. After the success of his play *The Glass Menagerie* in 1944 (which was later filmed, but is not relevant to this study), virtually all Williams' major plays enjoyed adaptations that were generally considered to maintain an extremely high standard, despite the strait-laced tinkerings to which they were subjected. Before the playwright's cavalier attitude to drink and drugs began to sap his creative energy, he furnished some remarkable material for the cinema in which overcooked emotion and fevered sexuality were couched in the most poetic of terms, and shot through with a genuine and nuanced grasp of character, however extreme the situations in which he placed his protagonists.

The massive success of his play *A Streetcar Named Desire* in 1947 established Williams' reputation as one of America's greatest playwrights, along with his contemporary Arthur Miller, while simultaneously instilling the personal fear that he always had to live with – that he would not be able to top his current success, whatever it was. Travelling with his companion and lover Frank Merlo to various European locations, the insecure Williams frequently attempted to recharge his creative batteries – and was successful in doing so for many years.

The film of *A Streetcar Named Desire*, which appeared four years after its theatrical premiere, was significant in several ways: in establishing

the actor Marlon Brando as a major screen star, although it was not his first film; in consolidating the reputation of its director, Elia Kazan; in granting the British actress Vivien Leigh one of her signature roles; and in inaugurating the film career of the composer Alex North. But, most significantly, the film pushed at the boundaries of the portrayal of sex on film and was inevitably blue-pencilled – although it is now available in the form in which its director intended it to be seen.

Looking at the body

In Kazan's film, the actress Kim Hunter – playing the wife, Stella, of the brutal Brando character Stanley Kowalski, and the sister of Leigh's fragile Blanche DuBois – is often seen provocatively dressed in a slip, but the most indelibly sexualised image in the film is that of the body of its male star. At this stage of his career, Marlon Brando was muscular and beautiful; this was years before his name became as much a byword for obesity as it did with the equally gargantuan Orson Welles. His striated muscles gleaming with sweat and accentuated by the famous torn T-shirt furnished one of the most famous images from the film: Kim Hunter passionately embraces Brando, her arms clawing at him, but the couple is shot from behind so that the actress is virtually invisible and the viewer's attention is directed entirely at the male physique – in this, it is very similar to another equally ubiquitous still, one of Burt Lancaster and Deborah Kerr embracing in the sea in Fred Zinnemann's *From Here to Eternity* (1953). In the latter shot, Kerr, dressed in a rather sensible, modest bathing costume with a buttocks-concealing fringe, is shielded from the camera by the toned body of her co-star; it is the male star, Lancaster, that we are being invited to look at. And Brando's thuggish Stanley Kowalski, uninhibited, rather stupid but undoubtedly charismatic, is the character we watch in fascination along with the sad, deluded Blanche DuBois. Blanche is hanging on to her memories of a boy, Allan, to whom she was married but who we (but not she) clearly read as gay. She is both drawn to and fearful of Stanley, as is, clearly, his creator. Tennessee Williams' work is full of such sexual but threatening 'rough trade' male figures, although the playwright himself is definitely closer to the sensitive but vulnerable women who are often at the centre of his narratives.

Elia Kazan had directed *A Streetcar Named Desire* on stage and was the obvious choice in 1951 to make a film, with Brando repeating his stage performance. Brando was joined by two other actors from the original production, Kim Hunter and Karl Malden, with Vivien Leigh having

played the part of Blanche in London. The film was a considerable hit, not least because of the presentation of the palpable sexual tension between Brando and Leigh that culminates in the brutal rape of the latter's character, the scene that caused notable problems for the film examiners of the day. Although Irving Rapper's 1950 film of the gentler *The Glass Menagerie* had been successful, it was *Streetcar* that established an enduring image in the popular consciousness of Tennessee Williams as the chronicler of dangerous, off-kilter sexuality and characters who were emotionally adrift; the fact that he was considered to be one of America's finest writers was added value. *Streetcar* remains as iconic as ever, even continuing to inspire modern films such as Woody Allen's *Blue Jasmine* in 2013, with Cate Blanchett as a Blanche DuBois *de nos jours*.

Sexual frustration and baby doll nightgowns

More scandal was to follow with a subsequent Elia Kazan adaptation of a Williams play: *Baby Doll* in 1956. The scenario of the play – and the film – was relatively straightforward, with a dishevelled, balding middle-aged man desperate for his slightly retarded sexpot wife – played in the film by Carroll Baker in a career-defining performance – to reach the age of 20 so that they can consummate their marriage. There is a snake in the grass in the form of a lubricious mill owner played by Eli Wallach who is hoping to claim the Baker character's virginity before her frustrated husband does. Once again, an image from the film came to define it in the popular imagination, and is still remembered today. Giant hoardings were produced showing Carroll Baker in what we now know as an abbreviated 'baby doll' nightgown riding up to her thighs, curled up provocatively in a child's cot with one hand between her legs and sucking her thumb. It became one of the most famous sexual images of the day, even parodied in William M. Gaines' *Mad* magazine, and is emblematic of a time when the depiction of childhood sexuality – while undoubtedly vexing – was not the hot potato it would be today. Kazan had now acquired both financial and artistic clout, and was able to make his picture of this steamy sexual ménage almost exactly as he wanted to. The film begins when the young girl has agreed to consummate the marriage, and such is Kazan's portrayal of Baby Doll herself that it is easy to understand why the male characters follow her, tongues practically hanging out, in a state of high erotic tension.

Once again, the highly educated Williams presents unlettered characters whose concerns (sex apart) are a million miles away from his

own, but he is able to suggest that his protagonists are products of their society, and their lack of self-knowledge – and their coarseness – is examined in much the same way that Neorealist filmmakers in 1940s Italy had approached such people. Williams' work – while undeniably indulging our voyeuristic fascination – is concerned not so much with condemnation as with observation. Baby Doll herself, for instance, is not the one-dimensional sexpot she might initially appear to be, but a trapped young woman obliged to come to terms with the service-able world she finds herself part of, and the grimy decadence of this milieu, while criticised, is nevertheless accepted as a quotidian reality. If the behaviour of the characters – and the playing by the actors – now seems a touch hysterical, that is a by-product of Williams' attitude to the ludicrousness of sexual pursuit, something he was well aware of in his own personal life. Baker's appearance, with her peroxide blonde hair and unintentionally alluring clothes, may seem like a caricature (as indeed she became), but she does embody something lively and human within the decaying house – and, by extension, the decaying society – in which the film is set. Her innocence is also presented as a snare and a delusion: it is a trap for the Malden and Wallach characters. The two men, like Baker, give performances informed by the naturalism of the Lee Strasberg Actors Studio that produced them, and at times they even appear to parody the excesses of the 'Method' school, as previously seen in Brando's performance in *Streetcar*. Inevitably, the mannerisms of the film and the performances as guided by Kazan now seem dated, and the usually excellent Malden appears to have been encouraged to approach his part *fortissimo* throughout; Eli Wallach's oily seducer, on the other hand, is more naturalistically played. But even when encouraging a degree of excess, Kazan remains quintessentially an actors' director, finding things in his players that other filmmakers were not able to access – the proof of this can be seen in Carroll Baker's later career in Italy, where she played a series of debauched, mature sexual predators without an iota of the unconscious eroticism of this early part.

Speakable poetry

The playwright himself had a theory as to why his plays so often made successful films. Williams noted that he constructed his work in cinematic fashion, with a multiplicity of short scenes that naturally lent themselves to the medium. But it should be added that the films of his work were the antithesis of the kind of pure cinema that Alfred Hitchcock dreamed of making, in which the images were all important

and the dialogue very much a secondary consideration. The film adaptations of Williams' plays were inevitably wordy – but what words! The poetry of the dialogue was nearly always unforced and, although not naturalistic, it was wedded to speakable exchanges that never suggested the artificiality of verse plays such as T. S. Eliot's *The Cocktail Party*. As noted earlier, his own personal interest in beautiful, slightly dangerous mavericks resulted in the appearance of such characters throughout his work, their charisma tempered by a callousness that frequently punctured the dreams of the more sensitive, often female, figures. Williams possessed the ability to place himself as writer in a space somewhere between the two sets of characters, equidistant from both. His work was an inspiration for other playwrights, such as the talented William Inge, and also resulted in some memorable Inge adaptations, including Joshua Logan's *Picnic* (1955), Franklin Schaffner's *Woman of Summer* (crassly retitled *The Stripper*, 1963) – both of which are discussed in Chapter 3 – and Elia Kazan's *Splendor in the Grass* (1961), since producers were ready to explore other Williams-style material. These were all just as centrally concerned with sex, and with its frustration, as Williams' work, but Tennessee Williams remained the poet laureate of the adapted American play, his value as a purveyor of sensational material doing absolutely no harm to the box office prospects of these films.

Suddenly, Last Summer (1959) boasted a collaborative screenplay between Tennessee Williams and another gay writer of distinction, Gore Vidal, with the direction entrusted to a filmmaker noted for his respect for the written word: Joseph L. Mankiewicz. With the formidable Katharine Hepburn in the key role of the manipulative Mrs Venable, one sequence at least was guaranteed a weight and gravitas that few other actresses could have brought to it: a lengthy monologue delivered with a growing sense of horror in which she describes a trip made with her now dead son Sebastian 'one long ago summer'. Mother and son are on a beach, noting that birds of prey descend from the skies to consume the bodies of newly hatched turtles. This memory has a metaphorical resonance when her son Sebastian, who has witnessed the animal slaughter, talks about having seen God and falls into a fever. His own death is to echo those described by Mrs Venable. Sebastian is a homosexual and what we would now describe as a sex tourist, and, as related by his cousin Catherine (played with intensity by Elizabeth Taylor), he is followed by a group of young boys who he has paid for sex but who grow angry with him when he withholds the money. What follows is a gruesome act of mass cannibalism, witnessed by and traumatising Catherine. Mrs Venable, refusing to accept the truth about her beloved

son, attempts to silence Catherine by all the means at her disposal – including medical means. This combination of Grand Guignol horror and a description of a sexual predilection until recently unacceptable in American cinema had a suitably electric effect on audiences, but by presenting the beautiful – and unseen – Sebastian as a sexual predator who comes to a grisly end, the playwright counterintuitively appears to be connecting his own sexuality with negative and proscriptive attitudes; this recalls Marcel Proust and *À la recherche du temps perdu*, in which predatory homosexual acts are often described in distinctly negative terms.

But the use of sexual imagery in *Suddenly, Last Summer* has a heterosexual aspect as well. In order to attract his bisexual prey, Sebastian persuades his cousin to dress in a clinging white swimsuit which leaves little to the imagination, bringing hordes of gawping onlookers to hang from the wire mesh of the private beach on which Catherine (Elizabeth Taylor) displays herself. The erotic image of Taylor, her décolletage on conspicuous display in the swimsuit, became one of the actress's most iconic sexual images, matching the tight slip she wore when playing a prostitute in the Daniel Mann film of John O'Hara's *Butterfield 8* (1960). Thus, in Mankiewicz's presentation, both heterosexual and homosexual sex possess a dark and exploitative aspect – but to look for more enlightened views of sexuality in the films of an earlier era is often a fruitless exercise.

In terms of the dialogue, the literate Mankiewicz had the full measure of the material that Tennessee Williams and Gore Vidal had given him to work with. Even as far back as the 1950s, the director was well aware that audiences had a short attention span and an impatience with lengthy dialogue scenes, but he had no intention of humouring them in this regard, perhaps presupposing that the more startling aspects of the material would still attract audiences. Montgomery Clift's psychiatrist in the movie is a dour figure seemingly present for expository reasons more than anything else, but the film's dramatic charge is unarguable.

Why won't Brick sleep with Maggie?

Were Tennessee Williams to be adapted for the cinema in the modern era, there would be no need for the inevitable snipping of scissors or pre-censorship rewriting that blighted all his work; some examples of this syndrome are more egregious than others. *Cat on a Hot Tin Roof* (directed in 1958 by Richard Brooks) is essentially about the exposure of a form of insidious corruption, as in Ibsen's *Ghosts*. In the latter

play, the dark secret was venereal disease, in the play *Cat on a Hot Tin Roof*, it is latent homosexuality – but not in the film version. Once again, the playwright's treatment of a subject to which he might have been thought to be sympathetic is distinctly ambiguous. However, the nervous clean-up process that took place on the film ruinously alters the revelation and makes a nonsense of what is otherwise a striking piece of work. The central characters, Maggie and her husband Brick, an alcoholic ex-football player, are attending Brick's father's sixty-fifth birthday. Other relatives are present, and they know that the father, Big Daddy, is dying of cancer. This Dickensian conceit – showing how the knowledge of an imminent death brings out all the worst qualities in those who are likely to gain from it – is only one of the themes of the play; the principal one is Maggie's desperate and sexually unfulfilled love for Brick. Maggie (played by Elizabeth Taylor) is keen for Brick (Paul Newman) to impregnate her – a metaphor for the sexual intercourse that is not taking place between this married couple.

Taylor does her best with the material, and is able to suggest the pressing sexual frustration that is expressed by the metaphor of the title – she is known as 'Maggie the Cat'. Burl Ives as the imposing patriarch is reliably imperious while conveying the character's vulnerability; a suggestion remains in the film that he may have had gay experiences in his youth, which is ironic given the removal of such notions concerning his son.

So, in this neutered version, what precisely is Brick's problem? The character is played in a surly, uncommunicative fashion by Paul Newman, and audiences are left to scratch their heads as to why he is so resistant to his wife's abundant charms, which are displayed in a tight white slip as they are in other Taylor films. The answer is to be found in the general softening the material has received in its transition from stage to screen. This softening includes a ludicrous clergyman from the play changed into a less offensive lay preacher; a similar wish to avoid giving offence to the church had previously been granted in a Hollywood version of *The Three Musketeers* (1948) in which Cardinal Richelieu loses his ecclesiastical title, and in the Hollywood film of Jane Austen's *Pride and Prejudice* (1940), in which the odious clergyman Mr Collins is similarly divested of his vestments. The dialogue, too, is softened in a variety of ways. But the key revelation of the play – the homosexual impulses in Brick towards his dead teammate Skipper – has been changed into a suspicion that Maggie was unfaithful with the latter, hence Brick's refusal to have sex with her. One would have to be placed into the mindset of an audience in the late 1950s to know

whether this ludicrous, unconvincing substitution persuaded anyone, even those unaware of the original theme of the play; today, it looks like one of Hollywood's most conspicuous acts of cowardice in the face of the censors. However, a great deal of the requisite Tennessee Williams atmosphere remains, which affords some pleasure, and the playing throughout is strong, but it is essentially not the play that Tennessee Williams wrote.

Period repression

Peter Glenville's translation of *Summer and Smoke*, filmed in 1961, utilised a period setting as the backdrop for the characters' problems of promiscuity and battles with self-control. The theme here, as so often with Williams, is sexual guilt, and while the characters are frequently unable to throw off the constraints that such guilt creates in them, there is a sense that some kind of amelioration is possible; although some characters are destroyed, a certain measure of happiness is parcelled out to others. The adaptation by James Poe and Meade Roberts goes back to one of the writer's earlier plays, but with the director sanctioning a degree of sentiment and overt symbolism. However, the playing of the actress Geraldine Page almost single-handedly saves the movie, along with a sensitive score by Elmer Bernstein that refuses to underline the more indulgent moments of the drama.

The repressed Miss Alma played by Page – a specialist in such roles, who was to play very successfully against type in a subsequent Williams adaptation, *Sweet Bird of Youth* – falls in love with an attractive but philandering young man played by Laurence Harvey with one of the unconvincing American accents he adopted throughout his Hollywood career. Harvey's character is a doctor and is attracted to Alma, but he is more prepared to indulge the pleasures of the flesh with women who – unlike her – have no problems with such things. As Alma becomes aware that her reserve has cost her the one thing that is most important to her, her fragile mental state collapses and she begins a journey that looks likely to end in the polar opposite of her virginal obsession – prostitution. The visual look of the film is finessed by Glenville's carefully observed period detail, which complements the material, but the director is well aware that the greatest asset his film possesses is not Williams' drama – hardly his best – in which the playwright is rehearsing some familiar themes (the neurasthenic Alma is a distant relative of Blanche DuBois) but his leading actress Geraldine Page. Her tightly wrought performances in such parts are usually mannered

and brittle, but for those prepared to look beyond the surface there is considerable truthfulness, the actress powerfully conveying the destructive effects of sexual waste and inhibition.

Castration and whisky priests

Following *Cat on a Hot Tin Roof*, in 1962 Richard Brooks made a more creditable stab at a Williams property with *Sweet Bird of Youth*, using Geraldine Page in a very different part from her role in *Summer and Smoke*. As the drunken, dissolute film star Alexandra del Lago, not averse to paying good-looking young men for sex, the part – flamboyantly tackled by the actress – demonstrated her considerable range. The film really is hers, despite Paul Newman's brash stab at a fading gigolo, played with a great deal more assurance than his part in Brooks' first Williams adaptation. The acerbic dialogue was delivered with éclat by a strong cast, but once again the dead hand of censorship – still active even as late as 1962 – removed a key element of Williams' original scenario. Chance Wayne, the Newman character, has upset a local bigwig by dallying with his daughter and the latter's vaguely incestuous brother catches up with him in the company of a thuggish associate. In the original play, Wayne has one testicle removed, with the line 'I'm going to leave you half a man'; the censored equivalent here is for the handsome Chance to have his nose broken – not so that his sexual performance will be reduced, but so that women will not look at him again. The make-up in the scene hardly suggests that Newman's character will have lost his looks for long, and the director himself was deeply unhappy with the compromise forced upon him. Nevertheless, the film, despite some overheated playing (notably from Ed Begley), is one of the more successful Tennessee Williams adaptations.

By the time of such Williams' films as John Huston's *The Night of the Iguana* (1964), the playwright's power to shock had diminished considerably, but his observations of a group of misfits who have washed up on the veranda of a Mexican hotel may have been able to indulge in a certain ribaldry that was not possible before. Although the basic theme is still a tricky one, it is executed in a somewhat anodyne fashion. Richard Burton plays the Reverend Lawrence Shannon, a defrocked alcoholic clergyman living a life of indulgence, and currently showing a group of women teachers around the country and concealing his past as a rapist of young girls. Burton, encouraged by Huston, makes commendably little effort to render his character sympathetic, but the transformation of his latest teenage prey from Williams' original into a

straightforward parcel of throbbing female hormones makes Shannon's half-hearted attempts to resist her a rather crass pantomime. The girl is played by Sue Lyon, who had already played Lolita for Stanley Kubrick and therefore carried a certain baggage in this kind of part. Ava Gardner brings her own baggage – this time her own private life – in her playing of a sexually voracious mature woman, a hotelkeeper with nymphomaniac tendencies (the part was originally created by Bette Davis). Completing the cast, Deborah Kerr unambitiously channels the virginal side of her CV as a repressed portrait painter. Dispiritingly, a pet iguana, constantly straining at the leash to which it is attached, brings an unwelcome symbolism reflecting the confined space of the characters, and reminds us that Huston as a director could be more engaged by an unpretentious thriller such as *The List of Adrian Messenger* (made the preceding year) than with a more overtly serious piece such as this. And the fact that Tennessee Williams – leaving aside his other skills – had lost his ability to scandalise was also noticeable in the films of such plays as *This Property is Condemned* (Sydney Pollack, 1966); this is passably entertaining but clearly lacks the voltage of the earlier Williams adaptations. Nevertheless, the playwright's place in both the theatrical and cinematic pantheons is assured.

6
Arthouse Cinema in Italy: The New Explicitness

Erotica italiana

Is sexuality the key to Italian cinema? Eroticism is ever present: from the unbridled sensuality of the orgy scenes in silent Italian cinema, through a topless Sophia Loren in a 1950s historical epic, to the image of Silvana Mangano, her skirt provocatively tucked into her underwear in the Neorealist classic *Bitter Rice* (*Riso Amaro*), and to the erotic obsessions of Fellini and the more cerebral but still passion-centred movies of Antonioni. And then there's the popular Italian cinema: the acres of tanned flesh (both male and female) on offer in the many sword and sandal epics of the peplum era through to the inextricable mix of sexuality and violence in the *gialli* of such directors as Mario Bava and Dario Argento. The latter may be said to be the final exhausted sigh of Italian concupiscence: a full-on Liebestod in which death and sex meet in a blood-drenched, orgasmic finale.

Of course, there is far more to the genius of Italian cinema than this one motivating factor, and, while the industry may be in abeyance today, its history represents one of the most glorious and energetic celebrations of the medium of cinema that any nation has ever offered. For many years, this astonishing legacy was largely unseen, but the DVD revolution is making virtually everything available, from Steve Reeves' muscle epics to long-unseen Italian arthouse movies, the latter often known to cinephiles by name only. The element of social commitment, often a key theme in Neorealism, gave way as the years progressed to delirious experiments with other genres, often with a strongly surrealistic overtone, but the one characteristic that most of the great (and not so great) Italian movies have in common is the sheer individualism of the directors. And this applies to the populist moviemakers as much

as to the giants of serious cinema. While Federico Fellini, Luchino Visconti and Michelangelo Antonioni have rightly assumed their places in the pantheon, such talented popular auteurs as Sergio Leone have acquired a copper-bottomed following over the years, after the almost derisory reaction that their otherwise highly successful movies initially received – mainly due to the fact that Leone and co. were using a popular genre, the Western, and doing something with it that no American director would dare to do, so radical was the rethink.

Sexuality is certainly the wellspring of one of the key documents of Italian Neorealism, Luchino Visconti's *Obsession* (*Ossessione*, 1943). This was a sultry, highly eroticised version of James M. Cain's *The Postman Always Rings Twice*, and one that made the Hollywood version with John Garfield and Lana Turner seem a very buttoned-up affair indeed – it was to be many years before Jack Nicholson and Jessica Lange would put tabletop intercourse back into the tale. Visconti's *Obsession* (with Massimo Girotti and Clara Calamai) is a key film in the history of Italian cinema, as it functions on so many different levels. The director had been associated with the writers and filmmakers of the journal *Cinema*, which was in fact a project put together by Vittorio Mussolini, the dictator's son, and he had already set out a manifesto that included a swingeing attack on standard Italian cinema of the day. This essay, entitled 'Cadavers', also articulated his feelings that the everyday life of men and women should be encapsulated in cinema, along with a keen and subtle response to the locales in which human dramas were placed. The Minister of Popular Culture, Alessandro Pavolini, had rejected a proposed film of a Verga short story, 'Gramigna's Lover', as it did not conform to the rules of Fascist cinema. As a replacement project, Visconti considered Melville's *Billy Budd*, later filmed by Peter Ustinov, but finally opted for a film based on a French translation he had read of Cain's *Postman*, with its betrayal, sexuality and resolutely blue-collar characters. With the assistance of such colleagues as Giuseppe De Santis (who would later become a director himself), Visconti relocated the book to a sweltering Italy, taking its classic tale of a couple who murder the woman's husband for his money, and then fall out in an orgy of what ultimately proves to be lethal squabbling, and making it quintessentially Italian. The characters of Frank, Cora and Nick become Gino Costa and Giovanna and Giuseppe Bragana; the latter is characterised as an admirer of Verdi – an element that would not have displeased the opera-loving Cain. But the principal change to the novel was the removal of the focus on the district attorney and Frank's lawyer. In their place, Visconti created the homosexual Lo Spagnolo (the Spaniard,

played by Elio Marcuzzo), an early example of the gay director's own interest in homosexuality. The first-person narrative of the novel was jettisoned for a cool and dispassionate camera style that brilliantly portrayed the baked, arid landscapes with what was striking novelty for the time. All the elements were brought together in a synthesis that was quite unlike anything else that had previously been attempted in Italian cinema. There are details that are far more striking than anything to be found in the Tay Garnett US version of the story, such as Gino shaving with a straight razor while, in the background, Giovanna massages the overweight body of her husband – as a harbinger of the violent death to follow, this is a perfect visual metaphor. The film created something of a sensation, particularly among such critics as André Bazin, and it was clear that Visconti had elevated the squalid sex and violence of Cain's plot into something that was genuinely operatic yet never over the top.

Needless to say, the film caused a scandal in the censorious atmosphere of Mussolini's Italy. Il Duce himself looked at the film, but did not halt its distribution. It was left to his son Vittorio to famously denounce the film, after a public screening, with the words 'This is not Italy.' Perhaps it was not the Italy of the Fascists, but the humanity and power of the film survive after so many of the dull propaganda pieces of the day have fallen by the wayside.

Giuseppe De Santis was, like so many filmmakers, a writer on film and produced celebrated work in the magazine *Cinema*. His experience with Visconti on *Obsession* inspired him to direct his own films; his first, *Tragic Pursuit* (*Caccia Tragica*, 1947) was a drama about Italian partisans. However, it was with *Bitter Rice* (*Riso Amaro*, 1949) that De Santis really made his mark and produced one of the defining works of Italian Neorealist cinema. Ironically, a great deal of the film's success lay in its erotic charge – another example of the sensuality often beneath the surface in Italian cinema. The image of the seductive Silvana Mangano, mentioned above, became one of the most famous images in cinema, and suggested to audiences worldwide that a more realistic eroticism was to be found in foreign films than in the neutered post-Hays Code world of Hollywood.

Bitter Rice mines similar territory to that of *Obsession*: a James M. Cain-style plot of erotic obsession and violence. The film involves four protagonists: Doris Dowling is Francesca and Vittorio Gassman Walter, a couple who have committed a jewel theft and have escaped on a train taking women to work in the rice fields of the Po Valley. Although they escape justice, great problems await them there. Francesca meets the charismatic Marco, an Italian soldier played by Raf Vallone. At the same

time, Walter takes up with a woman working in the rice fields, Silvana; the latter is played by the sensuous Silvana Mangano, who ironically would later become an image of reserved rectitude for such directors as Visconti in *Death in Venice*. Walter persuades Silvana to help him steal some of the rice harvest, but, at the climax of the film, Silvana shoots Walter after discovering that the jewellery he has given her is cheap costume junk, and then she takes her own life.

While the film ostensibly portrays the day-to-day existence of women rice workers who perform back-breaking labour under terrible conditions for a rice allocation and a handful of lire, the elements of melodrama imported from the American hard-boiled genre create a strange synthesis in which a variety of styles are evident. While this fusion may look less successful today than it did in the late 1940s, there is no denying the impact that the film had, not least because of Mangano's revealing outfits. But even though the sight of Mangano's breasts and exposed legs was probably responsible for more ticket sales than the social comment of the film, De Santis was still able to make more cogent points, possibly because of this tactic, than in many a more worthy effort.

Tasting the sweet life: Federico Fellini

The film that established Federico Fellini as a key voice in Italian cinema was *La Dolce Vita* (1960), followed by the autobiographical *8½* (1963) and *Juliet of the Spirits* (*Giulietta degli Spiriti*, 1965), which featured a sympathetic performance by Giulietta Masina. Later films, such as *Fellini Satyricon* (1969) and *Roma* (1972), were rich in the imagery that had become the director's trademark, but lacked the cohesion that made the earlier films so impressive.

La Dolce Vita, in which the feckless journalist Marcello (brilliantly incarnated by Marcello Mastroianni) wanders through a surrealist vision of Rome, is as much a picture of modern Roman society and attitudes to sexuality as it is an attack on both the spiritual aridity of the period and the meaninglessness of religion. The film's view of contemporary sexuality is embodied in the visiting foreign actress, the voluptuous Sylvia (Anita Ekberg), while its celebrated opening shot of the statue of Christ being hauled across the city by helicopter remains one of the best known images of Italian cinema. Ironically, the 'blasphemous' sections would not raise an eyebrow today, and the rather decorous orgies were hardly pornographic even in the 1960s, but the ruthless dissection of pointless celebrity culture is as à propos as ever.

Marcello is an amoral, attractive young journalist with a bevy of seductive admirers who is quietly satisfied with his status and surroundings: 'I like Rome, it is a dark jungle where you can hide yourself.' His is a happy, pointless existence that begins to pall as a series of incidents attacks his equilibrium, culminating in a rather tepid orgy. Mastroianni's performance is beautifully underplayed and sets off the often bizarre imagery perfectly. As so often in Fellini's work, his male protagonist is surrounded by adoring or sexually available females, and the performances of Anouk Aimée and Yvonne Furneaux are as well judged as Ekberg's brief but iconic appearance, famously wading in the Trevi fountain, cleavage resplendent.

Before the sanctioning of nudity in modern cinema, films such as *La Dolce Vita* were obliged to use other strategies to convey their eroticism. Nadia Gray's striptease in the film is discreet and displays little flesh, but Fellini has the actress sensuously caressing her own body with a fur coat, introducing a tactile element of which the audience is clearly meant to be aware; this is one of the reasons why the sequence still functions today, despite its relative modesty.

In the film, the director's avowed preference for physical over intellectual pleasures – despite his popularity with intelligent filmgoers – is personified in Marcello's intellectual colleague Steiner, played by Alain Cuny. Steiner takes Marcello to a slightly stultifying soirée, but the life of the mind he represents is not given a positive, ameliorative gloss – a fact confirmed when Steiner kills himself. Fellini's scalpel-like dissection of Italian decadence cleverly moves between the cruel and the operatic, and his love for the things he criticises grants the film its schizophrenic fascination.

Sprawling across the Totalscope screen in all its episodic glory, the director's epic essay on Italian morality is a vast, uneven work, which created a seismic division in critical opinion that persists to this day, although the striking of a new print in 2004 resulted in a slew of unreservedly enthusiastic reviews. There were those in the past who found the meandering plot and episodic structure irritating, but many saw this as an exhilarating rejection of the linear narrative that had maintained a stranglehold on film for so long.

Many cinemagoers were enticed by the publicity for *Boccaccio '70* (1962), anticipating a generous helping of décolletage from Anita Ekberg, Sophia Loren and Romy Schneider – which they got – although the contributions of the distinguished directors were less obvious. The three sizeable segments of this promising anthology were directed by Federico Fellini, Luchino Visconti and Vittorio De Sica. Fellini's

episode, 'The Temptation of Dr Antonio', was unpretentious and agreeable enough, but the *jeu d'espirt* seemed like a watered-down version of *La Dolce Vita's* derisive onslaughts. Visconti was his usually impressive visual self and provided the most serious entry, but the sombre mood of his sketch struck the wrong note in what was essentially a film of satirical squibs. And, alas, De Sica seemed to have been drained of all that made his work impressive, and 'The Raffle', while being superficially absorbing, was somewhat arid.

After some strikingly designed credits, *Boccaccio '70* opens with Fellini's 'The Temptation of Dr Antonio', which features Ekberg in an unlikely tale that devolves on narrow-mindedness and puritanical bigotry. Antonio (amusingly portrayed by Peppino De Filippo) is a vehemently radical self-appointed censor who objects to anything that conveys the suggestion that sex can be an enjoyable experience. His protests are generally ineffectual but cause much chaos. Antonio's moral indignation is inflamed when a massive hoarding depicting Anita Ekberg is constructed outside his apartment. Ekberg is seductively encouraging the public to 'drink more milk' – the lactation joke is similar to the one made by Frank Tashlin with Jayne Mansfield in *The Girl Can't Help It* – and the episode concludes with a 40-foot Ekberg stepping out of the poster and clutching the terrified Antonio to her breast, in the style of *Attack of the 50 Foot Woman*.

The second episode is set in surroundings of velvety opulence and elegantly suffocating decor. This is Visconti's episode, 'The Job', which tells of a pampered young countess who discovers that her husband is involved in a call girl scandal. Visconti accentuates the heavy, oppressive beauty of the countess's cloistered existence and shows how her every need is satisfied by hovering servants; she has become incapable of any profession in the world but prostitution, which she despairingly takes to at the end of the episode. Visconti's characters are dwarfed by the lushness of their surroundings, forever drifting through doors that lead to yet more lavishly furnished rooms, and their comfortable cages are impregnable. However, not even the fine performances by Schneider and Tomas Milian manage to give the episode much significance.

De Sica's colourful sequence with Sophia Loren as a fairground girl who raffles her body to drooling admirers is rewarding, but it is a long distance from *Bicycle Thieves*. Parcelled together, the three episodes are a pleasant enough *divertimento*, with several incidental voyeuristic frissons, but, ironically, the film is less erotic than many more serious movies, such as those of Antonioni, with their more reined-in sensuality.

The reception accorded to Fellini's *8½* in 1963 was even more divided than the response to his earlier masterpiece, *La Dolce Vita*. Undoubtedly, the seeds of Fellini's later indulgence are clearly in evidence in this thinly disguised autobiographical tale of a director (Mastroianni again) unable to come up with a concept for his next film, despite the endless probing of those around him. Seen today, the excesses seem perfectly apposite to the theme, with Guido Anselmi a somewhat idealised portrait of the director, but with a certain wry self-criticism evident – notably in his reaction to the erotic opportunities presented to him. While trying to finish a science fiction film, Guido is fighting the distractions of friends, mistresses, producers, wives and critics; unsurprisingly, the latter come in for some considerable attention in the film. The format of the film moves between reality and fantasy, and the structure of flashbacks shades into uncertainty: the viewer is constantly disoriented by this approach. Another subject of the film is psychoanalysis, as Guido attempts to examine why he behaves as he does to his wife Luisa (Anouk Aimée) and to his opulent mistress Carla (Sandra Milo, in one of several larger-than-life portrayals that Fellini coaxed from her). In addition, a recurrent theme of this era of personal Italian cinema is the irrelevance of religion in this most Catholic of societies; the figure of the cardinal here offers conventional platitudes, but can give Guido no guidance.

While asleep, Guido is visited by his mother, who takes him to a ceremony where he guides his father into a grave. His relationship with his mother is clearly more than the standard one, and the imagery of this sequence permeates the rest of the film. The film's set pieces are many and splendid, such as the mud bath sequence and the famous harem scene in which a farmhouse Guido knew as a child becomes a repository for all the women he has encountered during his life. When reviewing the women in his imaginary harem, Guido does not encounter the character played by Claudia Cardinale, who takes on various roles in the film. She is a representation of the ideal woman to which Guido aspires, and is the one figure in the film who appears not to want anything from Guido.

To the accompaniment of Nino Rota's distinctive and inimitable score, the film ends with a classically Fellini-esque circus, a motif that became overused in his work, but is fresh and pertinent here. While later films such as *Juliet of the Spirits* may have utilised colour in a more delirious sense, this remains Fellini's most phantasmagorical film.

By the time the director made *Fellini Satyricon* in 1969, his celebrity was such that his name could become part of the title. This loosely

structured, discursive piece, which was essentially a picaresque series of tableaux describing the sexual abandon of Nero's Rome, is seen through its youthful, serviceable protagonists Encolpius (British actor Martin Potter) and Ascyltus (the American Hiram Keller). The two figures wander through what is in essence a surrealist, science fiction landscape with outlandish production design and looking markedly unlike any Rome where Nero ever plucked a string; despite their unaffected manner, almost everything around the meandering young sybarites is operatically unreal. The sexually dextrous protagonists, who are both open to experiences from whatever quarter, move in a kind of half-amused dream state through a series of erotic frescoes. These frescoes are full of characteristic Fellini grotesqueries – his skill at choosing actors for their often bizarre physical appearance is in evidence throughout the film – but they have the effect of de-eroticising the proceedings and rendering the characters and their actions almost affectless. An exception to this is a poignant sequence in which one of the patrician characters, along with his wife, take their own lives rather than submit to the horrors of Nero's regime. There is, however, no denying the dreamlike effect of many of the scenarios, such as the one set in a stadium-sized brothel which offers a positively dizzying number of sexual opportunities in a variety of rooms, and an orgy in a swimming pool (the baths at Caracalla?) with all the participants carrying lighted candles. In another sequence, a sad hermaphroditic figure is spirited away from its cave by the two central characters then callously left to die in the desert. However, the antiheroes are often at the sexual mercy of those around them – for instance, when one of them is chosen to provide sexual services for a homosexual captain – and the film may be said to be a demonstration of a familiar thesis by Fellini: Ancient Rome's decline reflects the modern world in which all moral values are in flux. Some might accuse the director of hypocrisy here, given that he and the audience clearly enjoy the luxurious excesses with which we are presented, but there is no self-consciously moralising tone; we are invited to make up our own minds about what we see.

Fellini's career continued to produce more autumnal essays such as the almost plotless *Roma* (1972) and the anarchic *Orchestral Rehearsal* (*Prova d'Orchestra*, 1978), but what were Marcello Mastroianni and Federico Fellini thinking while they were making *City of Women* (*La Città delle Donne*) in 1980? The businessman who leaves a train to find himself in a society of women has many elements of the director's and star's earlier work together, notably in *8½*. The fact that all the things that made their previous films great appear here as inept clichés surely

must have occurred to them both, but the realisation did not provide the fresh injection of inspiration that was so sorely needed. Certainly, there are good things here: how can any film with Fellini and Mastroianni be devoid of interest? But there is none of the arresting cinematic flair of their earlier collaborations. In the final analysis – and misfires notwithstanding – Fellini's filmic legacy remains secure, although it is undoubtedly true that when any history of cinema is written, it is his 1960s movies that remain his greatest achievement.

Elusive consummation: Michelangelo Antonioni

Fairly early in Michelangelo Antonioni's *La Notte* (1961), Marcello Mastroianni makes a rather weak attempt to resist a voracious, mentally disturbed, naked girl in a hospital who gives every indication of nymphomania as she pulls him towards her bed. It was a scene that gave the censors trouble in its day, and it is only now in the twenty-first century that viewers are able to see (courtesy of a splendid restoration) the things that would clearly have totally destroyed our moral compasses had we been permitted to view them on the film's release.

The work that established Antonioni's pre-eminence in Italian cinema really began with the trilogy of *L'Avventura* (1960), *The Night* (*La Notte*, 1961) and *The Eclipse* (*L'Eclisse*, 1962) and would be consolidated by his first colour film *Red Desert* (*Il Deserto Rosso*, 1964). The international celebrity that began with the English-language films *Blow-Up* (1966) and *Zabriskie Point* (1970) remains a controversial period, not least because of *The Passenger* (*Professione: Reporter*, 1975) with Jack Nicholson.

The director's *La Notte* took the strategies of its predecessor (*L'Avventura*) even further forward in its examination of the unfulfilled lives of its protagonists. Myriad examples of Antonioni's artistry abound here, along with some of the coolest and most uninflected acting in Italian cinema, with a cast that includes Antonioni's muse Monica Vitti. Having worked with Fellini, the most operatic of Italian directors, Mastroianni was now cast in a film for the detached, analytical Antonioni. *La Notte* commits to film one of the actor's finest performances, very different from his Marcello in *La Dolce Vita* but equally buffeted by life's circumstances.

After the universal success his mid-period films enjoyed, Michelangelo Antonioni's later films are something of a mixed bag. But, of course, nothing Antonioni directed could be without interest, and such is the case with his 1982 drama *Identification of a Woman* (*Identificazione di una Donna*). A film director (Tomas Milian) is looking for a woman for a forthcoming project. He finds himself alienated from his upper-crust

girlfriend (Daniela Silverio) and begins a relationship with a young actress (played by Christine Boisson), but the solution to his personal and artistic problems does not lie with her. At the time he made *Identification of a Woman*, Antonioni had been working in video (with mixed results) and some of that new sensibility is to be found here. While the visual appeal of the film is as commanding as one might expect, there is a glacial quality to the proceedings that is rarely transcended in the way that similarly cool surfaces concealed intense emotion in early films such as *L'Avventura*. Although the film evokes the director's earlier work, the effect is in fact to remind the viewer how much more assured such films as *La Notte* were. With the director back on the familiar turf of the perennial difficulty of relationships in the modern world, the customary beauty of his work is overlaid here with an overt eroticism as Antonioni's filmmaker hero entangles himself with two women.

The art of the shocking: Pier Paolo Pasolini

In terms of pushing boundaries, the filmmaker Pier Paolo Pasolini had few rivals. *The Canterbury Tales* (*I Racconti di Canterbury*), directed by Pasolini in 1972, was a brave, and perhaps foolhardy, attempt at filming a classic English author. Chaucer was himself influenced, of course, by *The Decameron*, which Pasolini had already filmed the previous year. The film is a mixed success, and in some ways very strange indeed. Plunging with gusto into some of the blackest and bawdiest of the tales, Pasolini celebrates almost every conceivable form of sexual act with a rich, earthy humour and weaves a visual magic that draws on the work of artists such as Brueghel and Bosch. Pasolini himself takes the part of Chaucer. One might have thought that the presence of English actors such as Hugh Griffith and Tom Baker in the film might have the effect of anglicising it, but as they are cast alongside Laura Betti and Pasolini regular Franco Citti, the final effect suggests some bizarre alternative universe that has little to do with Chaucer – or even Italy, for that matter. As always in Pasolini's sex trilogy (*The Decameron*, *The Canterbury Tales* and *The Arabian Nights*), comic invention is to be found alongside enthusiastic sexuality. If some of the performances seem strained, that is perhaps understandable; less acceptable are the rather dull stretches that interleave what one might expect to be a constantly eye-opening experience.

The Arabian Nights (*Il Fiore delle Mille e Una Notte*, 1974) is perhaps the most accessible of Pasolini's trilogy. The three films created something

of a censorship stir in their day, with the bawdiness of the sexual depictions, including the occasional erection. Today, of course, they would hardly rate a mention, and time has, generally, been kind to them, even though Pasolini's use of non-actors achieved mixed results, as it always does. The ten tales from *1,001 Nights* were handled with real brio by the director, whose celebration of heterosexual love is not at all compromised by his own gay leanings. While the non-professional actors often find the demands of their roles beyond their limited abilities, an undoubted earthiness is conveyed by the use of such a cast, and the settings are stark and beautiful. Looked at today, the trilogy has much to offer, as well as its occasional clumsiness and longueurs. Shot in the exotic settings of Ethiopia, Yemen, Nepal and Iran, *Arabian Nights* celebrates guiltless, heterosexual love within a universe of magical signs and evil djinns who are all subject to the vagaries of Destiny. Ennio Morricone contributes beautiful, sparse musical motifs.

Pasolini's earlier *Theorem* (*Teorema*, 1968) is an enigmatic fable used by the director to explore family dynamics and in particular the subversive power of sexuality. The film presents a seductive, mysterious stranger (played by a young and charismatic Terence Stamp) who arrives at the home of a wealthy Italian bourgeois family and seduces each member of the household in turn, including the maid. The effect of his visit is seismic. The film is a visually striking and disturbing political allegory, examining the mechanics of family interaction, class and sex. *Theorem* bagged a prize at the Venice Film Festival, but was subsequently banned on an obscenity charge. However, Pasolini later won an acquittal on the grounds of the film's 'high artistic value'.

Cinematic excess

However, Pasolini's truly scandalous magnum opus in terms of graphic, twisted sexuality is the much-banned *Salò, or the 120 Days of Sodom* (1975). For a long time, the very title of Pasolini's film was an index of the unacceptable in cinematic excess – a film so disturbing in its uncompromising violence and perverted sexuality that it seemed as if it would forever have censorship problems. The horrors of the last reel were famously among the most unsettling ever put on celluloid, all the more disturbing for the director's consummate skill at using sex as a metaphor for power. It is also a prophetic view of our contemporary corporate-run culture of consumerism. Drawing on the Marquis de Sade's original novel, the film depicts the series of sexual tortures inflicted by four libertines upon a group of young men and women.

Unavailable in Britain for many years, *Salò* was finally passed uncut by the BBFC in late 2000.

Is it possible, even for film scholars, to regard *Salò* as an integral part of its controversial director's oeuvre – or does its continuing notoriety mean that any consideration of the film demands that this most shocking example of Pasolini's films be viewed in isolation? Issues of semiotics are forced into any discussion of the film; *Salò's* procession of good-looking, often naked young men – precisely the kind of available youths that Pasolini visited in the male red light areas of Rome – reflects on his own life, and not least on the violence of his death at the hands of one of these young men, which meant that *Salò* was the director's final film. Can *Salò* be read as a personal testament – Pasolini's loathing of Fascism and political conformity being writ large in the film – or do we read it as an ingenious modernisation of de Sade's iconoclastic text, with a notably ambiguous layer of voyeurism? The initial affront to middle-class morality may be seen in the film's lubrication by a variety of substances: blood, urine, excrement and semen, although the ejaculations of the film are suggested rather than seen. And although it is quite widely known that the banquet of excrement consumed with enthusiasm from a silver salver by the Fascist libertines and with disgust by their tormented sexual slaves consists of chocolate and chopped nuts, this knowledge of the actual ingredients does not make it any easier to watch. This scene shows that Pasolini even had the food industry in his sights; his description of the film's coprophagy suggested that it was a comment on processed foods – and, whether or not one accepts the director's suggestion, his view of junk food is just as pertinent today.

Catholic moralists were one of the director's much-relished establishment targets – the film's monstrous authority figures represent the state, the church and the judiciary, all of whom are shown to possess an enthusiastic penchant for depravity of every kind – and religious commentators could barely contain their glee at the news that the 'dissolute' director had died at the hands of a member of the rough trade with whom he conducted commercial sexual transactions. Pasolini would not have been surprised at the uncharitable schadenfreude of his opponents, as he expected as little in the way of charitable attitudes from them as he was prepared to extend. But despite the intense seriousness of his work, Pasolini shared with exploitation filmmakers a knowledge of, and pleasure in, the fact that the church and the courts would customarily criticise and raid his work, thereby validating his credentials as the ultimate intellectual rebel of the Left. He was also well

aware that in the intensely macho attitudes of Italian society, his avowal of homosexuality would be perhaps his greatest sin, far more shocking than his anticlericalism.

Thus, in answer to the question posed above, it is impossible to consider *Salò* in isolation.

The director (as intellectual, prestidigitator and showman) prefixes the film with a variety of heavyweight names as suggestions for further reading, from Simone de Beauvoir to Roland Barthes. Our appreciation of the film is always filtered through the prism of its provocative director, interrogating our responses to it as much as we interrogate his own agenda, which often remains impenetrable. How, for instance, are we to regard the three principal groups taking part in the orgies in the chateau near Salò? The corrupt authority figures, the libertines, are such a thoroughly loathsome bunch without an iota of humanity that our response to them seems preordained. But what to make of the enforcers, the good-looking young men who ensure by violence that the tortures and depravities ordered by their masters take place? They are also called the 'fuckers' and are invited by the libertines to take advantage of the brutalised victims whenever the fancy takes them – although there are, in fact, ludicrously arbitrary rules that can be broken, it seems, by the libertines alone, proving that establishment figures adhere to their own rules only when it is convenient for them.

The enforcers/fuckers are marginally less monstrous than their bosses, but are united by a swiftly acquired common callousness – and by their prodigious endowments. In the recruitment scenes, the camera pans down to view their genitals, ensuring that they meet the judges' specifications; the actors in the early scenes have normally proportioned genitals, but these are replaced late in the film by obvious, and unlikely, prosthetics. But although all the young men are equally endowed with massive penises, the only erection we see – in shadow on a wall as a young woman victim is brutally buggered – is patently false; is the director expecting us to be taken in by the sleight of hand or to realise that such fakery is part of a kind of grotesque adult puppet show?

Finally – and crucially – there are the victims: the young males and females rounded up ruthlessly at the beginning of the film, stripped so that their bodies can be assessed as suitable for humiliation. How do we regard them? Are we meant to identify with their appalling suffering? It is the victims who present the greatest problem for the viewer who (hopefully) does not share the dehumanised pitilessness of the libertines. There is very little attempt to characterise the luckless young men and women who are subjected to sexual humiliation, torture and

ultimately death in the chateau to which they are brought, although the distress of one victim whose mother died trying to save her is given a certain emphasis. Pasolini's explanation for this blankness on the part of his attractive young sacrificial victims is that the film would have been completely unbearable had he attempted to stress their humanity. In fact, one might see this attitude on the director's part as being somewhat disingenuous; even without any attempt to characterise the victims, the viewer's natural humanity will make us suffer along with them as each fresh horror is served up. Rare will be the viewer of *Salò* who can watch the activities on the screen at a dispassionate distance, *sub specie aeternitatis*; such dispassionate spectators would be akin to the Mussolini-era monsters that the film depicts. Pasolini's endeavours to keep his victims at a distance is certainly rigorous: when the daughters of the libertines are married off en masse to each other's fathers, they appear (as so often with the victims in the film) to be dull and bovine, hardly responding to the hideous things expected of them. One corollary of Pasolini's representation of his victims in this fashion is that when one of them attempts to break away from the horrors by springing out of a car or running across a room to a window, they pay for their rebelliousness by being machine-gunned or having their throats ripped open. There is no escape in *Salò* but death.

The sense of prelapsarian loss that pervades the work of Pasolini perhaps originates in the director's youth in the Arcadian region of Friuli near Venice, and, like Marcel Proust – another intellectual (and gay) chronicler of decadent aristocracy intersecting with low life – Pasolini regarded his vanished childhood as the most important period in his life. Like the author of *À la recherche du temps perdu*, the filmmaker distrusted the forces of modernism that swept away this idealised past, and the rigid systems that regulate how people must lead their lives were anathema to him; his revulsion finds its most telling expression in the doctrines laid down by the libertines of *Salò*. Certainly, the director's fascination with Marxism – a creed he never fully embraced without caveats – would not suggest an embrace of the shibboleths of doctrinaire political systems.

Pasolini's attraction to the past inspired his last four films, all based on pre-existing literature: the *Decameron* (after Boccaccio), *Canterbury Tales* (Chaucer), the *Arabian Nights*, and, in his final film, the Marquis de Sade. The carefully arranged structure of the latter's novel, with its orgies set within the context of the 'storytellers' who set up each encounter, is here presented in almost terpsichorean fashion. The sexual encounters are dictated or prompted by a series of mature, elegantly

dressed courtesans whose function is to arouse the libertines as well as the 'fuckers', who often perform a variety of random sexual acts even as the stories are still being told by the always decorous narrators – although one of them is asked to display her best feature, which she does with a smile, lifting her skirt to reveal her naked buttocks.

One of the taboos repeatedly broken in the source novel is incest, but Pasolini replaces that frisson with a variety of more shocking tableaux: the aforementioned banquet of excrement, repeated flagellation and the enjoyment (by one of the libertines) of being urinated upon. One of the most shocking scenes occurs when the character played by Paolo Bonacelli – perhaps the one libertine given slightly more nuance than simply being presented as a vicious psychopath, although he certainly is that – insists that one of the more innocent girls urinate upon him as he enthusiastically drinks it. The scene, like many of the sexual acts in the film, shows no genitals; all we see is the girl lifting her skirt and then a stream of urine playing on Bonacelli, straddled beneath her, but it is rendered particularly outrageous by the excited response of the male character. Another scene, similarly discreet in its presentation, involves simultaneous urination by one of the male oppressors and a young girl; the socially unacceptable aspect of this relatively innocent transgression has, counterintuitively, more impact than the more brutal simulations elsewhere in the film.

There is also a disturbing hint of complicity in the behaviour of the victims; it is not made clear whether or not they understand from the very beginning the grim fates in store for them, and there is a strange mixture of uneasiness and sometimes wryly amused acceptance, which suggests – as may be discerned on several occasions during the film – that the universe Pasolini unfurls for the viewer is as much the 1970s as the Fascist era. There is a certain sexual bartering across gender divisions that has become part of the lingua franca of all participants, with even a hint that the sadomasochistic practices that were more ideologically acceptable in Pasolini's own day were already attaining a currency in the 1940s.

In terms of the presentation of the nude male and female body in *Salò*, a cursory reading of the film might suggest that Pasolini maintains an 'equal opportunities' policy in terms of his invitation to the spectator's gaze, whatever their sexual preferences. A similar amount of screen time is given to the libertines' contemplation of the young men and women corralled for their pleasure, and the breasts and pubic hair of the young girls are exposed just as much as the genitals of the young men, although the latter are given close-ups. Pasolini's own preferences are

apparent in the greater attention paid to the scenes of sodomy between libertine and 'fucker', which often appear to be of a more consensual nature than any of the representations of heterosexual intercourse; in fact, the one scene of sexual relations between a young male and a female victim is brutally interrupted by the libertines. And while Pasolini may make no comment on the sexual activities of his libertines, although we never forget that everyone apart from them is there under duress, the vagina remains a shameful thing throughout the film. In one of the courtesans' stories, she is told as a young girl by one of her lovers to hide her vagina and display only her much-preferred buttocks. In fact, during the course of *Salò*, any sexual penetration involving women is always anal. Generally speaking, the attitude to straightforward heterosexual sex in the film might best be described as one of disgust, albeit tempered with an unflinching curiosity.

In the final section of the film, 'Circle of Blood', we are shown the images that gave the film its greatest notoriety: the cruel torture and murder of the victims. The breasts of one of the female victims are burned by a candle, as are the (prosthetic) genitals of one of the boys; an eye is prised from its socket and one of the girls is graphically scalped. What makes these latter scenes particularly disturbing is the fact that they are observed from a distance by the libertines, watching from a far-off room through binoculars. This distancing, far from creating Brecht's *Verfremdungseffekt* or alienation from involvement with the action, lends a grim verisimilitude to the atrocities as Pasolini wisely cuts away from the gruesome special effects (such as the obvious putty on the forehead of the young girl being scalped) before we are allowed to 'rumble' the subterfuge.

Viewed in the twenty-first century, Pasolini's last film has not lost its power to shock and it remains one of those examples of extreme cinema (including Tom Six's *The Human Centipede* (2009), with its naked victims sewed together mouth to anus) that many viewers simply refuse to see on principle, having heard descriptions such as the ones detailed above. Nevertheless, Pasolini's film remains a serious work by a serious director and it makes its uncompromising points in a fashion that is both utterly unsparing and curiously ambiguous, constantly inviting the viewer to look beyond the initial disgust they might feel at what they are actually being shown. A picture of a corrupt establishment by no means lends itself, as one might imagine, to the kind of Marxist interpretation that the director's well-known radical views might suggest; he was always too complex a filmmaker to allow for such a reductive analysis.

Perhaps the most disturbing thing about the film, however, is its abrupt ending. It is thought that lost footage demonstrated that the libertines might meet a similar violent end to that of their master, Mussolini, but they are never shown receiving any kind of punishment for their appalling behaviour. The last scene of the film is a curious, slightly homoerotic dance between two heterosexual guards; as with so much else in the film, we leave the cinema trying to decide just what response the director was attempting to instil in the viewer.

Celebrating the female body: Tinto Brass

Is Tinto Brass a filmmaker who sacrificed an authentic talent in order to move into more lucrative pornographic endeavours? A pornographer, however, still boasting many of the accoutrements of a film artist, even as we are invited to contemplate a lustrously shot parade of rounded female bottoms? For many years, Tinto Brass's Italo-German production *Salon Kitty* (1976) was available only in a heavily cut form, but nevertheless enjoyed considerable notoriety for its depiction of the sexual excesses of the Nazi regime. Based on actual events, Brass's film takes place in Berlin in 1939 and is principally set in a brothel, staffed by girls of good Aryan stock and impeccable National Socialist credentials who are used to worm secrets out of indiscreet clients. In fact, *Salon Kitty* begot an entire subgenre: the Italian Nazi excess movie, with the graphic sexuality of Brass's film shored up with equally unflinching violence. But now that a director's cut of *Salon Kitty* is available with nearly 18 minutes of censored material restored, it is possible to judge the director's intention, hopefully shaking off the excrescences that have attached themselves to the film since its release.

How does it look in the twenty-first century? The good things first: it was a considerable coup for Tinto Brass to acquire as his set designer the man who bids fair to be the finest in the history of the cinema – the two-time Oscar-winner Ken Adam, no less, fresh off turbulent work with Stanley Kubrick. His settings for this vision of a decadent Third Reich are full of his trademark glittering surfaces, uncluttered expanses and modernistic design; this is probably the film's key asset (along with 'frequent sex'), as the DVD sleeve notes.

But Brass has another ace in the hole: one of the great actresses of the cinema, Ingrid Thulin, long one of the most reliable muses of Ingmar Bergman, before younger actresses such as Liv Ullmann usurped her. She is the eponymous Kitty, the vulnerable madam who takes on the corrupt SS Officer Helmut Wallenberg; the latter is played by Helmut

Berger, in a replay of his role in Visconti's *The Damned*. Thulin's performance is more mannered than her work for Bergman, but she retains a pathetic dignity, appropriate in the face of the sexual shenanigans of which her character is the ringmaster. Another plus is the vocal dubbing of her Kurt Weill-like songs by the English jazz singer Annie Ross – past her best, but supplying the right Lotte Lenya-like note. And, probably best of all for most people, the restoration of the highly stylised, in-your-face eroticism that became the director's stock in trade is still eye-opening, even today. The nudity is almost non-stop, and most of the orgies contain shots of labia and semi-erections that really would have brought about the fall of Western civilisation had we been allowed to see them.

On the debit side, this is a salutary reminder that Brass was never a sympathetic director of actors: most are encouraged to play full out (including a Nazi officer who comically shouts every single line of his dialogue), and they labour under the disadvantage of acting in something other than their native language. This comprehensively sinks Helmut Berger's performance, as his English simply is not good enough – even post-synched – to pass muster. Subtlety is nowhere to be found, and other mysteries include the presence of American actor John Ireland, top billed, but given virtually nothing to do. So, a disappointment. Nevertheless, it is always a cause for celebration when censorship is routed, and a director's intentions (however dubious) are given their head – anyone who would argue with this proposition is clearly not a cinema buff.

When Brass asked that his name be removed from the credits of *Caligula* (1979) after the producer Bob Guccione had ordered sexually graphic inserts between the emoting (as Ancient Romans) of such British thesps as Dame Helen Mirren and Sir John Gielgud, there were those who felt that the director might be splitting hairs with his insistence that there was a difference between pornography and erotica. He has puzzlingly described this schism as follows: 'Pornography is there to give you an erection. Erotica is there to give you emotions.' Certainly, the penetrations and ejaculations of *Caligula* – which do not involve the principal actors – were firmly in the pornography category, and there were those who speculated that the scene in which Gielgud opens his wrists in a warm bath was not just a representation of the death of a Roman patrician but a metaphor for the actor's wish to get out of the film. However, Malcolm McDowell has said that Gielgud was pleasantly bemused, surrounded by all the concupiscence.

But by the time of the director's next major film, the sensuous *The Key* (*La Chiave*, 1983), audiences had been made aware of Brass's

distinction between the two different approaches to sex on the screen. This film again starred a respected British actor, the silver-maned Frank Finlay, who had form in this area as Dennis Potter's *Casanova*. Finlay plays a man who is desperately afraid that he is to lose his voluptuous wife Teresa (played by the pneumatic Stefania Sandrelli), as he is finding that he is unable to satisfy her sexually. He arranges clandestinely for his wife to have an affair by taking nude photographs of her and suggesting that the lover he has lined up for her develops them. Then, in voyeuristic fashion, he keeps track of this burgeoning relationship by reading her diary. But she is also reading his ...

What is the most significant thing about *The Key*? Is it the splendidly shot, wintry Venetian locations? The evocative Ennio Morricone score? The composer was clearly able to turn his hand to more genres than any of his confrères. Or the beautifully realised sense of period? The timescale here is 1940, just before Mussolini's Italy entered World War II. Although all of these elements – including the sumptuous production design – grant the film an impressive veneer, its clearest imperative, frankly, is a loving exploration by camera of the body of its leading lady, whose every curve and crevice is examined in forensic detail. These scenes almost always show Sandrelli wearing exotic lingerie, and most shots end with a close-up of her buttocks – clearly, in her director's eyes, the actress's prime asset. In fact, Brass's own erotic preoccupations are as clear to read as those of Luis Buñuel and Federico Fellini. But while all the sex in the film is simulated, there is no doubt that *The Key* caused something of a stir in its day; with its respectable cast and expensive production values, it was clearly something more than straightforward erotica. What it was not, of course, was an examination of sexuality in the same questioning manner adopted by the two directors discussed above, and there is no denying that Brass's agenda is to present his female star in a celebratory way. Although Brass unashamedly indulges his own (and the viewer's) voyeurism, the film has little more to it than its striking cinematography, despite the presence of the reliable Finlay who sketches in a chilling portrait of obsession; this was also a characteristic apparent in Malcolm McDowell's role in the director's earlier *Caligula*. *The Key* takes on a variety of contentious sexual politics: what are we to make of an Italian male (played by a British actor) who arranges his unconscious wife's naked body into a variety of provocative poses, which he then photographs? In fact, as originally seen in a softened version in the UK, the film remained within the bounds of acceptable soft-core eroticism,

with the exception of one briefly glimpsed scene on a bed between the wife and her young lover, but carefully detailed shots of genitals have now been restored. Other films of this era were similarly converted from their hard-core originals into mainstream versions, such as the science fiction spoof *Flesh Gordon* (directed by Michael Benveniste and Howard Ziehm in 1974), which lost most of its orgy sequence – although sharp-eyed viewers might spot quite a lot that is still going on in some of the long shots.

By the time of *All Ladies Do It* (1992, named after Mozart's *Così Fan Tutte*), Brass had moved into more straightforwardly erotic territory with an unblushing examination of an off-kilter erotic relationship, now treated with far less seriousness – a change underlined by the move away from actors of the status of Frank Finlay to the less starry Paolo Lanza and Claudia Koll. The film deals with a happily married couple (Diana and Paolo) whose fidelity is tested by the woman's far more voracious sexual appetite; the husband seems content to listen to her dictating her erotic adventures. But when Diana begins an affair that is far closer to home, Paolo bridles and throws her out. Diana then begins a truly Olympian erotic odyssey in a new Venetian flat while at the same time attempting to win back her exasperated spouse.

Although Brass's earlier films did not shy away from photographing the female genitals, the other signal change here is the readiness in *All Ladies Do It* to show the sexual parts of both the male and female actors – but there is something of a cheat here. While the labia we are shown are the real thing, the jutting erect penises constantly springing from trousers are clearly plastic prosthetics, and one wonders about the director's strategy: is this a way of circumventing censorship restrictions of the day by not showing a still-forbidden image, a male erection? Or is Brass, with the sheer absurdity of these unlikely appendages (also used by Pasolini's *Salò*) offering some kind of parody of the excesses of pornography, in which all male stars are constantly ready for sexual activity and never suffer erectile dysfunction? Whatever the rationale, the film offers a certain lively, irreverent take on Italian sexual life – although some may find the endless couplings a touch repetitive.

In recent Blu-ray incarnations, every single detail of the actors' physical accoutrements (real or synthetic) are shown in crystal-clear detail, which makes viewing the films a startling experience in the twenty-first century. But the fact that they are being allowed at all by the newly lenient BBFC is a testament to the liberalism that, for the moment, holds sway.

Italian miscellany

Other Italian directors were able to examine the issue of sexuality without unrealistic box office expectations snapping at their heels; one example was Pietro Germi, whose work was far less urbane than the films of Antonioni. Germi's *Divorce Italian Style* (*Divorzio all'Italiana*, 1961) was the first of the Italian sex comedies of the 1960s that enjoyed considerable success abroad. Stalwarts of the genre, Marcello Mastroianni and Stefania Sandrelli, are present, moving effortlessly from their work in more sedate art films to the rumbustious comedy on offer here. What made the film rather daring in its day was its attack on Italian male values, as well as on the outdated laws relating to divorce, and it upset a few people at the time. Mastroianni's appearance in the film became very well known, with his oiled hair and Hercule Poirot-style moustache.

Also directed by Pietro Germi was the film *Serafino* (1968), whose protagonist (played by Adriano Celentano) is a virile young shepherd whose erotic concerns are divided between his seductively tempting cousin and a prostitute in the village. When he unexpectedly inherits a sum of money, he learns that his cousin is to be used as a way of controlling his inheritance by the girl's father; and at this point, he decides that the prostitute is a more acceptable proposition, despite her multiple children by various fathers. Germi's earlier films, including the aforementioned *Divorce Italian Style* and *Seduced and Abandoned* (1964) had channelled a certain Rabelaisian gusto, but *Serafino*'s sexual encounters seem a touch chaste by today's standards.

Luchino Visconti, another great Italian director of the older generation, and one not averse in his own private life to a rejection of orthodox sexuality, was to film a notable picture of decadence, one of a historically significant kind: his film *The Damned* (1969) depicts the birth of the Nazi regime. A famous director of opera, Visconti was more than willing to incorporate into his work elements perhaps more suited to that field, which Samuel Johnson described as 'an exotic and irrational entertainment'. *The Damned* has a central character, Visconti's lover Helmut Berger, given to transvestism, and it features a child molester and an incestuous relationship. Everything is photographed in the kind of enjoyably sumptuous detail that provides a feast for the eyes, but the film lacked the intellectual rigour of such earlier Visconti films as *Rocco and his Brothers* (*Rocco e i Suoi Fratelli*, 1960).

The hypnotic effect of Luchino Visconti's version of Thomas Mann's novella *Death in Venice* (*Morte a Venezia*, 1971) was immeasurably

enhanced by the use of the music of Mahler throughout, notably the adagietto from the composer's Fifth Symphony. This was facilitated by Visconti changing the profession of his repressed central figure from a writer to a composer, so that his futile pursuit of a beautiful young man in a plague-stricken Venice could be played to the plangent orchestrations of the great symphonist. It was this, as much as Dirk Bogarde's superbly understated performance, that made the film such a massive international success in its heyday, but the astonishing visuals remain as impressive as ever, as do such details as the fragile performance of Silvana Mangano as the mother of the seductive boy Tadzio. Looked at today, the dialectical discussions between the composer and his associate (played by Mark Burns) wear less well, but the film is still a work of consummate craftsmanship.

Certain sexual predilections were long considered to be beyond the pale – not least the act of flagellation. The beautifully shot Italian version of *Venus in Furs* (1973) directed by Massimo Dallamano as *Le Malizie di Venere* (also known as *Devil in the Flesh*) moved the writings of Leopold von Sacher-Masoch into a later time frame and dramatized one of the most famous scenarios in the book. The protagonist as a child had come across a female servant having sex. His punishment was to be struck by her, then consoled by being pressed against her uncovered breast. The suggestion in the original book, as discussed by a poker-faced psychiatrist in the film to grant it a spurious air of seriousness, was that the boy (now a man) was subsequently unable to obtain sexual satisfaction without administering – or receiving – physical punishment. The film's scenes of flagellation were spotted by an outraged customs officer when the film was exported to the US, and a court ruling later proscribed its public showing. Similarly, a film touching on the same subject by the Italian horror maestro Mario Bava (more noted for his exquisitely shot Gothic bloodletting than his celebration of eroticism) enjoyed the unwelcome attention of the censor. *La Frusta e il Corpo* (1963) translates as *The Whip and the Body*, and that title perfectly encapsulates the scenario of a film that was censored in virtually every country in which it was shown. The tormented heroine Daliah Lavi fantasises (or does she?) that her dead lover – played by Christopher Lee at his most Byronic and saturnine – whips her naked back in a frenzy. Bava makes no secret of the fact that the punishment, which is shown at some length in the uncut versions, results in her orgasm. Not only was this seen as utterly unacceptable and excised both in Britain and in America, the title of the film was changed in the UK to *Night is the Phantom* and in the US to the equally meaningless *What!*

As such, the film was promoted as another entry in Bava's sequence of Hammer-inspired Gothic horror films, which includes such titles as *Black Sunday* and *Black Sabbath*. This censored version conveyed – as with so many filleted films of the period – a distinct sense of filmic 'coitus interruptus', and its sumptuous Gothic beauty is appreciated more fully now that the film is available in a restored version (without, seemingly, bringing about an orgy of flagellation in British and American households).

7
Sex à la Français

It is instructive to examine the fashion in which French cinema, by virtue of its cachet of perceived quality, broadened the limits of what was acceptable in cinema; Gallic sangfroid pointed up cultural differences between that country's films and the more cautious British and American varieties. Unsurprisingly, the popular conception, whether true or not, that France was the land of the untrammelled libido, with copious sexual activity – a reputation rivalled only by that of another liberated European country, Sweden – did absolutely no harm to the healthy box office prospects of the French films that were shown (sometimes maladroitly dubbed) in the UK and the US. What's more, French cinema had produced the most important female sex symbol of the modern era; the actress Brigitte Bardot swiftly supplanted Marilyn Monroe as the cinema's defining image of female sexuality. And cineastes were also aware that French directors were more ready than most to engage with sexually charged subjects.

These tempting factors aside, there was a certain added value in the fact that French cinema enjoyed a particularly noteworthy cultural standing; France had produced *La Nouvelle Vague*, the most groundbreaking movement in modern cinema, and one that was to influence filmmakers working far from Paris, and therefore it was generally considered that most of the films imported from the country were made by copper-bottomed filmmaking talents, whatever their erotic possibilities. These talents included Claude Chabrol, François Truffaut, Jean-Luc Godard and Alain Resnais, all highly respected filmmakers and all perfectly prepared to engage with sexually contentious subjects. In addition, none of these serious directors ever used sex in a gratuitous fashion: it was always integrated into the filmmakers' individual visions. There is a distinctly different approach to the portrayal of the

sexual act in American and European filmmaking of the more main-stream variety; the latter is frequently more sensitive and rhapsodic, with considerable attention given to tender foreplay and caresses. This strategy was fairly essential in films that were obliged to shy away from showing the act itself, which meant that a certain displacement was required. In contrast, pornography and more recent, franker depictions of sex in mainstream cinema have tended towards the abrupt, rutting interaction in which all movement is violent and energetic and is directed towards the production of an orgasm rather than a full-body, sensual arousal.

The absence of the kind of inhibition frequently evident in the work of British and American filmmakers (however such restraints may have been imposed on them) was central to the identity of the French directors mentioned above. If the corollary was that audiences were accorded more views of sexual activity and female nudity, so much the better; that was considered to be the icing on the cake. A key name among these French filmmakers was Louis Malle – and one of his earlier films was to show for the first time a method of sexually pleasing a woman that had hitherto been left unexplored in the history of the cinema.

The Lovers

The Lovers (*Les Amants*, 1958) was an early demonstration of the per-sonal and committed filmmaking of Louis Malle, with its significant casting of a middle-aged woman who is given a lift by a young man – with inevitable consequences. The woman, Jeanne, is played by one of the most luminous actresses in French cinema, Jeanne Moreau, one of the eponymous 'lovers'. But the film created a sensation – not least in the US, where it was the subject of a court case, after having already scandalised conservative opinion in Italy and France. For the first time in a mainstream film, it depicted cunnilingus: Jean-Marc Bory's head is seen to slowly move down the screen to find a place between Moreau's thighs, and we are then shown her face as she is pleasured. Despite its avoidance of any shots of genitals, the film was considered unacceptable for this particular sexual practice; ironically, in 1958, there were those who suggested that the idea of a woman's pleasure being prioritised over that of a man was a key aspect of its transgressiveness – and similar scenes still apparently cause problems in the twenty-first century, with more restrictive categorisations still recommended for scenes of oral pleasure given to women, giving

a certain credence to the interpretation just described. A bath scene for the protagonists in *Les Amants* – as well as moving into areas that had previously been forbidden to the cinema – allows for an expression of the sensuous connection between the characters, with the simultaneous cleansing of their naked flesh suggesting intimacy just as much as the lovemaking scenes elsewhere.

A pitiless universe

Sexuality, in terms of its pleasures and its cynical usages, was an abiding concern in the films of Claude Chabrol, beginning with his early *Nouvelle Vague* classics *Le Beau Serge* (1958) and, a year later, *Les Cousins*. It is possible to see the director's dyspeptic view of humanity – with which we were to become very familiar – fully in evidence in these intriguing early films. Sex is a motivating factor for the protagonists, notably the amoral Juliette Mayniel character in the latter film, but less than ego. The old Adam was to be invoked more forcefully in such later films as *La Femme Infidèle* (*The Unfaithful Wife*, 1969), in which a dull middle-class husband re-establishes his sexual credentials by killing the lover of his promiscuous wife. As so often in Chabrol's films, the seductress at the heart of the narrative is played by the director's wife, Stéphane Audran. We are invited to have a complex response to her character, and, despite ensuring that cinematographer Jean Rabier photographs her in a charismatic fashion, Chabrol is not really interested in Audran's erotic appeal – unlike, for instance, another French director, Roger Vadim, who maximises the sensuousness of a succession of his sexual partners that he placed in his films, from Brigitte Bardot and Annette Vadim (née Stroyberg) to Jane Fonda. In Chabrol's pitiless universe, sexuality is merely one component in an examination of bourgeois *mauvaise foi*.

Forbidden love, past and present

Hiroshima Mon Amour (1959), Alain Resnais' influential first feature film, remains as mesmerising and enigmatic as ever, with its dialogue between a young French actress and a Japanese man reflecting the city of Hiroshima's own attempts to 'forget the unforgettable'; in this, the film kick-started what would become many cinematic explorations of memory and forgetting. With its famous opening, the camera caressing the nude bodies of the lovers as they intertwine in mysterious fashion, it is exquisitely beautiful and intensely moving, if stately in pace; it is

the defining film of modern French cinema. In terms of technique, the film was as revolutionary as many of the cinema's most famous classics. The director had asked the writer Marguerite Duras to supply him with a love story set in Hiroshima, with the then current fears of the bomb an obvious motif. The film deals with an actress (Emmanuelle Riva) who meets an attractive Japanese architect (Eiji Okada) in the city; they spend the night and a day together, making love twice, and then part. After witnessing their nude bodies entangled in a bed in the opening scene – and at one point seemingly covered in sand – we hear their voices. The woman talks about what she has seen of the city, the man arguing that she has seen nothing. Later, in a crucial revelation, she talks of an earlier love: a German soldier she had intercourse with in occupied France in the town of Nevers. We are shown how her hair was cropped by the vengeful inhabitants of Nevers and we see her grief for her dead German lover. The subject of the film – as was to be the case so often with the director – is memory and its deceptions, a theme explored more fully – if more cryptically – in his subsequent *Last Year in Marienbad* two years later. While the horrors of Hiroshima are ever present in the integuments of the narrative, it is the sympathy engendered by human sexuality that, Resnais and Duras suggest, is how we can all deal, however inadequately, with reality. The memory motif is explored in such moments as the gesture of the Japanese lover's hand, which brings back for the young woman the pain of the past; her affair with him in the present is a poignant reminder of the time when she lived most fully in her life – with the enemy soldier who was her earlier lover. But her experiences will send her back to France irrevocably changed. Apart from the film's visual beauty and memorable imagery – from the embracing bodies at the start to the tracking shots of modern-day Hiroshima – its most considerable asset is the actress Emmanuelle Riva, whose performance is infused with nuance and sensitivity. Her performance during the lovemaking scenes has an intimacy and truthfulness that makes most screen acting appear synthetic; as an elderly woman, the actress demonstrated that she had not lost her skills with a heartbreaking performance in *Amour*, directed by Michael Haneke in 2012.

Eden and after

Other French directors, however, demonstrated a readiness to engage more directly with the erotic and even relished sex scenes, such as the writer-director Alain Robbe-Grillet, one of the literary progenitors of

the *Nouveau Roman.* He had included sadomasochistic elements in his early work, including Marie-France Pisier in a basque and stockings, tied to a bed before being strangled in *Trans-Europ-Express* (1967); the same film, a parody of crime and espionage thrillers, ended with a striptease in a nightclub that leaves a girl with only a tiny *cache-sexe* to preserve her modesty – strong stuff for 1967. The director's later *Eden and After* (1970) dealt with a group of vaguely disinterested students in search of diversion who try out simulated gang rape, black masses and a variety of unorthodox sexual practices at a café called Eden. In narrative terms, the film is all over the place, and one might be forgiven for thinking the director is too distracted by the youthfully attractive nudity (as was Antonioni in *Zabriskie Point*) to channel the experimental rigour of his earlier films such as *L'Immortelle* (1963) and the above-mentioned *Trans-Europ-Express.* Another problem with the film is its writer/director's obvious infatuation with his leading lady; attractive though Catherine Jourdan is, she is not called upon to do a great deal more than wander around in a vaguely confused state, just about wearing an extremely abbreviated dress (the viewer becomes extremely familiar with her red knickers). Catherine Robbe-Grillet was closely involved in the making of the films and has said that her husband had an affair with Jourdan for the duration of the film; the fact that *Eden and After* is demonstrably a love letter vitiates any more complex intentions the director may have nurtured. There is a great deal of tying up and binding with ropes and chains in the films of Alain Robbe-Grillet, and it is possible to speculate that the director (an admirer of comic strips) may have been familiar with the creation of the psychologist William Moulton Marston, Wonder Woman, who spent a great deal of time being tied up in her adventures – a fact not lost on the more censorious 1950s scrutinisers of popular culture.

Very different filmmaking, however, is to be found in *Goto, Island of Love*, directed in France by ex-animator and surrealist Walerian Borowczyk in 1969. It is one of the most unusual of modern films, not so much for its brief nudity – something much more enthusiastically indulged in the director's later films – but because his first live-action movie is a surrealistic fantasy, crammed full of odd, eye-opening imagery. The animator and filmmaker Terry Gilliam and the Brothers Quay owe a debt to its quirky sensibility. There is nothing here to match the copious (and fake) ejaculations of the titular creature in the director's later, much slighter *The Beast* (1975), but the picture of a Kafkaesque small town frozen in aspic has a certain resonance.

Gallic boundary-pushing: Schroeder and Breillat

More recent French cinema continues the Gallic taste for the provocative and boundary-pushing. Having lived under illiberal censorship laws for so long, it is still refreshing to encounter more evidence of the enlightened times we now (temporarily?) live in, such as the new availability of Barbet Schroeder's sexually challenging *Maîtresse* (1975). This controversial study of a Parisian dominatrix was initially heavily scissored by the BBFC but is now viewable completely uncut. The film, Schroeder's fourth feature, stars a slim and youthful Gérard Depardieu (unrecognisable as the Brando-sized behemoth he has become) and the delicate Bulle Ogier. After upsetting moral guardians in 1975 with its uncompromising, un-faked scenes of torture and fetishism – including a genuine nailing of a client's genitals performed by Bulle Ogier, provoking leg-crossing discomfort in many a male viewer – it was shown only in club cinemas upon its release. It received a grudging 'X' certificate in 1981 after the BBFC insisted on several minutes of cuts. Apart from its sexual content, *Maîtresse* exudes a marked stylishness, with striking costumes by Karl Lagerfeld.

From the director of *Romance* (1999, in which the engorged penis of porn star Rocco Siffredi was called upon to do the same kind of duty in a mainstream film as in his usual fare) and the similarly explicit À *Ma Souer!* (2001), *Brief Crossing* (*Brève Traversée*, 2001) was another blistering examination of sexuality, full of Catherine Breillat's usual causticness, but less sexually graphic than most of her work; still, it is emphatically not for the narrow-minded. As ever, Breillat's view of female sexual experience is bleak – men have a less lacerating time, but (in her films) they are less open to wounding because of their more restricted sensitiveness; there is an echo here of a male filmmaker, Ingmar Bergman. But does Breillat's unedifying view of female sexuality, so reminiscent of the films of Lars von Trier, have more authenticity than her Danish colleague's because of her gender? Or is Breillat's view just as distant from that of most women?

8
World Cinema Strategies: Britain and America from the 1960s

In 1967, audiences had put down their money and waited breathlessly for the brief glimpse of female pubic hair in Antonioni's *Blow-Up*, but the candlelit nude wrestling between Alan Bates and Oliver Reed in Ken Russell's *Women in Love* two years later and the nude tableaux of male and female actors in the rock musical *Hair* began to accustom audiences to such hitherto forbidden sights. Literature had long blazed a trail in the sexual arena, from James Joyce's *Ulysses* to John Updike's *Couples* (1968) with its partner-swapping lovers, while the theatre – always ahead of the cinema when it came to *épater les bourgeois* territory – had seen great success with Mart Crowley's gay-themed *The Boys in the Band*, a show that enjoyed the imprimatur of such theatregoers as Jacqueline Kennedy. In Britain, the drama critic Kenneth Tynan – celebrated for the first use of the word 'fuck' on British television – was certainly not going to be outdone by American theatre producers when it came to edgy material. Inspired by the success of *Hair*, Tynan created the nudity-filled review *Oh! Calcutta!*, which resulted in the entire cast being arrested for obscene behaviour at its Los Angeles premiere. But this was no mere catchpenny endeavour written by a collection of hacks; the contributors included no less than the highly successful (and shortly to be murdered) gay playwright Joe Orton, no stranger to outraging staid audiences with such thoroughly amoral plays as *Loot* and *Entertaining Mr Sloane*. Orton's relish in putting one over on the moral reformers of the day extended to his writing letters of complaint to newspapers about his own plays, complaining of the lack of respect that young playwrights were demonstrating towards middle-class moral values. The letters were signed 'Edna Welthorpe (Mrs)', a clear reference to the campaigner Mrs Mary Whitehouse, a sworn enemy of people such as Orton – not to mention her other *bêtes noires*, the director of

the BBC Hugh Greene and the writer Dennis Potter. Other elements in the moral furore of the period included W. H. Auden being obliged to pseudonymously publish his one-poem pamphlet 'The Platonic Blow' in 1965 with its description of a sexual encounter between two men – two years before such sexual activity was legal. *Women in Love* also dealt with this taboo. With Alan Bates and Oliver Reed sporting facial hair and nothing else in their celebrated nude wrestling scene, cinema was subtly changed in a sequence shot with chiaroscuro candlelit effects. It was this scene, more than those involving the actresses in the film, that was much discussed; Jennie Linden's dress being pulled up by Bates and Glenda Jackson's naked breasts kissed by Oliver Reed had the requisite effect on audiences, but similar things had been seen before – the homoerotic wrestling was something new.

Ken Russell had made his name with TV biographies of such classical composers as Delius, Elgar and Debussy, and was well aware that yoking in the other arts would enhance the effect of his feature films; the most serviceable element in this strategy, he knew, was music, although the swelling strings traditionally used in Hollywood lovemaking scenes had become the hoariest of clichés. Accordingly, Russell encouraged a more wistful, Poulenc-inspired approach from composer Georges Delerue's sweeping orchestral score in his version of *Women in Love*.

Double bluffs of the sex comedies

The Hollywood sex comedies of the 1960s – principally those starring Doris Day and Rock Hudson – were hardly authentic indices of US societal attitudes to sex, given that a ring had to be firmly placed on the finger of the heroine before any sexual consummation was sanctioned. And although these smart, handsome-looking and well-written comedies sported the accoutrements of Sixties modernity, their conservative attitudes – forced upon them by the restrictions of the day – were precisely those of the crassly written romantic novels of the British novelist Barbara Cartland, whose frisky, breast-heaving heroines were permitted to enjoy sex only after marriage. But the coding of the Day/Hudson comedies was also intriguing; while audiences may have read the hero's best friend or colleague (customarily played by Tony Randall or Gig Young) as gay, given the lightweight mannerisms the actors incorporated into the parts, there was often a private double bluff going on when it came to scenes involving the male lead. Rock Hudson was himself gay, but was not 'out' during his professional career. As the novelist Armistead Maupin noted in the documentary *The Celluloid Closet*

(1995), Hudson enjoyed showing his films to his friends, who would chuckle at the scenes in which – in order to get the virginal Doris Day character into bed – Hudson's character would destabilise her by playing gay. As Maupin said, it was a gay actor playing a straight character pretending to be gay.

It is hard to imagine that these glossy, relatively innocuous films were particularly satisfying to make for such directors as Richard Quine, as their principal appeal lay in their good-looking stars and the handsome production design: the characters in the film were always given aspirational professional lifestyles. But layered into these scenarios was a variety of contemporary worries, from hypochondria to (veiled) impotence to the efficacy (or otherwise) of psychoanalysis. The fact that the films almost always ended with the triumph of the female character – in the sense that the recalcitrant bachelor male is always cajoled into matrimony – may not necessarily be seen today as a feminist victory. That being said, the appeal of such films as Michael Gordon's *Pillow Talk* (1959) does not reside entirely in their coding; these are highly accomplished pieces of work, well played by experienced comic actors.

Eros rampant

The *Lady Chatterley* trial in 1960, with such heavyweight literary witnesses for the defence as E. M. Forster, had brought about a liberalisation of censorship in literature, with uncompromising stage innovations following up these detonations. Literature, though, remained on the printed page, while the theatre was considered to be an elitist activity, but the medium of cinema was dangerously democratic – any member of the public could go to see, and inevitably be corrupted by, an uncensored film. 'Eros rampant' in the cinema was still a dangerous thing, almost as if the etymology of the first word (as in the *Iliad*) still held currency; the god originally represented both the act of love and conflict between men, with Eros's arrows considered to drive men mad with desire or hatred. But by the end of the 1960s, such subtle definitions of Eros had been lost (including Socrates' notion of Eros somehow being connected with ambition), and the sexual impulse alone presented sufficient danger.

Australians of the period were well aware that their cinema was among the most censored in the world, but Britain had hardly anything to be proud of either. The Profumo scandal, which had brought down the government, had demonstrated in the soundest terms just how disruptive sex could be – and the British were notably slow to accommodate any loosening up in terms of its representation in popular media.

The French ethos in such matters was notably more liberal, and, while sexual scandals still have the capacity in the twenty-first century to rock the British government, French sophistication was demonstrated in 1996 at the funeral of president François Mitterrand, with the dead politician's wife and former lover standing side by side, surrounded by his children both legitimate and illegitimate. A similar event in Britain might have occasioned hypocritical outrage; in France, there was barely a ripple.

Against the background of governmental sexual scandals, it is amazing to think that a brave (but doomed) 1967 filmic stab at the greatest novel of the twentieth century was once the subject of feverish attempts at censorship, but perhaps this was to be expected, given the fulminations of the morally uptight when James Joyce's novel *Ulysses* first appeared. Nowadays, the four-letter words and unblushing descriptions of sexual activity have earned the DVD a harmless '15' certificate; this could be because director Joseph Strick was forced by the more straitened era in which the film was made to avoid showing any sexually explicit images – no doubt any fresh attempt at the novel would remedy that omission, but would it be a better film? It is doubtful – after all, of all unfilmable novels, James Joyce surely produced the prime contender, although his subsequent *Finnegans Wake* might vie for that title.

While Strick faithfully reproduces a not-very-eventful day in the life of a Jewish advertising canvasser in 1920s Dublin (although the period setting of the film is uncertain), he only fitfully captures the mesmeric power of Joyce's astonishing use of language. One section, the phantasmagoric Nighttown sequence, in which Bloom and his surrogate son Stephen Dedalus visit a brothel, is disastrously miscalculated. But there are good things here: notably, the playing. Maurice Roëves is a lacklustre Dedalus, but Milo O'Shea and Barbara Jefford give career-defining performances as Bloom and his sensuous, unfaithful wife Molly. In fact, Jefford's performance of the magnificent, erotic stream-of-consciousness soliloquy that ends both the novel and the film is absolutely impeccable – and makes the film something more than a mere snapshot of a great novel.

Reasons for film censorship in the Britain of the 1960s can sometimes (by today's standards) seem somewhat quaint, particularly the interventions by wayward county councils who had the right to over-rule the certificates granted by John Trevelyan and his team at the BBFC. An egregious example of this was the treatment of Karel Reisz's film *Saturday Night and Sunday Morning* (1960), which presented an

unvarnished picture of the sex life of its rebellious factory worker hero Arthur Seaton (played by Albert Finney), on the grounds that the film was a slur on the morals of factory floor workers in the Midlands – as, presumably, was Alan Sillitoe's original novel, possibly not known to the Grand Panjandrums of the local watch committees. Another 1960 film created problems: a thriller made in Britain by the American actress Jayne Mansfield. In Terence Young's *Too Hot to Handle*, Mansfield was displayed in all-revealing outfits; this was customary for the actress, who was most noted for her spectacular embonpoint. The problem in making the required cuts in a film that revealed its star so conspicuously was insoluble, until a novel solution was found: illustrators were commissioned to airbrush the more provocative parts of Mansfield's body, a time-consuming job that (unsurprisingly) led to highly unconvincing results. Similarly, the rape during a drunken session with a group of jazz musicians of the character played by Claire Bloom – clearly signalled as a nymphomaniac – in George Cukor's 1962 film *The Chapman Report* was considered totally unacceptable, and was hacked out, causing a ruinous jump in the film. As so often with such cuts, the result was a suggestion that far more contentious material had been removed than was in fact the case. Subsequent DVD issues of the film restored the sequence, and it hardly merited any contemporary comment. *The Chapman Report* was not one of George Cukor's more accomplished works, but the restoration nevertheless allowed audiences to see precisely what the director intended. In fact, the cutting of the rape scene caused such an abrupt rupture in the film that the effect was both unintentionally hilarious and annoying; viewers were bemused by the speed with which the Claire Bloom character was moved from one setting to another, and they were well aware that they had been 'protected' from something.

One might have thought that such launderings of sexual subjects in the 1960s would have been more infrequent, given the earlier impact of Jack Clayton's film of John Braine's influential novel *Room at the Top* in 1959. In that film, the sexual frankness of the dialogue had been passed uncut, seeming to herald a new, more adult approach to such material – but that liberal approach was to be something of a false dawn. The scene that caused a reassessment of the treatment of sexual frankness was the one in which the cynical arriviste Joe Lampton (played by Laurence Harvey) has taken the virginity of an industrialist's inexperienced daughter (played by Heather Sears). Although we do not see the sexual act, not only was it discussed in direct terms, it was even – equally shockingly for the day – talked about as something

pleasurable by the woman involved. The film is humorous about the misogyny of Joe Lampton; the young woman is anxious to talk about the life-changing (for her) moment they have just shared, whereas he is not. With what might be perceived as a typical northern post-coital male attitude of the late 1950s, he is bored and impatient. Heather Sears' line 'Oh, Joe, wasn't it super?' may seem unexceptional now, but at the time it appeared to mark a sea change in the representation of sex. Trevelyan, who considered himself a cineaste as much as a censor, recognised that the film treated the subject of sex responsibly, but he and his team were often arbitrary in later judgements, such as the one regarding the George Cukor film mentioned above – the American director's prestige and reputation cut no ice with Trevelyan, who saw *The Chapman Report* as exploitative.

Orgy-free zone

Because of censorship, even films that seemed to promise a more unabashed vision of an earlier, sexually liberated age were likely to disappoint audiences. Titillating stills were available from films such as Robert Baker and Monty Berman's *The Hellfire Club* (1961), with its debased noblemen indulging in orgies with topless serving girls. However, by the time the film was screened, these scenes had already been removed – they were seen only in the more licentious export versions made available to the Far East – and the libidinous behaviour of the eponymous Hellfire Club was so sanitised that the film was finally released with a 'U' certificate as a kind of jolly swashbuckling adventure. Audiences of the day must have wondered quite what they actually got up to in the Hellfire Club – much as the removal of the depravity in Robert Aldrich's *Sodom and Gomorrah* (1962) had people scratching their heads as they tried to work out why God had brought down his wrath on these putatively sinful cities; for instance, all that was left of the lesbianism of Aldrich's original version was a few longing glances cast at women by Anouk Aimée. The butchery done to the film – on which a young Italian director called Sergio Leone also briefly worked – has proved long-lasting: as of 2014, no decent uncut print of the film has ever been seen in the United Kingdom.

There were, however, still hints of a new liberalism, as evinced in Trevelyan's willingness to pass films with a homosexual motif, such as two similarly themed films made in 1960: Gregory Ratoff's *Oscar Wilde* with Robert Morley presenting a fairly one-dimensional picture of the disgraced playwright, and Ken Hughes' better acted *The Trials of Oscar Wilde*, with Peter Finch's far more nuanced characterisation.

Undertones

Speaking of the subject, by 1963 – two years after Basil Dearden's portrayal of homosexuality in *Victim* – the theme could be explored with more shade in films such as Joseph Losey's *The Servant*, with a screenplay by Harold Pinter after the novel by Robin Maugham. The plot centres on a rich, indolent young Englishman from the upper classes who hires a self-effacing manservant and then undergoes a process of subtle corruption, as the manservant proves not to be the perfect gentleman's gentleman that he first appeared to be. The latter, Barrett, brilliantly played by Dirk Bogarde (who had played the bisexual solicitor in *Victim*) is a slyly Machiavellian figure who uses a variety of tactics in the power struggle with his employer, including bringing his girlfriend to the flat to seduce the young man. (The role of the girlfriend is taken by Sarah Miles; this was a period of her career when she played a variety of temptresses.) This seduction of the James Fox character seems to suggest that his sexuality lies in one direction, but the film is heavily freighted with homosexual undertones in the bickering, interdependent relationship between the two men. As the gay element was understated, there was nothing to draw any disapprobation to the film, but the sex scene between Sarah Miles and James Fox was at one point looked at askance, until Trevelyan decided that the prestige of the playwright Harold Pinter and Joseph Losey's cinematic reputation (which Trevelyan fully acknowledged) would allow the film to be passed without a cut. In fact, the arresting seduction scene, in which Sarah Miles' naked legs and upper thighs are seen ambiguously positioned on a modern designer chair, actually showed no explicit sexual activity, and was thus uncuttable. Needless to say, being a Losey film, the agenda at work here was about much more than just sex; the English class system in particular comes under his critical scrutiny. Barrett is presented as a working-class predator, with Bogarde adopting an accent somewhere between his own and that of those for whom he works; however, the effete young man, Tony, is hardly let off the hook either. Regarded today, Tony can be seen as a scion of the privileged public school class exemplified by the Conservative Party rulers of the country in 2014, and Losey suggests both a parasitic nature to match Barrett's and a readiness to be degraded as a sign of an ineluctable moral weakness.

The film of 1,000 cuts

However, another director working in Britain, the versatile J. Lee Thompson, was not to be so lucky with his American thriller *Cape Fear*

(1962), which became known as 'The film of 1,000 cuts'; the problems here principally involved the sexual threat to the prepubescent daughter of the lawyer played by Gregory Peck, with Robert Mitchum at his most menacing as a potential rapist. And the threat was exacerbated by a typically minatory Bernard Herrmann score. Trevelyan and the BBFC were most worried by the continually maintained and insistent rape threat in the film; although it is not stated explicitly, the audience is aware that the Mitchum character has been serving time for a sex crime, and so they are allowed to draw their own conclusions about what will happen to the Peck character's daughter. The director was widely reported as saying that he had been told that his film would need to be cut in 150 places – although this statement has since been an issue of some contention – but he declined to undertake this butchery himself. The cuts were eventually effected, but once again recent home cinema issues of the film have reinstated them, and – as so often – the director's original vision is vindicated.

Stanley Kubrick's film of Vladimir Nabokov's *Lolita* made in the same year (with the UK masquerading as America) had already had a pre-censorship vetoing; the screenplay, which was written by the novelist himself, had been studied before the film was made, and the Board was satisfied that the film might be passed uncut – but with one major compromise. The nymphet of the title – so irresistible to the middle-aged protagonist Humbert Humbert (played by James Mason) – is a 12-year-old in the novel but has aged to 14 in the film. However, Kubrick and his actress Sue Lyon still managed to suggest the unacceptability of the relationship, and a later version directed by Adrian Lyne handled the material far less effectively. It is possible that in the current climate – where the greatest outrage-generating shibboleth is child abuse – a more modern remake would not even be considered.

Curtains for the Code

Perhaps the final nail in the coffin of the film industry's Production Code, which had imposed a squeaky-clean, unrealistic attitude to adult subject matter, was being hammered in by 1964. The specific bone of contention was a short scene in a demonstrably serious production, Sidney Lumet's *The Pawnbroker*. Rod Steiger gives a typically searing performance as the eponymous character, an elderly Jewish survivor of the death camps who has seen his wife murdered there and is now working in New York in a pawn shop. The Production Code insisted that cuts

must be made to the scene in which a black prostitute strips to the waist in a vain attempt to make the pawnbroker stump up more money for an item that she wants to sell him. Her action, however, is counterproductive; rather than arousing him, it brings back a painful flashback of his own wife stripped and abused by Nazi concentration camp guards. It was perfectly clear that the scene had total artistic justification and was by no means designed to titillate. But the administrator of the Code, Geoffrey Shurlock, was not interested in such niceties as artistic justification; he considered that his job was to enforce the letter of the law where the Code was concerned. The film's producer, Ely Landau, was a man of principle and firmness of character, and he declined to cut Lumet's film, taking the case to the appeals board.

While Landau was successful in his bid, there were those who saw such advancing freedoms as the thin end of the wedge, notably Monsignor Thomas F. Little, whose formidable organisation the Legion of Decency objected to the lenient treatment of *The Pawnbroker*, claiming it would lead to much licentious indulgence – and that, furthermore, a pair of naked female breasts in a film, whatever the justification, would always be totally unacceptable. Little even suggested a compromise for the filmmakers – reshoot the scene with the prostitute seen only from behind so that we just see the pawnbroker's reaction.

The Legion of Decency had recently brought about a cut in a relatively discreet nude scene that showed (from behind) a naked Natalie Wood running hysterically from her bathroom in Elia Kazan's *Splendor in the Grass* (1961). However, by now the writing was on the wall and it was clear that the Production Code would have to be revised in order to accommodate the new subject matter that the cinema was tackling. All of this was anathema to the Legion of Decency, whose edicts were basically those of the Roman Catholic Church; the fact that, over the years, the latter's imposition of cuts had affected material that non-Catholics were permitted to view was beginning to rankle with more and more people. Filmmakers had long chafed at these religious arbiters of the arts, and were becoming ever more incensed at the power of the Legion over what was considered a 'permissible' topic. These restrictions meant that such contentious subjects as brothels had to be treated in an extremely circumspect fashion. The Edward Dmytryk 1962 film of Nelson Algren's pungent novel *Walk on the Wild Side* was thoroughly compromised in hundreds of ways – its only really impressive sequence being the titles, with a prowling cat shot by Saul Bass and scored with a jazzy swagger by Elmer Bernstein – and the film's discreet depiction

of the brothel, run by lesbian madam Barbara Stanwyck, presented an establishment some distance from the real thing. Although audiences – even those who were not familiar with Algren's book – knew what was going on in this neat New Orleans house, things are still subtle enough for one to believe that the naive hero Link (played by Laurence Harvey) does not realise quite what profession his straying ex-girlfriend is plying there.

But change was on the horizon. From the 1960s onwards, the cinema has been able to be more frank about the connection between emotional love (in the romantic sense) and the expression of that emotion through physical love. And films can also deal with the frustrations that a thwarted sexual instinct may produce in mentally or emotionally disturbed characters, although the new frankness is not always advantageous. In Gus Van Sant's ill-advised, pointless 1998 re-jigging of Hitchcock's *Psycho* (1960), one of the few changes made in this shot-for-shot remake was to the detriment of Joseph Stefano's original screenplay. When the Norman Bates character peers through the peephole he has made in the motel cabin wall to watch the luckless Marion Crane undress, the only sexual expression after arousal left to this damaged character is murder – the final expression, and result, of the malformed sexual instinct that has been instilled in him through parental abuse. The Bates character in the remake (played this time by a charmless Vince Vaughn without an ounce of the nuance that Anthony Perkins brought to the role) is allowed to masturbate after the peeping episode, suggesting that he can find some more normal form of sexual release; this entirely misses the point that Joseph Stefano and Hitchcock were making.

BFI excavations

The British Film Institute's (BFI's) wholly admirable excavation of neglected and once-censored British movies continues to unearth and rescue hard-to-find and little-seen films. In 2013, two mid-Sixties items, effectively lost for decades, resurfaced for reappraisal: Gerry O'Hara's largely unseen Swinging Sixties opus *The Pleasure Girls* (1965), featuring Francesca Annis, Ian McShane and Klaus Kinski (exploitation with ambition), and, most cherishably, an uncensored pre-release cut of Guy Hamilton's long-banned and controversial *The Party's Over* from the same year, which so upset the British censors, who were worried about the influence of counterculture on the cinemagoing public. In fact,

director Guy Hamilton (of *Goldfinger* fame) was obliged to remove his name from the credits. This never-before-seen version is truly fascinating, and reminds us how we (thankfully) live in a far more liberal age. And the BFI has restored a key Ken Russell film in the most complete version we are likely to see of his scandalous magnum opus. Four decades ago, *The Devils* (1971) was something of a cause célèbre after a lengthy censorship debate with the BBFC. Generally acknowledged as Russell's most fully achieved film and a landmark in British cinema, *The Devils* finally received a DVD premiere in the original, shortened UK 'X' certificate version, and Russell's death in 2011 re-awakened interest in this long hard-to-see feature. Based on John Whiting's stage play (and on Aldous Huxley's novel), the film is set in seventeenth-century France, where the sensually inclined local priest Urbain Grandier (Oliver Reed) manages to protect the city of Loudun from destruction by the establishment. But he is accused of the demonic possession of Sister Jeanne (Vanessa Redgrave), whose erotic fixation on him whips up sexual hysteria among her nuns – which the film shows graphically. With impressive Derek Jarman sets and a striking score by Sir Peter Maxwell Davies, *The Devils* is a scabrous commentary on religious hysteria, hypocrisy and collusion between the church and the state.

Desert love-ins

In much the same way that Ingmar Bergman had tackled sexual themes in his much-respected arthouse classics, Italian directors of the stature of Fellini were moving into this edgy territory. Michelangelo Antonioni, whose films had frequently dealt with an absence of human passion – despite the apparent pursuit of it by his alienated protagonists – was something like a child with a new box of toys when filming *Zabriskie Point* in America in 1970.

The film, with its 'trippy' ethos, was a considerable *succès d'estime* – particularly with the college crowd. But although the director wisely eschewed his customary young middle-aged performers for once, he placed too much emphasis on his colourless, untried leads: Daria Halprin and Mark Frechette, both of whom subsequently sank without trace. When an older actor appears in the film, the reliable Australian Rod Taylor, there are inevitably hints of what might have been achieved if the younger actors had matched his professionalism. The film's most celebrated sequence is its mass 'love-in' in the desert, with caressing couples viewed decorously in the sand dunes, and later scenes involved

Halprin regarding her boss's sexually unorthodox friends at an Arizona mountain resort. However, the erotic charge of the film, already somewhat dissipated, was obliterated by the astonishing slow motion explosions of a variety of objects at the end, accompanied by a Pink Floyd soundtrack. Antonioni's commentary on American materialism clearly energised him more than his middle-aged view of the hedonism and tribalism of American youth.

9
World Cinema Strategies: Europe

If the shoe fits: Luis Buñuel

One of the great directors of arthouse cinema, the Spanish filmmaker Luis Buñuel, demonstrated a variety of obsessions throughout his lengthy career. One of these was a ruthless desire to strip away the pretensions of the middle classes, a mischievous concern to which he gave particular expression in his Indian summer colour films, although, unlike the many middle-class directors given to idealising their working-class characters, Buñuel had no interest in such politically correct finessing; his characters from lower down the social scale are driven by impulses quite as base as those of their 'betters', and the director's excoriation of them is just as lacerating. Buñuel shows us all of his dramatis personae in the same uncompromising light, although there is no attempt at facile moral judgement. His early film, *Un Chien Andalou* (1929), made in collaboration with Salvador Dalí, is full of violent sexual imagery; a particularly famous image shows ants crawling from a hole in the centre of a human hand as a (possible) metaphor for sexual desire, while another sequence has male hands grasping a young woman's breasts as her dress vanishes, leaving her nude. Buñuel and Dalí were concerned with sexual repression in their 'priest-ridden' Catholic country (Joyce's phrase nicely summarises their scathing attitude), and their shot of a sexually unsatisfied woman with her mouth pressed to the marble toe of a statue remains shocking. There is no sexual consummation here, although there is unconsummated foreplay. As Buñuel's career progressed, marked by spats with church and state, the filmmaker continued to be concerned with confrontational material, such as a young killer's seduction of the much older mother of a friend in *Los Olvidados* (1950). Foot fetishism – adumbrated in the toe-sucking

referenced above – remained a recurrent theme in such films as *Diary of a Chambermaid (Le Journal d'une Femme de Chambre*, 1964), in which Jeanne Moreau's obsessed employer takes erotic pleasure from trying a variety of shoes on his complaisant servant. The Surrealists had long noted the subversive, subterranean qualities of eroticism, and Buñuel, throughout his career, assiduously mined this territory, with sex rarely presented in a straightforward fashion but always through a glass darkly, refracted in some curious, fetishistic fashion. A typical example might be the sad, ageing man in *Viridiana* (1961), who gazes in melancholy fashion at himself in the mirror, dressed in the corset that was worn by his deceased bride on their wedding night decades before.

Inevitably, though, the director's best-known film dealing with sexuality is the much-acclaimed late-period *Belle du Jour* (1967), with Catherine Deneuve perfectly encapsulating the frustrated wife of a successful young man who becomes a day-time prostitute for her own mysterious reasons. The film's catalogue of perversity – including mud being thrown at Deneuve as she is tied to a tree, her bra hanging down from her shoulders – is as fascinating as anything in the director's early work, if sometimes inscrutable: what is it making a buzzing noise in a box brandished by an Asian client that Deneuve gazes at but which we are never allowed to see? Religion and piety in the director's films are never a match for the urgent demands of sexuality, which represents a force of destabilisation, as it does in the surrealistic ethos of his early work. Take, for example, one of his most impressive films, *Viridiana* (as mentioned above), in which the nun played by Silvia Pinal finds that her attempts to do 'good works' are frustrated at every turn by the worldliness of those she encounters; a final card game with a sardonic, attractive male relative suggests a capitulation to the real world in which people prefer to follow the sexual rather than the religious impulse.

Sex meets agitprop

The Swedish *I Am Curious (Yellow)* and its less successful sequel *I Am Curious (Blue)*, directed by Vilgot Sjöman in 1967 and 1968 respectively, had supporters who were able to mount a defence based on the films' avowed social and political agendas, with a left-wing critique of Swedish society clearly being foregrounded as much as any sexual content in the film: famously, the plump Lena Nyman's nudity and her fondling of the actor Börje Ahlstedt's genitals. However, it was the sex that, unsurprisingly, gleaned the column inches more than the dour agitprop, the latter very much of its time. Ironically, other more contentious foreign

films – which might be said to wear their exploitation credentials more overtly on their sleeves – such as Michael Miller's West German film *Pornography in Denmark* (1970) and Jorgen Lyhne's American-made *Pornography: Copenhagen 1970* (1970) were passed uncut in America as they were promoted as 'documentaries', even though both featured unsimulated sexual intercourse. The film *Pornography in Denmark* was able to show the sexual sequence as part of a visit to a film studio where such scenes were supposedly being filmed; had it been simply incorporated into the narrative of a mainstream film, it would not have been allowed.

Sex education films had been utilised as a way of circumventing censorship since the days of such films as *He and She* and *Man and Wife*, which had demonstrated sexual positions – even cunnilingus and fellatio – with clearly serious (it seemed) sexual experts talking about them dispassionately. But by the time of Torgny Wickman's *Language of Love* (1969), the problems of sexual dysfunction were routinely included in unblushing fashion, the apparent seriousness of their treatment underlined by the narration by a writer who had worked on the Alfred Kinsey reports, Dr Wardell Pomeroy. According to those who defended them, these films had a point to make beyond titillation, and were thus more legitimate than popular entertainment that simply invited the audience to enjoy the carnal activity on offer.

Sex in Sweden

A constant source of annoyance – or wry acceptance – among Swedes visiting Great Britain is the fondly held, slightly envious British (and American) belief that Sweden is a fount of sexual liberation and erotic adventure: a land without inhibitions where all forms of erotic behaviour are tolerated, and saunas are used more creatively than simply to open the pores of the skin. Much of this perception stems from the sexual revolution of the 1960s, which was by no means a solely Swedish phenomenon. The writer Håkan Nesser is fond of nailing one particular culprit in this identification of unbuttoned Swedish sexuality: the great international success of *I Am Curious (Yellow)* (as mentioned above), which, although largely a dispiriting but would-be humorous left-wing political tract, famously featured a great deal of nudity. According to Nesser, the film's massive success outside Sweden and the censorship furore that surrounded it, largely because of its relatively minimal erotic content, established a template in the minds of non-Swedes for the country; a template, what's more, that hardly told

the whole story. Swedes, according to Nesser, have been living with this lazy cliché ever since. But other, more prestigious Swedish film-makers might have been said to have contributed to this perception of Nordic carnality, notably the man many cineastes consider to be nonpareil, Ingmar Bergman (discussed in the next chapter). His mid-period masterpiece *Summer with Monika* (1953) enjoyed a great deal of attention not only for its undeniably impressive cinematic qualities, but for a scene in which a nubile Harriet Andersson removes her sweater – at a time when actresses kept their bodies largely covered. Later Bergman films such as *The Silence* (1963) further expanded the sexual parameters with actress (and Bergman muse at the time) Ingrid Thulin in a particularly joyless masturbation scene, while a young couple have sex in a theatre in a sequence that was considered very graphic at the time. Despite the impeccable reputation of the director, *The Silence* encountered much crass tampering by censors; but, as with most such storms in teacups occasioned by our moral guardians, the film's sexual candour would be considered mainstream today.

Dutch transgression: Paul Verhoeven

Certain directors make no secret of the fact that they relish their power to shock and outrage those who feel that cinema should have defined limits. In Britain, the late Ken Russell was an exemplar of this mindset, and the Dutch director Paul Verhoeven clearly enjoyed upsetting the censorious, with the graphic *Basic Instinct* (discussed elsewhere) his Hollywood calling card. But his European work deserves attention – and also has a keen focus on sexual issues. Starring his then favourite actor Rutger Hauer, *Katie Tippel* (*Keetje Tippel*, 1975) is the director in firmly social-realist vein. Escaping the poverty of rural Holland and lured by the promise of riches, Katie moves to Amsterdam with her family. All they find is squalor, and the only way out for Katie is prostitution. As a result, she becomes the mistress of a well-to-do banker who introduces her to – and trains her for – an upper-class lifestyle. The film, despite its rough edges, is a canny reworking of *Pygmalion*, unless, of course, *My Fair Lady* was Verhoeven's template.

More confrontational fare was to follow with *Spetters* in 1980. By now, Verhoeven was beginning to push the envelope in his native Holland with such films as this episodic, slightly ramshackle narrative of three young male friends from a working-class background who we watch as they encounter a series of crises and successes. The film was noted at the time for its uninhibited treatment of sex, and an actress who was to

become the director's Dutch muse, Renée Soutendijk, makes a mark as the charismatic 'bad girl' of the film. *Spetters'* most notorious sequence involves one of the boys undergoing a gang rape, and there are two elements that created controversy at the time: the very graphic depiction of the rape (the rapists are clearly shown to have erections); and the fact that the victim is shown to enjoy the assault, which forces him to confront his own sexuality.

With *The Fourth Man* (*De Vierde Man*) three years later, the excellent Jeroen Krabbé plays gay novelist Gerard Reve, who meets the bewitching blonde Christine (Renée Soutendijk again) only to have premonitions of death. In addition, he falls for her bisexual boyfriend. If her previous three husbands died mysteriously, could she be lining up her next one? And could Reve become the eponymous 'fourth man'? The tone here is blackly comic and this last film Verhoeven made before his move to Hollywood was a memorable adieu. There is one scene with a piquant comment on sexual identity: the Krabbé character (who we know to be gay) is straddled by the film's femme fatale, but in order to consummate the sexual encounter, he reaches up with his hands to flatten out her breasts, creating a more stimulating (for him) boyish appearance in his lover.

Such accomplished films demonstrated that Verhoeven would have deserved a place in world cinema even had he not succumbed to the lure of Hollywood.

10
Stretching the Parameters: Bergman and Oshima

No fun being a pornographer: Ingmar Bergman

The crucial importance of one of the cinema's most respected directors to the theme of this book cannot be overestimated. Always confrontational, the Swedish giant of film Ingmar Bergman dealt in an honest and serious fashion with issues of sexuality, along with his other concerns: the relevance of art and music in the modern world; the false consolations of belief; and, a crucial theme, the uncomfortable relationships between men and women. In the latter area, he reflected the plays of August Strindberg, which Bergman had directed in the theatre. Bergman's work altered the parameters of the treatment of sex in film, and the battles over such films as *The Silence, The Virgin Spring* and *Summer with Monika* were much reported in their day and paved the way for such Swedish films as Vilgot Sjöman's *I Am Curious (Yellow)*, with its incendiary melange of left-wing politics and graphic lovemaking scenes. Bergman, however, rejected modish notions of agitprop and facile political solutions to society's problems.

Summer with Monika and *The Virgin Spring* are two of Bergman's most famous earlier films, the first notable for its innovative, erotic celebration of its young female star. *Summer with Monika* (1953) enjoyed great box office success as much for the sweater-clad Harriet Andersson's sensuous appeal in her nude and semi-clad scenes as for Bergman's incisive, un-clichéd direction. The film is a love letter to Andersson. Bergman and his director of photography, the masterly Gunnar Fischer, carefully enshrine the actress's natural, non-synthetic beauty in a fashion very different to that in which mainstream actresses were photographed in commercial movies. Featuring one of the first nude scenes in art cinema, the director complements Andersson's unaffected appeal and

uncomplicated relationship to nature; this is a key theme of the film, in which a pantheistic embrace of nature gives way to the reality of quotidian existence – summer with Monika hath all too short a date. Andersson was to continue as a crucial element in the director's films, up to her deeply moving performance as a dying woman in *Cries and Whispers* (1972).

The *Virgin Spring* (1960) was notable for its astonishingly powerful depiction of violent medieval life; in fact, the film, with its brutal and unflinching tale of rape and revenge, directly inspired such horror movies as Wes Craven's *The Last House on the Left* (the director of that film, the erudite Craven – despite his exploitation background – was an admirer of Bergman). These films are forceful reminders that Bergman was a master director: the striking imagery and finely honed drama of both still exert a considerable grip today, despite the miracle at the end of *The Virgin Spring*, which Bergman disowned when his Christian faith fell away. Neither is in the class of such later masterpieces as *Persona* (1966) and *Hour of the Wolf* (1968), but they are essential viewing for any true aficionados of world cinema.

Sex and miracles

Ulla Isaksson worked with Bergman on the screenplay for *The Virgin Spring*, which was based on a medieval ballad that had something of a legendary status in the Nordic countries. A young virgin, Karin, is on her way to early mass when three degenerate herdsmen stumble upon her; there is some historical evidence of the young daughter of a farmer being kidnapped, raped and killed by a group of vagabonds. After her death (and its avenging), a spring wells up from the ground at the point where she was killed with a stone – the eponymous virgin spring, and, in effect, a miracle. Interestingly, Bergman's always troubled, doubting faith was to swiftly fade away and his mature films focus on the silence – or non-existence – of God. He came to regret the very obvious miracle of this film, which can only be interpreted in a Christian fashion – at least Graham Greene's miracle in *The End of the Affair* can be seen as mere chance. To some degree, the film is about the dichotomy between pagan religion and Christianity, and, apart from the rape sequence, its most famous scene is the savage killing of the rapists by the father of the murdered girl (played in typically uncompromising fashion by Max von Sydow). This violence moves the film resoundingly from the notion of Christian parable and is a template for the bloody violence of Wes Craven's notorious American remake. Bergman himself was clearly exploring the limits of a dogmatic view of Christianity, which he had

come to find constricting; this is perhaps one of the reasons why he regarded the film in later years with some disdain as a poor imitation of the director Akira Kurosawa, under whose influence he fell.

The scene of the rape itself caused censorship problems – not for the last time in the director's career. The young girl Karin innocently enjoys the company of the three goatherds she has encountered, although we – the viewers – are full of apprehension. She is persuaded to share their lunch, and the mute member of the trio leads her horse into a glade. The moment of the rape is precipitated by the surprise appearance of a toad dropping out of a loaf of bread, settling on a piece of white cloth. Finally aware of the danger, Karin tries to run away but is caught in the branches of a tree and is pinned down and raped by both of the older men. The third goatherd, a boy, throws himself on her breasts. Ironically, given the upset caused by the rape scene – which was heavily trimmed by the British censor on the film's original release, notably a shot of the buttocks of one of the rapists – it is perfectly clear that Bergman makes no attempt to show the violation as anything other than a truly horrendous act. He films the rape in such a way as to excite the disgust of the audience, as he does her subsequent murder when she is struck by the mute herdsman as she staggers, groaning, around the glade. Despite the terrible vengeance visited by the father on the three men when they are sleeping in his central hall, the film conveys a terrible feeling of loss, and there is no sense of release in the violence, which Bergman could have suggested was cathartic. In fact, the father lifting the boy up and flinging him against a wall is as terrible an act as the death of his daughter, something that is highlighted by Max von Sydow gazing at his bloody hands after the slaughter.

While certain aspects of the film now seem forced and artificial, the director's own retrospective judgement was far too harsh and the film's focused dramatic power remains undisputed. There is still a moral ambivalence to the film that has not dated, and if the vision of the medieval world has been superseded in other films, *The Virgin Spring* remains a genuinely rigorous work – and unprecedented in its day. It is intriguing to see the fashion in which Bergman utilises the actress Gunnel Lindblom as a servant in the household; she is presented as a dark atavistic figure, suggesting an earthy sexuality, while a much more sophisticated but parallel use of the actress would appear (in modern dress) in the later *The Silence*, discussed below.

The flesh and the intellect

When the world's greatest film director was accused of making pornographic films in the Sixties and suffered swingeing censorship cuts

throughout the world, the opponents of censorship were united in their defence of his film *The Silence* (1963). This was a typically harrowing study of repressed sexuality from Ingmar Bergman and was one of the great works of his late period. By then, all religious belief had disappeared, and the director concerned himself with a pinprick-sharp dissection of human motivation and the alienation of the modern world. But was *The Silence* pornographic? The British censor thought so and wielded his scissors, but the complete print now available gives audiences a chance to make up their own minds. Of course, by current standards, the unbridled sexuality (including a graphic coupling in a theatre) has lost some of its capacity to shock. But the film remains as powerful as ever, with lacerating performances by Ingrid Thulin and Gunnel Lindblom as sisters in a strange land. As accomplished in its way as such Bergman films as the near contemporary *Winter Light* (1963), *The Silence* is an austere and brilliantly acted chamber piece. Viewed today, other directors of the period such as Fellini, while frequently brilliant, seem hit-and-miss; Bergman just seems more and more relevant.

As with much of the most nuanced, allusive art, the precise meaning of Ingmar Bergman's censor-baiting *The Silence* is hard to discern; after the more conventional melodramas of his early years, Bergman's much richer and more complex middle-to-late period was marked by a steadfast (and commendable) refusal to spoon-feed the viewer. We were given a certain variety of character interaction and some narrative incident and allowed to draw our own conclusions. And if Bergman's agenda was not pellucid, there was at least the consolation that we were seeing the most incisive and intelligent use of the cinema that the medium had to offer, along with an unparalleled repertory company of Swedish actors who were constantly setting new definitions of what film acting could do.

Publicity for *The Silence* in Britain stated that Bergman was addressing 'the fierce struggle between the demands of the intellect and those of the flesh'; the filmmaker, like the writer D. H. Lawrence before him, was always concerned with the balance of these often contradictory elements of the human personality. Bergman himself declared that 'love must be open' (in other words, not tyrannical in one person's demands on the other), otherwise 'love is the beginning of death'. The central characters are two sisters with very different personalities, holidaying in an unnamed foreign country and irritating each other. The forms of 'love' in the film are many and varied, and both women are conflicted, dealing with their own alienation in very different ways. The fact that they are played by two of the finest actresses in Swedish film – and, for that matter, in world cinema in general – finesses the

power of Bergman's vision. Ingrid Thulin (Bergman's muse at the time, before the actress Liv Ullmann succeeded her) takes the role of Ester, all bitterly frustrated intellect and unfulfilled sexuality, while Anna is played by Gunnel Lindblom, who had previously had smaller parts in such Bergman films as *The Virgin Spring*. Accompanying the sisters is Anna's young son, Johann (Jörgen Lindström). Anna is given to casual, loveless sexual encounters and roams the streets of the threatening militaristic country like an animal in heat, seeking a quick physical release; Bergman indicates to us that this is as unsatisfying as the unhappy solitary sex we see her sister indulging in.

Anna is youthful, earthily attractive and seemingly in touch with the demands of her body, while Ester conveys an air of frigidity and is clearly presented as the intellectual (and more dominant) member of the duo. The dynamic between the sisters is a reminder – not for the first or the last time in his work – that one of Bergman's specialities as a theatre director was the plays of August Strindberg; the latter's play *The Stronger* comes to mind here, as it does in the subsequent *Persona*, with the characters played by Bibi Andersson and Liv Ullmann echoing the instinctual and intellectual division presented in *The Silence*. The conflicting temperaments of the sisters mean that they maintain a constant antagonism, and their stay in a foreign hotel is to bring that ever worsening conflict to a head. Anna leaves the hotel and is aroused when she encounters a young couple having intercourse in a theatre; this scene, powerful but hardly explicit by today's standards, was one of the elements of the film that caused a censorship furore. She wanders the streets looking for someone – and it is implied that almost any young male will do – who can help bring about the desperate orgasm that will vitiate her own self-loathing. She finds a bartender (played by Birger Malmsten) and drags him back to the hotel room for sexual congress that is merely an animal experience without a trace of warmth. Gunnel Lindblom is particularly impressive as Anna, fully justifying the director's decision to move her from small roles into holding the screen alongside Ingrid Thulin, one of his most impressive actresses. And Lindblom's physicality is used powerfully by the director: while her sexual pickup leans on a table, she sprawls on the bed in a short slip, her legs akimbo, or she is seen through the bars of the bed while embracing him – suggesting that sex for her is a prison as much as it is a release. Her older sister, the sickly Ester, whose own devotion to the life of the mind has proved as unsatisfying as Anna's sensuality, has no outlet other than masturbation; Ingrid Thulin's hand slipping down between

her legs was one of the other scenes that resulted in the film becoming the cause célèbre that it was.

As with much of Bergman's work, *The Silence* seems to be suggesting that our lives in a minatory modern age have only as much meaning as we can find for ourselves, and although Ester's intellectual approach might seem futile, we are conscious that she is attempting to find a rationale for the decisions she has made. However, such character considerations were ignored, along with the implication that the sisters are travelling through an authoritarian – possibly communist – country (we see tanks progressing through the streets). What counted most for detractors was the film's frank treatment of sex. *The Silence* is very much about the human body, and Bergman suggests that the sensual Anna is in tune with hers whereas Ester tries to deny her own physicality. There is an immediacy to the scenes in which the former is seen washing and undressing herself, while Ester appears to show a certain distaste for her sister's intense corporeality.

Negative sex

The sociologist Joaquim Israel in Stockholm's *Tidningen* newspaper attacked the film as anti-sex and said that 'by its negative attitude to sexuality, *The Silence* becomes pornography'. Bergman was also later attacked by feminists for what was perceived as a reactionary view of women in *Persona* – which was particularly ironic given the sympathy for (and centrality of) the female characters not just in this film but in all his work. Although aware of these charges, the director rejected any notion that his morality was of a puritan variety, and he was a notable rebel against the religious strictures of his clergyman father. Bergman pointed out that as the product of a 1920s bourgeois household he was well aware that there were two things that could never be mentioned in respectable company: sex and money. His virtually obsessive connection with the female sex was something that he utilised as a driving force in his work, and his rejection of the conservative Christian values with which he was brought up meant that he was constantly questioning the attitudes to women and their sexuality that were perceived to be God's edicts – although he clearly refused to be reductive, and would not offer ameliorative feminist consolations.

The Silence resists any schematic content suggesting a division of body (Anna) and intellect (Ester), as mentioned above; we are made aware that the two women are inextricably linked, despite their apparent differences. Sexuality is central to the ethos of the film, as reflected in such

disturbing sequences as the one in which the boy is dressed in female clothing by a troupe of dwarfs. And the scene in which Anna is excited by watching the couple having sex in the theatre is given a certain connection to the voyeurism of the audience itself: we are shown that the lovers are aware that Anna is watching but continue to perform, and the act of observation in which we are engaged reflects that of the character on screen. The censorship cut in Britain, which removed the lovers' climax, rendered the scene sterile and unfulfilling; in fact, despite its violence, this is the only sexual act in the film that is presented in a relatively unproblematic fashion. Objections were raised to the suggestion of lesbianism in Ester, with her apparent revulsion at her sister's heterosexual abandon, but this is to take a simplistic approach to Bergman's more general points about sex. When Anna arranges what is virtually a sexual display (with a suggestion of anal penetration) with the waiter she has picked up for her sister's benefit, it is more an illustration of the power struggle between the two women than an attempt to show Ester's disgust with carnality. And while fulfilling sexuality eludes both characters in the film – as does any kind of equanimity in their general condition – there is a sense that such things are possible, given a release of human sympathy.

If the above makes the film sound a dispiriting experience, it is anything but. As so often with Bergman, there is an awareness that human empathy – while difficult to attain for the characters in the film – is nevertheless still somehow a possibility. What's more, the sex as expressed in *The Silence* may not be enjoyable, but Bergman seems to be offering no critique of it – if anything, he appears to imply that it is just one more level of human experience. Perhaps less successful is the young son's wandering around the hotel corridors, when he is not watching with curiosity the anguish of his mother and his aunt, and his surreal encounter with the dwarfs would seem to belong in a Fellini film rather than something by Bergman. But there is no question that the director engages with our emotions, despite his reputation as the most coolly intellectual of filmmakers. In discussing the strategy behind his work, he drew an analogy with music, which works directly on the emotions rather than the intellect.

The photography by the director's cinematographer of choice, Sven Nykvist, is absolutely stunning, and the film is full of the most intensely observed detail, from the opening scenes in an overheated train, with the young boy gazing at other travellers sleeping in their compartments, to his encounter with an almost senile waiter in the hotel; the latter's jokey playing with a sausage to amuse the boy suggests impotence and

ties in to the film's central theme. While the film – like most of the director's work – will not appeal to those who have a limited attention span, it is without question a masterpiece of cinema – and the points it makes inter alia about the ways in which human beings use sex for a variety of purposes are illuminating. The director was wry about people wanting to see the film for 'certain sequences', and noted that it was 'no fun being a pornographer' when everyone else was doing it.

Late revelations

Those who know Ingmar Bergman only from such mid-period classics as *Wild Strawberries* and *The Seventh Seal* (both 1957) may need to make some adjustments for the more rigorous demands of his later chamber masterpieces, of which *Persona* is probably the greatest. A searing analysis of the nature of identity, *Persona* features astonishing performances by two of the director's key actresses: Bibi Andersson and Liv Ullmann, the latter playing an actress who decides (voluntarily, it seems) to stop speaking, while Andersson is the nurse who looks after her on an isolated island. As the conflict between the two women reaches a climax, the viewer is treated to acting the like of which is simply not available elsewhere in the cinema. Bergman's remarkable film looks as radical today as when it was made, and for those willing to give themselves over to the total experience presented here, this is nothing like anything else that cinema has to offer. The film is now available, finally, in an uncensored 'director's cut'. But quite what that means is, as we shall see, curious.

I should at this point introduce a personal note. Seeing, and being riveted by, Bergman's *Persona* (1966) in the cinema in 1970 – and not speaking Swedish – I recollect being uncomfortably aware that a certain subtle censorship of the film was taking place, through omission rather than excision. None of the film's images, I was later to learn, were censored – not even an almost subliminally glimpsed image of an erect penis in a montage at the start of the film, which either escaped the censor or was shown so briefly as not to be considered a threat. But the subtitles in the long erotic monologue about a sexual encounter between the Bibi Andersson character (Alma) and her female friend with two young boys on the beach appeared to have long stretches in which the actress's dialogue was not rendered into English. My suspicion that British audiences were being sheltered from Swedish frankness proved to be true – and when subsequent DVD issues of the film were truthfully able to claim that they were the first uncensored appearances of *Persona* in the UK, what this meant was that

we were finally allowed to experience the monologue translated in full, without the previous mealy-mouthed omissions. This monologue, as well as conveying the nervous frustrated sexual energy of Andersson's nurse, is also an indication of the vulnerability of the character. Earlier in the film she has warned a psychiatrist that she may not be able to cope with the elective muteness of the actress, Elisabet Vogler, she is to care for; this is precisely what proves to be the case – Elisabet's refusal to communicate is in fact what precipitates a breakdown.

As with so many films by Bergman, *Persona* hints that a confrontation with what is perhaps our own ultimate loneliness brings about a kind of equilibrium. And it is the silence of Elisabet that prompts Alma to tell her of the encounter on the beach, in a scene that is performed in extraordinary fashion by Bibi Andersson, always one of the finest actresses in Bergman's films. The story she tells – which she has clearly repressed and not talked about until now – is more erotic and prolonged and, perhaps, more powerful than anything in the multiple sexual encounters to be found in so many books and films (ironically, the monologue was recently used as an audition piece for the film of *Fifty Shades of Grey*). A parallel here might be John Fowles' novel *The French Lieutenant's Woman* (1969), in which a single sexual encounter has immense force: not just because it is described graphically but because it is the only one in the book. Alma talks of sunbathing on a beach with a female friend when they are approached by two boys. Slowly, inhibitions are discarded along with their clothes, and the intercourse and other activities – there are references to a girl 'taking a boy into her mouth' and 'coming' – that occur subsequently on the hot beach are described in a hushed fashion; it is, in fact, uniquely erotic in its power, although everything is conveyed by the actress's narration alone. Bergman noted that he was pleased with Andersson's performance, as she told the story in a voice that carried a tone of shameful lust, which he claimed was not something he had encouraged. The director's resistance to flashbacks as Alma sits in an armchair is a brave move, and his decision to frame the scene mostly in medium shot pays off richly. What we hear is a description of physical ecstasy in the past, but it hardly appears to have had a liberating effect on Alma, whose later life (including an abortion) has been less than satisfactory. But this sexual encounter puts her in touch with a truthfulness about herself that she may since have lost, and the fact that this communication is one way – she tells the story to Elisabet, who simply stares at her intensely – suggests that Bergman is aware of the importance of human interaction (and its absence). This scene – and

the film in its entirety – has been interpreted by Gwendolyn Audrey Foster in terms of suppressed lesbian desire in a study published by Cambridge University Press (*Ingmar Bergman's Persona*, edited by Lloyd Michaels, 1999), and certainly the most famous still from the film – in which Liv Ullmann kisses Bibi Andersson's neck as the latter closes her eyes – would seem to support this interpretation. However, it might be argued that Bergman's agenda here is neither heterosexual nor homosexual, but an examination of human interaction in which the expression of female bonding seen in the film (such as it is) operates on a more subtle level than the physical.

Blood and sex: Nagisa Oshima

A young Japanese woman squats on the floor, her groin covered by a thin strip of fabric. There is blood on the carpet between her legs, and her gown is pulled open to reveal her naked breasts. With the index finger of her right hand, she draws a line across her stomach in menstrual blood.

A young man, virtually nude, stands in front of a fully clothed crowd. He has a traditional Japanese hairstyle and has a large flower tattooed on his stomach. His groin is thrust aggressively forward, covered by only a wisp of material, leaving his pubic hair fully exposed.

A young woman moves her mouth gently around the penis of her lover, and smiles at him as seminal fluid runs down from either side of her mouth.

All of these deeply provocative images come from the films of one of the most uncompromising directors in modern cinema, the Japanese filmmaker Nagisa Oshima. His turbulent career began in the 1960s, and his films were always ready to engage with the problems of society – the society of both the past and the present. Frequently at the centre of his work was a readiness to utilise graphic sexual imagery in a way found unacceptable in many countries; the last of the three images mentioned above comes from his best-known film, *Empire of the Senses* (*Ai No Corrida*, 1976; aka *In the Realm of the Senses*, discussed more fully later), which, although subsequently available almost completely uncut on video and DVD, was considered so shocking in this country that the only way to see it in London was to temporarily join a 'pop-up' cinema club. (For this legal circumvention, a Notting Hill cinema was converted to a cinema club for the period of the film's showing.) The curious problem with this wheeze was that there had to be a delay between signing

up and being allowed into the cinema, which made it impossible for viewers to see the film from the beginning. As in the heyday of cinema-going, people had no choice but to wait till sometime after the opening of the film and sit through it till the beginning of the next showing. Oshima was the first major modern Japanese director whose work was seen in the West, and his achievement was recognised in a significant fashion when London's National Film Theatre showed a selection of his work, although there had been earlier showings at the now-defunct Gala film club. The director's subject was post-war Japan and he dealt directly with the problems of living in his country, but in a different manner from that of his much respected predecessors Ozu Yasujirô and Kenji Mizoguchi, showing a more focused concentration on society's outsiders. In ten years, the director made 15 features and worked in television, but most of this work remained (and still remains) unseen in Britain. His celebrity as an outrageous and audacious breaker of rules resulted from two films made for the major studio Shochiku on the subject of teenage rebels and featuring acts of violence and carnality: *Naked Youth* and *The Sun's Burial* (both 1960).

Adolescent angst

The treatment of the director's favourite themes in these two films – which were both remarkably prescient of the imminently pending sexual revolution – was more extreme than that to be found in other Japanese cinema of the day, not to mention the more censorious cinema of the West. The violent *Naked Youth*, for instance, showed a young woman whose foot is caught as she tries to free herself from a moving car and is dragged along the road on her face. The subsequent *Death by Hanging* eight years later used Brechtian devices distancing the viewer from the film, while *Diary of a Shinjuku Thief* (1969), while still using such distancing effects (which makes watching the film an often infuriating experience), simultaneously went for a direct visceral appeal. Unlike his predecessors, the director was concerned with the effects of Western society on traditional Japanese mores, and particularly the changes taking place in the lives of young Japanese. Student riots, for example, were treated in non-judgemental fashion; if any judgement was present, it was an impatience with the stiff-necked values of the earlier wartime generation. A recurrent motif of Oshima's films is a kind of refraction of Kabuki theatre through the strikingly posed performances of his cast, combining the artificiality of an ancient theatrical tradition with Neorealist observation: an almost impossible marriage that the director is repeatedly able to bring off. The shadows of Japanese

imperialism fall heavily on his work, and Oshima rejects such values by stressing the freedom that sexual expression brings – even though there is often a heavy price to pay for such licence.

Diary of a Shinjuku Thief features a young couple – the eponymous thief and the girl who catches him – who are having sexual problems; they ill-advisedly visit an eccentric sexologist for therapy, who shows them pornographic drawings and suggests that the girl has lesbian tendencies and that the boy is effeminate. The young man's naivety in terms of sexual experience might be seen as an expression of the enforced child-like innocence that was a way of life for the Japanese under a feudal emperor. Oshima imports a double criticism into the scene: the sexologist, putatively a source of authoritative knowledge, imparts particularly antediluvian advice that appears hardly to have moved on since the days of Freud; his pronouncements are often ineluctably comic. Don't listen to authority figures, Oshima seems to be telling us. In fact, the sexual problems of the hero are not solved in any realistic fashion in the film but only in a kind of metaphorical fantasy; there is a broader implication in the film of a gap between the sexual expectations of Japanese men and women – a gap that cannot be bridged unless there is a new, more generous accommodation of gender differences. Rebellion, the guiding force of so many of the director's films, may be motivated, he suggests, by sexual frustration. And sex itself in *Diary of a Shinjuku Thief* is always slightly shambolic and aggressive rather than romanticised; the only misstep in the film is the use of a conventional orchestral score, which appears to hint at sexual release and undercuts the chaotic sex we see on the screen.

Perhaps most striking in the film is the image mentioned at the beginning of this section, when the film's female protagonist (in a Noh play) places her finger in her menstrual blood and draws it across her abdomen. In the context of the film's narrative, the image has a twofold significance: it is a metaphor for hara-kiri, which is a repeated theme in the director's work; and it is also one of the ways in which the heroine attempts to sexually stimulate the under-motivated hero, playing on the notion to be found in several religions (such as Judaism and Islam) that women's menstrual blood is something unclean and to be shunned, but is therefore something that holds a 'forbidden' attraction – Oshima demonstrates a very modern disdain for such retrograde attitudes.

Provocative though the film was, however, the director took his unflinching engagement with sexual subjects to a whole new level in the film he made in 1976.

Empire of the unacceptable

Empire of the Senses is a Japanese production that took the representation of unsimulated sex further than ever before in mainstream cinema. The film's graphic qualities resulted in it being banned in several countries and also being ineligible for the Cannes Film Festival. The director was fully aware that he was confronting accepted ideas concerning pornography and obscenity when making the film, but, as his entire career had been built on an interrogation of existing forms of cinema, this was not exactly a new challenge for him. However, the earlier bruising skirmishes he had fought would now be replaced by a full-scale bloody battle. The director saw his engagement with sexual material as liberating, and considered that the concept of pornography would become meaningless if societal strictures against it were removed. *Empire of the Senses* has never been shown uncensored in the director's home country and its celebrity – or notoriety – throughout the rest of the world has to be taken on trust by Japanese viewers.

The narrative is based on an actual incident from history. A woman whose name was Sada Abe was responsible for the death of her lover (accidentally, it seems) during sadomasochistic sex games. On the run from the police, she had severed the penis of her lover and carried it around with her; she had it with her when she was caught. Abe was later convicted of the killing. There had been earlier Japanese film versions of the story, but these were less graphic in their presentation of the facts, and caused nothing like the furore that Oshima's film was to do. In fact, Japan had a tradition of sex films in the soft-core category known as 'Pinku Eiga', or 'Pink' films, but with Oshima's portrayal of sexual intercourse and ejaculations, as well as such scenes as the heroine inserting an egg into her vagina, there was absolutely nothing soft core about his film. And whereas films in the 'Pink' category were designed for the purposes of arousal, Oshima nurtured far more ambitious intentions, continuing (and extending) his fearless dissection of Japanese society and its 'bad faith'. As in all his work, there would be no easy solutions offered to the problematical situations he depicted, and there was certainly no easy adoption of either left-wing or right-wing ideologies to ameliorate the corrupt society we are shown.

The film is set in 1936 and shows a couple gradually drawing themselves apart from the conventions of polite society, choosing to live in a cloistered world of their own making; this world is initially about freedom but becomes dangerously inward-looking and obsessive, and the film presents the lovers' destruction as being as much the result of their own behaviour as the consequence of society's intolerance of

rebels. Sada (played by Eiko Matsuda) is employed by Kichizo (Tatsuya Fuji) as a maid, and, despite the disapproval of the man's jealous wife, they begin to have sex. They choose as a setting for their passionate trysts a nearby inn and they begin a series of sexual experiments that are as much about exploring their own erotic possibilities – and the limits of sexual expression itself – as they are about simple sexual release. Their lovemaking is almost non-stop, and their sexual capabilities seem to be limitless. But while the scenes of coupling in the film are initially depicted as being liberating, they soon take on a taint of obsession, particularly on the part of the intense Sada. At one point we are shown her fellating the erect penis of her lover, but the camera pulls back to reveal that he is asleep; while he is subsequently bemused by and tolerant of the fact that she cannot even wait for him to wake up before continuing their endless sexual adventure, the viewer has begun to think that there is something unwholesome about the couple's incessant lovemaking. However, Oshima allows any criticism of his lovers to become a matter for the audience; his target is rather the society that they inhabit, and, despite the 1930s setting, there is a suggestion that Japan, with its repression and anti-individualistic politics, remains largely unchanged four decades after the events of the film take place.

The lovers' erotic odyssey continues and they become even more cut off from society, leading to the final sexual games; at this point, the woman attempts to half-asphyxiate her partner, but the catastrophe happens and he dies. And in a scene that is difficult to watch – especially for male viewers – she bloodily cuts off his genitals before carrying them away with her for the short time she has left before retribution.

Making obscenity and taboo disappear

Japanese cinema of the 1950s and 1960s was already permitted a greater degree of sexual frankness than its Western equivalent and displayed a remarkable string of sadomasochistic concerns. Even Akira Kurosawa's *The Hidden Fortress* in 1958 has a princess with a clear interest in corporal punishment, as evinced by the bamboo stick she frequently flourishes, while films such as Okinu Otaman's *Girls of the Night Storm* demonstrate a curiosity about bondage that would appeal to the similarly inclined William Moulton Marston, creator of Wonder Woman. But even the American cinema allowed a certain amount of S&M playfulness, such as a scene in which the sexually frustrated Susan Kohner in Michael Anderson's *All the Fine Young Cannibals* (1960) lashes out at her

husband with a riding crop. Such scenes were not censorable as they could be read as violent frustration – but not necessarily of the sexual kind.

By the 1970s, the parameters concerning the representation of sex on film were being stretched worldwide. However, in examples such as Bernardo Bertolucci's *Last Tango in Paris* (1972, discussed in Chapter 11), the sex between the characters was simulated; what's more, the desperately nihilistic misogyny of the male protagonist seems to inform the whole film, and the attitude to sex depicted there is markedly different from that in Oshima's films.

Japanese definitions of pornography were somewhat nebulous, but there was one sacrosanct shibboleth: society must not be disturbed by any sexual representation – this was a red rag to a bull for a director of Oshima's philosophy. To him, the most sure-fire way to 'disturb society' was by presenting real sex rather than simulated sex, as in the 'Pink' films. He remarked that nothing that is expressed is obscene; what is obscene is what is hidden. 'When we are free to see everything,' he said, 'both obscenity and taboo disappear.' This sanguine expression of an ideal, sexually liberated state of society was to be hotly contested, but the prosecutions against him for obscenity failed and the director was acquitted in 1982. However, *Empire of the Senses*, the film that had caused so much outrage, could be seen only with the genitals pixilated; a print with slightly fewer cuts circulated in Japan at one time in which more female nudity was allowed but none of the male nudity – doubtless because of the frequent erections. Oshima was disgusted by this version and pointed out that the purity of his intentions had been rendered dirty. There is one cut extant in the current UK version – the nonsexual tweaking of a little boy's penis by the Sada character; this scene fell foul of the 1978 law regarding the sexual representation of children in film that was championed by morality campaigner Mary Whitehouse. Martin Scorsese's *Taxi Driver* (1976) was similarly shorn of a relatively inoffensive scene involving Jodi Foster's adolescent prostitute once the law was implemented.

The way in which the actors in Oshima's film are shown when having sex is notably different from standard pornography. Although fellatio is shown in close-up, we are repeatedly presented with medium and long shots containing the actors' entire bodies rather than cutting to their interacting genitals. There is also a strong sense that the film incorporates a female vision of sexuality rather than the customarily male perspective of most pornography. Furthermore, the powerful and naturalistic performances of the two actors, Tatsuya Fuji and

particularly Eiko Matsuda as Sada, decisively remove the film from the realm of cinema designed simply to arouse. However, the Japanese response to the actors' performances was notably sexist; while the male actor enjoyed a lengthy subsequent career, there was some sniffy disapproval of Matsuda, as if her role in the film had amounted to a form of prostitution, and she ultimately left Japan.

Viewed in the twenty-first century, *Empire of the Senses* looks even less like pornography than it did when it was made; the director's considerable integrity and the rigour with which he addresses the subject keeps any notion of titillation at bay, and in an era when unsimulated sex in the cinema is more normalised, Oshima's film may be seen as both brave and innovative.

11

The 1970s: Exploitation Joins the Mainstream

Assaults on the moral probity that had ruled in Hollywood cinema for so long may have been initiated by filmmakers such as Otto Preminger in the 1950s and 1960s, but it was the trumpet call of a new cadre of rebels in the 1970s that really brought down the walls of Jericho. The decade saw a revolution in popular cinema, from the 'women in prison' series of films, with their sadistic lesbian warders and inmates in buttocks-exposing shorts and abbreviated halters, to 'blaxploitation' movies, with a ballsy Pam Grier taking on The Man while exposing her formidable assets. Through their confrontational tactics, their naked appeal to an ethnic demographic and their testing of boundaries, such films changed the face of mainstream cinema – although they may have lacked any overt artistic intentions.

In Britain, the male and female nudity in Lindsay Anderson's *If....* (1968) had been influential, although this innovation had been considered as appropriate mainly for London audiences. I saw the film in London, and, shortly afterwards, in Liverpool, and I noted that the scene in which the matron of a public school wanders naked through the empty boys' dormitory had been excised, presumably on the basis that northern audiences would be adversely affected by such images. Similar cuts were performed on Lindsay Anderson's film in America, and such important work as cinematographer Haskell Wexler's political (and Godardian) *Medium Cool* (1969) was also attacked by its distributor, Paramount. But it was another British film that created a stir on both sides of the Atlantic for its presentation of nudity – male nudity in this instance – Ken Russell's film of D. H. Lawrence's *Women in Love* (also 1969; discussed in Chapter 8). Other unacceptable themes were beginning to appear with some regularity, such as the once-taboo subject of miscegenation, which found its direct physical representation in films

including Richard Fleischer's *Mandingo* (1975), Hal Ashby's *The Landlord* (1970) and *The Liberation of L. B. Jones*. The latter was made in 1970 by the veteran director William Wyler, who, like his colleague Alfred Hitchcock, was able to tackle material in the 1970s that was previously forbidden to him. The new frankness had been marked by the fashion in which dialogue-led films such as Mike Nichols' *Carnal Knowledge* in 1971 (from a sardonic and caustic screenplay by cartoonist Jules Feiffer) had tested the limits of what was acceptable on the screen, bringing about an intersection of the new politics and sexual topics.

Inevitably, any depiction of the sexual act in a film – unless designed for simple arousal – must incorporate a variety of elements: the fore-grounding of character, so that the protagonists we are viewing remain clearly differentiated rather than the anonymous flesh of pornography; the advancing of the narrative flow, assuming that the sex scene is not incorporated just for the purpose of titillation; and a mise en scène that reflects the film's overarching cinematographic style – in other words, to be successful, such scenes should always be organically assimilated into the film rather than arbitrarily inserted. However, a variety of approaches flourished in the 1970s. Sex is frequently presented in cinema as a destructive, destabilising force, and *amour fou* rarely ends well for the protagonists who are struck by it. And, in the film medium, the sexual impulse is at its most ruinous (as in films such as *Basic Instinct* and *Fatal Attraction*) when it is not accompanied by love but is simply the result of overwhelming physical attraction and a desire for consum-mation. Such physical conflagrations lever protagonists away from self-awareness and self-knowledge towards their destruction – precisely the trajectory that was standard in American Film Noir of the 1940s, even though films of that era had to be circumspect about the sexual aspects of their characters' downfall.

The walls crumble

Sexual practices that had previously been unacceptable in the cinema, such as fellatio, now became possible, as long as they were shot dis-creetly. The act was performed by Lynn Redgrave on the black actor Robert Hooks in Sidney Lumet's *Last of the Mobile Hot Shots* (1970) in a sequence that managed to break a couple of taboos, since it involved miscegenation and a once unorthodox sexual practice; as the screenplay for the film and the original play were by two sexual outlaws, Gore Vidal and Tennessee Williams respectively, this was hardly surprising, although the film was one of Lumet's misfires.

In fact, this particular sexual act was also suggested in the Mike Nichols film of *Catch-22* (also 1970), with a young Italian girl performing it on a soldier in a doorway.

The walls surrounding homosexuality had started to be knocked down in 1969, when the director William Friedkin filmed *The Boys in the Band*, Mart Crowley's acerbic and witty play that put gay characters centre stage. (Friedkin had already tackled other theatrical subjects, such as Harold Pinter's *The Birthday Party* in 1968, while his signature film was to be *The Exorcist* – another breaker of taboos with its masturbation by crucifix.) Some of *The Boys in the Band*'s memorably acid dialogue has passed into the popular lexicon: 'Who do you have to fuck to get a drink around here?'; 'What I am ... is a 32-year-old, ugly, pock-marked Jew fairy ... and if it takes me a little while to pull myself together, it's nobody's goddamned business but my own!' Gay audiences, however, were somewhat conflicted about the film; despite its sympathetic portrayal of gay characters, Friedkin's version of the play was felt to convey a familiar negative attitude, with an emphasis on unhappiness and self-destructiveness as a corollary of the lifestyle. These elements, however, were to be found in Crowley's original play, and there is no gainsaying the energy and humour of the piece – particularly in Leonard Frey's playing of the sardonic, self-critical Harold, whose description of himself is the second quote above – the humour, in fact, counteracts the unhappy lives of the characters. At the time, the film was thought to be brave and extreme in tackling the subject of homosexuality, and voices were raised to the effect that it would never find an audience outside its natural fiefdom, particularly as the film took some of the sequences further than had been depicted on stage – a reversal of the standard cinema strategy. Looked at today, the film is dated, but it must nevertheless be regarded as important.

Lesbianism was also beginning to feature in the films of the day, such as the adaptation by the director Mark Rydell of D. H. Lawrence's *The Fox* (1967); despite the lesbian relationship at the centre of the film, it was the scenes involving a naked Anne Heywood bringing herself to orgasm that drew gasps from cinemagoers. However, the dyspeptic actress played by Beryl Reid in Robert Aldrich's *The Killing of Sister George* (1968, from Frank Marcus's play), who is in competition with another middle-aged woman, the predatory Coral Browne, for the pretty, more feminine Susannah York, occasioned criticism from gay viewers of the kind that would be directed against *The Boys in the Band* – although, once again, the original play might be said to be responsible for the film's view of lesbian characters.

The new frankness in representations of physical lovemaking was matched by a new honesty in the dialogue of contemporary films, with such phrases as 'fuck you' appearing in Stuart Hagmann's youth-centric *The Strawberry Statement* and the use of a word that is still unacceptable in newspapers in the twenty-first century, 'cunt', in the Joseph Strick film of Henry Miller's *Tropic of Cancer* (discussed below) and in the same author's *Quiet Days in Clichy*, filmed by Jens Jørgen Thorsen – all three films appeared in 1970, clearly a significant year. Miller's view of sexual liberation has fallen from favour ('phallocentric' is the standard description) but his credentials as a sexual revolutionary are *sui generis*, and both of these films did some – qualified – justice to his work.

The wry, sophisticated newspaper comic strips by Jules Feiffer preceded Woody Allen in anatomising the mores and interactions of a certain kind of New York demographic, with a neurotic Jewish sensibility and self-deprecating wit. Despite the fact that they were only three or four panels long, Feiffer's gag strips accessed the American literary traditions from which his humour sprang, along with his love of the American comic strip. A film of his cynical, excoriating script *Carnal Knowledge* was made in 1971, mining the same territory of the modern sex wars as his strips, and with a perfect director for the material – Mike Nichols, who came from precisely the same New York comedic tradition as the writer. The film covered three decades, from the late 1940s to the 1960s, in the sexual lives of two roommates from college: the womanising, misogynistic character played by Jack Nicholson, in the kind of part that he was to make a speciality, and his shy, inexperienced friend played by Art Garfunkel. The latter was no actor, but he was cleverly utilised by a variety of directors who were able to coax from him a convincing simulacrum of a performance. With a career-defining turn as Nicholson's wife by the voluptuous, vulnerable Ann-Margret, previously better known for such musicals as *Bye Bye Birdie*, the film was a considerable hit, not least for its quickly acquired reputation for dialogue featuring obscenity, not to mention its final scene suggesting oral sex. The exchanges spoken over the opening credits and describing sexual matters in a completely unabashed fashion were unusual for the time and caused a rustle of shock in audiences, the like of which would be hard to imagine today.

Bertolucci's *succès de scandale*

The most famous of the more ambitious erotic movies of the 1970s was Bernardo Bertolucci's controversial *Last Tango in Paris* (1972), which

was ambitious in a variety of ways, as with most films by this director. Bertolucci, from his earliest films to his most recent, has shown an uninhibited readiness to deal with human sexual activity – for example in such films as *The Dreamers* (2003), in which the actress Eva Green shared a close-up with the penis of the actor Michael Pitt – but nothing else in his career has caused such a fuss as *Last Tango in Paris*. The various, increasingly desperate (and unsuccessful) attempts at prosecuting the film brought it to the attention of many people who would not otherwise have heard of it – and possibly helped the sales of a certain kitchen commodity utilised as a sexual lubricant.

Bertolucci's sombre, despairing film is really the study of a personality in disintegration and a middle-aged American widower's doomed love affair with a vulnerable young French woman, and Marlon Brando's alternately volatile and lachrymose performance is characteristically hypnotic. The film has sometimes been interpreted as a study in misogyny, and the subsequent real-life problems of the actress Maria Schneider have been retrospectively interpreted as a signifier of this, feeding into this interpretation; after becoming famous for the film, she latterly became critical of it. Speaking of *Last Tango in Paris*, Bertolucci has said that he wanted to ask forgiveness from Maria Schneider, whose life after the film was one of tragic decline; she was, he noted, unable to deal with the success, the celebrity and even the notoriety that the film brought her.

It should be noted that while the Brando character is undoubtedly misogynistic, his own self-loathing far outweighs his dislike of anyone else of either sex; in fact, it is this self-loathing that motivates his bad behaviour. Female critics of the film have pointed out that Bertolucci had to conform to a standard trope of films involving nudity: while female flesh is always well in evidence – and Schneider's heavy breasts become very familiar to the viewer, although the use of butter as a sex aid is off camera, as it perhaps would not be today – most males remain decorously clothed, as Brando mostly does here. Part of the problem is inevitably to do with what was permissible in this era: although flaccid penises were occasionally acceptable, tumescent ones definitely were not – and if the latter had been on display, the film would not have been certificated or shown. As a limp penis in a love scene would demonstrate quite clearly that the male actor was not really involved, it meant that discretion was often preferred by filmmakers of the time. (Later, when Jack Nicholson was appearing in Bob Rafelson's 1981 film of James M. Cain's *The Postman Always Rings Twice* and making violent love to Jessica Lange on a kitchen table,

he claimed that he wanted to show the 'first hard-on' in mainstream cinema. However, the scepticism of those who heard this remark was justified; the time was still not yet right, and that duty fell to later actors such as Mark Rylance in Patrice Chéreau's *Intimacy* in 2001.) As for photographing Brando's naked body in the nude scenes with Maria Schneider, the actor's alarming weight gain, which began to be noted at the time of this film, perhaps necessitated a certain sleight of hand on the part of the director.

Attacks on community standards

One can scarcely blame the filmmakers of this era for giving whatever justification seemed necessary to grant their films a certain seriousness; they were, after all, in the business of making movies that were designed to be seen, and would hardly have approved of the line in Gray's *Elegy*: 'Full many a flower is born to blush unseen.' These flowers were designed to be enjoyed, and if talking up (however hopefully) either their artistic or educational aspects helped the films escape censure, all well and good. But certain adjectives – when used as ammunition by the prosecution – were almost immediately expected to rule the offending works as *hors de combat*. A classic example here was the dread adjective 'prurient', which was used, for instance, in an attempted prosecution of Russ Meyer's 1975 film *Supervixens* – although the fact that the meaning of the word had to be explained to the jury in this case perhaps meant that it was not the best tactic to use.

In America, prosecutions in the 1970s were often based on the concept of 'attacks on community standards', suggesting that sexually frank material not only offended religious ideals but even wrought societal damage; although this approach is used less often these days, the phrase 'to deprave and corrupt' is still central to many prosecutions.

These accusations were even levelled against films that would now be seen as mainstream fare, such as British director John Schlesinger's 1969 American film of the James Leo Herlihy novel *Midnight Cowboy*, a film as much about seismic social change as about amorphous sexuality. Although the scenes of sexual activity in the film's phantasmagoric, anything-goes New York – both gay and straight – were candid for the time, they were hardly pornographic. What perhaps upset the censors was an element carried over from the original novel: a clear-eyed acceptance of all the vagaries of human sexual behaviour, whatever form they took. However, the naive hustler Joe Buck's beating up of a sensitive gay man was sometimes misinterpreted by audiences, not necessarily

reading what the (gay) director was saying about Buck's own attitude to his confused sexuality. In other words, they read him as essentially 'straight' and therefore disgusted by the homosexual attentions of his would-be client. Cinema audiences were not yet ready for a mainstream actor (here Jon Voight) to present a variety of sexual perspectives – something that is more common today.

The ultimate dirty word: liberal

In America, the Nixon administration reacted against the perceived liberalism of its immediate predecessors in the Warren era, with solicitors expressing fear that hard-won liberal decisions would be reversed, just as attempts to re-criminalise abortion in America appear at regular intervals; Britain, too, has experienced similar syndromes.

But at least the liberal revolution could be sabotaged in various ways. Giving an 'X' rating to films in the United States had a more prescriptive effect on them in terms of their showing than it did in the UK. When Schlesinger's aforementioned *Midnight Cowboy* was given such a rating, its commercial prospects were accordingly curtailed. However, such disincentives were not an issue for MGM when distributing Michelangelo Antonioni's pro-liberal, anti-establishment *Zabriskie Point* (1970) in America. The company was more tempted by the sales potential of the film's erotic encounters than with the director's customarily acerbic examinations of materialism and alienation, but their expectations were to be disappointed when the film did not significantly ignite any box office interest. It would be pleasing to report that now, when such temporary considerations as ticket sales have receded into the past, the director's more pertinent concerns can be examined dispassionately. But Antonioni's foreigner's eye was not able to bring any personal engagement to America's zeitgeist, as he had done with London in *Blow-Up*. His vision of the sexual mores of the drug-oriented California youth scene was, as so often in such cases, the bemused, slightly voyeuristic fascination of a middle-aged man, while the more sophisticated approach to sexuality seen in his Italian films seemed to have drained away.

Despite the era's reputation for sexual adventurousness, the early 1970s were (looked at retrospectively) slightly more sedate than memory might suggest. In Britain, although the relevant films were hard to see, there was a perception (whether true or not) among cine-literate audiences that American underground filmmakers were pushing the boundaries, not least in terms of explicitness. The influence of these innovatory movements began to spread and was discernible in the

documentary *Woodstock* (1970), with its three-hour-plus celebration of music and casual carnality. The film utilised the fragmented film-making techniques of the underground movement to considerable commercial success, thereby illustrating audiences' new responsiveness to experimental conceits. Director Michael Wadleigh and his team of fellow filmmakers braved the mud and chaos of the rock concert to create a film that was not exclusively about the often substance-fuelled music-making on the stage. The filmmakers were as interested in the 'love-in' engendered around the event, and nude sunbathing and sexual intercourse in the long grass were glimpsed as electric guitars wailed at treble fortissimo levels. The film's refusal to make any value judgements on what the cinema audience was witnessing was commended at the time and is one of the elements of the film that still survives today, even though the whole event seems a curious historical artefact when viewed in the twenty-first century.

Gore Vidal traduced

It is hard to say which was considered the most exploitable element of Mike Sarne's ultimately disastrous film of Gore Vidal's parody of eroticism, *Myra Breckinridge* (1970). However, the film was undoubtedly expected to be a success thanks to its combination of the pneumatic film star Raquel Welch, wearing abbreviated costumes, and the notorious title: *Myra Breckinridge* had come to suggest an unbridled – and taboo-breaking – sexuality for audiences of the day, much as Lawrence's *Lady Chatterley's Lover* had done for an earlier generation.

Welch herself was an example of a phenomenon that barely exists today, except for a few tenuous examples: the star whose success is predicated far more on her (or his) physical sexual appeal than on acting ability. In the latter area, Welch rarely demonstrated that she was capable of much more than hitting her marks and projecting a healthy sexuality, and this was largely the case when she played the title role in *Myra Breckinridge*, after the character's sex change and *sans* the healthiness. However, she channels some comic possibilities and seems aware that her own image is essentially a parody of the cinema sex symbol, in the same way that Marilyn Monroe guyed her image in the 1950s.

The film itself uneasily synthesised the gung-ho procedures of exploitation cinema with all the glossy resources of a big studio. And, as with virtually all such marriages, this ended in tears, certainly in terms of critical opprobrium and box office failure – a double whammy, in fact.

But during its making – and before negative word of mouth began to adversely affect its commercial chances – the film was something of a cause célèbre because of its lavish nudity, although not of Raquel Welch herself, who was largely seen in a succession of revealing outfits and would rather curiously pride herself on never appearing completely naked. It also boasted some bizarre stunt casting, with an elderly Mae West – always knowingly lampooning female sexuality, even in her heyday – looking like a superannuated drag act as she runs her hands over her ample hips and delivers the kind of lines that the censors would not have allowed her to speak in the 1930s or 1940s. On hearing that a potential lover is six feet seven inches tall, she says: 'Never mind the six feet. Let's talk about the seven inches!'

Of course, West had been a fearless breaker-of-taboos in her own productions of such plays as the uncompromisingly titled *Sex*, and her personal take on female libido was both ahead of its time and largely her own creation. Welch, however, was something of a product of the photographer's studio and the publicity department where her husband Patrick Curtis created for her a highly commercial public image; she was to take part in a variety of photo shoots that adorned a wide range of magazines. (Ex-film star John Derek was to perform a similar feat with his partner Bo Derek, whose underachieved performances and startling looks allowed her to slip into Raquel Welch's role for a later generation, notably as the object of Dudley Moore's lust in Blake Edwards' *10* (1979).) Such films as the ingenious science fiction epic *Fantastic Voyage* (Richard Fleischer, 1966) undoubtedly had their commercial prospects finessed by the presence of Welch in a tight-fitting costume, and Welch herself was perfectly prepared to play the publicity game. She appeared on various talk shows where she played upon her strange blend of coyness and exploitation of her physical attributes; her description of her whole persona as 'anachronistic' showed a certain level of self-knowledge, but this did not stop her making a series of fairly unmemorable films that nevertheless did well at the box office.

Myra Breckinridge, however, was a misstep in terms of the actress's usually shrewd financial acumen. In this bizarre parody of pornographic writing, in which the central character changes sex from male to female, the name of the game was ritual sexual humiliation. Myra, in her female identity, sodomises a young stud with a dildo, and it was this scene that both created a minor moral furore and suggested that Welch had moved on from mild titillation to an engagement with the outer fringes of sexual practices. Sarne's film features such diversions as the surgical removal of Myron Breckinridge's penis (played

in his male, pre-Myra incarnation by the camp Rex Reed) to produce the female character played by Welch, while the latter was obliged to prove her gender by standing on a table in front of a group of gawping men, hitching up her skirts and dropping her panties. En route to this scene – which was much used in promoting the film – she has indulged in the aforementioned spot of anal rape with a none-too-bright young hustler and has taken part in an orgy in which the women present wear only body paint. The final effect is one of desperation, with the satirical swipes at and celebration of laissez-faire sexual mores in Vidal's original novel nowhere to be seen.

The wunderkind British director Mike Sarne, whose *Joanna* had gleaned some praise in 1968, comprehensively torpedoed his career with the massive indulgences of *Myra Breckinridge* and had many bitter battles with Welch, who repeatedly declined to perform the sexual scenes that he requested, although she was persuaded to use the dildo in the sodomy scene. The film also represented a clash of female sex symbols from different ages, and Welch, the young pretender, was not best pleased when the mature Mae West promoted the film exclusively as her 'comeback', indirectly suggesting that Welch was the lesser star. Perhaps Welch's gamest performance was not in the film itself – which was almost immediately dismissed as a catastrophic failure, although it looks dated and unthreatening when viewed today – but was to be found in the star's hopeful defence of it in her subsequent promotional appearances on the chat show circuit. All of the above would not matter if Sarne's collage-style approach to the film, with much interpolated footage – even including Laurel and Hardy – had found some kind of filmic equivalent for Gore Vidal's parodically fevered prose, but the material defeated him.

Misogyny and Henry Miller

Any attempt to record all the changes in attitudes to sexual mores over the years is like taking a ride on a rollercoaster – and a modern viewing of Joseph Strick's 1970 film of Henry Miller's *Tropic of Cancer* provides an index of how seismic the changes have been. The film, while deeply flawed, is undoubtedly brave, and sports the same provocative engagement with a literary work as the director had previously demonstrated in his far more successful version of James Joyce's unfilmable *Ulysses* in 1967. He had also taken on another literary work with his film of Jean Genet's *The Balcony* in 1963, whose brothel setting and frank language caused quite a stir in that era, but *Tropic of Cancer* was the first mainstream

film to (repeatedly) use the word 'cunt' – sometimes as a description of the female genitals, but more frequently to refer to the women characters in the film. There is no question that Miller's use of such terminology was commensurate with his attempts to break down shibboleths, as can be seen in his battle with a Supreme Court judge – more on that shortly. However, in the twenty-first century, such blunt language seems less brave than misogynistic, although it does still carry a charge in a film starring such mainstream actors as Rip Torn and an uncredited (and frequently nude) pre-*Exorcist* Ellen Burstyn. The film's attitude towards the female sex – as seen through the eyes of the Henry Miller character (played by Rip Torn) and his middle-aged male friends – now seems like the sort of casual contempt for women shown in the lyrics of the most misogynist rappers; the women here, although differentiated in terms of character, are treated appallingly by both the Miller character and his friends, and Strick's film seems vaguely unsure as to whether to regard him as a woman-hating creep or as a comically charming sponging chancer.

Miller's battle over his novel with the US Supreme Court occasioned a famous description from Pennsylvania Supreme Court justice Michael Musmanno. Outraged by a 1961 ruling that the original novel was not obscene, Musmanno fulminated that the book was (as noted by Tim Lucas in *Sight and Sound* magazine) 'a cesspool, an open sewer, a pit of putrefaction, a slimy gathering of all that is rotten in the debris of human depravity'. In his tirade, the judge was not concerned with such niceties as the book's attitude to the protagonist; as noted above, were readers supposed to find common cause with the unpleasant, lying, irresponsible figure that Miller presents himself as? Similarly, like many of a censorious disposition, the judge did not really take into account what the book – and, subsequently, Strick's film, which echoes the modus operandi of the original – actually says about sex: it is less a celebration of fulfilling sexual experiences as a description of a desperate, joyless attitude to the act of copulation, which is frequently described in negative, violent terms. It might be argued that the film and the original book were anti-sex, despite their explicitness, in a way that would surely please the censors if they took the trouble to look beneath the concupiscent surface. A similar misreading would happen later with the blasphemy charge bought by the Christian moral campaigner Mary Whitehouse against a poem by Professor James Kirkup in the now-defunct *Gay News*, which was in fact about religious conversion – Whitehouse's own avowed agenda – but couched in homosexual terms via a centurion's physical appraisal of Christ.

What appears to interest Strick least about the novel is Henry Miller's Proustian attempts to become a writer by communicating the experiences – sexual and otherwise – of his impoverished life in the intellectual quarters and brothels of Paris. We are given some detail about the latter and appear almost to be invited in the film to cordially dislike the cruel and selfish Miller, but we are not shown the more positive effect of his struggle to become an artist. The film updates Henry Miller's novel from the 1930s to the film's present day, but it offers a curious variety of sexual attitudes; the Miller character's casual sexism seems understandable in a young man, as Rip Torn, subsequently a venerable character actor, was at the time of the film. But the same attitude is discovered in his friends, who are all older than him and simultaneously – and unattractively – middle-aged but adolescent in their opinions; they share his prurient and dismissive view of women, with copulation described in a self-consciously 'dirty' way rather than in a celebratory, erotic fashion. What's more, Miller's friends echo his maliciousness. In an early scene, after Miller and his wife have made love, he wakes her to say that her body is crawling with fleas from the bed of the downmarket hotel in which they are staying, and he laughs cruelly at her distress; we are not surprised when she abruptly leaves him, never to return. Similarly, one of Miller's friends laughs loudly when a woman has wine spilled over her dress. The fact that the friends are all well played by such actors as James Callahan and David Baur makes us all the more uncertain about how we should read them. Was Strick ahead of his time and looked upon these men as sexist boors for whom women are a simple sexual receptacle? Or does he see them as rebels against bourgeois norms? One of Miller's friends makes what is perhaps the most interesting remark in the film: having said that he is tired of the French and ready to go home to America, he says: 'Of course I hate those prudish bastards at home. But I suppose I'm one of them.' At this point, it seems that the film is examining the whole ethos of the displaced American in Paris – not just Miller but Hemingway too.

It should be noted, however, that the film portrays the battle of the sexes as something played out with bad faith on both sides. When Miller steals money from a prostitute's purse, after having had sex with her, he runs from the house laughing unpleasantly. However, she has already been shown to be a mercenary liar, using a possibly non-existent mother as a weapon against him. Perhaps the only sympathetic woman in the film is Miller's wife, played by Ellen Burstyn; better known these days as a character actress, her unabashed nudity in the film – pubic hair and all – may be a little startling for modern

viewers. Her character's carnal encounters with Miller are perhaps the only pleasant ones in the film, but she soon comes (correctly) to regard their relationship as a dead end and abandons him. As she lies naked on the bed and reaches seductively towards the camera, there is a sense in her openness of what ultimately proves to be unfulfilled potentiality in the sexual relationship between men and women – and although Miller rather arbitrarily laments the fact that she has left him, we feel no sympathy for him whatsoever.

As mentioned earlier, the film's notoriety results from its use of the word 'cunt', spoken for the first time in a release from a major studio, Paramount, although Strick had previously baited the censors by reproducing Molly Bloom's famous soliloquy at the end of *Ulysses* largely intact, with its orgasms and the use of the word 'fuck'. That film, for all its failings, had shown a more complex attitude to the variety of sexual experience to be found in the source novel. And, crucially, Strick had established a sympathy for its overweight, unhappy central character Leopold Bloom, obliged to masturbate sadly even as his wife enjoyed adulterous sex with her crass lover. Such human sympathy is not to be found in Strick's film of *Tropic of Cancer*, although its historical interest must be admitted, particularly when set against another version of the story, Philip Kaufman's *Henry & June* (1990), which made more of an attempt to make us empathise with its characters in their endless quest for orgasm.

Storyville blues

Having pushed the boundaries of what was acceptable in the presentation of sex on the screen with *The Lovers* (*Les Amants*, 1958), the French director Louis Malle showed further interest in this endeavour with 1978's US-made *Pretty Baby*. The director's first American film is set in Storyville in the early twentieth century. In the red light district of New Orleans, Hattie (played by Susan Sarandon) and her adolescent daughter Violet (Brooke Shields) are both working as prostitutes. A young photographer, Bellocq (Keith Carradine), makes an arrangement with the madam of the brothel to photograph the girls; the latter consider him to be distinctly strange as he does not appear to be sexually interested in them. Violet's feckless mother marries a customer and forsakes her, leaving for St Louis. The Storyville district is shut down, and the abandoned Violet is taken up by the photographer Bellocq; he even proposes to her. All of the above moves into tricky narrative territory, as child

prostitution is always a difficult subject for the cinema, as illustrated by the retrospective cuts made in the UK to Martin Scorsese's *Taxi Driver*. What makes *Pretty Baby* so unusual is the fact that it is not only concerned with a mature male photographer who has an unhealthy interest in a 12-year-old prostitute but with Violet herself, who shares his fascinated gaze on the sexual arena. In fact, Malle suggests that the couple, despite their age difference, are similar in other ways; there are hints in Bellocq's behaviour that he is not fully mature and that he is sometimes rather childlike. His attempt to keep Violet in a similarly childlike state is not about simple control; he wants the two of them to remain on the same level, if at all possible. Of course, the film was deeply unacceptable to many at the time; and, viewed in the early twenty-first century, when such issues have become the combustible stuff of daily trials and tabloid headlines, there are those who might look at the film and reject what they consider to be its conclusions – but, as in most of the director's films, any such conclusion is left up to the viewer.

Despite the current flurry of investigations into historical child abuse, it is easy to forget that there was an equivalent of the phenomenon taking place in 1978, and Louis Malle received a great deal of criticism for not presenting Violet as an abused figure, although he does show her as being vulnerable. The women who work in the brothel are presented as relatively comfortable and do not appear to be coerced, something that also occasioned criticism. However, there was one area in which the director could not be described as culpable: any kind of exploitation of his youthful star. None of the scenes in the film show her at work, and she is never seen in a straightforwardly erotic situation – apart from, perhaps, her poses for the enamoured photographer – although there are certainly moments that are problematical.

Perhaps because of his lack of experience with English-speaking actors, Malle does not find the best in his performers, and even the presence of one of the best actresses in current American cinema, Susan Sarandon, as the young prostitute's mother is not a particular asset, as her character has relatively little screen time. The film's cinematography is beautiful, its painterly visuals demonstrating the genius of Ingmar Bergman's cinematographer Sven Nykvist, and this goes some way to make up for the unaffecting performances and the flat-footed dialogue. But Malle is too good a director not to salvage something from the material and the film remains intriguing and provocative – perhaps *too* provocative in the current climate, although in the past it has had showings on British television.

12
Vixens and Valleys: Russ Meyer's Cinema

In the introduction to this book, I pointed out that I would not be in the business of providing moral condemnations of filmmakers whose entire oeuvre is an affront to particular sensibilities, feminist or otherwise. That caveat should definitely be borne in mind in any discussion of the films of exploitation king Russ Meyer, who was either a cutting satirist of the American obsession with large breasts – an epithet he could share with the director Frank Tashlin – or one of the most maladroit and naive filmmakers in the history of the medium: take your pick. His outrageous, operatically pitched films featured copious nudity; his heroines were argumentative, loud women of voracious sexual appetites, usually endowed with unfeasibly voluptuous figures. Largely speaking, Meyer eschewed – and claimed to dislike – hard-core pornography, and the occasional glimpse of a prodigiously sized but non-erect male organ would fool only the most gullible into believing it was anything but prosthetic. His films, with such titles as *Vixen!* (1968), *Common Law Cabin* (1967), *Cherry, Harry and Raquel* (1970) and the more mainstream *Beyond the Valley of the Dolls* (1970), made the director a millionaire, and he was often able to film his outrageous melodramas in his own opulent house and large swimming pool. The work he did while enjoying this commercial success might be said to be the product of his own cottage industry – his house was in essence a mini studio, and Meyer frequently used his cast (the noun 'actors' is only occasionally applicable) as crew members, in much the same fashion as fellow independent Roger Corman, keeping the budget tightly under control and usually recouping far more than the initial outlay. Meyer was also his own cameraman and shot such scenes as an underwater lesbian tryst in *Cherry, Harry and Raquel*, carefully keeping the more gynaecological aspects of the encounter below the waterline; Meyer was nothing if not forensically

aware of the censorship restrictions in various states, and was always treading a fine line to avoid the attentions of pressure groups such as the Citizens for Decent Literature.

Defying gravity

Meyer's personal obsession – of which he made absolutely no secret – was with large-breasted women, and his appetite for featuring new stars with ever more gravity-defying proportions led to a considerable turnover in the casts of his films. There was notably more consistency in his male actors, who were generally presented as idiotic sex toys for the women, and, for the men, any glimpsed accoutrements could be faked – such as the latex penises mentioned above.

Ironically, in three distinct areas, Russ Meyer might be described as the Ingmar Bergman of the soft-core 'nudie' film: he was very much the auteur of his works, both writing and directing the films, as well as being the cinematographer; his women tend to be presented as stronger characters than the males (though Liv Ullmann was probably a better actress than Evelyn 'Treasure Chest' West); and finally – in an off-camera congruence with the great Swedish director – Meyer often had relationships with the actresses he photographed so lovingly in his films.

For the scene mentioned above involving the torrid underwater coupling, Meyer used two actresses who were not the ones he had already shot for the film – the original women playing the protagonists were no longer available. But this relatively significant detail hardly mattered to him; he was not even concerned about the fact that one of the new actresses was black, unlike her predecessor. When tackled about such narrative incoherence in his films, Meyer pointed out that there was some obscure symbolism involved – quite what kind of symbolism was never examined in any detail. But it is likely that he would have relied on the same response as an auteur filmmaker in another field, Dario Argento. The specialist in the Italian horror or *giallo* film, when faced with a similar lack of rigour in his storytelling, would make it clear that what counted in his films were the set pieces – sanguinary in the case of Argento, erotic on the part of Meyer – and that the principal imperative was, respectively, to inculcate suspense and to create arousal. Or was it that simple? Those who turned to Meyer's films expecting the erotic to be a key component might have been disappointed. Except for a specialist audience, the films were not designed to arouse the viewer – unless, that is, the viewer's predilection was for frequently violent, clumsy and notably inelegant couplings, with the vigorous simulated

intercourse accompanied by a soundtrack of exhortations ('Faster! Harder!') and gasps more calculated to promote laughter than heavy breathing in the cinema.

The director's first film, which was shot in the buttoned-up America of 1959 on a parsimonious budget of $24,000, was *The Immoral Mr Teas*. This is a film whose ramshackle quality at times suggests the improvisatory air of the French *Nouvelle Vague* already germinating across the Atlantic. It was, in fact, the inaugural entry in what came to be coyly known as the 'nudie' genre: relatively innocent pin-up or striptease fare that was inspired by similar features being made in Europe at the time. These exercises in mild titillation, which were invariably accompanied by banal elevator music, included such healthy pursuits as naked ball games and had to be shot in such a way as to avoid the genitals but to make the most of the effects of gravity on female breasts. Strategically placed towels for the groin were par for the course. The eponymous protagonist of *The Immoral Mr Teas* (played by a friend of the director, whose name was, conveniently, Bill Teas) was shown as an unimpressive casualty of modern life with one particular ability, not unlike Superman's X-ray vision: he was able to mentally undress women. The premise of the film was therefore that he would, for example, disrobe a nurse at a dental office – for his own benefit and for that of the audience.

The immense success of this bargain-basement feature – which had only its inoffensive pulchritude and its director's enthusiastic shooting tactics to recommend it – inspired over a hundred imitations (of varying degrees of ineptitude) within a very short time, with such titles as *Not Tonight Henry* (1960). However, all the imitations lacked Meyer's exuberant sense of humour. The director then became a one-man 'skin flick' factory with such shakily but energetically directed films as *Europe in the Raw* in 1963 and the totally plot-free, terminally boring *Mondo Topless* three years later. The latter film's choreography consisted of Meyer's well-upholstered female stars dancing – or, more accurately, jiggling – as the camera zoomed in and out while a cheap transistor radio putatively supplied the muzak soundtrack.

Recognition as a filmmaker resulted from such films as *Lorna* (1964) and the celebrated *Vixen!* (1968), which were accompanied by public pronouncements by the director in the manner of more ambitious auteurs. Meyer claimed that his films were more than simple voyeuristic exercises; rather, they were a kind of apogee of pornographic fantasies, with the director fully aware of the caricatured nature of his pneumatic heroines and the general incompetence (and sometimes impotence) of his masculine characters, who were a comment on the American male.

Such assertions by Meyer often confounded commentators. Was he a serious filmmaker? Did he really have artistic pretensions? Or was the elaborate, half-baked theorising a disguised two fingers to his intellectual critics?

Erotic alienation

Apart from the sex scenes, Meyer's films often featured sustained action sequences delivered with the gusto of the action directors who were being lionised by such magazines as *Cahiers du Cinéma*. And his skill was evident in such films as *Lorna*, which had pretensions to being better acted and written than his previous films; the inevitable hectic sexual activity was on display, but here it was tied into a not unintelligent plot about the erotic alienation of American men and women of the era. By the time of what is perhaps his best-known film, the ludicrously titled *Faster Pussycat! Kill! Kill!* in 1966 (made in black and white), analogies were even being drawn with Thomas Kyd's *The Spanish Tragedy*, although the director himself invoked John Steinbeck for his fascination with dungaree-wearing dirt-poor types. And *Mudhoney* (1965) drew semi-serious comparisons for its visual style to the baroque filmmaking of the director King Vidor.

Perhaps the most viewed of the director's string of 'sexploitation' movies is the almost plotless *Vixen!* (aka *Russ Meyer's Vixen!*), in which the central character – the Amazonian Erica Gavin – is a woman with a limitless contempt – and a limitless, frustrated sexual appetite – for the male sex. She lives with her husband, a forest guide, in the sylvan setting of the Canadian Northwest. The couple share a cabin with Vixen's brother and a young black American who has been dodging the draft. Also stirred into this heady brew are a hectoring Scottish Communist with an unlikely red beard and a young American couple. Apart from having a variety of sexual consummations – and failed consummations, a standard theme in Meyer – the characters bicker endlessly about everything from politics to race; the result is often hilarious and always either subconsciously naive or unwittingly idiotic. The same syndrome can be found in one of the director's studio-financed movies, a 1970 sequel to Mark Robson's soap opera-like *Valley of the Dolls* called *Beyond the Valley of the Dolls*; this pushed the absurdity of Jacqueline Susann's over-the-top original novel to almost cosmic levels and to divertingly eccentric effect – the climax involves a transgender killer with a penchant for decapitation.

Sophisticated audiences of the day were not quite sure whether they were laughing at or with *Beyond the Valley of the Dolls*. The screenplay

for Meyer's film was co-written with the respected film critic Roger Ebert, an advocate of the director's work. The canny Ebert was fully aware of the absurdity of the idea behind the film: not only the plot idea of an all-girl rock group attempting to achieve success in sexually corrupt Hollywood, but a narrative couched in terms of the most crass soap opera, with a dramatis personae of nymphomaniacs, homosexuals, male prostitutes and transvestites. The fact that the film was a big-budget production sponsored by a major studio, Fox, was less surprising in 1970 than it might at first appear. The studio had lost money on such major films as Gene Kelly's *Hello, Dolly!* (1969), and was banking on films that would benefit from the new sexual freedom and might appeal to both a standard exploitation market and a more sophisticated crowd. Another of their productions, *Myra Breckinridge* (1970), was also meant to appeal to both audiences, being based on the novel by Gore Vidal and with its frank content. But, as noted earlier, it turned out to be a financial disaster to rival the studio's other flops.

The Fox producer Darryl Zanuck counselled relatively low-budget productions and suggested that anything costing over $1 million was to be avoided. It was this philosophy that was taken up by Zanuck's son Richard, who invited the exploitation filmmaker Meyer to work for the studio. Zanuck Jr had noted that the director's *Vixen!*, which had been made for a fraction of the cost of most of the studio's films, had grossed over $6 million, and he thought that the maverick filmmaker might make something provocative out of the inevitable sequel to the 1967 Fox success *Valley of the Dolls*, a follow-up that had stalled despite the involvement of its original author Jacqueline Susann. Meyer did indeed do just that, producing something that made even the tawdry original look like a film by Michelangelo Antonioni. But Meyer's cottage industry approach could not be translated unaltered to the logistics of the studio production system, with such considerations as studio overheads to accommodate. The resulting film was as full of outrageously shocking images as Zanuck Jr might have wished for: a mysterious figure is pursued in the moonlight by a killer wielding a samurai sword; a sleeping girl is woken as the barrel of a gun traces up her naked body into her mouth, and is fired – all of this before the appearance of the unrealistically proportioned young women who were always to be found in Russ Meyer's films, two of them *Playboy* magazine 'playmates' Cynthia Myers and Dolly Read.

But – most importantly – did Meyer's film make up for the disaster of the same year's *Myra Breckinridge* (discussed in Chapter 11), with its out-of-control young British director Mike Sarne signally failing to marshal an intriguing cast including Raquel Welch, John Huston and an elderly Mae West?

Many films of the time were employing the new freedom that was invading cinemas: for example, Mike Nichols' misfiring black comedy based on Joseph Heller's novel *Catch-22* included a frank brothel scene and a naked Paula Prentiss standing on a raft with her legs apart. However, it began to be apparent that audiences now required more than nudity and sexual realism. In the event, Meyer's *Beyond the Valley of the Dolls*, while only a qualified commercial success, was enjoyed by audiences for its undeniable high camp quotient, but was ultimately to prove something of a last hurrah for its director.

In the final analysis, Russ Meyer's florid verbiage about what he was trying to do with his films matters less than the final effect of viewing them. The director's sheer, unabashed enjoyment of his medium strongly echoes that of another low-budget trash auteur, Ed Wood. But was Meyer, like the self-deluding Wood, a director who considered that he was doing interesting, ambitious work in a non-respectable genre when he was actually producing the most meretricious rubbish? Only by watching his lively, often demented body of work can we answer that question – and the answer may be different for each individual viewer.

American maverick

A footnote to the text above on Meyer: the wily American distributor and producer Harry H. Novak, an assiduous promoter of sexploitation movies – with a particular gift for outrageous titles, including a hucksterish retitling of existing films – died in 2014 after a long career noted more for remuneration than respectability. Like many older members of the 'adult' profession, Novak had enjoyed a career in mainstream cinema, working in his youth for RKO and honing his skills on posters and lobby cards. This discipline gave Novak a keen appreciation of exactly what it was that sold films to the public – usually the most sensational elements. When RKO closed its doors in 1957, Novak moved into distribution and enjoyed an early success with a Swedish film called *Flamman* (directed by Arne Ragneborn in 1956), which he renamed *Girls Without Rooms*. Novak's success with this piece of repackaging inspired him to re-sell and retitle more foreign films for the US market; he created the company Boxoffice International Pictures for this purpose. But his creativity (such as it was) ultimately extended to making his own films, and his first erotic venture (under the ludicrous moniker 'Seymour Tuchus') was *Dr Breedlove* (1964). The title may have suggested a play on Stanley Kubrick, but the film itself made references to James Whale's *The Bride of Frankenstein*. It was retitled *Kiss Me Quick!* – presumably with no reference to English seaside towns.

Cheap and cheerful (if maladroit), the film turned a profit, and Novak winkled out the continuing commercial possibilities of acres of naked female flesh in such movies as the psychedelic *The Agony of Love* (1966), with the opulently proportioned Pat Barrington. He also contributed to the putatively serious pseudo-documentary exposés of middle American mores with *Suburban Pagans* (1968), adorned with some particularly hilarious wife-swapping dialogue. Like the highly successful horror/ exploitation producer/director Herschell Gordon Lewis, Novak realised that there was money to be made in white-trash, blue-collar eroticism, and cashed in with such enthusiastically awful efforts as *Country Hooker* (1974), scored with excruciating country and western songs that make mainstream fare in that genre sound like Franz Schubert.

There were two kinds of exploitation filmmaker: those who remained firmly in the soft-core market and had no desire to move into close-ups of interacting genitals – Russ Meyer was in this group; and there were highly prolific directors such as Jesús (Jess) Franco who, with his partner Lina Romay, went where the market took them – which was ultimately in the direction of hard-core pornography. Novak was of the latter school, and in the 1980s he made a variety of hard-core efforts under the pseudonym H. Hershey before, to his surprise, he received some critical attention with essays on his work (rather like the one you are reading now). His motley collection of films enjoyed re-releases on DVD with the producer/director providing deeply scurrilous commentaries, and he enthusiastically took part in documentaries about the world of exploitation filmmaking.

13
British Smut

There are certain films that drop off their directors' filmographies, and, frankly, it is not hard to see why a certain process of discreet tidying up has been undertaken. After all, in the United States, it is hardly surprising that the director Francis Ford Coppola suggested that his career began with an imaginative, and borderline-respectable, *Psycho*-inspired effort called *Dementia 13* (1963, retitled *The Haunted and the Hunted* in the UK, and trimmed of its axe murders), when in truth his first film as a director was a 'skin flick' made a year earlier with the lubricious title *Tonight for Sure*. And, in Great Britain, the director Michael Winner was wont to draw a veil over an early nudist film he had cut his teeth on called *Some Like It Cool* (1962, with the healthy-looking Julie Wilson), one of the hilariously anodyne brand of British naturist films in which strategically placed towels always concealed the genitals of male and female stars alike. Volleyball games were popular in such affairs, as they could be shot from behind: as noted earlier in this study, bouncing breasts were acceptable; genitals in piquant motion were not. But leaving aside its acres of naked flesh, Winner's film, despite being made with a knowing comic eye, was saddled with a screenplay of stupefying asininity – and it was performed by non-actors chosen more for their readiness to divest themselves of their clothes than their desire to spend time perfecting their line readings. Winner, however, was no fool and was well aware that any British exploitation film selling itself on its amount of sexual material would never be respectable, and that remains the case to this day – although, ironically, a certain nostalgic sheen has been spread retrospectively over this period, which, as a convenient starting point, might be said to begin in the US in 1954 and in the UK in 1960.

Take off your clothes and live

In the repressed Britain of the 1950s, the sight of female nipples in a film was strictly verboten. Foreign films were quickly snipped by the censors and British filmmakers knew not to even bother shooting such material, except for the export versions; for example, Hammer's *The Hellfire Club* (1961; mentioned earlier) featured topless orgies, but they were unseen in the UK.

The first successful films to mount an assault on this puritan era began with the naturist cycle: the first important home-grown example was *The Nudist Story* in 1960, while the glamour photographer George Harrison Marks' *Naked as Nature Intended* (1961) is another landmark film in the genre. By the time of the crass British sex comedies such as *I'm Not Feeling Myself Tonight* (1976) and *Confessions of a Window Cleaner* (1974) a decade or so later, the sex comedy genre had supplanted such films with an even coarser version (if possible) of the none-too-subtle double entendres of the Peter Rogers/Gerald Thomas *Carry On* series. The once-scandalous seaside postcard humour of Donald McGill – with his fat termagant wives, mousy henpecked husbands and buxom leggy blondes in low-cut dresses – had become safely mainstream, local authority prosecutions of such material a thing of the past. What's more, it had become virtually harmless; female nudity, as well as a touch of male nudity, no longer raised watch committee ire – or, for that matter, temperatures – in a series of films that became a byword for the paucity of achievement in British cinema. The principal difference from the *Carry On* series, such as 1969's *Carry on Camping*, famous for Barbara Windsor's projectile bikini top, was that the characters in the *Confessions* series actually *had* sex rather than endlessly fantasising about it. In the final analysis, however, it doesn't do to be too po-faced about a genre that, with a little patience, affords some rewards – albeit scant ones (no pun intended).

Come into the garden

Shrewd British filmmakers in pursuit more of lucre than of art had taken notice of the great success in 1954 of an American nudist exploitation film called *Garden of Eden*, which arrived in the UK with the spurious blessing of the US Sunbathing Association. Its copious and entirely innocent nudity purported to show the freedom and happiness that a lack of clothes brought about, with a variety of decorous models disporting themselves to prove the point, but it occasioned fuming outrage at the BBFC, which refused the film a certificate. However, the UK distributor of the film, the streetwise Nat Miller, had a carnival showman's

skill when it came to outwitting the ever-circling watch committees and arranged private showings of the film for the London County Council. These showing – which, unsurprisingly, were well attended – led to the finessed LCC putting aside the BBFC decision and allowing *Garden of Eden* to be shown in the capital. The floodgates had been prised slightly open, and various local councils followed suit, which meant that the film could be seen in a great many British cities. Seeing the way the wind was blowing, the BBFC bit the bullet and granted the film a belated certificate. Nat Miller, emboldened by his successful ploy, realised that there would be a market for home-grown product along the lines of *Garden of Eden* and put into production a similar domestic item, *Nudist Paradise* (1958). The avowed pretence of such films was that they were virtuously extolling the virtues of the nudist ethos. Although John Trevelyan, the canny British censor of the time, was well aware that this argument was utterly specious, he nevertheless allowed this new wave of filmic nudism to continue unabated, while insisting on several caveats. The aforementioned modest covering of genitals remained an absolute given, as did the fact that the locations – the purported nudist camps themselves, however unreal – must remain the default setting for any naked cavorting. Sharp-eyed aficionados of the genre quickly realised that the films shot in actual nudist camps had a remarkably variegated clientele. Apart from the pale-skinned, skinny or paunchy individuals with drooping breasts (both female and male) – the real naturists, in other words – highly attractive models with pneumatic bodies might be seen rubbing shoulders, but not other body parts, with the genuine nudists and enjoyed far more of the camera's prowling attention. British filmmakers were aware that the ordinary human body, for the most part, was nothing to write home about and notably unaesthetic – not to mention unphotogenic. Accordingly, they hired several toothsome professional models to ensure that the flesh displayed in their films was of the most attractive variety. The same syndrome was evident in the print equivalent of such films: the naturist magazine *Health and Efficiency* similarly used bussed-in models among the less impressive physiques of those who genuinely spent their weekends shivering in British holiday camps. (The magazine also featured bizarrely airbrushed pubic regions, which left a generation of British schoolboys with the idea that women's pubic regions were smooth, featureless blanks.)

Laughter in paradise

If a selection of the British nudist films of the 1960s were shown to a modern cinema audience, there is little doubt that they would prompt

gales of derisive laughter – not just for the ridiculous strategies involved in maintaining the modesty of the performers but for the hilariously arch espousal of nudist values presented either in quaint 1930s-style voice-overs or by one of the characters in the film itself. The latter usually took place in an early scene, when, after her arrival at the naturist camp, a shy novice nudist is persuaded by her more experienced girlfriend that she will be able to commune with nature much more easily if she takes off her petticoat and garter belt. Tedium quickly set in with most of these films because of the necessity to set the nudist antics within a physical context; there was therefore much numbing footage devoted to travelogue scenery and the surrounding countryside – not really what the target audience had paid its money for. At the same time, it was hardly surprising that the response of genuine nudists to the films was dismissive, even though the owners of the various naturist clubs (such as the famous Spielplatz in Hertfordshire) were prepared to take the filmmakers' shilling and allow their grounds to be used for filming.

Cinemas often screened such films simultaneously with continental movies by serious directors in which the libidinous characters clearly wanted to have sex with each other; and these foreign films with their sexual elements would receive 'X' certificates. However, the anodyne, asexual pursuits of the nudists largely ensured that their films were usually classified as 'A' certificate fare, meaning that children under the age of 14 could not be admitted without an adult.

As might be expected, the once-provocative appeal of these deeply innocent films finally began to wane, and even a generous nipple count lost its forbidden charge. Exploitation film producers and directors such as Robert Hartford-Davis introduced edgier ingredients into the adult film; for instance, Hartford-Davis's *That Kind of Girl* (1963) dealt with sexually transmitted diseases. It was clearly time for more risqué material.

Sin in the shadows

A thriving subgenre of the era was the 'exposé' film, mostly along the lines of *West End Jungle* (1961), produced by the prolific Stanley Long, who had already made a name for himself in the nudist genre. The poster read: 'Now for the first time – the world's greatest city laid bare! Thrill to its gay excitement ... its bright lights – but be shocked by the sin in its shadows!' This hopeful come-on strapline was accompanied by smiling girls with underwear barely covering their breasts and buttocks – and to establish the fact that it was indeed London that audiences would be seeing in the raw, illustrations were also incorporated of

Big Ben and Eros in Piccadilly Circus (the latter, perhaps, appropriate). Despite censor disapproval, the producer followed up *West End Jungle* with the equally gimcrack *Primitive London* (1965); this listless parade of salacious material was a million miles away from the anodyne innocence of the nudist films, presenting the capital as a hotbed of unbridled lust. But at the same time as such films were being made, imported foreign films with far more explicit material – material that would not be permitted in the domestic product – were being shown more frequently and becoming better known, not least through such magazines as *Continental Film Review*. This was a combination arthouse review and girlie shots magazine that was perfectly happy to run inflammatory stills from unpretentious sex films alongside suitably erotic shots from such directors as Ingmar Bergman and Federico Fellini.

Ironically, the slight thawing in the direction of liberalisation by the BBFC represented, however belatedly, something that would have benefited the earlier wave of nudist films with their rigorously maintained strictures against the showing of full-frontal nudity. Conducting his own research, John Trevelyan noticed that the public appeared to be more accepting of the sight of pubic hair and acknowledged that he and his examiners were being more lenient in this direction. His job, he maintained, was to reflect public opinion rather than to attempt to mould it. However, the new salaciousness of the exposé film had become the latest taboo in terms of censorship battles, and most such films were cut. Wholesome, breast-bouncing volleyball games had been replaced by a determined sleaziness – the entire *raison d'être* of the new genre – and the BBFC was upset.

Stanley Long, ever alert to both the erotic tastes of the public and the possibilities of what was allowable under the current certification regime, made such films as *The Wife Swappers* in 1969, capitalising on the then current interest in the subject. Suburban wife-swapping was read about with a combination of eagerness and faux-disapproval by readers of Sunday newspapers, but those who consumed the details of such indulgences in the *News of the World* would expect the heavily fictionalised reports to be served up with a substantial ladling of moralising commentary; in fact, this subject matter continued to fascinate the newspaper right up until the first decade of the twenty-first century. Sunday paper revelations, while gleefully relishing the acts of moral dereliction they described, nevertheless adopted a position of principled rectitude that would have done the sternest preacher or imam proud. However, although nobody took the impeccable moral standards of Sunday newspaper journalists seriously – even when such newspapers

outsold far more serious journals – it had become something of a joke that a reporter, after inveigling his way into some sexually abandoned situation, such as a brothel being run in a suburban house, would invariably 'make his excuses and leave'. Such moral equivalence was the status quo in the 1960s; it wasn't until 2013, when the British phone-hacking scandal brought about the closure of the *News of the World* by its under-siege proprietor, that the chickens came home to roost.

When filming *The Wife Swappers* (directed by Derek Ford), Stanley Long knew that he would have to walk a similar tightrope of hypocrisy; audiences were keen to see what went on at these 'depraved' parties, but a disapproving tone – either tacit or overt – would be needed to get the film past the censor. The film therefore was obliged to feature a bogus psychiatrist who unblushingly presented for viewers the various concupiscent episodes, but described them in anthropological terms and reminded the audience that the wages of sin are death. However, the nascent guardians of public morality, on the point of becoming national organisations, were already deeply worried by what they perceived as the lenient decisions of John Trevelyan and the BBFC, and they began impassioned campaigns against the moral laxity of current films – even though their ultimate target was to be the equally licentious medium of television, which was far more dangerous as it reached into people's homes. These moral campaigns were parodied in films such as Jim Clark's *Every Home Should Have One* (1970), which dealt facetiously with the hypocrisy of religious campaigners attempting to ban sexual material while secretly relishing every carnal thrust.

A new respectability

It is something of an irony that the cheaply made films of this era, which prompted such disapprobation, now enjoy the serious attention of the august British Film Institute, which is reissuing the best of them in spruced-up Blu-ray packages with serious commentaries and the kind of extras previously reserved for impeccably arthouse material. An example of this surprising excavation is Norman J. Warren's *Her Private Hell* (1967), which was perhaps the first straightforward synthesis of drama and exposé film. A pretty young girl arrives in London from Italy and is persuaded to be photographed for girlie magazines. As its director admits, the film today would hardly raise an eyebrow, and it was passed for its recent Blu-ray release with no cuts, but *Her Private Hell* was considered very strong stuff in 1967. Its notoriety ensured that it quickly earned back its modest production costs, and it ran in one

London cinema for two solid years. The plot is another mock-solemn cautionary tale of an innocent girl encountering the darker side of modelling in London, and its status as Britain's first narrative sex film has now been noted (as mentioned above). As a time capsule of an era it has a certain interest, although its star, Lucia Modunio (aka Modugno), is palpably not equal to the histrionic demands the director makes of her; her talents lay elsewhere. And Norman J. Warren was to make his mark in other fields; he is better known for his home-grown horror films.

Others who worked in the genre were talented filmmakers rather than hacks. The director Martin Campbell realised that he could deliver the requisite amount of flesh while still indulging a playful, witty attitude to the sex comedy genre in such films as *Eskimo Nell* (1975), which was essentially a parody of the whole process of making sex films in the UK. Campbell went on to achieve success with such major films as *GoldenEye*, which rebooted the James Bond franchise in 1995, as well as directing the rather less successful superhero movie *Green Lantern* (2011).

Modest ambitions

Looked at retrospectively, the real interest of the sex films made in this era lies in what they tell us about British attitudes to sexuality at the time; as with the more mainstream *Carry On* films, the basic approach was a repressed, allusive one in which any real celebration of sexuality, or even sophisticated humour, was hardly to be found. This contrasted with the way in which foreign directors repeatedly tackled such subjects – Jirí Menzel's *Closely Observed Trains* (1966), for example.

When the producer Harry Saltzman was attempting to sell the James Bond franchise to the United States, he had difficulty persuading American distributors that an Englishman such as the hero of his films could enjoy so much sex, and he was obliged to point out that the English were not quite as repressed as their popular image abroad would suggest; however, the sex films of the 1960s might have given the lie to his argument, seeming to confirm the stereotype. Actors such as the massively ubiquitous Robin Askwith demonstrated a schoolboy reaction to sex that was somewhere between hysterical fear and slack-jawed lust; as the bumbling, gurning everyman of a hundred British sex films, he mostly kept his Y-fronts on while a coterie of sexually voracious housewives in déshabillé pursued him. Other actors, such as Barry Andrews in 1976's *I'm Not Feeling Myself Tonight* (directed by Joseph McGrath), also channelled this basically fearful anti-sex attitude. The fact that the sexual revolution was in full flood in the British Isles in the 1960s and 1970s

was not always reflected in the film product of the day. Although the era saw the introduction of new censorship certification – an 'A' category for those aged 14 or over and a new categorisation for the 'X' certificate that pushed the age of admission from 16 to 18 – the most notable result of this change was in the boundaries of what material might be shown rather than in the films' lip-smacking, end-of-the-pier view of sex.

Confessions of a Window Cleaner – with the unavoidable Robin Askwith in his underpants, as ever – was made in 1974 by Val Guest, whose filmography was otherwise relatively distinguished. The thoroughly dispiriting comedy was a massive commercial success and led to a lengthy series of imitations, demonstrating (it appeared) that British audiences – at least the kind who went to such films – were not at all worried by the retrograde, sniggering attitudes that were the lingua franca of this material. The rude health of the British sex comedy continued through the 1970s and threw up several unlikely stars, such as Fiona Richmond and Mary Millington. Neither woman – though mostly seen nude – was possessed of the kind of voluptuous body that one might have thought was de rigueur for the stars of such films, and certainly neither was likely to appear at the National Theatre as Hedda Gabler, but their uninhibited enthusiasm and total lack of inhibition were exactly right for the kind of ramshackle vehicles they made. Less appealing was the parade of solid British character actors who paid the rent by appearing in such films as comic relief; these included middle-aged, chubby actors Alfie Bass and Ronald Fraser, both of whom looked mildly embarrassed when, clad only in towels wrapped round the waist, they were obliged to gawp lustfully at a variety of topless young girls who (inexplicably) seemed to be sexually interested in them.

But exhaustion of ideas aside, the writing was on the wall for such films when hard-core material began to be successful in the United States – even though it was not to be seen in Britain, where UK audiences were accorded heavily cut versions. But British cinemagoers were becoming aware that the 'risqué' films they had been watching for so long were nothing of the sort, a situation further compounded by the greater amount of explicit sexual activity and nudity in more serious mainstream films. The era of the British sex film was about to come to an end.

A modern footnote

A strange, late hybrid filtering elements of the humorous British sex movie surfaced in 2013 with *The Look of Love*. Despite the sex and nudity, which were mostly tongue-in-cheek, this was less confrontational,

censor-baiting fare than viewers were used to from the director Michael Winterbottom: he had previously shown the vagina of actress Margo Stilley in close-up during cunnilingus in *9 Songs* (2004), a film in which she subsequently caressed the actor Kieran O'Brien to ejaculation. The much more soft-core *The Look of Love* starred comic actor Steve Coogan, who had appeared in the director's *24 Hour Party People* in 2002, and the film is a lightweight but diverting treatment of the life of Paul Raymond, the controversial (and eccentric) entrepreneur and property baron who made his fortune from the Raymond Revue Bar and *Men Only* magazine and went on to become Britain's richest man by the early 1990s – and a target of certain feminists. The tragic subplot involving Raymond's self-destructive daughter Debbie (Imogen Poots, who is excellent in the film) changes the tone, but the film has a marked non-censorial attitude to Raymond's profession in porn, although his relationship skills are presented as being utterly derelict.

14
The Porn Revolution

In the 1970s, a remarkable change in mainstream cinema was wrought by an iconoclastic commercial revolution. This revolution resulted in previously clandestine pornographic films becoming (relatively) mainstream, and a brief period began in which such material was considered acceptable fare for couples visiting the cinema – as opposed to the raincoat brigade that traditionally constituted the porn audience. Leaving aside the gender politics of such material, going to these films was seen as a specific rejection of the hypocritical sexual attitudes of an earlier generation. Within a few years, the burgeoning video market made such material accessible in living rooms, where its primary function – arousal for the purposes of masturbation or coitus – might be indulged in private. This period of 'porno chic' was typified by celebrities (Sammy Davis Jr, for example) being seen at such films as Gerard Damiano's *Deep Throat* in 1972, but its appeal quickly faded, as the new mainstream audience became alienated as much by the repetitive and poorly made nature of most of the films as by their ideology. Women's sexual arousal in such films was invariably bogus – female orgasm could always be faked, and often was – while male porn stars, because of the demands of the material, had to obtain erections and ejaculate; the 'money' or 'cum' shot was obligatory. Male orgasm during intercourse was invisible, so the market demanded that semen should not be released unseen in vaginas but rather on female faces or breasts, thereby signifying the end – or 'climax' – of the scene. Ironically, such forbidden material is now occasionally to be seen in mainstream cinema (cf. Michael Winterbottom's *9 Songs*, mentioned in the previous chapter) while porn has moved from the cinema to the internet and the DVD.

Makers of erotic (as opposed to pornographic) films customarily pride themselves on the female-friendly, visually pleasing, sensuous qualities

of their material and the well-upholstered production values. We are shown attractive people having simulated sex against exotic or upmarket locations. The original *Emmanuelle* film, directed by Just Jaeckin in 1974, is the yardstick here, along with its many imitators; languorous, soft-focus photography is the order of the day, with a portion of the budget being allocated to elaborate lingerie and long-stemmed flowers through which the not-very-explicit action may be shot. Pornographic films, however, generally have little truck with such niceties and make no bones about their primary objective: to provide material for sexual arousal and release in audiences more interested in seeing the lubricated interaction of human genitals, so that viewers are assured that this is not a simulation but the real thing. The principal audience for such films is heterosexual, but there is a considerable market for gay material and for even more specialised byways such as fetishism. The fact that the majority of porn films are directed to a male viewer has frequently resulted in a sidelining of the female response, and in recent years female directors and producers have attempted to redress the balance, making explicit porn that prioritises female sexual pleasure alongside that of the male.

The genre began with a series of short 'loops' (a trend stretching back to the silent era) and seamlessly adapted to a variety of formats, from regular film to VHS – particularly when the latter became the medium of choice for most consumers. Currently, the internet and dedicated pay-per-view channels are the standard methods of transmission for such material. But from the 1890s to the present day, such films have habitually been uncensored and their makers have sometimes been imprisoned; 'safe' screenings were considered to be in 'stag' or smoking clubs for men, dedicated adult movie theatres and even brothels. The Times Square district of New York – as seen in Martin Scorsese's film *Taxi Driver* (1976) – used to be the most famous location for such cinemas, but the area has since been 'cleaned up' and divested of its colourfully seedy character.

After the early silent films, the 'Super 8' film of the 1950s introduced a phenomenon that also found a home in British pornography from the 1970s onwards: amateur female participants, women who did not necessarily possess the pneumatic bodies of the more conventional performers of the genre. The popularity of the 'Readers' Wives' sections of the British porn magazines was considerable, with ordinary women posing slightly shamefacedly in the attitudes of professional models – but without the airbrushing and blemish-free complexions and bodies that usually characterised the latter. The 1970s was also the golden age

of what might be categorised as the mainstream porn film, and even the notably censorious opinions of judges began to undergo a certain tentative relaxation. Danish entries in the field were popular in the earlier 1970s, often featuring mainstream performers involved in hard-core sexual activity: certainly, any kind of Scandinavian connection became a sort of easy shorthand for sexually explicit material, and the adjectives 'Swedish' and 'Danish' were often applied willy-nilly to material that was filmed a continent away from Stockholm or Copenhagen.

The *Citizen Kane* of hard-core 1970s pornographic films was *Deep Throat*, but such is the weight of contentious material concerning the making of the film – from its coerced actress, according to her retrospective claims, to its financing by mob money – that it is virtually impossible to discuss it in any objective fashion (although an attempt is made a few pages hence). However, another film might be said to have initiated the massive, money-making wave of mainstream hard-core films of the era, and it would perhaps be useful to begin with a discussion of this mostly forgotten and largely unseeable film – Mike Light (the nom de plume of Michael Benveniste) and Howard Ziehm's *Mona*. After, that is, an opening sally in the porn wars from no less a figure than Andy Warhol.

Factory product and meeting Mona

Not all pornography had the same genesis – or the same aims. The extent to which the artist Andy Warhol actually participated in the films that bore his name is open to dispute – his studio, the Warhol 'factory' was, as its name suggests, a factory. However, there is no gainsaying the fact that he imported the unconventional genre-stretching strategies of his art into his films, although his actual achievement is certainly open to question: the 1969 film *Fuck*, also known by the less controversial title *Blue Movie*, essentially shows lengthy foreplay before copulation and a half-hearted attempt at fellatio performed by a giggling Viva on Louis Waldon after a desultory conversation about Vietnam. But the film for which Warhol is best known – and one that occasioned a variety of censorship furores, and even arrests, in the UK – is *Flesh*, made in 1968.

Warhol intended the film to move away from the underground work for which he was known into a more populist field, and *Flesh* consists of a series of loosely structured scenes; any attempt at a more concentrated narrative was consciously excluded. On the streets of New York and in a variety of apartments, Warhol stalwart, the bisexual actor Joe Dallesandro, spends the film attempting to obtain money from gay men to please his endlessly complaining wife. Dallesandro was noted for his

Brando-ish good looks and physique rather than any noticeable acting talent or charisma, while Geraldine Smith plays his wife in a caustic performance that suggests that Warhol's view of women was less than enlightened – her role is so one-dimensional that it is (deliberately?) irritating. When not attempting to have encounters with gay men, a frequently nude Dallesandro – virtually fetishized by the film – is involved in various strangely unsatisfactory sexual scenes with a group of eccentric beat or counterculture friends.

The actual director of the film was Paul Morrissey, who was later to do most of the heavy lifting on other films that bore Warhol's name, including the parodic *Andy Warhol's Flesh for Frankenstein* (1973) and *Andy Warhol's Blood for Dracula* a year later. Morrissey uses a variety of styles and devices borrowed from both underground films and the French director Jean-Luc Godard, jettisoning, or at least reinventing, the standard language of cinema. A certain incoherence and lack of continuity is encouraged, as we watch the characters explore themes that would have been largely unfamiliar to audiences of the day, from homosexuality (with its attendant male prostitution) and transvestism to the sight of Dallesandro's erection. It was perhaps the latter, now almost commonplace in commercial films, that led to one of the most mocked examples of heavy-handed policing of the cinema when the entire audience was arrested – or at least had their names taken – at a London arthouse showing of the film. As a picture of a particular sub-culture, both drug-using and sexually flexible, *Flesh* was eye-opening on its initial release and still is of interest today, although there is never a point at which Morrissey or Warhol attempts to persuade us that the lifestyle of these characters is at all attractive: it is just their quotidian existence. A second film by the team, *Trash* (1970), was filmed in more self-consciously semi-humorous mode, with the stentorian-voiced Holly Woodlawn added to the cast.

There are several 'firsts' in the cinema that are remembered for the trends they initiated, which could be profitable both creatively and fiscally. Richard Donner's *Superman: The Movie* (1978) is recognised as the defining template for almost every superhero movie that followed. Jules Dassin's crime drama *Naked City* (1948) began a new fashion in cinematography with its innovative location shooting in New York. And the first hard-core pornographic feature film? That honour – perhaps a source of just as much pride for its directors Mike Light and Howard Ziehm as any of the above achievements – goes to *Mona: The Virgin Nymph* (1970, sometimes abbreviated to just *Mona*). The plot is minimal: the heroine (played by Fifi Watson) has made a decision that

she will not have sexual intercourse until she is married, but she finds sexual satisfaction by performing oral sex on her boyfriend and a variety of other men – it is unclear exactly how, except by her simple generosity of spirit. The parameters of most of the films that were to follow are painstakingly set out here: Fifi's oral predilections, an orgy sequence, a lesbian encounter and female masturbation. The film's clearly unsimulated alfresco sexual encounters were something new and added a certain guerrilla filmmaking quality to the enterprise – not that UK viewers have been permitted to make a judgement in this regard, as it is still unseeable here. Later films featured both better production values and more sophisticated filmmaking techniques, and so *Mona*'s haphazard 16mm photography looks decidedly substandard now.

While the film was popular in its day in the US, it has largely vanished from sight, as have many of the 1970s films that enjoyed commercial success. At the time, it was not viewable at all in other territories – not even in a censored form. Those pornographic films that succeeded in making the journey to UK shores were regularly cut down in drastic fashion and certain sequences were then reshot, from much more discreet angles, to make the running time acceptable for feature length. Filmgoers in Britain must have wondered what all the fuss was about when they saw these anodyne versions of films they had heard about and that had originally contained far more explicit footage. Ironically, new licensing laws were recently introduced for home cinema products, and many of the films have subsequently reappeared as uncut British DVD releases, presumably on the assumption that any potential harm they might have done in the past has been neutered by the passage of time. *Mona* may be granted a similarly belated release at some point.

A new phrase in the language

Deep Throat moved hard-core pornography into the mainstream in 1972 – even for those who did not actually see it. Its title was sanitised by turning it into a joke (audiences laughed at Bob Hope's references to it) and it became famous as the name chosen for the journalists Woodward and Bernstein's whistle-blowing exposé of the Watergate scandal. For a brief period, *Deep Throat* was a sort of talismanic symbol of a new era of sexual freedom, before the subsequent storm broke after its star disowned the film when she became a born-again Christian. Such cultural critics as Camille Paglia noted that women were empowered by such films to the extent that they could sit and watch pornographic movies alongside men; she considered this to be a radical gesture. Other

people who increased the significance of the film included the writer Erica Jong (the author of *Fear of Flying*, with its concept of the 'zipless fuck'), while other viewers included Jackie Onassis, Truman Capote and Jack Nicholson, and Frank Sinatra arranged a showing of the film for Vice President Spiro Agnew.

At the time, Linda Lovelace's own description of the circumstances under which she made the film were unknown, and to some degree the anti-pornography movement among young women in the early twenty-first century was fuelled and inspired by Lovelace's own disowning of the film. There are, however, women in the industry who claim that Lovelace's story does not apply to everyone in pornographic films, and that her own principal problem was not so much her involvement in the porn business as the fact that she was the victim of a brutal and abusive husband. The Rob Epstein/Jeffrey Friedman biopic *Lovelace* (2013) draws a veil over one area that might not have sat well with its own denouncing ideological position: the actress was subsequently involved with such books as *The Complete Linda Lovelace* (written with Eric Danville), and she would happily sign posters for the film *Deep Throat* alongside copies of her unsparing autobiography *Ordeal*. She even continued to appear in pornographic magazines; money may well have been an issue, but this contradiction is perhaps encapsulated in the actress's own comments – she repeatedly stated that she was 'very anti-censorship' and 'very pro-sex'.

Artistic pretensions

Of the three films that moved the 'X' certificate into the mainstream – the other two being *Behind the Green Door* and the aforementioned *Deep Throat* – Gerard Damiano's *The Devil in Miss Jones* (1973) is perhaps the most adroitly made in terms of something approaching film technique. Damiano, who also directed the far less accomplished *Deep Throat*, was motivated by his ill-advised attempt to import the ethos of Ingmar Bergman into his film; its threadbare philosophical underpinnings were an attempt to give a little texture to material that was largely designed simply to arouse. Georgina Spelvin – another porn star with not particularly impressive looks or figure but with an enthusiastic approach (or a facsimile thereof) to the variegated couplings of the film – plays an unmarried woman who commits suicide and discovers herself in a particularly frustrating version of hell. She is to take part in a host of erotic encounters without ever being allowed to reach any kind of sexual climax herself. Spelvin, more mature than most of the women who

appeared in such films, displays some acting ability, and there is a kind of curious existential angst running as a seam through the film. In the end, though, this really is not enough to salvage it, unless the viewer's sole aim is stimulation; a scene in which Spelvin in extreme close-up uses her mouth in a great variety of imaginative ways on the sexual organs of one of her leading men is like a porn film equivalent of Jean-Marie Straub's utterly immovable camera in *The Chronicle of Anna Magdalena Bach* (1968) – and has the same deadening, DVT-inducing effect.

In the brief period when pornographic films were considered chic and suitable for something other than the raincoat trade, a handful of films achieved a reputation that moved their names – and the names of their principal female stars – beyond the exploitation ghetto. One of these was *Behind the Green Door* (1972, directed by Jim and Artie Mitchell). The film creates a strange dreamlike atmosphere in which an attractive young woman (played by Marilyn Chambers) is kidnapped and then obliged by shadowy figures to take part in a variety of sexual activities for the delectation of the members of an exclusive club. In unsurprisingly non-PC fashion, rather than regard this as an unpleasant coercion, she comes to regard the experience as something that has freed her and has allowed her to divest herself of her inhibitions. As in several of the slightly more sophisticated films in this category, the stress in *Behind the Green Door* tends to be on the sensuous aspects of coupling rather than on simple unadorned copulation, although, as in pornography from *The Devil in Miss Jones* up to E. L. James' *Fifty Shades of Grey*, there is not a great deal of interrogation of the paternalistic notion that men know best what women find pleasurable in sexual terms. In fact, the central premise of the plot had a precedent in a pamphlet that was popular among soldiers in the Second World War, and any criticism of the attitudes behind the film must be set against the fact that (as contemporary reviews suggested) certain women viewers of the era found the notions expressed appealing.

Directors Jim and Artie Mitchell make a conspicuous attempt to maintain the Daliesque, nocturnal atmosphere, and they moved beyond the parameters of male fantasy into certain more ambiguous areas, although these remain highly contentious. Perhaps the real coup on the part of the filmmakers was their canny choice of actress for their sexual innocent; however, this choice was rather lost on British viewers of the film, who had not seen the advertisements for the soap product Ivory Snow that utilised Marilyn Chambers' fresh-faced, girl-next-door appeal. The notion that such a familiar household figure would have her face ejaculated upon in extreme slow motion was calculated to have

a shock value that simply would not have been present with actresses known only for their work in the porn genre and hence used to such scenes. The film is also the first major feature to include interracial sex scenes, but the most famous (or notorious) sequence in the film is the ultra-slow-motion fellatio described above; with its semen travelling through the air for seven minutes, it was quite unlike anything that had been seen before in the genre, finally achieving the numbing effect of Andy Warhol's 485-minute *Empire*, with its interminable tracking shot of the Empire State Building. Vague fascination and close examination of detail finally shade into boredom and inertia on the part of the viewer.

Marilyn Chambers' career in the field was to be a brief one, but she is remembered for this film and for a memorable turn in a later, more mainstream film, David Cronenberg's *Rabid* (1977). The actress later attempted a comeback in the pornographic field in 1980 with *Insatiable*, directed by the pseudonymous 'Godfrey Daniels' (the latter a well-known exclamation of comedian W. C. Fields); Chambers undertook a massive promotional tour for this film, ensuring its considerable commercial success. It has her as a model spending time at the lavish English estate of a relative. Graphic sex scenes were present, including one with the ill-fated porn star John Holmes, but such material was sidelined in order to make the most of the obvious production values; admirers of the actress appeared not to be fazed by this, and the receipts for the film were impressive.

In the early days of the video industry, a film with erotic content appeared that enjoyed a certain brief fame, principally because British viewers had never seen anything quite like it. The punning title was *Flesh Gordon* (1974), establishing that it was a riff on Alex Raymond's classic science fiction comic strip hero and the subsequent film serial starring Buster Crabbe. Audiences in the UK were bemused by the fact that none of the principal players in this modern spoof had an iota of thespian skill; this was par for the course for pornographic films, but *Flesh Gordon* had no visible hard-core material. More puzzling was the fact that in this demonstrably low-budget effort, money had clearly been spent on some of the special effects sequences, including some stop motion for the film's unlikely monsters; one was described as a 'penisaurus', an amusing animated creature that behaved much as its name might suggest, but with slightly more flexibility. There were signs for the alert viewer that this was the limbless torso of another movie: long shots in orgy sequences showed the occasional erection, and the presence of stars of hard-core pornography such as the amply

proportioned, unlikely named Candy Samples (wearing eyepatches both on her face and on one of her nipples) tipped the wink that this was once conceived as a hard-core movie that the producers and directors (Howard Ziehm, William Osco and Michael Benveniste) had modified into more commercial fare. Sadly, the filmmakers had massively exceeded their scarce resources, and although there is a certain frisson in seeing such famous fictional characters as Flash Gordon and his girlfriend Dale Arden being obliged to perform (or have performed on them) oral sex, the film's sporadic imaginative elements were spread too thinly for it to work, either as erotic spectacle or as parody. Incidentally, the same material was to be treated with a similar tongue-in-cheek attitude when the director Mike Hodges made his big-budget version in 1980, allowing the sultry Italian actress Ornella Muti to convey in a few short scenes hints of the depraved sexuality that the considerably more explicit *Flesh Gordon* is not able to conjure in all its running time.

Private afternoons

Two of Radley Metzger's films, *The Private Afternoons of Pamela Mann* (1974) and *Naked Came the Stranger* (a year later), were both made with the director's customary careful attention to production values, something of a rarity in the pornographic genre, and enshrined Metzger's interest in stretching the boundaries of the kind of material that was feasible in this oft-despised field. The earlier film, in which a husband hires a private eye to photograph the sexual adventures of his unfaithful wife (with the inevitable result of the detective being seduced himself), has a self-reflectiveness almost worthy of Harold Pinter's play *The Lover*. The revelation here is that everything we are witnessing is a charade created to pique the erotic interests of the couple themselves. Despite the regulation hard-core interludes – which are inserted at regular intervals as the target audience would expect – the film has a certain slipshod exuberance in its utilisation of the medium of film itself. As the director employed talented cinematographer Paul Glickman (who later went on to work with other acclaimed directors such as Larry Cohen), he may have been supplying some added value that was not necessarily required by the paying customers, but was clearly there to give the filmmakers a certain satisfaction in the filmmaking process itself.

The Private Afternoons of Pamela Mann (which, incidentally, is far better acted than most entries in the genre, though that is faint praise) was followed by *Naked Came the Stranger*, a film version of a highly specious 'novel' that was presented as a series of authentic case studies but in fact

was entirely fictitious. As in the earlier film, we have a libidinous couple – this time two radio hosts who broadcast from their elegant house, once again giving Metzger the chance to present the kind of sumptuous production design rarely seen in this type of film. There are playful moments dealing with the traditions of the cinema, such as a pastiche of a silent film shot in black and white in a hotel ballroom. Those seeking film art rather than titillation should perhaps look elsewhere, but any student of film will be able to see just how the use of technique and enthusiasm can transform even the most tawdry of material, however fitfully.

Shavian sex

How George Bernard Shaw would have responded to a pornographic film version of one of his plays is not recorded, but – given his sexual abstemiousness – it is unlikely he would have looked with anything but disgust at Henry Paris's eccentrically titled *The Opening of Misty Beethoven* (1976). The pseudonymous 'Henry Paris' was actually the director Radley Metzger, and this hard-core riff on Shaw's version of the Pygmalion story is nevertheless generally thought to be one of the best made of pornographic films by those rash enough to draw such distinctions. Certainly, like other films by the director, it boasts more lavish production values than most of its stablemates (admittedly, hardly a difficult task), facilitated by a larger than usual budget. And Metzger – a director with more ambitious aims than most of his journeyman colleagues – utilised a more challenging plot than was common in most exploitation entries and also featured a variety of exotic locations. Another claim to distinction (of sorts) was the film's portrayal of a forbidden sexual indulgence involving sexual intercourse performed on a man by a woman with the aid of a strap-on device.

The central character is Dolores Beethoven, known as 'Misty'; her surname is a cheeky attempt to grant a patina of culture to a distinctly non-cultural endeavour. Misty (played by the actress 'Constance Money', aka Susan Jensen) is discovered working as a low-rent prostitute in a downmarket Paris theatre, giving manual sexual relief to an elderly man dressed as Napoleon – Metzger always goes for the eccentric option. Her Henry Higgins in this version is an author called Dr Seymour Love, who writes about sex. Love places a cynical bet with his well-heeled patron that he can rescue Misty and transform her into a top-flight, sexually adept member of her profession; he makes his Shavian prototype look like a model of altruism. The equivalent of Shaw's ball scene, when Eliza Doolittle's transformation into a society

figure is validated, is a ball held by the publisher of a pornographic magazine in the Metzger film. The publisher is an unsympathetic figure, who, in *roman-à-clef* style, is likened to Hugh Hefner of *Playboy* magazine fame. What follows is a series of sexual encounters in a variety of locations, while Misty undergoes rigorous training regimes; her Higgins figure, however, is more interested in her sexual accomplishments than in her vowel sounds. Interestingly, these encounters attempt something different from the standard heterosexual model; if gay characters are present in such films (either male or female), they are customarily there simply to add another layer to the frisson of the forbidden or transgressive in what we are watching, but here Misty is instructed to sexually entice a gay art dealer (played by Casey Donovan) in an opera house to the accompaniment of a Rossini overture (predictably, *William Tell*). She also reawakens the sexual impulse in a man suffering from impotence. However, for all its aspirations, the film remains firmly located within its primary genre, not least for the derelict histrionic skills of its players, who are better at sexual activity than delivering lines. There are comments about class here, though not very insistent, in the interaction between the *haute bourgeoisie* author and a downmarket prostitute; and there is an ironic reference to Shaw's original, rather than to Lerner and Loewe's musical adaptation *My Fair Lady*, in that there is no final liaison between the Eliza Doolittle figure and her slightly contemptuous instructor. He does, admittedly, change his mind about her, but there is a suggestion that this belated realisation of her value comes too late – and his approbation is hardly based on her inner worth. In line with the better-appointed-than-usual production values, the sex on display in *The Opening of Misty Beethoven* is of a more well-scrubbed variety than is usually found in such fare, and the film remains the prolific Metzger's signature work.

Contact sports in Dallas

If multiple parodies are indexes of celebrity, then *Debbie Does Dallas* (1978) is assured of a place in cinema history – or at least a place in the history of the pornographic film. In fact, so often has the title of director Jim Clark's low-budget exploitation effort been parodied and otherwise riffed on (there is even a musical) that it has virtually become shorthand for the entire genre. In the process, it has been drained of any residual erotic charge; many people are familiar with the title but have never seen the film, and they would be quite surprised by its multiple penetrations and releases of bodily fluids. The film was made when

the Dallas Cowboy cheerleaders were enjoying nationwide fame in the US – a phenomenon that viewers from the British Isles would have had to take on trust – and the eponymous Debbie and her female friends work in a variety of part-time jobs in order to afford the trip to Dallas to make their mark as professional cheerleaders. Unsurprisingly, they all end up trading sex for the wherewithal to make their dreams come true, and the result is a series of unadventurously shot sexual encounters. What is mildly interesting about this maladroit film, though, are the different demands made on the non-professional stars and what they are obliged to bring to their roles. Bambi Woods, the Debbie of the title, palpably cannot act – a characteristic she shares with all her fellow cast members – and nor is she beautiful. However, her freshness and prettiness are sufficient to provide a perhaps more realistic scenario for the male consumers of the film (the principal audience) and for their girlfriends, who, in general, are likely to be no more stunning than Woods. What's more, Woods at least has a natural figure; this was before silicone implants became de rigueur for the female stars of such films and breasts became unrealistically inflated, unyielding spherical objects. This combination of virtues, slender as they are, clearly get her through the film – she is even able to get away with making only the most cursory attempt to stifle a yawn in one of the overlong sex scenes.

Come to the cabaret

Viewers of a very strange film made in 1982 called *Café Flesh* might just have surmised that the name of the director, 'Rinse Dream', was a pseudonym (for Stephen Sayadian), but this unlikely moniker is only one of the many curious aspects of a film that unquestionably earns its cult status. Despite the film's pornographic content, it enjoyed a reputation beyond the usual market for such films because of its marked surrealism and despairing tone. The graphic sexual imagery probably did not deter audiences, but there was a respectable overlay: for example, the influence of the important avant-garde filmmaker Jean Cocteau can be seen when, behind the jutting buttocks of one of the film's female performers, male arms extend from the floor of a stage, snapping their fingers and evoking the torch-bearing human arms that grow out of the wall in Cocteau's *La Belle et la Bête* (1946). In its heyday, *Café Flesh* was considered suitable fare for student audiences, who were always ready to test the parameters of the acceptable. Such films also had the extra charge of being a clear affront to the respectable bourgeois values of the period, and the occasional film that possessed obvious artistic intentions

(whether realised or not) had an added value. There is no doubt that this film – for all its misfiring ambition – at least possesses the courage of its convictions. And it is clear that the filmmakers tried to resist attempts made at the behest of the film's money-minded backers to include more sex for exploitation purposes; the director's preferred cut was one that eliminated the money shots of ejaculation, and a version with such material removed played widely. However, the sexual activity in *Café Flesh* is actually there as part of the narrative rather than to fulfil the 'every five minutes' necessity of the standard porn film. In addition, few of the sex scenes are shot in a crude or gynaecological fashion in order to visualise for a literal-minded audience exactly what is going on.

The film, set in the eponymous nightclub, sometime in the future, boasts an oleaginous MC (played by Andrew Nichols) who is clearly inspired by Joel Grey's memorable figure in the Bob Fosse film of Kander and Ebb's *Cabaret* (1972), and his bitingly contemptuous dialogue is leavened with a variety of cultural references. The MC, 'Max Melodramatic', is our guide to a grim post-apocalyptic world with the central characters Lana (played by Pia Snow, an actress with previous experience in the sex film genre) and Nick (Paul McGibboney) among the last vaguely normal individuals on a planet that is suffering from the after-effects of a nuclear war. The government of the day presides over a regulated sex circuit – sex is proscribed as ruthlessly in this society as it is in the two great British dystopian science fiction novels, George Orwell's *Nineteen Eighty-Four* and Aldous Huxley's *Brave New World* – and Lana is obliged to maintain the fiction that she is not sexually aroused by her partner. By doing this, she (counterintuitively) allows him to retain the damaged image he has of himself, and she avoids being required to leave him for the government organisation. But, as in more conventional sex films, the demands of the flesh prove too strong, with disastrous results for the young couple.

The film's writer, Jerry Stahl, postulates a future in which sex, rather than being a positive, life-enhancing force, is a desperately nihilistic attempt to keep chaos at bay – an attempt that is always doomed to fail. The characters who arrive at the café, it is suggested, all have the death-watch beetle tapping away in their souls, and none of their efforts at validating their humanity through sexual acts are successful. Ironically, while sex fails as a motivation, self-torture remains for the characters an appreciable response to a dying world; the despairing Nick says at one point: 'Torture is the one thing left I can feel.' As so often, those in modern society who would happily embrace the label of being 'anti-sex', if they troubled to look at films such as *Café Flesh*, might see that the very

material they want to ban is doing their job for them, bleakly pointing out that sex cannot fill the vacant spaces in people's lives. However, it should be noted that Jerry Stahl's cynicism here has more than a touch of (self-mocking?) hypocrisy; it is clear that he and his director are relishing the very acts that are putatively designed to occasion disgust.

Andrew Nichols makes the cabaret's MC an apotheosis of cynicism: his comments on the performers on stage and in the nightclub audience – and, by extension, on us, as the viewers of the film – are consistently negative (he reserves particular contempt for a woman having sex with a man dressed in a grotesque rat costume). Like the film's director and writer, the MC suggests that our own *amour propre* is no more elevated than that of the characters we are watching. And as if to suggest that we, the audience watching *Café Flesh*, are being inextricably drawn into the dark world of the film, two of the characters, Angel (played by Marie Sharp) and the heroine Lana, suddenly leave the nightclub audience and begin to take part in the onstage sex. The scene is shocking because, for the most part, Lana has been an observer, like us, but now is prepared to be a performer.

In one particular area, the film succeeds in its stated aim: it is never sexually arousing. There is, in fact, no straightforward sex in the film, just as there is no complete nudity: all of the participants are wearing some kind of clothing, although in some cases this consists of revealing items such as crotchless pants. Despite its unblushing parade of sexual activity, shot in shadow much of the time, we often appear to be watching almost an alien species – as indeed we are: these denizens of the post-nuclear world have clearly lost a great deal of their humanity.

As the 1970s drew to a close, the pushing of boundaries in terms of sexually explicit material was to move in a variety of different directions in terms of representation and attitude – directions to be examined in the following chapters.

15

Sex Moves Centre Stage:
The 1980s and 1990s

At the start of the twenty-first century, it is perhaps hard to remember the fuss caused by the explicit sex scenes in such films as Bernardo Bertolucci's *Last Tango in Paris* (1972), Nagisa Oshima's *Empire of the Senses* (1976), Ken Russell's Aldous Huxley-derived *The Devils* (1971) or even Sharon Stone crossing her legs *sans culottes* in Paul Verhoeven's *Basic Instinct* (1992). We live in an era when relatively mainstream films – with the uneasy consent of the BBFC – frame carefully lit male and female genitals, separately or engaged in sexual congress. Such once-forbidden images as close-ups of vaginas and erect penises – and even ejaculation – appear in the work of directors including Michael Winterbottom (*9 Songs*, 2004) and Lars von Trier (*Antichrist*, 2009); the latter said of himself, 'I am but a simple masturbator of the silver screen.' But to say that we live in a more liberated age does not precisely convey the reality – a triple-pronged attack is under way from religious groups, politicians eager for column inches and those who legitimately feel that the sexualisation of popular entertainment is robbing a generation of its innocence. Any newly won freedom of expression should not be taken for granted. One man's (or woman's) meat is another's poison, and that is perhaps more true of the sexual instinct than of many other things. And it is also why, in an age of political correctness in which the 'male gaze' at an undressed female is now a default subject for censure, filmmakers are obliged to make one of two decisions: either to pander to their critics and omit anything that could be deemed unacceptable; or to simply say 'The hell with it,' and risk the disapproval of those with very specific guidelines about what is permissible in the realms of the erotic.

But how important are the sexual elements in cinema, particularly today when the once-newsworthy shock value has begun to diminish and such images have become almost quotidian? Over the years, such

matters have been invested with a keen edge by artists, who have long chafed at the constraints imposed on them by the morality of their particular period, and they have become emblematic points of debate. The phenomenon is hardly new: Thomas Hardy ruefully pointed out that he could not honestly address physical relationships between men and women for his prudish Victorian readers, and even his toned-down descriptions of sexuality resulted in bishops burning his books and accusations that he belonged to an 'anti-marriage' league. But is sexuality in the cinema of Britain, America and the rest of the world now free from the shackles that resulted in an unrealistic, chaste view of human relationships, as in the famous Hays Code censorship notes for *Casablanca*, with their strict edict that there must be no suggestion of a sexual relationship between Bogart and Bergman? Such historical absurdities aside, is the ever more desperate pursuit of sensation resulting in films that are a hybrid of serious drama and pornography? Several directors have, in fact, resorted to the use of body doubles for the close-ups of genitals and sexual activities in their films, as a concession to the reluctance of more mainstream actors to participate in such scenes.

Beyond the missionary position

Before the descending curtain of the Video Recordings Bill, the UK in the 1980s enjoyed a brief period of freedom from swingeing censorship cuts. The bill, introduced by Conservative MP Graham Bright in (appropriately) 1984, was designed to proscribe 'excessive human sexual activity', among other pernicious elements in films. This begged the question of what exactly would constitute 'excessive human sexual activity' – presumably anything beyond the missionary position.

Across the country, thriving video rental shops had shelves groaning under the weight of 'adult' videos; these were usually censored versions of stronger American fare, but they proved exceedingly popular with the public, who savoured such once-forbidden films – and not just the stereotypical porn audience. Ordinary married couples who would not have been seen dead in a Soho sex cinema clearly felt that it was perfectly acceptable to rent these items from the brightly lit video shops that routinely had families milling about, and some even sold popcorn. Some retailers mentioned that couples often used such tapes for aphrodisiac purposes – although the acres of dull dialogue scenes that such movies often contained might have been more likely to induce sleep than passion. But the sudden severity of the new Video Recordings Act, which was heartily endorsed by Prime Minister Margaret Thatcher, a

supporter of moral campaigner Mary Whitehouse, removed many films from the shelves; eroticism could now be found only in more upmarket output that paid somewhat more attention to plot and acting than its unpretentious predecessors. Mainstream films with erotic components were largely safe from the attentions of the censors: seriousness of intent was sometimes the best defence against legal strictures, as it had been in the famous 1960 attempted prosecution of Penguin Books for publishing *Lady Chatterley's Lover*. And speaking of D. H. Lawrence's explicit novel – well-thumbed copies of which were circulated around many a British school playground in the 1960s – a variety of film versions have been attempted, including one with the star of the original soft-core hit *Emmanuelle*, the inexpressive Sylvia Kristel, as an unlikely member of the British aristocracy, along with Nicholas Clay glowering as Mellors, the obliging gamekeeper. This 1981 film reduced Lawrence's hymn to unbridled sexuality to a series of painstakingly composed tableaux that were mildly erotic but hardly as heady or as revolutionary as the author might have wanted – or perhaps not, as Lawrence had a curiously counterintuitive puritan streak and may well have disapproved of the various movies of his book. Needless to say, any hint of Lawrence's ideological stance regarding sex was ruthlessly expunged.

Films that made judicious use of speedy camera zooms as zippers were unfastened were typical of the 1980s; these included *They're Playing with Fire* (directed by Howard Avedis in 1984), which features some erotically charged scenes between a mature teacher (played by the strapping Sybil Danning) and an inexperienced male teenage student. At first this film – like so many of the era – appears to be shaping up as an entry in the 'sexual initiation by an older woman' genre (and it was certainly sold as such), but it quickly settles down into more straightforward thriller mode. Inevitably, it was the scenes in which the half-Austrian, half-American Danning demonstrated her Teutonic attributes that were utilised in the film's advertising. Another film that presented a mixture of erotic arousal and killer on the loose was Don Carmody's *The Surrogate*, made in the same year. The central plot concerns an ailing marriage that is helped by the professional female surrogate of the title, played provocatively by Carole Laure; soft-core queen Shannon Tweed is also on hand as the frustrated wife to up the nudity ante. Although the film has more than its share of exposed flesh – particularly in the wife's self-arousal scene in a bar – the most sensual sequence is unquestionably the one in which the surrogate slowly raises her skirt above her waist in front of the transfixed hero (played by Art Hindle), who until that point has been having some doubts about the whole idea of

sexual surrogacy. It is interesting to note how often the slow removal of clothes in a film can create a more powerful charge than acres of instant nudity. Unsurprisingly, the film has no trace of a subtext – its agenda is completely straightforward.

Obsessions

A director who routinely pushed the envelope in terms of the erotic in his work was a filmmaker firmly in the shadow of his master, Alfred Hitchcock. Brushing off any feminist criticism of the perceived 'sexism' in his work, Brian De Palma always made sure that elements of often feverish carnality were foregrounded in his films. In this, it could be argued that he extrapolated and developed such scenes from sensual hints to be found in the films of Hitchcock, who had to work under censorship restrictions until *Frenzy* in 1972, when he was finally able to include nudity. De Palma's work put such things centre stage – the two prime examples perhaps being the *Psycho*-derived *Dressed to Kill* (1980), with its famous body double in a shower scene for a mature Angie Dickinson playing a woman on the prowl for sexual adventure, and *Body Double* itself (1984), with Melanie Griffith delivering one of her slightly terrifying sexualised women and projecting a far more graphic sexuality than her mother, Tippi Hedren, ever did in her films for Hitchcock.

By 1986, there was something of a lull in the attacks mounted by governmental and tabloid forces on the video industry, but it was only a matter of time before the wrath of the censors refocused. Those attempting to cut the lovemaking and eroticism in contemporary films made wistful references to David Lean and Noel Coward's *Brief Encounter*, lamenting the loss of an era of romance in which the hero and heroine never actually got around to consummating their passion – although they had to ignore the fact that the writer of the film was considered a sexual outlaw at the time, and the chaste, asexual *Brief Encounter* was hardly a personal statement for Coward. The sexlessness of *Brief Encounter* is epitomised by the scene in which the lovers (powerfully played by Celia Johnson and Trevor Howard) visit a cinema where advertisements for coming attractions include one promising *'Flames of Passion* – All Next Week'; their response is one of derisive laughter, particularly as the next thing to appear is an advert for prams. If Lean and Coward regarded the piece as a critique of the reserved remnants of Victorian morality, their own private lives bore testament to a far more libidinous lifestyle than they permitted their fictitious lovers. And even a decade or two later, the expression of sexuality in British cinema still

presented the subject as a source of frustration and lack of fulfilment; such films as John Schlesinger's *A Kind of Loving* (1962) confirmed the post-coital tristesse of its lovers, who are forced into a loveless marriage, while Lindsay Anderson's *This Sporting Life* (1963) centres on the total non-communication – on both an emotional and a physical level – between a brutish rugby player (played by Richard Harris) and a bitter widow (Rachel Roberts) who has shut down her sexual responses as thoroughly as she represses any possible fellow feeling. This does not mean that the artists making these films presented the situations they dramatized as being in any way admirable; in fact, their efforts might be read as a plea for overthrowing the restrictive mores that still informed British sexuality long after the death of Victoria.

Ice cubes and blindfolds

Adrian Lyne's *9½ Weeks* (1986) quickly established itself in the consciousness of audiences as the kind of soft-core material to which couples could flock without any sense of shame. The screenplay was by exploitation merchant Zalman King, long a specialist in this kind of material, and the film channelled a pre-*Fifty Shades of Grey* parade of unorthodox S&M sexual encounters, with Kim Basinger and Mickey Rourke (still a presentable leading man before his looks spectacularly deserted him) engaging in a variety of episodes involving chocolate syrup, ice cubes and blindfolds. Given that the narrative theme of the film has now been taken up by other hands, there may be those tempted to see whether or not Lyne's film retrospectively seems to be something more than a glossy and well photographed piece of soft-core indulgence. In fact, it doesn't: the critical consensus – mostly negative – that *9½ Weeks* accrued on its first appearance still seems accurate.

Leg-crossing moments

The actress Sharon Stone has expressed mixed feelings about the celebrity that resulted from her all-revealing leg-crossing moment in Paul Verhoeven's *Basic Instinct* in 1992 – the first time the unadorned genitals of a major Hollywood female star had been shown in a feature film. However, there is no denying that the person in charge in that sequence is not any of the sweating, lip-licking male cops, but rather the woman who is sexually manipulating those around her. The fact that her character, Catherine Tramell, is murderous and deceitful led to accusations that Verhoeven's film equated a sexually liberated woman with psychopathic

behaviour – an accusation that was also levelled at the Glenn Close character in Adrian Lyne's *Fatal Attraction* (1987) – but there is no gainsaying the fact that she is a far more interesting and multifaceted figure than the detective played by Michael Douglas, the character most in her thrall.

But what is the film's titular basic instinct? It may be located in either the libido or the desire for power. It is significant that Catherine's murder weapon of choice is an ice pick, paralleling the many knives used in films that have an essential phallic displacement: Norman Bates' lethally wielded kitchen knife in *Psycho* is (we are told by the sober psychiatrist in the film) a twisted expression of a frustrated sexual instinct. The sexual impulse in films such as *Basic Instinct* is of a different variety to that which most ordinary filmgoers will experience in their own lives; sex here is an overpowering, operatic affair clearly emblematic of the most extreme expression of the human psyche. While murderesses such as Catherine have no limits when it comes to sex and are essentially unknowable, ordinary males such as the Michael Douglas character are surrogates for the audience – both male and female. He will sacrifice everything, including his career and self-esteem, for the chance of repeated encounters with the femme fatale – an *amour fou* indeed.

The movie's reception was counterpointed by attempts from US gay groups to get the film banned, although the treatment of the gay characters is no less misanthropic than that afforded to the straight ones. Hitchcockian influence is, of course, strong, and the take-no-prisoners sex scenes still pack a punch. Few cinemagoers at the time of the first *Basic Instinct* film regarded Catherine – however charismatic – as a realistically observed character study, and it is a measure of the director's and the actress's achievement that she acquires a kind of verisimilitude despite the unlikeliness of both her character and her actions. This is particularly thrown into perspective when one views the ill-advised 2006 sequel, not directed by Paul Verhoeven, who was wisely absent. In Michael Caton-Jones' *Basic Instinct 2*, she transmogrifies into an almost supernatural killing agency along the lines of Michael Myers in the *Halloween* films, virtually all simulacra of reality dispensed with. If the first film had any influence, it may perhaps be detected in such dark visions of female sexuality as Darren Aronofsky's *Black Swan* (2010), which presents an even more destructive vision of eroticism.

The postman rings thrice

As one of the directors has now changed sex, the subtext of the Wachowski duo's *Bound*, the mid-1990s neo-Noir that marked the debut

directorial feature of the siblings (Lana, formerly Larry, and her younger brother Andy), becomes even more provocative with its lesbian motif. Opening in late 1996 in the USA and early 1997 in the UK, *Bound* looks today like a film that was waiting for its time to arrive. On its initial appearance, it was noted as one of a group of edgy, low-budget indie films that demonstrated an unusual vision. With its crime-based plot, *Bound* was bracketed with such films as Tarantino's *Pulp Fiction*, but the Wachowskis appeared to be channelling crime films of the 1940s and 1950s, specifically the hard-boiled genre. The actor Joe Pantoliano was instructed by his directors to base his performance as the mobster Caesar on Humphrey Bogart's character in *The Treasure of the Sierra Madre*, and the Violet character played by Jennifer Tilly has the fashion sense of the femmes fatales of the past. The scenario references James M. Cain's *The Postman Always Rings Twice* with its murderous dynamic within a trio of protagonists. But no 1940s film could have directly addressed the erotic same-sex couplings here – and the fact that the lovers with an inconvenient partner in the way were now two women. What made *Bound* so unusual was its foregrounding of these female characters and their desire: more specifically, the unapologetically lesbian theme allowed the directors to tackle sex and gender issues in an uncompromising fashion.

Gina Gershon (a survivor of the outrageously kitsch *Showgirls*) plays Corky, a young woman recently released from a five-year jail term for robbery. After a brief encounter in the lift with her sexy, uninhibited neighbour Violet (Jennifer Tilly), the pair begin a steamy love affair under the nose of Violet's brutal Mafia boyfriend Caesar (Pantoliano). Soon the two women are concocting a plot to steal $2 million from Caesar and his associates – with, inevitably, messy results. The film sports sharply etched performances from all three leads, but, understandably, it was the frankly shot lesbian sex scenes that caught press attention. The British tabloids attempted to work up an indignant protest against the film – as also happened with David Cronenberg's film of J. G. Ballard's *Crash* in 1996 – but the condemnation didn't stick. What has had more traction is the feminist criticism that the film has a 'male gaze' concerning the sexual encounters of the two women; it would be interesting to hear how Lana Wachowski retrospectively regards her 'male gaze' when she was Larry Wachowski.

16
Anything Goes:
The Twenty-first Century

The films of the early twenty-first century finally brought down the last trembling walls of censorship, with explicit imagery now a regular part of mainstream cinema; the controversial Danish director Lars von Trier reached an apotheosis with the self-performed cliterodectomy of *Antichrist* (2009) and the sadomasochistic antics of *Nymphomaniac* (2013). This new erotic cinema had a literary obbligato with the amazing phenomenon of E. L. James' functionally written *Fifty Shades of Grey* trilogy, the first book of which was filmed in 2014 by Sam Taylor-Johnson. A debased *Jane Eyre* for the *Twilight* generation, James' books were a fannish revival of earlier erotic 'capital punishment' writing that moved out of the self-publishing arena and enjoyed success far in excess of anything that had preceded them.

Salander and sexual abuse

In my book on Scandinavian crime fiction and film, *Death in a Cold Climate*, I discussed the controversial treatment of rape and sexual abuse in Stieg Larsson's *Millennium* trilogy, both in the books and in the subsequent films. The two films of *The Girl with the Dragon Tattoo* – the original Swedish film directed by Niels Arden Oplev in 2009 and the American version ('Not a remake!' claimed the director) filmed by David Fincher two years later – confront these issues uncompromisingly. Larsson might be said to have bought himself some moral leeway for his repeated and brutal portrayal of rape in his books by his avowed feminist stance, and chapters of the books are preceded by a variety of superscriptions detailing the appalling treatment of the female sex by men through the ages. However, Larsson's unsparing and graphic descriptions of violent sexual acts still caused much controversy, not

least inspiring furious debates over whether or not the author's books are exploitative or feminist. Interestingly, the duo who were the inspiration behind Larsson (and much current Scandinavian crime fiction), Maj Sjöwall and Per Wahlöö, are notably chaste and discreet on the subject of sex; Larsson is an heir apparent at several removes. The first film of *The Girl with the Dragon Tattoo* did more justice than was expected to the writer's original concept through a combination of pared-down writing (by Nikolaj Arcel and Rasmus Heisterberg) and effectively utilitarian directing by Oplev. But perhaps the key factor in the success of the film was the canny casting, with Noomi Rapace proving to be the perfect visual equivalent of Larsson's tattooed and pierced sociopath Lisbeth Salander. Utilising methods derived from the approach of the Russian acting teacher Stanislavsky and the later New York Method School of Lee Strasberg, the dedicated Rapace was able to find a truthfulness and verisimilitude within what is essentially an impossible character – she was already unrealistic in the books, but became even more so when depicted on film. Lisbeth Salander is a woman who is barely able to function on any kind of social level, but shows a variety of nigh-superhuman skills in situations that put her *in extremis*, not to mention a flexible sexual impulse when sex is on her terms. As in the books, the films rigorously maintained the dynamic of Larsson's gender role reversals, with Rapace demonstrating the conventionally masculine traits of violence, sexual initiative and retribution while Michael Nyqvist, as the journalist Blomkvist, was placed in the traditionally feminine role, being rescued from certain torture and death in the first film.

The second example of Salander's abuse at the hands of the corrupt advocate Bjurman (played by Peter Andersson) is what remains the film's most indelible scene. Lisbeth Salander arrives at her guardian's flat after an earlier scene in which he forces her to fellate him, and his cynical assumption is that she requires more money. In a scene that is difficult to interpret, she makes her way to the bed but provokes him into hitting her. Things are not going well, she realises, as he tears her T-shirt and reaches for handcuffs in a drawer by the bed. What follows is an excruciating scene of forced anal sex, but Bjurman is to pay a heavy price for his violence.

To some degree, Larsson (and Oplev) are in tune with the feminist writers of an earlier era, whose attitude to male sexuality often evoked violence and violation as part of the sexual experience. The feminist writer Andrea Dworkin's ineluctable linking of male desire with rape is

echoed, in both the books and the films, by all the violent brutalisation that is to be found in the trilogy, and her assertion that sexual intercourse is the pure, sterile formal expression of men's contempt for women has a Larssonian ring. But such apparent misandry – on the writer's part – is undercut, as if to exonerate the male sex, by Mikhail Blomkvist's formidable series of positively described amorous conquests; their number is reduced in both films of the first book, and are perhaps more plausible when the character is played by Daniel Craig than by Michael Nyqvist. The author counterpoints the brutally coercive sexual experiences that Salander is forced to suffer with the pleasant, consensual ones between Blomkvist and his new love; in fact, Larsson cuts from Salander's anal rape to the affectionate post-coital conversation between Blomkvist and Cecilia Vanger (Marika Lagercrantz in the Swedish film), as if to remind us that sex need not be as unpleasant as it has been for Salander. These consensual encounters – both heterosexual, as here, and notably the lesbian scenes involving the bisexual Salander – are presented in the films (as in the books) in a non-judgemental fashion. What's more, the trilogy's crucial episode involving heterosexual, consensual sex (as opposed to the similarly positive lesbian encounters) takes place between Lisbeth Salander and Blomkvist, and is conducted exclusively on Lisbeth's own no-nonsense terms rather than his – and in both films of Larsson's novel, the two directors completely understood the point that Larsson was making here.

Sex meets violence

In the modern era, sex is no longer enough: other visceral sensations are routinely conjoined with the erotic, notably audience-pleasing violence. But let's be honest: right from the start, it has always been the job of cinema to shock, along with its variety of other objectives, and there is no question that Virginie Despentes and Coralie Trinh Thi's controversial, deeply nihilistic film *Baise-Moi* does just that. For audiences who prefer their cinema graphic and unstinting, this is very much a piece for them: the title is an indication, translating as 'Fuck Me', and there is nary a sympathetic character, either male or female. Featuring two antisocial young women on a suicidal sex-and-killing spree, *Baise-Moi* has been described as *Thelma and Louise* on acid, and it was banned on its release in its native France in 2000 for its refusal to look away from any action. The sex, though explicit, is notably – and deliberately – cheerless.

Looser bonds

New films that tested the ever looser bonds of censorship seemed to appear by the week, but Michael Winterbottom's taboo-busting piece *9 Songs* (mentioned in a previous chapter) was more astonishing than most. All of the traditional no-go areas are covered here, as the two young protagonists indulge in every kind of sexual activity, and two images that had been forbidden for years to mainstream audiences were included: female genitals (not just pubic hair, but with the legs spread) and masturbation by the female star (Margo Stilley) of the male actor (Kieran O'Brien) up to the release of semen. The nine songs of the title consist of concert footage of such artists as Super Furry Animals, since – between their explicit sexual encounters – the two lovers go to rock concerts. Anyone reading this will already have a view as to whether or not the film is likely to be to their taste, but the days when elderly maiden aunts (of both sexes) decided what we could and could not watch seem ever further away.

The considerable furore surrounding its premiere in Cannes in 2002 had barely subsided before Gaspar Noé's unsparing *Irreversible* appeared uncut on DVD. This saga of revenge and misguided retribution features blistering performances by husband and wife team Vincent Cassel (star of the similarly brutal *La Haine*) and Monica Bellucci (charismatic in *The Matrix Reloaded*), but, significantly, the story is told in reverse, as with Harold Pinter's play *Betrayal*. Opening with uncompromising scenes of murder and rape, the film moves events backwards to examine the issues that led to such horrendous acts. The killing in a gay S&M club called the Rectum is the most realistic – and grim – you will ever see, with a man's head beaten slowly to a pulp with a fire extinguisher, defying the viewer to work out the point at which CGI takes over in the bloody sequence. This is a deeply unsettling experience – not least for the film's vertiginous camerawork, which makes similarly queasy cinematography in Woody Allen's *Husbands and Wives* look positively sedate – and those with fragile sensibilities should steer clear. But for those prepared to undertake a gruelling rite of passage, Gaspar Noé, as ever, is the man to take you into new areas.

Eros and Thanatos

The Canadian director David Cronenberg may be one of the most intelligent and innovative filmmakers in modern cinema, but one would hope that his filmic approach to sexuality – however fascinatingly

individual – is nothing like his own private views. He customarily renders the subject in a minatory and unpleasant fashion, from the phallic slugs of *Shivers* in 1975 (which invade one of the victims through her vagina, enter the subsequent genital-like apertures in victims and cause sex mania in other infected characters) to the unsettling vaginas of *Dead Ringers* a decade or so later, not to mention the bloody damage to human bodies that creates sexual orifices in *Crash* (1996). Cronenberg is the onlie begetter of the cinematic body horror genre, in which the fallibility and capacity for decay of the human organism are central concerns, as is the fascinated gaze that we turn on our own and other people's bodies. There is a prescient version of this vision in the director's relatively early film *Videodrome* (1983), which has a totally Cronenbergian take on society's consumption of pornography; inevitably, this is not shown as a good thing, but the director's vision is never that of the tongue-clucking moralist so much as that of an artist whose fixation on the human body and sexuality has few limits.

It was perhaps unsurprising that Cronenberg would at some point tackle the life of the father of psychoanalysis, the man whose name is synonymous in the popular imagination with the word 'sex': Sigmund Freud. However, the director's uncharacteristically restrained film *A Dangerous Method* (2011) could not be further from the standard Hollywood biopic – or, for that matter, from John Huston's extremely sober treatment of the psychoanalyst in his *Freud*, aka *Freud: The Secret Passion* (1962). But as with Huston's film, Cronenberg makes a female sexual hysteric a test case and exemplar for the theories of the central character – or characters, plural, in the Cronenberg film.

A Dangerous Method is set in Switzerland in 1904, with the young hysteric Sabina Spielrein (played by Keira Knightley) in an asylum under the care of the psychologist Carl Jung (Michael Fassbender). This intelligent young Jewish girl is presented as being articulate and self-aware, at least in some areas, but she is sexually repressed; we are later shown that she achieves orgasm when being spanked by Jung, with whom she engages in a sexual relationship in the film. (Jung himself is depicted as being in an unhappy marriage with a wife he regards as comfortable but conventional, although he becomes concerned that the sadomasochistic relationship he has with Sabina will damage his reputation and social position.) Jung suggests that Sabina be treated using a method of analysis devised by his colleague Sigmund Freud (Viggo Mortensen), the 'talking' cure, but begins to feel that Freud is making no progress, while Sabina herself decides that she would like to train to be a psychoanalyst.

Given the promising subject matter, in Cronenbergian terms, it surprised commentators that the director appeared to tread cautiously with material that he would have made considerably more capital with a decade or two earlier. Given Cronenberg's repeated embrace of extreme cinema, his cinematic vision of Freud is cool and measured, and the subject is certainly not granted the operatic treatment that one might have expected. What we have here is a relatively restrained, strongly acted period drama in which three articulate characters discuss tangled sexual issues – all using the correct nomenclature, with which they are all familiar. For the most part, the emotional temperature is relatively low, although it is raised by the sexually voracious Dr Otto Gross (played by a strangely cast Vincent Cassel), who is far more direct than the other characters: for instance, he says at one point, 'Freud's obsession with sex has a great deal to do with the fact that he never gets any.' Viggo Mortensen appears to channel Montgomery Clift's equally morose turn as Freud for Huston, while Michael Fassbender manages to inject more life into the nervy Carl Jung, passionately defending his controversial interest in parapsychology, something that Freud worries will bring the whole profession into disrepute.

An earlier generation of filmmakers presented the psychoanalytical process as a kind of detective story mechanism in which the location of the trauma would swiftly lead to its cure, as illustrated by Alfred Hitchcock's *Spellbound* (1945), and it could be argued that Cronenberg might have been better served in this film by the naive but more dramatic methods of an earlier era, however specious they may have been.

17
The End of Sex?
The New Puritanism

Despite the resurgent interest in literary erotica via E. L. James, the days when a variety of sexually explicit films could enjoy large cinema audiences are undoubtedly on the wane in the first decade of the twenty-first century. While a fascination with sex remains as keen as ever, the massive success of such television shows as *Game of Thrones* (based on the rumbustious novels of George R. R. Martin) is usually remarked upon in twofold fashion: the show is praised for its intelligence and sophistication, but there is the inevitable rider that the copious amounts of female nudity must surely have an effect on the viewing figures. Similarly, such comedy dramas as *Girls* take far further the frank discussions of sex to be found in earlier programmes such as *Sex and the City*; while the latter allowed the occasional sight of a nipple and non-aroused penis, *Girls* was even able to show a man ejaculating on a woman's breasts. In fact, ejaculate – or a milky facsimile thereof – has eventually become almost as commonplace in films as blood was in the Hammer films of the 1950s and 1960s. *Girls* was an HBO show, and the sight of the company's logo at the beginning of a given programme is now read as a signifier that what follows will be almost always adult, and often unblushing, in content. The internet, too, provides a steady stream of imagery to complement the new erotic cornucopia, and not just in the comfort of the home, with the popularity of iPads and smartphones. But does all this reflect a new liberalism? In fact, there are indications that along with this burgeoning permissiveness is another, more restrictive, strand, suggesting a new puritanism – or at least a purely commercial appreciation that only certain erotic films can enjoy massive success, and that adult content might even (horror of horrors) circumscribe box office success. And this is a sure-fire recipe for

self-censorship, more rigorous than any externally imposed strictures religious groups might come up with.

Men (and women) in tights

In an era when superhero films virtually rule at the box office, it is worth noting that at the heart of these colourful, and often intelligently made, fantasies is a celebration – both aesthetic and libidinous – of the well-developed male and female human body. The physiques of the superpowered protagonists are repeatedly showcased in their obligatory tight-fitting costumes, and the preponderance of male superheroes means that audiences are invited to appreciate the male form just as much as (if not more than) the female. This aspect of the films has even been built into the dialogue; in the screenplays of the movies featuring Chris Hemsworth as the imposing Asgardian Thor, female characters murmur approvingly – and even lustfully – of his impressive build, as they do of the latest Superman in *Man of Steel* (2013), played by the buff British actor Henry Cavill. The most striking female manifestation in the superhero genre is the corrupt Mystique in the *X-Men* movies (played by, successively, Rebecca Romijn and Jennifer Lawrence); what distinguishes this blue-skinned mutant is the fact that she spends most of the movies naked, with only her skin colour and some diplomatically placed scales providing a touch of modesty. (She is not the only blue-skinned naked superhero: another – a male – is the godlike Dr Manhattan played by Billy Crudup in Zack Snyder's 2009 movie *Watchmen*.) The films are a far cry from the characters' greatest period of popularity in the 1940s and 1950s; at that time, the industry's Comics Code, which made similar censorship organisations in the cinema look like the last word in liberality, suggested that no sexual aspects should be emphasised in the costumes. Wonder Woman was saddled with an unbecoming pair of Bermuda shorts, although both she and the latest incarnation of Supergirl now wear costumes cut as high as a G-string in the largely uncensored comics of the modern era.

But all of the above points up an awkward dichotomy in the selling of these movies to the public. The new superhero films are obliged to be smartly written and strongly characterised, with adult themes often featured prominently – *Watchmen*, like the original graphic novel by Alan Moore and Dave Gibbons, even references sexual dysfunction between its superheroes. However, at the same time, a juvenile audience must not be excluded if producers hope to accrue immense revenues – which, of course, must be an imperative, given the daunting costs of making such films.

This requirement to appeal to a younger audience means that erotic pieces that once packed cinemas, such as Adrian Lyne's *9½ Weeks* (1986) and *Fatal Attraction* (1987) and Paul Verhoeven's *Basic Instinct* (1992), would be far less likely to be commissioned today. Such films had often cannily synthesised a variety of elements: bankable stars, acclaimed directors and writers – even people who knew little about such things heard about the record amount that Joe Eszterhas was paid for the screenplay for *Basic Instinct*: $3 million. And the opportunity to see famous stars in a state of undress and in transgressive sexual situations was the icing on the cake. What's more, all these hit movies achieved one of the desired aims of film producers – they were talked about. And talked about. But the market for such material has undoubtedly shrunk, or at least has moved in the direction of newly liberated television channels. This is not to say that a great many films with edgy sexual themes are not being produced outside the major studios; after all, such films will still be popular in the independent sector as it is far cheaper to film a photogenic copulating couple than a survivor of the planet Krypton levelling a city in battle. If this suggests a cynicism about the motives of independent filmmakers, it is not meant to; the treatment of sex still remains a perfectly legitimate pursuit of the cinema.

Stars without clothes

There is no denying the inevitable fascination of popular stars appearing au naturel; Daniel Radcliffe, post-Harry Potter, has shown that he is not averse to appearing nude in a London stage production of Peter Shaffer's *Equus*, and he followed this up with gay sex scenes as beat poet Allen Ginsberg in John Krokidas's *Kill Your Darlings* (2013). Similarly, the female star of the *Twilight* films, Kristen Stewart, appeared naked in Walter Salles' film of Jack Kerouac's *On the Road* (2012) – to no great effect, as the film was underwhelmingly received. And stars such as Michael Fassbender and Carey Mulligan both showed no hesitation in stripping off in Steve McQueen's relentless *Shame* (2011), which was in fact a film about sex addiction, demonstrating that prickly subjects such as this could still find financing. The director and writer Paul Schrader used the actress Lindsay Lohan in his film from a Bret Easton Ellis script, *The Canyons* (2013), but this did not have the same frisson as the films mentioned above; Lohan's chaotic private life and the presence in the film of real-life porn star James Deen (*sic*) had most people regarding the film as straightforward exploitation (which it wasn't), despite the respectable credentials of its writer and director. Schrader noted that *The Canyons* was a by-product of the 1970s dream of many filmmakers: that

a mainstream film could be totally explicit and still be a serious piece of drama – in effect, a crossover. But he recognised how difficult this was, making the point that 'the part of our brain that responds to explicit imagery is a different part of our brain from the one that responds to long-form narrative'. The proof of this difficulty may be found in the fact that the lengthy and explicit lesbian lovemaking scene in *Blue is the Warmest Colour* (directed by Abdellatif Kechiche, 2013) actually slows down the narrative considerably and requires a different application on the part of the viewer compared with the surrounding scenes; it serves no real plot purpose as we have already accepted the reality of the relationship between the two young women played by Léa Seydoux and Adèle Exarchopoulos.

More recent movies have had something of a post-modern, self-referential take on the erotic film genre itself, such as James Franco and Travis Mathews' *Interior. Leather Bar.* (2013), which addresses the famous missing sequence (cut to avoid an 'X' rating) from William Friedkin's highly controversial gay serial killer film *Cruising* (1980, with Al Pacino); the original film had occasioned something of a gay backlash as it was considered that it did not treat the leather and S&M scene – or its gay clientele – sympathetically.

The hostility towards the films and career of Linda Lovelace was not confined to a feminist backlash but was felt by the actress herself, who combined a born-again Christianity with a thoroughgoing rejection of her earlier career as the most famous of all porn stars; she revealed in the book *Ordeal* that she was forced to make films such as Gerard Damiano's *Deep Throat* by her brutal, dominating husband. A film of her life, Rob Epstein and Jeffrey Friedman's *Lovelace* (2013), with Amanda Seyfried as the actress and James Franco as *Playboy* editor-in-chief Hugh Hefner, attempted to present a dual perspective on the heyday of porn movie-making, showing the kind of camaraderie and exuberance to be found in Paul Thomas Anderson's detailed evocation of the era, *Boogie Nights* (1997, with Mark Wahlberg as a prodigiously endowed porn star based on John Holmes), but setting it against a much darker and more desensitised version of the same events. This, however, was hardly a scenario calculated to allow viewers to make up their own minds about the objective truth, as the later, far-less-pleasant version completely, and inevitably, obliterated the earlier one.

An intriguing take on gay sexuality was to be found in the much acclaimed *Behind the Candelabra* (2013), which dealt with the outrageous pop pianist Liberace and his unhealthy relationship with a handsome young protégé (the parts played skilfully by straight actors

Michael Douglas and Matt Damon). In the UK in 1959, the showbiz writer Donald Zec had been successfully sued by Liberace for suggesting that he was gay, and it is a measure of the way in which attitudes have changed that the film is so straightforward in its presentation of the pianist's homosexuality. It is interesting to note that one of the reasons why the film could find no initial funding was because it was felt that it would appeal only to the gay community, but director Steven Soderbergh (who had made an impressive debut at Cannes several years before with *Sex, Lies, and Videotape*) was able to see such limiting notions confounded as the film enjoyed virtually universal acclaim, not least for the impressive performances of its two stars. However, the drug-addled, almost vampiric – though often very funny – vision of gay life set against a massively kitsch Hollywood backdrop was no more positive than the image found in *The Boys in the Band* or other films criticised for their negativity by some (but not all) members of the gay community in the past.

Changing attitudes

It was becoming clear by the year 2013 that audience reactions to such elements as graphic sexuality had become more liberal, both in the cinema and in the more carefully proscribed area of television, and that viewers were less likely to be shocked – though not in newsprint, where topless tabloid models seem to be falling victim to a lengthy campaign to remove them. Even older viewers, at one time the group most likely to complain about nudity or sexual activity on the screen, were much more relaxed about such things, and the equally contentious area of 'bad language' (a tendentious phrase if ever there was one) underwent a change when the BBFC noted that the shock value of some swear words was diminishing with each successive generation. As always, the protection of children from such things remained a key consideration, with the BBFC remarking that the public had made it clear that it wanted greater strictness regarding the language allowed for a 'U' certificate, but they were happy to concede more flexibility for 'strong language' in films that 15-year-olds were permitted to watch. In 2014, the new film classifications for teenagers allowed far greater latitude, although there were still complaints about the content of such films as *Black Swan* from those who felt that its categorisation should be more restricted.

Attitudes to female sexuality – and the cautious pre-censorship of sexist material advocated by some feminists – have to some extent been thrown into chaos by the huge sales of the sexually explicit *Fifty Shades*

of Grey trilogy of novels written by a woman, E. L. James. The fact that plans were mooted for two film versions – one sexually explicit and one a more discreet version of the first book – underlined the fact that the massive success of the books with women (their principal readership) appeared predicated on material that heavily featured spanking, bondage and other sadomasochistic activities – areas, in fact, that are frequently described as male sexual fantasies. (The Sam Taylor-Johnson film, starring Dakota Johnson and Jamie Dornan, opted for a non-'X' rated approach, which meant the book's notorious tampon scene being quietly dropped, among other things.) The male sexual fantasy figure for women in James's trilogy is the super-rich, attractive entrepreneur Christian Grey, indulging in rigorously organised corporal punishment games with Anastasia Steele, a college student and the female reader's surrogate. Male readers and observers of the phenomenon found themselves excluded from this new, lucrative sexual arena in which a woman was writing about sexual fantasies for other women. Responses to the novel included the despairing shaking of heads by some female commentators, whose reaction to the fact that a female author writing for female readers had placed so much stress on sexual power games involving subjugation was a suggestion that many women have been conditioned to regard such material as an acceptable part of their sexual fantasies. However, it might be argued that this is condescending to the great mass of the books' readership, the demographics of whom cut across socio-economic boundaries and mystified male commentators.

The phrase 'mommy porn' began to enjoy a certain currency, but Dana Brunetti, a leading producer of the film of the first book, stated that the filmmakers were trying to avoid this demeaning term, as they considered that the film would have a more elevated intent. At the same time, female fans of the novels utilised social media in great numbers to claim that they wanted the 'dirtiness' of the books to be retained. The production company hoped that the films would become safe 'date' movies to which couples might go and perhaps later discuss the erotic possibilities of bondage.

The publishing industry has noted that sales of printed erotica in the wake of the *Fifty Shades* phenomenon are showing signs of slowing, although other authors in the E. L. James vein still sell well, such as Sylvia Day and the pseudonymous Vina Jackson, the latter a nom de plume for the male writer Maxim Jakubowski. However, there are still such spin-off products as lines of lingerie inspired by the book, greetings cards, T-shirts, iPad covers and even a classical anthology issued by EMI that features a selection of music namechecked during the sexual

encounters between Anastasia and Christian. The days when prosecuting counsel could ask (during the trial over D. H. Lawrence's *Lady Chatterley's Lover*) 'Is it a book that you would even wish your wife or your servants to read?' seem very distant indeed.

As a postscript, there are limits to sexual expression, however – embarrassing ones. The police and fire brigade have said that, since the massive success of the *Fifty Shades* trilogy, they have had many sheepish call-outs by couples where one or other partner has been handcuffed to the bed and unable to cut themselves free.

The modern minefield

One thing is clear: the ethos of sex and sexuality remains as much a minefield in the liberated twenty-first century as it was in the more constrained eras of the past, and the cinema is as much a barometer and an index of flux as it has ever been. While, to all appearances, virtually anything goes today (apart from underage sex), notions of political correctness and acceptable sexual behaviour are making ever more strenuous demands on society's ability to accommodate change – Western society, that is; much of the Middle East seems bent on a return to medievalism in its attitudes to women and sexual freedoms.

A series of high-profile cases arraigning celebrities for historical sexual abuse has made many men – both well known and obscure – examine their sexual behaviour of decades before, and the defence that 'things were different then' can no longer be proffered. And with proven cases of criminal sexual abuse casting a shadow over once acceptable interactions between the sexes such as flirtation, the very act of seduction is now fraught with notions of consent and influence. As a result, male sexuality is under a merciless spotlight, even more so than was the case in the 1970s and 1980s, when writers such as Andrea Dworkin, Marilyn French and Betty Friedan suggested that the masculine sexual impulse was ineluctably linked to patriarchy and control. Not that the situation is necessarily less complex for women today, as they are obliged to police the new rules of flirtation and sexual engagement with quite as much caution as nervous men. And the lesbian community has had lengthy battles over the acceptability of lesbian S&M porn, with one feminist London bookshop involved in a bitter dispute over whether or not such material simply mirrors the coercive sexual imperatives of men.

But one thing is certain: despite the greater scrutiny of sexual mores, the demands of sex and sexuality are as pressing as ever, and there are positive elements about the new attention to the subject, such

as women's laudable insistence on their equal rights to sexual pleasure. Notwithstanding the disapproval of religious obscurantists, sex is recognised in mainstream opinion as a key element of an organic, healthy, well-adjusted life. Nevertheless, a key component of the sexual experience for many of us, if truth be told, is the transgressive, even the 'dirty', however unacceptable it may be. We might be more careful about exploring such areas in our own private lives, but the cinema will always remain bloody-mindedly prepared to tackle unorthodox thinking and to rock the boat. Films were boundary-pushing in their representation of sex from the silent era onwards, and despite the greater explicitness sanctioned today, there is every sign that they will continue to perform a very useful social function: to shock.

18
Painful Odysseys

Finally, any contemporary study with the title *Sex and Film* is obliged to examine – in some detail – the most controversial film dealing with the subject in the early twenty-first century, a film that has been celebrated and criticised in equal measure.

Quite what did the director Lars von Trier mean by making the central 'O' in *Nymphomaniac* appear in the advertising as a pair of brackets suggesting a vagina? A marketing ploy? But words are important in the film: his assertive, sexually omnivorous heroine uses a blunt, Anglo-Saxon word for her genitals – her 'cunt'. As she says, 'Each time a word becomes prohibited, you remove a stone from the democratic foundation.'

What is the most shocking thing about von Trier's four-hour erotic epic, which is divided into a pair of two-hour slots? Is it the erect penises being fellated, even in the version without the hard-core inserts? Or the shots of the labia of the central female character (played by two different actresses)? Or is it the difficult-to-watch sadomasochistic scenes in which the heroine's bare buttocks are rendered red raw by an enthusiastically applied strap? Or her looking on bemusedly as the erections of two casual black lovers she has picked up jiggle in front of her face while the men argue about which one is entitled to her vagina and which to the rectum in the sexual sandwich that is their objective? Or the erotic union between the mature heroine and a barely pubescent girl she has taken under her wing? In fact, it is none of these scenes: it is something that occurs in the final four minutes of the second film, and perhaps those readers who have yet to see von Trier's controversial movie should avoid the next paragraphs.

Having posed at considerable length a series of philosophical questions in his erudite and very literary screenplay concerning the

motivation and existential ethos of the heroine's condition, the director reminds us again and again that there is no simple explanation. This is a point most eloquently made when Joe (played by Charlotte Gainsbourg) turns somewhat viciously on a sex therapy book group in which young women are trying to deal with their own sex addiction. They listen in tears as she rips to shreds their carefully built defences, proudly claiming that she is a nymphomaniac. She sees herself as being in an almost elemental state, something existing in a perfect unalterable condition like one of Plato's 'essences'. And, we wonder, is that von Trier's point – that we must accept Joe on her own existential terms, above and beyond the sexual imperatives of ordinary men and women?

But then, in a shocking and utterly unexpected resolution, there is a radical change in the character of the sympathetic Seligman, played by Stellan Skarsgård, who has listened to Joe's lengthy and indulgent history of sexual obsession from childhood to the present day after he has found her bruised and bleeding in an alley. Seligman abruptly veers away from the philosophical tone he has maintained throughout – and in which he has drawn analogies concerning Joe's behaviour with everything from Bach's counterpoint to the Fibonacci sequence – and virtually exonerates Joe from the self-loathing that her nymphomania has caused her by proving through his own sudden bad behaviour that the entire male sex is indirectly responsible for her condition, very much in the fashion that Stieg Larsson presents his own gender in the *Millennium* trilogy. He proves – with a forcefulness he has not shown elsewhere – that she was not the free agent she considered herself to be throughout her multiple sexual encounters, but instead she has been a helpless victim of misogynistic male lust, rather like Lisbeth Salander. In these final minutes, we learn that Seligman is not, however, an understanding man along the lines of Larsson's Blomkvist (as we have been led to believe). Either the infinitely flexible, kind and understanding man we have watched for the last four hours was a sham, or he undergoes a surprising – and unlikely – transformation at the end of the film as the old Adam reasserts itself and the demands of masculine desire emerge in this asexual figure. Seligman enters the room in which Joe is sleeping peacefully, her harrowing story told. He is not wearing anything on his lower body. He pulls back the duvet to reveal Joe's buttocks and begins massaging his own penis before attempting to enter her. She wakes in alarm and shrugs away from him, reaching for the revolver that we have seen earlier. The screen goes black and then we hear a sound that suggests that Seligman has paid the ultimate price for his betrayal. While this is certainly the kind of *coup de théâtre* that will send an audience

out of the cinema hotly debating the film they have just seen, the scene seems both melodramatic and banal in telescoping the complex argument of the previous four hours in a disappointingly reductive way. It is, however, a message that would find favour with the most polemicizing 1970s feminists: however considerate and sensitive men appear to be towards women, in the final analysis they simply cannot be trusted. Men will always be at the service of their genitals, even when they appear to be understanding.

The act of looking

This final lack of intellectual rigour on the director's part, however, does not undercut the achievement of von Trier's often mesmerising, often infuriating film. If he had not incorporated this last scene, which essentially comments unfavourably on the male sex as opposed to the female, we would be left with the central puzzle of *Nymphomaniac*: the 'Joe' character herself. What drives her? She claims to have reached orgasm in pre-puberty, in a curious scene in which she is lying in a field and appears to levitate with mystical apparitions around her, but sex quickly becomes an unhealthy compulsion. We see evidence of this in her teenage trawl through the male passengers on a train as she competes with a female friend over the number of men they can have sex with in the toilet. Her success here seems joyless, but it is nothing compared with her desperate, futile attempts to masturbate years later, when we are shown – in unflinching close-up – the rawness of her vagina from an army of men, not to mention her own repeatedly violent self-stimulation. But the essence of what has set her on her self-destructive erotic odyssey remains an enigma, despite the fact that she and her slightly sociopathic male interlocutor talk endlessly about the reasons for her behaviour.

By the time of the film, the director had become notorious for the graphic nature of the previous work he had made as part of the Dogme movement, which avoided standard film techniques. The most notable of these films was *Antichrist* (2009), which shares *Nymphomaniac*'s leading actress and its lack of embarrassment about the presentation of male and female genitalia. Given to ill-advised public pronouncements, including one that appeared to be a defence of Nazism, von Trier subsequently decided to remain silent about his philosophy and intentions, and stated that *Nymphomaniac* was to speak for itself. But a key motif of the film is 'looking', channelled in a not dissimilar fashion to Michael Powell's *Peeping Tom* (1960), another film with a caustic take

on sex. Everyone looks: we see things through Joe's eyes even when she is a participant; the brutal minders she has when she works for a debt collector (Willem Dafoe) watch, smiling, as she strips or performs oral sex on her victims; and Seligman looks (metaphorically) at her encounters through her descriptions of what we, the audience, are shown. In fact, the ambiguous gaze (as in Powell's film), rather than being liberating, represents instinct being repressed and controlled by 'organising' forces, which results in massive damage to the psyche. Von Trier suggests that everyone's personality incorporates elements of voyeurism: as in *Peeping Tom*, the very act of watching a film is a way of gazing at private, behind-closed-doors experiences – an element that is also to be found in that other once-maligned, now celebrated masterpiece of 1960, Hitchcock's *Psycho*.

The true masturbator

Salvador Dalí called one of his paintings 'The Great Masturbator' – it depicts a female face with closed eyes pressing unambiguously against a male penis and testicles – and the phrase was half-appropriated by Lars von Trier, who styled himself 'The True Masturbator of the Silver Screen'. But this nomenclature remains perplexing, as the director's films bring the viewer no closer to his view of, for instance, female sexuality. There are moments when what appears to be his disgust with regard to female sexuality – and, by implication, one of its signifiers, menstrual blood – has all the misogynistic fervour of the theocratic religions of the world, but there is the simultaneous presentation of a female Eros principle as a vital energising force that somehow keeps at bay, at least for a time, the self-destruction that the central female character appears to be willing for herself.

What are we to make of the scenes in *Nymphomaniac* in which Joe visits a cold, controlling S&M master, K (played, unattractively, by Jamie Bell)? Joe joins a group of similarly dispirited, nervous-looking women who are paying for the privilege of being beaten and violated by K; one of his most invasive actions is to insert his fingers into Joe's vagina as she straddles a sofa, her knickers around her ankles, to see whether the ferocious whippings she has received – or is about to receive – produce the kind of lubrication that is supposed to precede intercourse. In these scenes, there is no question that the male character is ruthlessly in command of the situation; when an aroused Joe grabs at her tormentor's groin and gasps, 'I want your cock,' K is not interested. In fact, his own sexual response (if any) to the punishments inflicted on his willing

female clients remains unreadable. But, generally, Joe remains in control of her encounters, even though we see her paying a heavy price for this control.

Although Joe's command over the situations in which she finds herself remains a constant throughout the film, there is a certain inconsistency on the director's part here, with the young Joe (when played by Stacy Martin) appearing to be an altogether different character from her mature self (Gainsbourg) – and not just because she is played by different actresses. A charitable reading of this might be that it reflects the character's growing levels of self-revulsion, despite her proud avowal of nymphomania as a life choice.

A debased Scheherazade

Again and again we are asked whether or not we can take Joe's statement 'I am a nymphomaniac and I love myself being one' at face value, particularly given the joylessness of most of the sex we see on screen. Joe's own unremitting masturbation, for instance, is never presented in a gentle, caressing fashion but always as fierce and determined; at one point she whips her own genitals with a towel when she finds that she has lost the ability to orgasm. Male sexual consummation, however, is hardly presented in the film in a more positive fashion; again, we are always shown a violent thrusting copulation rather than any more gentle or sensuous encounters. The two unsimulated examples we see of Joe fellating men also have a negative overlay: in the first instance, the young Joe forces a blow job on a sympathetic middle-aged man she meets on a train. He has been kind to her and politely resists her advances as she undoes his flies, protesting that he is on his way back for a romantic tryst with his wife, who is currently ovulating. Joe sucks his penis and brings him to orgasm, despite it being clear that she is damaging the chances of the man and his wife creating the child they both want. In the second example, Joe performs fellatio on a man who she has brought to erection by telling him a variety of erotic stories – she finds that only the one relating to children has any effect. She claims to a horrified Seligman that this was a generous gesture, as she realised that he was lonely (as is she), but her actions, by making him aware that he is a paedophile, have destroyed his life. Once again, the act is far from being pleasurable: the man is tied to a chair as Joe uses her mouth on him, and two brutal thugs (Joe's minders) look on after wrecking his room. Oral sex in *Nymphomaniac* has distinctly mixed connotations for the men; Joe, however, is allowed some pleasure when it

is administered to her by a plump, lonely man whose greatest delight is to bathe her and use his tongue to bring her to climax. Incidentally, the porn body doubles for the leading players in *Nymphomaniac* are cleverly integrated even in the print without the hard-core inserts – faces and genitals are simultaneously visible in the same shot, although they belong to different actors. Similarly, the prosthetic penises employed in some scenes are far more convincing than the ludicrous concoctions to be seen in the films of Tinto Brass and Russ Meyer.

The second film is markedly different from the first, not least in the division between pleasure and pain – the penultimate sexual encounter is very much within the arena of pain – although in both films the narrator Joe (as played by Charlotte Gainsbourg) has a bruised and bloodied face as she tells her tales like a debased Scheherazade. Joe's initial lesbian encounter with her young protégée P seems to suggest that the love Joe has been seeking lies in a sapphic relationship – if it can be said that she is looking for something quite so straightforward. But this consensual episode is illusory, as we discover when we are shown why she is so heavily bruised. The treacherous P – who looks like a schoolgirl when we first see her but who clearly has a fully developed woman's body when she appears naked – has a sexual alliance with the man who kicks and beats Joe, leaving her bleeding in a squalid alley. And as Joe watches, numb with pain and her face smeared with blood, P takes down her own knickers and forces Joe's assailant to have vaginal and anal sex with her. The scene is unpleasantly ended by the young woman straddling the comatose Joe and urinating on her. It is difficult at this point not to think of the similar scene in Pasolini's *Salò*, but in this case the individual providing the 'golden shower' is doing it willingly on an unwilling victim, the reverse of the situation in the Pasolini.

Von Trier's film is set in a country that might be Britain, judging by most of the accents, but is never identified as such. It is distinguished by some superb acting, not least by Gainsbourg and Skarsgård, who inevitably have to do most of the heavy lifting in their many dialogue scenes together; these scenes, it should be pointed out, are not without their longueurs in a markedly overlong film. There are also some remarkable cameos from celebrity actors, most notably Una Thurman as a hysterical wife who forces herself upon the young Joe and the husband Joe has inadvertently stolen.

The final measure of the film's achievement is that we are unable to pin down the director's attitude. Is it a cruelly misogynistic film? Is it a cold-eyed commentary on male sexuality and a wake-up call to women to seek Lysistrata-like celibacy? In the end, like the work of all

serious artists – and von Trier is certainly that – there is no attempt to make things clear for us; one of the pleasures of art is that the viewer is allowed to decode and deconstruct what is happening before us. And when we become accustomed to the parade of carnality we are seeing on the screen, it is finally possible to try to do just that.

Appendix 1: Selected Films

The very random selection of films in this appendix may appear to be arbitrary, but it is an attempt to suggest, from a varied collection of titles not otherwise fully covered in this volume, that approaches to the treatment of sex in the cinema can represent a broad church indeed. Not all the films listed below are accomplished – and some are frankly maladroit – but they all have areas of interest in the ways in which they utilise some form of erotic expression.

Barbarella (1968, directed by Roger Vadim)

This French/Italian adaptation of the witty and transgressive science fiction comic strip embraces its own trash ethos with gusto, and creates an eccentric, utterly artificial world for its foolhardy female astronaut, who Jane Fonda plays as basically a female Candide in space. The film is full of off-kilter sexuality, such as the evil Black Queen played by Anita Pallenberg as a predatory lesbian, while the opening scene features a space-suited figure stripping in zero gravity under the credits to reveal a naked Jane Fonda. Her peekaboo outfits in the film are cleverly designed, but belong firmly to the actress's pre-feminist persona – although it might be argued that Barbarella herself, rather than being the sexual plaything for men one might imagine, in fact uses men to grant herself sexual gratification.

The Blood Rose/La Rose Écorchée (aka Ravaged, 1970, directed by Claude Mulot)

The delirious *The Blood Rose* was trumpeted as 'The First Sex Horror Film Ever Made'. In its uncut European version, Claude Mulot's film begins very much like an arthouse movie of the kind made by such directors as Alain Resnais: unorthodox editing and tricks with time and the film's chronology are used to destabilise the viewer. But then two homicidal sex-crazed dwarves appear (bizarrely clad in animal skins) and it becomes completely impossible to take any of the blood-drenched – and erotic – goings-on seriously.

The Body (1971, various directors)

In the United States, Metro-Goldwyn-Mayer presented this British documentary that they had picked up in a slightly mendacious fashion, suggesting that it was a far more salacious film than its makers had intended. *The Body* began with a lengthy travelling short along a line of men and women, the majority of them naked, supposedly suggesting the progress of the human body from birth to death. The actual strategy of the film was ambitious, showing, for instance, the human organism's inner organs with special photography. But the film was sold in the US on the basis of its brief inclusion of scenes of sexual intercourse and

childbirth, as well as one scene in which a couple indulge in oral sex. Inevitably, those who had queued up for these brief moments were largely disappointed.

Brimstone & Treacle (1982, directed by Richard Loncraine)

The singer Sting was given the central role here as a mentally unstable young confidence trickster who inveigles himself into the home of a bourgeois couple (played by the dependable Denholm Elliott and Joan Plowright, making up for Sting's one-note performance). The couple have a mute daughter (played by Suzanna Hamilton) who never leaves her bed, and she is taken advantage of by a visitor who might be satanic or might be an emissary from God. Dennis Potter's original play was the subject of much criticism from TV reformers who saw it as blasphemous, and who cited the scenes where the character played by Sting in the film takes sexual advantage of the unresisting young girl as a reason for banning it. By the time it was filmed for the cinema, the outrage had died down, but although it was effectively made, *Brimstone & Treacle* lacks the corrosive charge of the original television play.

Closely Observed Trains (1966, directed by Jirí Menzel)

One of the great favourites of international cinema from the 1960s comes up as fresh as paint despite the passage of time. Milos, a dispatcher's apprentice at a village railway station in occupied Czechoslovakia, longs to lose his virginity. Oblivious to the war and the resistance movement that surround him, he embarks on a journey of sexual awakening and self-discovery, encountering a universe of frustration, eroticism and adventure. Menzel's delightful film won numerous awards including the Academy Award for best foreign language film in 1968.

Crimes of Passion (1984, directed by Ken Russell)

For all its infelicities, Ken Russell's bizarre sex drama – or sex comedy – boasts two memorable performances: Kathleen Turner excels as a woman without a fixed identity (fashion designer by day, downmarket prostitute by night) and Anthony Perkins, channelling his Norman Bates persona, dials up the hysteria as a sex-obsessed, psychotic preacher. As 'China Blue', Turner echoes Hitchcock's Marnie as a frigid woman who uses her sexual attraction to cheat men, but – unlike Marnie – China is able to use sex directly and as a form of revenge against the male sex. Apart from Russell's kinetic, unfocused direction, the film was compromised by a blank performance from John Laughlin as an ordinary man who becomes obsessed with China. The sex scenes that caused such a rumpus at the time – including the abuse of a policeman, gleefully sodomised with his own nightstick – now seem faintly ludicrous.

The Crimson Petal and the White (2011, directed by Marc Munden)

Word of mouth made this sometimes shocking and unusual piece of sexually charged period drama a great success. Based on the best-selling book by Michel Faber,

The Crimson Petal and the White was an uncompromising and explicit British television series with a stellar cast featuring Romola Garai as the prostitute Sugar, Chris O'Dowd, Richard E. Grant, Mark Gatiss and an unrecognisable Gillian Anderson. Directed by Marc Munden (of *The Devil's Whore* and *Conviction* fame) and adapted by Lucinda Coxon, it presents a disturbing and unsettling vision of Victorian London.

Deep End (1970, directed by Jerzy Skolimowski)

Rarely seen since its original screenings and long overdue for reissue, Skolimowski's erotic, surrealistic classic, with its bizarre, foreigner's view of London, finally became more widely available in 2011 with a three-disc DVD release. It looks astonishing – although what the now pious Cat Stevens would make these days of the use of his songs in this frank study of sexual mores is open to question. Surreal and unsettling in its vision, with Munich largely standing in for London.

Emmanuelle (1974, directed by Just Jaeckin)

The most famous (and most often imitated) of all soft-core films features a 19-year-old woman (played by Sylvia Kristel) whose lengthy series of sexual interactions with both men and women are, according to the film, a path to her sexual liberation. The film is very obviously a series of realisations of male fantasies, and the subplot in which she is instructed in the ways of sex by an older man (played by Alain Cuny) is as creepy and unconvincing as such scenarios always are. Nevertheless, Kristel conveys in this film at least a rather winning mixture of naivety and subtle sexual allure; as a woman utterly at ease with her own body, she convinces throughout. The film's original tagline was 'X was never like this', but it certainly was in the host of increasingly more desperate imitations and sequels that followed the original film.

Grande École (2004, directed by Robert Salis)

Sex, class and race collide at a French private school in Robert Salis's powerful and moving drama, adapted from the stage play by Jean-Marie Besset. The film is set in an elite French educational institution, a 'grande école', where each year the government filters out students, particularly those from privileged backgrounds, to become the country's future leaders. The story centres on Paul (Grégori Baquet), a new student embarking on his first term. Paul finds it hard to fit in with his bourgeois classmates, but becomes emotionally and sexually attracted to his handsome roommate Louis-Arnault (Jocelyn Quivrin). Although he tries to suppress his feelings, his long-term girlfriend Agnès becomes jealous and proposes a bet: whoever beds Louis-Arnault first wins. This is a passionate and erotic film that explores new sexual awakenings as well as a brave statement on the state of contemporary French schooling.

Gwendoline (1984, directed by Just Jaeckin)

For many years, this colourful (if superficial) version of the famous erotic comic strip was available only in a heavily cut, neutered form – the video issue, moreover,

was panned and scanned, totally destroying all the widescreen compositions. It was a small pleasure, therefore, when a wholly uncut widescreen DVD issue finally appeared. Admirers of good screen acting are unlikely to be impressed – the hilariously named Tawny Kitaen is delectable looking, but no actress, and there is a particularly charmless Indiana Jones-style hero – but the slightly desperate cocktail of sex and violence on offer here may be catnip to the aficionado.

Hardcore (aka The Hardcore Life, 1979, directed by Paul Schrader)

Opinions are mixed about the ideology behind this disturbing piece directed by Paul Schrader. Does Schrader disingenuously utilise the imagery of the porn subculture he ostensibly condemns – in other words, is he trying to have his cake and eat it? But whatever side of the argument you come down on, this is still a powerful, unflinching glimpse into the dark, bizarre world of the industry, with strongly etched performances from the ever-reliable George C. Scott and Peter Boyle. A rigid Calvinist minister (played in monolithic fashion by Scott) follows his teenage daughter to Los Angeles where he is horrified to find that she is in thrall to a vicious pimp. Helped by a young prostitute (played by Season Hubley), he undertakes a nightmare odyssey through a dark sexual subculture, where the sordid is the norm, and all sexual congress is brutal. Like his central character, Schrader had a Calvinist upbringing, but the notion of a voyage of discovery by the strict Scott (as imposingly authoritative as ever) is compromised rather than enhanced by the director's palpable fascination with the world he depicts. Schrader appears to be inviting us to share his bifurcated view of the grim world he shows us, but we spend the film trying to decide just where our sympathies lie, with no guidance provided by the director's schizophrenic vision.

The Harem (aka Her Harem, 1967, directed by Marco Ferreri)

This eccentric erotic piece is a rarity from one of Italian cinema's most contro-versial directors, Marco Ferreri. It is a sumptuously sensual, darkly satiric drama, with Carroll Baker as a seductive woman who lures the three men she desires to her villa, pushing them to their limits by toying with their sexual needs and egos. Ferreri, noted for his ability to shock the unshockable, established a reputa-tion as a maker of blackly humorous satires on middle-class life and attitudes. He provoked a scandal at the 1973 Cannes Film Festival with his film *La Grande Bouffe*, a reworking of the Marquis de Sade's *The 120 Days of Sodom*, which won the Grand Jury Prize and entertained and disgusted in equal measure. Ferreri's many other pungently original features include *The House of Smiles*, *La Carne* and *Tales of Ordinary Madness*. The film features a score by the idiosyncratic (and prolific) Ennio Morricone.

The Hunt (2012, directed by Thomas Vinterberg)

Mads Mikkelsen has made a speciality of playing unpleasant villains (from his chill-ing Le Chiffre in the Daniel Craig Bond film *Casino Royale* to his television incarna-tion as Hannibal Lecter), but there is much more to the actor than his undoubted

capacity for the sinister, as Thomas Vinterberg's highly impressive *The Hunt* demonstrates. Mikkelsen plays a primary school teacher in a small provincial town who is wrongly accused of molesting a small girl. The way in which his character's life is inexorably destroyed by thoughtless accusations – and by a readiness to rush to judgement by the adults of the town – is handled with great dramatic power; Arthur Miller's *The Crucible* is perhaps a template. Mikkelsen finds a wide range of expression in the progress of his character and resists the temptation to make a bid for easy sympathy; his character, Lucas, often makes mistakes, and is sometimes his own worst enemy when fighting back against his accusers. In a Britain in which accusations of sexual impropriety now seem to appear routinely, the film is perhaps salutary in suggesting that all such claims need to be examined very carefully for signs of innocence as much as of guilt. But this controversial notion is never handled tendentiously; this is a drama in which it is impossible not to become involved.

In My Skin/Dans Ma Peau (2002, directed by Marina de Van)

Dans Ma Peau is no life-affirming celebration of sex; David Cronenberg has been invoked as the yardstick for this one, and its deeply unsettling tone is in the Canadian director's best vein. Self-mutilation and a dark sexual quest are at the heart of Marina de Van's uncompromising and unflinching movie, with a striking and brave performance by de Van herself.

Looking for Mr Goodbar (1977, directed by Richard Brooks)

In 1977, Richard Brooks' gritty study of a woman's search for casual sex, *Looking for Mr Goodbar* (from Judith Rossner's novel), quickly accrued a degree of notoriety for what it appeared to be saying about the lifestyles of promiscuous young women as embodied by the damaged, doomed heroine played by Diane Keaton. But those who decided that the film's essential message was 'the wages of sin is death' were ignoring certain specific aspects of the Keaton figure's psychological make-up; this is very much a character-driven film, and Brooks does not appear to be criticising de facto the sexual freedom of young women in the 1970s. Rather, the film is a portrayal of the heroine's desperate, joyless need for existential contact with others, as a woman who has insufficient faith in her own capabilities. Her series of one-night stands certainly made for one of the most challenging cinematic experiences of the day, and the incoherence at the centre of the film might perhaps be down to the fact that the middle-aged director was looking at an unfamiliar, uncongenial world from outside. However, the criticism that the character's unceasing search reaches a grim climax when she brings home a psychopathic murderer does not necessarily make Brooks' film a morality play: the film can equally be read as a comment on society's difficulties with women who wish to be in charge of their own sexuality, still a potent message today.

Mädchen in Uniform (1931, directed by Leontine Sagan and Carl Froelich)

One of the most important films in the history of the German cinema was also one of the first to integrate sound and visual elements in a creative fashion, but

it is mainly remembered for being the first film to handle the theme of lesbianism with sympathy and an avoidance of criticism. A 14-year-old girl is a new border in a girls' school run by a strict and unyielding mistress. All the girls are oppressed, but there is a beautiful young teacher who is very popular with all her pupils. The variety of lesbian relationships in the film are treated with nuance, and, unlike later depictions of the subject, this sexual predilection is not shown as an automatic recipe for destruction.

Maison Close (2010, directed by Mabrouk El Mechri)

This handsome television series is not for the narrow-minded, though its analysis of the mores of its characters is only skin-deep. The setting is a nineteenth-century brothel in Paris, and the eight-part series is distinguished from earlier similar dramas (notably Louis Malle's *Pretty Baby*) by the modern sensibility with which the material is handled. Its sexual nature echoes another ground-breaking (and far more complex) piece of period drama, which also had an uncompromising sex-for-hire theme: the television adaptation of Michel Faber's *The Crimson Petal and the White* mentioned above. The central characters in *Maison Close* are a trio of prostitutes, who ply their trade in a well-appointed house of pleasure, 'Paradise', with a speciality client list including bluebloods and other society notables. The basic impulse of the three women is to try to break free from their cloistered life, and the film's treatment of the world of prostitution is never romanticised in the way that, for example, the recent adaptation of *Secret Diary of a Call Girl* was accused of being – in *Maison Close*, the men are almost all universally appalling. Performances are strong, reminding us that the wealth of acting talent in France is the equal of that in the English-speaking world.

Merci la Vie (1991, directed by Bertrand Blier)

Bertrand Blier's *Merci La Vie* is a charming and affecting film. Camille, a naive schoolgirl, meets an intriguing influence in Joelle, a slightly older and much more experienced spirit. Camille follows her new friend through the discovery of sex and the darker side of life. As the film progresses, Camille discovers AIDS and fears that she may have picked up the disease in her early encounters. Sterling work from Charlotte Gainsbourg, Anouk Grinberg and Gérard Depardieu.

The Music Lovers (1970, directed by Ken Russell)

By the time Ken Russell made his Tchaikovsky film, his more ordered and conventional – and much-acclaimed – biographies of composers such as Delius, Debussy and Elgar were some way in the past and he had adopted a manic, all-stops-out approach that was to be his modus operandi for the rest of his career (with a few exceptions). Tchaikovsky's homosexuality had been notably ignored in a much more respectful Dimitri Tiomkin film biography of the composer, but it was the perfect grist to Russell's mill, and *The Music Lovers*, while always exhilarating and imaginative, was too often ratcheted up to a hysterical pitch. The actress Glenda Jackson had made a great impact both for her performance and her nudity

in Russell's film of Lawrence's *Women in Love* and was cast as the composer's neurotic wife Nina, who Tchaikovsky (played by Richard Chamberlain) marries in the vain hope of 'correcting' his own despised sexuality. Inevitably, the marriage is a disaster, and the scene that encapsulates this has Jackson writhing orgasmically (or in exasperation) in a rocking train compartment as Tchaikovsky gazes in horror at his wife. Her sexual frustration leads to madness and imprisonment in an asylum that looks like something out of the paintings of Hieronymus Bosch. Tchaikovsky scholars were horrified by the film, but popular audiences responded well, particularly when Russell's artistic choices on screen were accompanied by well-known pieces of the composer's music, such as the 1812 Overture.

Naked Killer (1992, directed by Clarence Fok Yiu-leung as Clarence Ford)

Clarence Fok Yiu-leung's erotic Chinese epic *Naked Killer* was not the most graphic of films, but it was still eye-opening. This was initially seen in the UK only in a trimmed form, with the director's surname unconvincingly changed to the Anglo-Saxon 'Ford', but it was subsequently made available in the 2000s without the gentle ministrations of the censor's scissors. Stylish, brutal and operatic, Yiu-leung's/Ford's movie forged a free-falling vision of delirious sado-eroticism in the designation 'Category III' (as such films are described in China). A sensuous action adventure shamelessly borrowing elements of *Nikita* and *Basic Instinct*, *Naked Killer* dealt with the twilight existence of an attractive female assassin, played by Carrie Ng.

Nudes of the World (1962, directed by Arnold L. Miller)

It is instructive to remember that such utterly harmless exploitation films as Arnold L. Miller's *Nudes of the World* (the title is a pun on the now-defunct – and disgraced – British scandal sheet newspaper) had such censorship problems in their day. Apart from the profuse nudity, there is absolutely nothing to startle the horses in such innocuous fare when viewed today. However, the combination of naivety and knowingness makes for curiously entertaining, amusing viewing in the twenty-first century.

The Piano Teacher (2001, directed by Michael Haneke)

The immensely talented Austrian director Michael Haneke likes nothing better than to tackle dangerous territory in films such as *The Piano Teacher*, an unflinching study of sadomasochism featuring a mesmeric performance from Isabelle Huppert, who combines proficiency in Beethoven and Schubert with acts of genital self-mutilation. One scene in *The Piano Teacher* shows just how effective suggestion rather than demonstration can be, even in such a visual medium as film. Huppert masturbates her pupil Benoît Magimel, but we – the audience – have only the sound of flesh against flesh to indicate what is happening. However, like all the other sexual activity in the film, there is a desperate, joyless quality to this encounter.

Portnoy's Complaint (1972, directed by Ernest Lehman)

With Philip Roth's novel adapted and directed by Ernest Lehman, the auguries were reasonably good for the film of a novel whose central theme is onanism, but the results were lacklustre. Lehman's screenplay for Edward Albee's play *Who's Afraid of Virginia Woolf?* stretched the boundaries of the kind of language that was acceptable on screen, and *Portnoy's Complaint* was to move into similarly risky territory. During the production of the film, a marked liberalisation was evident in the offices of the Motion Picture Association of America, even though new censorship organisations (such as Citizens for Decent Literature) were simultaneously springing up in response to Hollywood's perceived moral dereliction. Rather in the fashion of Kubrick's *Lolita*, which had avoided showing any direct sex, Lehman eschewed any scenes of masturbation; also, the language was softened from the original novel, but it was still franker than audiences had encountered before, including Richard Benjamin (as the onanistic Portnoy) talking about using an apple, his sister's panties or a piece of liver for sexual gratification. The frankness, however, was not matched by any palpable wit.

Princess (2006, directed by Anders Morgenthaler)

A remarkable – and very adult – feast of stylish animation, with a narrative clearly inspired by Scorsese's *Taxi Driver.* The visuals are stunning, but in some ways the film tried to have it both ways, portraying the porn industry as irredeemably sleazy and corrupt, but nevertheless utilising its imagery knowingly. However, this is further proof that some alumni of the animation field are not content with the juvenile market.

Prostitute (1980, directed by Tony Garnett)

This is now available uncut in a welcome release mastered from original film materials, but it is easy to see why it could not be seen in this version before, even under the liberal regime of Stephen Murphy at the BBFC; it features a lengthy sequence in which a cheerful working-class client is masturbated by a boisterous female sex worker, with the liberal assistance of bay oil (though stopping short of orgasm). Garnett's film about the lives of a group of Birmingham sex workers in an era when drug addiction was generally not an issue is dated but riveting – although the director's tendentious conclusions are (perhaps deliberately) confusing.

Saturday Night and Sunday Morning (1960, directed by Karel Reisz)

Of all the films in the 1960s British New Wave in cinema, *Saturday Night and Sunday Morning* was in many ways the most influential, with its powerful anti-establishment stance, unblushing treatment of sex and its working-class protagonist – Arthur Seaton was something new in British cinema. While other films of the period have dated somewhat, most of Reisz's ground-breaking film

looks as fresh and powerful as ever, and it is salutary to observe just how good Albert Finney was in the pivotal role of Seaton, when the actor is now something of an elder statesman of the profession.

Taking Off (1971, directed by Milos Forman)

Universal Studios was pleased to have the coup of the much respected Czech director Milos Forman directing an English-language film for them, and one with a cleverly written, often very funny screenplay. *Taking Off* proved to be a modest hit, although the studio was uncomfortable with a song sung straight-faced to camera in a madrigal style called 'Ode to a Screw'. In the song, the word 'fuck' was repeated dozens of times, and Universal decided that it was necessary to bleep out the offending word in several less enlightened parts of the US, making a nonsense of the song. Not quite as contentious, but still capable of giving offence, was the very funny strip poker scene at the end of the film with middle-class couples having their inhibitions loosened by pot. The use of Dvořák's exquisite Stabat Mater was a perfect contrast to the gentle satire of bourgeois thinking in the film.

Varietease and Teaserama (1954 and 1955, directed by Irving Klaw)

When, in one of their periodic awakenings from torpor, various moral caretakers complain about the increasingly explicit representations of sex in the cinema, perhaps they should look at these two entertainingly naive, similarly excoriated films from a much more innocent age. Although the titillation on view in these films, which feature cult striptease performer Bettie Page, is unlikely to ruffle any feathers these days, it should be remembered that such images earned cries of outrage and censorship fervour in their day. Plus ça change ...

The Wonderful World of Sex (2003, various directors)

The Wonderful World of Sex provides a cheerfully cheesy look at the sex industry. Made by a UK company, Bullseye Productions, the viewer is afforded a motley series of features – with a relentlessly upbeat voice-over – on subjects as diverse as a strip club for girls only in Los Angeles and a sushi bar in Australia where customers eat off the naked bodies of beautiful girls. Viewers are invited to sample such exotica as genital sculpture at the Oasis Swingers Club, the history of suspenders, Hugh Hefner and his Playmates and – believe it or not – strip karting (which somehow doesn't seem to have caught on as a sport).

WR: Mysteries of the Organism (1971, directed by Dušan Makavejev)

This is a film that thoroughly deserves its cult status but that has also been the victim of much censorship throughout the world. On the surface, Dušan Makavejev

appears to be concerned with discovering the links between politics and sex, with the apparent argument that there will be no threat to the established order in any society that removes sexual repression. This, in fact, is the radical thesis of the psychoanalyst Wilhelm Reich (the eponymous 'WR'), but there is no clear through line in the director's examination of these notions; instead, he presents us with an often dizzying montage of images including a young man in the streets of America with a toy gun, a grotesque 1940s Soviet propaganda film presenting the tyrannical Stalin as a kindly and avuncular figure, and even Nazi torture scenes. As one would expect, the sequences that caused the greatest problems were those showing unsimulated sex and the often bizarre footage of Reichians undergoing therapy to liberate their bodies for orgasms, but these images are ineluctably comic. The film alternates scenes that utilise the mechanics of cinema in an exhilarating way with attention-testing dead spots.

Yesterday, Today and Tomorrow
(1963, directed by Vittorio De Sica)

This intriguing portmanteau film, which is famous for its climactic Sophia Loren striptease, gives Loren and Marcello Mastroianni the opportunity to play a variety of different characters in the various episodes. Although the scriptwriters included Cesare Zavattini, this is clearly not the socially committed Vittorio De Sica of *Bicycle Thieves*, but although the director was forced to work in lighter genres, his skills never deserted him. Here, he brings out the best in his actors – notably in the second episode, where Loren plays an unsympathetic and spoiled rich woman, the sort of part she had not been asked to tackle before. On its cinema release in the UK, the film suffered crass dubbing, but today's audiences can see an Italian-language, subtitled print on DVD.

Appendix 2: Continental Icons of the Seductive

This appendix provides a consideration of a few of the key female stars whose appeal may be perceived as primarily sexual, as opposed to being valued for their acting skills. Similarly iconic stars (such as Germany's Marlene Dietrich and America's Marilyn Monroe) are discussed in relevant chapters.

La Lollo: Gina Lollobrigida

Even before Sophia Loren, Gina Lollobrigida was the first major European star whose name became synonymous with earthy sexuality: her voluptuous appeal, soon to be copied by a whole host of other Italian actresses (Loren among them), seemed far more sensual and vital than the often bloodless charms of her English and American rivals. She was, of course, 'La Lollo', and had a remarkable career in which some excellent movies rubbed shoulders with a host of truly execrable ones. There was a rivalry with Loren; although the latter probably had a more distinguished career, Lollobrigida prided herself on her superior English – although neither woman could have been said to be completely at ease in the language. Her career was truly international, and there was barely a major European country in which she did not make films. Lollobrigida's range was more restricted than Loren's, but she undoubtedly possessed masses of charisma, and her sexuality fairly leapt off the screen.

Lollobrigida was born in Subiaco near Rome in 1927. Along with her three sisters, she moved to Rome and studied for a time to be a commercial artist. Her 'Lana Turner discovered at Schwab's drugstore' moment came when she was spotted by Mario Costa, the director of *La Sua Strada* (*The Street*, 1946), who persuaded her to take a screen test for the film *L'Elisir d'Amore* (1947) with the great baritone Tito Gobbi. Her film career continued in this operatic strain for the same director and she appeared in *Folia per l'Opera* in 1948 (again with Gobbi, and with another great singer, Beniamino Gigli) and in the same year's *I Pagliacci*, once again with Gobbi. She was dubbed, needless to say, as she did not possess a great singing voice herself. But other films quickly followed, such as *La Sposa Non Può Attendere* with Gino Cervi and *Alina* with Amedeo Nazzari, an unconvincing melodrama.

Her first appearance before international audiences was in the film *A Tale of Five Cities* (1951, with Bonar Colleano). By now she had married Milko Skofic, whose sensuous photographic studies of her were heavily promoted in magazines. She was supported by a famous connoisseur of pulchritudinous female beauty, Howard Hughes, who asked her to journey to Hollywood and who put her under a long-term contract. This actually had the effect of inhibiting her Hollywood career, but she continued to make films in Italy, such as *Amor Non Ho ... Però ... Però* (1951, with Renato Rascel), and she made a notable appearance in *La Città Si Difende* (also 1951), which was a marked improvement on her earlier work, the director, Pietro Germi, finding more interesting layers in her

persona than simply the pouting sex bomb. However, she still took workaday roles in such films as *Enrico Caruso: Leggenda di una Voce* (1951); the latter was an attempt to make Ermanno Randi a new Mario Lanza, even though his voice was supplied for the film by Maria Callas's long-time tenor partner Mario Del Monaco.

Recently, prints have resurfaced of one of her most attractive and colourful films of this period, the costume epic *Fanfan la Tulipe* (1952), with Gérard Philipe buckling a swash with all the abandon of a young Errol Flynn. If Lollobrigida's performance came as much from her ample décolletage as from any acting skills, she nevertheless made her heroine a creature of flesh and blood, when many actresses in similar parts were able to make little impression. One of her biggest American films was 1956's *Trapeze*. Here, Lollobrigida (wearing a provocative bustier) played opposite two fine slices of American beefcake, Burt Lancaster and Tony Curtis, although the film's appeal lay more in the visible charms of its stars than in anything director Carol Reed had to offer. Her stint as the eponymous Queen of Sheba in King Vidor's *Solomon and Sheba* (1959, opposite Yul Brynner) demonstrated something of her fire as an actress, but *Never So Few* (1959) made little impact, with a by-the-numbers performance from Frank Sinatra as her lover.

She had not, however, deserted the Italian cinema. *La Bellezza di Ippolita* had her as a prostitute in a blond wig and *Venere Imperiale* (both 1962) was an unexciting historical epic with Stephen Boyd. She coasted on her charisma in *Woman of Straw* (1964) opposite an uninvolved Sean Connery and the scene-stealing Ralph Richardson, but 1965's *Le Bambole* was a diverting spin on Boccaccio with Jean Sorel. Later films were not particularly memorable, and only 1988's *La Romana* (with Francesca Dellera) had much to offer; this, in fact, was a television remake of a film she had appeared in earlier. If Lollobrigida made nothing as impressive in her career as Loren's film for De Sica, *La Ciociara*, she will be eternally ensconced in the public imagination alongside her rival as the two most voluptuously sexy actresses in Italian cinema.

Une Parisienne: Brigitte Bardot

In the long history of the cinema, the names of many stars have become synonymous with sex, starting in the early days with the fervour inspired by Rudolph Valentino and Theda Bara. However, no one, before or since, has had such a total identification with an image of the erotic as the French actress Brigitte Bardot, born in 1934. It is ironic that she was so well known, given that the original French versions of her films were little seen outside France at the time of their appearance, and the crassly dubbed versions that did make it into non-Francophile cinemas were usually given more trivial names that stressed their sexual content. For example, Claude Autant-Lara's *En Cas de Malheur* (*In Case of Disaster*, 1958) became the more catchpenny *Love is My Profession* in English-speaking territories. Those individuals who know Bardot by name only might be surprised by the fact that she could actually act, as was evident in those films – the majority – in which the actress did not simply coast on her looks. But there is also a peculiarly Gallic hint of rebellion and iconoclasm in the film persona she presents, intimately tied up with the sexual freedom that was a component of her early work.

In 1956, when Bardot began to achieve worldwide fame, she represented a new phenomenon: a starlet who gleaned a prodigious recognition factor without appearing in an American film. But Bardot was not simply an object of desire for male cinemagoers; she quickly became a key source of fascination for French intellectuals, including Simone de Beauvoir. De Beauvoir's 1960 article 'Brigitte Bardot and the Lolita syndrome' was much quoted; the writer saw Bardot as a liberating figure. Every aspect of the actress's private life was examined in forensic fashion – such as the fact that her film gamines were usually from a working-class background, although Bardot herself was the product of a mon-eyed middle-class family. Early films such as Robert Wise's *Helen of Troy* in 1956 gave little indication of the volcanic sexuality to be exploited in later work; similarly unimpressive was her French sex kitten role opposite the sexually naive character played by Dirk Bogarde in Ralph Thomas's *Doctor at Sea* (1955), peeking seductively but innocently from behind a shower curtain with an incongruous dark bob. But the days when Martine Carol was considered France's most seductive export were numbered; the writing was undoubtedly on the wall when Marc Allégret's *En Effeuillant la Marguerite* (1956) was renamed in the UK as *Mam'selle Striptease*.

The real, seismic breakthrough, of course, was Roger Vadim's *Et Dieu Créa la Femme* (*And God Created Woman*, 1956), a strange mixture of overcooked melo-drama and cool *Nouvelle Vague* aesthetics, in which the female character was cen-tral to the film while the men were notably of less interest to the director. The censorship battles of Vadim's film unsurprisingly did its prospects no harm what-soever, and nor did manufactured suggestions (perhaps for the first but certainly not for the last time in the cinema) that the sex scenes in the film were being played for real. And the fact that *Et Dieu Créa la Femme* was a massive hit in the United States, taking over $4 million, was matched by another significant point: it was the first foreign language film ever to obtain a general release in Britain. Artistically, Vadim's love letter to his *inamorata* looks thin today, but nevertheless it is still a memorable piece of work that attempts something more than simply allowing the viewer to gaze in wonder at Bardot's sumptuously photographed body. The star's acting abilities were sometimes disputed, but such films as *Les Bijoutiers du Clair de Lune* (1958, also for Vadim) is a reminder that her appeal extended beyond her indisputable physical attributes. Impressively cast (Alida Valli and a glowering Stephen Boyd give powerful support), Vadim's heady tale of lust and death is appropriately overwrought.

The French themselves were slow to recognise Bardot's talents beyond the obvious, although – in patriotic fashion – they were not displeased by the celebrity achieved by this French actress. However, the shocking and explicit reputation of her films, and their inevitable attendant censorship, was looked at askance just as much by the more stolid members of the Gallic bourgeoisie as it was by the Daughters of the American Revolution in the US. It was to be expected in that climate that her image was considered so destabilising that her direc-tors (notably Roger Vadim) were not permitted to show her engaging in sexual activity or fully nude – except from the rear. She was customarily seen prowl-ing in her underwear or partially naked, slowly building up a head of steam for off-screen sexual activity, or languorously stretching in post-coital fashion. Her early films were often a triumph of suggestion and nuance, with strategically placed items concealing those parts of her body that could not be shown. Louise

Brooks may have played the all-consuming, omnisexual erotic symbol Lulu in G. W. Pabst's film *Pandora's Box* (1929), but, in truth, it was Bardot who embodied this archetype most thoroughly, particularly as she was generally shown to be sexually available to most of the male characters who desired her, whatever their age. And unlike the Hollywood cliché in which the attractive heroine invariably settles for the younger male seeking her favours over older, more sophisticated men, things were never quite that simple *chez* Bardot. Was this a wish fulfilment scenario on behalf of the producers and directors of her films? Or, simply an admission of the actress's siren-like appeal, which – although predicated on her youth – was protean in its inclusiveness?

In some ways, Bardot represented the opposite end of the spectrum from her most distinguished female contemporary, Jeanne Moreau. Moreau, although frequently presented as an object of desire (in such films as Louis Malle's *Les Amants* (*The Lovers*, 1958)), possessed more subtly nuanced sexuality and was allowed to play a wider range of female characters – including several who could demonstrate a cool intelligence, not a character trait Bardot was frequently called upon to display. Of course, another factor at play in this distinction is the fact that Moreau was clearly the more accomplished actress.

More than with most female stars, film stills were used worldwide to disseminate the image of the actress, such as the celebrated horizontal shot of her from Vadim's *Et Dieu Créa la Femme*, with the swell of her buttocks lovingly emphasised, or the more outrageous image (seen only in specialist film magazines or *Playboy*) from the aforementioned *En Cas de Malheur*, where she pulls her skirt up above her stocking tops to demonstrate that she is not wearing any underwear. The object of her seduction in the latter film is a middle-aged judge played by Jean Gabin – one icon of French cinema encountering another from a later era: an example, in fact, of the standard Bardot film persona, always ready to have sex with much older men. *En Cas de Malheur* was the first film in which it was clear that Bardot was an actress, and the mark of her success in it was that she was able to hold the screen alongside such an experienced scene-stealer as the veteran Gabin.

With her ample curves and tousled blonde hair, her pouting and her aggressively jutting hips – which expressed in the most direct fashion, 'I don't give a fuck for your bourgeois morality' – Bardot very quickly became as easily reduced to a shorthand image as, for instance, Superman with his 'S' shield, which denotes the character throughout the world. And in many of her films, she displayed (as mentioned above) a careless rejection of the pietistic middle-class morality of the people who disapproved of her, both in the films themselves (as incarnated by older actresses such as Alida Valli and Edwige Feuillère) and in the audiences who tut-tutted at the stories – enthusiastically promoted by film company publicity departments – that she wandered around at home naked, much as the characters did in her films. The actress's steady stream of love affairs, most notably with the director who first perfected her image, Roger Vadim, and her much photographed voluptuous bikini appearances at film festivals were freighted into popular perceptions. Her success speedily inaugurated a host of imitators; these included other blonde actresses such as Annette Stroyberg, whose appeal was manipulated in a variety of ways by Roger Vadim when she became one of the women who supplanted Bardot. But although Stroyberg was a perfectly capable actress, like many of Bardot's successors, she lacked Bardot's

almost primeval appeal, even in such sexually accentuated films as Vadim's *Et Mourir de Plaisir* (*Blood and Roses*, 1960).

Michel Boisrond's 1957 film *Une Parisienne* had little more to offer than a frequently stripped Bardot in its trivial tale of a romance between the wife of a diplomat and a blue-blooded foreigner, and at about the same time there were several films that were not made, such as a musical with Frank Sinatra. While the actress's private life began to be even more turbulent (including a suicide attempt in 1960), Bardot did more solid work in *La Vérité* (directed by Henri-Georges Clouzot in 1960); even though the actress was not quite up to the histrionic demands of the courtroom drama, she acquitted herself well.

The English title – *Love on a Pillow* – given to Roger Vadim's *Le Repos du Guerrier* (1962) may have been uninspired, but this is a film that remains an intriguing excavation from a lost era. Brigitte Bardot plays a well-brought-up girl from an upper-class family who encounters an unstable young man, Renaud (Robert Hossein), who has tried to commit suicide in her hotel room. She embarks upon a self-destructive love affair. This was unusual fare, more challenging than usual for Bardot as an actress (although semi-nudity is inevitably on offer), but Bardot is no Jeanne Moreau and is not really capable of meeting the demands of the part. A teaming with Jeanne Moreau in the slight *Viva Maria!* in 1965 was entertaining but not a great deal more, and, in her later career, some of her decisions were unwise. In Edward Dmytryk's listless 1968 Western *Shalako* with Sean Connery, the actress – clearly disengaged – insisted, perhaps aware of her faltering appeal, on ludicrously anachronistic eye make-up that would have been more appropriate for 1960s Carnaby Street than nineteenth-century America.

Her later years saw Bardot accrue some controversy due to her espousal of far right politics – she has written letters of support for Marine Le Pen of the *Front National* – and like her almost-contemporary Doris Day, a truly single-minded dedication to the welfare of animals has informed her mature years, along with an expressed distaste for human beings and for her own frivolous earlier life. But does an elderly Brigitte Bardot give a damn what people think of her? It seems that the young Bardot's avowedly insolent stance has been firmly maintained into old age.

Glacial appeal: Monica Vitti

The thriller writer Peter O'Donnell could not believe his luck when he learned that the woman who was to incarnate his sexy, intelligent heroine Modesty Blaise on film was to be no less than Monica Vitti, the charismatic muse of such directors as Antonioni. And the Modesty film was to be directed by Joseph Losey, with Dirk Bogarde as the villain – how could it fail? O'Donnell subsequently groaned at any mention of the movie, and one of the many reasons for its failure is, of course, Vitti. She appears briefly in the film in a black catsuit and dark wig that makes her the epitome of O'Donnell's heroine, but the actress's laziness – shamelessly indulged by the director – pretty much sinks Modesty without trace. However, truly bad movies by Vitti do not remain in the mind. Mostly, we think of her as the fascinating centre of a selection of remarkable movies directed by Michelangelo Antonioni, for whom she was the perfect muse.

When in 1957 she performed dubbing chores for the actress Dorian Grey in *Il Grido*, she ran into Antonioni, who was to change her life. Vitti was born in

Rome in 1931 (her real name was Maria Luisa Ceciarelli), and she had made a promising start in the Accademia d'Arte Drammatica in Rome. Small film roles in undistinguished comedies with actors such as Ugo Tognazzi had made little impact, but when she started to work with Antonioni on plays including *I am a Camera*, the director began to plot her career in much the same way as Hitchcock had done with actresses Grace Kelly and Vera Miles, among others.

L'Avventura (1960), of course, was the signature film for Antonioni and Vitti, a masterpiece that established the duo in a similar fashion to the teaming of Mastroianni and Fellini in *La Dolce Vita*. The film was shot in Sicily and the Ligurian islands, and Vitti's performance represented a new kind of film acting, eschewing all the dramatic tics that had been standard both in Hollywood and at Cinecittà. It is the cool, underplayed neurosis of many of her roles for Antonioni that looks as modern as ever today, with her refusal to rely on any kind of artificial dramatic semaphore. The actress's interior life seems quite as rich and convincing as anything played by graduates of the Stella Adler/Lee Strasberg schools. Her performance in Antonioni's *La Notte* (1961) was equally striking, although the role was a small one: the film belonged to Marcello Mastroianni and Jeanne Moreau as the estranged couple attempting to find some meaning in their lives. Next came one of the director's most controversial films, *L'Eclisse* (1962); this had Vitti involved with energetic stock broker Alain Delon, trying to protect her stock market-obsessed mother. There are those who regard the film as one of Antonioni's great masterpieces, but there is no denying that a certain application is required to fully appreciate it. Similarly, some critics thought that Vitti's acting style was now turning into mannerism, but the film today gives the lie to that: her character in *L'Eclisse* is subtly different from characterisations she had given us before.

Work for other directors followed, such as the French *Les Quatre Vérités* in 1962, which was an overwrought comedy with Rossano Brazzi, and Roger Vadim's *Château en Suède* (1963), where her supposedly bewitching character actually looked drained and uncharismatic. But her appearance in Antonioni's first film in colour, *Il Deserto Rosso* (1964), as yet another in the director's gallery of alienated heroines, showed that she remained as fascinating a screen presence as ever, even though her character's actions (in relation to a lip-synched Richard Harris) are often as infuriating as they are intriguing.

A comedy with Tony Curtis, *The Chastity Belt* (*La Cintura di Castità*, 1968), followed and made little impression, and, of course, there was the Modesty Blaise debacle that did nothing for the careers of anyone involved. Other choices seem equally uninspired, such as Ettore Scola's *Dramma della Gelosia – Tutti i Particolari in Cronaca* in 1970, in which neither she nor Mastroianni could make much of an indifferent script. However, some of her later work still showed the skills that had distinguished her debut movies, such as Miklós Jancsó's *La Pacifista* (1970), where her performance as a TV journalist made a mark, and she turned once again to the stage, appearing in Neil Simon's distaff version of his *The Odd Couple*.

The popular image of Vitti is of a cool, restrained, intellectual sexuality, very different from the earthy charms of Loren and Lollobrigida. If the broadcaster Joan Bakewell was England's 'thinking man's crumpet', Vitti undoubtedly deserves that non-politically correct epithet for her own country. However, there was much more to her than a slightly glacial sex appeal; Vitti's performances in

a variety of excellent movies demonstrate that she was one of the most consider-
able actresses of the Italian screen.

Via Veneto to Sunset Boulevard: Sophia Loren

Born in Rome in 1934, Sophia Loren and her mother moved to Naples, where
she spent the early years of her childhood in less than salubrious conditions.
At the age of 14 she won a beauty contest, which prompted her ambitious
mother to take her back to Rome and try for a film career. The *fumetti* (comic strips
illustrated with photographs) were enjoying their greatest popularity at the time,
and Loren was a natural for these; her impressive figure assured her a stream of
work. Small parts in films quickly followed, and even before her greatest success
as an actress, she had met her future husband, the producer Carlo Ponti. She had
worked with Silvana Mangano, but while that actress was to achieve a break-
through in *Riso Amaro*, Loren's ultimate success was to be more long-lasting, and
was to have an international dimension that Mangano barely enjoyed. Ponti
began to shape his wife's career, and he facilitated her starring role in a film of
Verdi's *Aida* (1953) in which her voice was supplied by the great soprano Renata
Tebaldi. The film today looks faded, and other early movies, such as *Un Giorno in
Pretura* (1954, with Alberto Sordi), give little hint of the seductive charisma that
was to propel her later career.

Noting that Mangano's provocatively dishevelled clothing in *Riso Amaro* had
made such an international impact, Carlo Ponti ensured that Loren performed a
similar trick in *La Donna del Fiume* (1954), in which her voluptuous charms were
barely concealed by skimpy, and sometimes wet, apparel. The film enjoyed some
success abroad – despite its crass dubbing – and inaugurated Loren's ascent to
fame that was soon to gather considerable momentum. American films followed,
such as *Boy on a Dolphin* (1957), co-starring Alan Ladd, which once again gave
Loren a chance to dive into water – this time as a Greek peasant woman – and
allowed the camera to record every inch of her opulent charms. But the film
added little lustre to any opinion of her acting talents. Similarly, the ill-fated
The Pride and the Passion (1957), with a temperamental Frank Sinatra matching
Loren's fieriness, was one of Stanley Kramer's least interesting films. Carlo Ponti,
however, had not given up on the idea of his wife appearing in more ambitious
films, such as Delbert Mann's 1958 attempt at Eugene O'Neill's *Desire Under the
Elms* with Burl Ives and Anthony Perkins. This film conveyed much of Loren's
dramatic power as an actress, which was often sidelined in more workaday
productions, although it seems unlikely that Loren could convey the requisite
subtlety for the part on stage. Other Hollywood work called upon Loren to be
more of an iconic presence than anything else; one of Hollywood's most talented
and individual directors, Anthony Mann, used this aspect of the actress's skill set
in *El Cid* (1961), made in Spain.

A return to Italy and the De Sica episode of *Boccaccio '70* (also 1962) showed
that the earthy ebullience of Loren's Italian films had not vanished under a
Hollywood gloss. Hopes were high for *I Sequestrati di Altona* (1962), De Sica's ver-
sion of Jean-Paul Sartre's play *The Condemned of Altona*, but the film proved to
be a worthy and unexciting run-through of the Sartre drama. However, De Sica
had provided the actress with one of the key parts of her career in *La Ciociara*

(1960), a version of Alberto Moravia's *Two Women*, with Loren devastating as a widow in an Italy riven by war; the rape of the Loren character and her daughter and its aftermath were handled with a power that surfaced all too infrequently in the actress's career. Loren won the best actress award at Cannes and the first ever Oscar for best actress in a foreign language film – both of which were fully deserved, although the film itself had been distributed abroad in a poorly dubbed version.

Loren starred in other unimpressive American films such as *Judith* (1966), as well as an end-of-cycle entry in the Hitchcock pastiche stakes, *Arabesque* (1966) with Gregory Peck. Chaplin's *A Countess from Hong Kong* (1967) augured well, with the actress as an impulsive noblewoman sexually involved with Marlon Brando, but none of the participants cover themselves in glory. Even less successful films followed, such as the disastrously dull version of the hit Broadway musical *Man of La Mancha* (1972), with Loren and Peter O'Toole making nothing of their parts. And it is best to draw a veil over the ill-conceived remake of *Brief Encounter* (1974) with Richard Burton. The idea of Burton and Loren, glamorous superstars, replacing the more quotidian Trevor Howard and Celia Johnson is absurd enough even as a concept, and the film proved such misgivings all too prescient. After such plodding thrillers as *The Cassandra Crossing* in 1977, Loren began an astonishingly misconceived vanity project, a film for television called *Sophia Loren: Her Own Story* (1980). This version of her autobiography featured the actress playing herself as the mature Loren and even her own mother, while Ritza Brown played the younger Sophia. By now Loren was in danger of losing all the goodwill her earlier films had accrued, but she will always remain the best known of the great Italian film stars.

Mamma Roma: Anna Magnani

From her humble birth in Alexandria near the beginning of the twentieth century, Anna Magnani's life trajectory was to be a preparation for her greatest roles in the cinema. Brought up in a shabby suburb of Rome, she decided to break out of the poverty of her environment by applying to study at the Eleonora Dusa school of acting, but kept body and soul together by performing near-the-knuckle songs in music halls. Her entry into the world of films came after her meeting with film director Goffredo Alessandrini, who married her in 1935, although the marriage did not last. Her first film gave her a career-making part as a 'kept woman' in *La Cieca di Sorrento* (1934). She also appeared as a music hall performer in the film *Cavalleria* in 1936, a jaundiced vision of upper-class Italian society.

As Magnani slowly began to build her film career, she was simultaneously forging a name for herself on the stage – a path that had been followed by so many of the better film actors, as opposed to film stars. Her performance in Eugene O'Neill's *Anna Christie* was much applauded, but films such as *La Fuggitiva* in 1941 added little credit to her reputation as an actress. Vittorio De Sica was one of the film directors who saw her potential and cast her in *Teresa Venerdì* (1941), where a hint of her opulent eroticism made a mark with critics and audiences. Several inconsequential films followed, and slowly but surely she established her name as a star. Like many other non-operatic actresses in Italian cinema, she was cast in

a musical role – in this case as a Tosca figure in *Avanti a Lui Tremava Tutta Roma* (1946) opposite Tito Gobbi, who made a speciality of such films. Her singing voice was, of course, dubbed. An early film of which she could be proud was Alberto Lattuada's *Il Bandito* (1946), in which Magnani inveigles Amedeo Nazzari into a criminal lifestyle, much as Carmen performs the same function for Don José.

Vittorio Cottafavi, later to make one of the most imaginative of the Hercules films in *Ercole alla Conquista di Atlantide*, cast her alongside Vittorio De Sica in *Lo Sconosciuto di San Marino* (1948, written by Cottafavi, but directed by Michal Waszynski), but this, like many of her early films, was made for domestic consumption only. For Luigi Zampa she made the first film that was to impress foreign audiences, *L'Onorevole Angelina* (1947), which gained her the best actress award at Venice and also created something of a critical stir in both the UK and America.

While the Production Code was forcing a ludicrous innocence on American product at the time, Magnani, like so many continental actresses, could deal with the realities of life, erotic or otherwise, in a more frank and honest way – although, inevitably, when the films travelled abroad they were often mauled by censors. An example was Roberto Rossellini's *L'Amore* (1948), a two-part film: one half of the film was Cocteau's *La Voix Humain*, while the Magnani segment (*Il Miracolo*) had the actress as a peasant woman who is raped and becomes convinced that her child will be the Messiah. The film was mangled abroad, and its US showing under the title *The Miracle* upset the censors. Of course, Magnani's best work for Rossellini (with whom she also had a relationship) is to be seen in one of the great Italian Neorealist masterpieces, *Roma, Città Aperta* (1945), where her tragic performance is almost combustible in the context of this bleak and powerful film.

Visconti's *Bellissima* in 1952 was a lively and energetic comedy with Magnani as a stage mother forcing her child into a film career, and she worked for Jean Renoir in *The Golden Coach* (*Le Carrosse d'Or*) in 1953, another film made in a variety of versions. However, by now an international career beckoned, and she was persuaded to appear in the film of Tennessee Williams' *The Rose Tattoo* (1955, directed by Daniel Mann). The part of a volatile Italian woman having an affair with an inarticulate, brutish truck driver seemed tailor-made for her, and it became one of her most memorable roles, although she had turned it down when she had previously been approached to do the play on Broadway. Opposite Burt Lancaster, she instantly established her international career, winning an Oscar as best actress and numerous other awards, including the New York critics' award. *Wild is the Wind* (1957) continued her American career as a mail-order bride for Anthony Quinn; although directed by the most distinguished of 'women's' directors, George Cukor, this was only fitfully successful, as was her next Tennessee Williams film, *The Fugitive Kind* in 1960, in which she played a sexually frustrated store owner who seduces a fey, guitar-playing young man. Although Williams wrote the part for her and tailored it to her talents as an actress, and although the casting of Marlon Brando promised fireworks between the stars, the film has not worn well and looks artificial and pretentious today.

Another great part remained for the actress, to be provided by one of the most promising young directors of the time, the Marxist and homosexual Pier Paolo Pasolini. *Mamma Roma* in 1962 starred Magnani as a prostitute prepared to make

every sacrifice for her worthless petty hoodlum son. If Pasolini was inclined to indulge the actress, and some of her mannerisms are allowed to become too strident, there is no denying the sheer incandescence of her performance, which still looks impressive today. She followed this with an Italian TV series, *Made in Italy* (1965), which, despite the presence of several notable Italian actors, was not seen much abroad. An indifferent Hollywood effort followed in Stanley Kramer's *The Secret of Santa Vittoria* in 1969, again with Anthony Quinn. Both stars almost contrived to rise above their material, but her last impressive appearance was in a cameo playing herself in Fellini's nostalgic *Roma* in 1972.

By the time of her death in 1973, her stock had declined somewhat, and her kind of flamboyant but truthful acting had fallen out of favour, but there are signs of a critical reassessment, and her best work is now being looked upon once again with favour.

Selected Bibliography

Screening Sex by Linda Williams (Duke University Press)

A book aimed primarily at the film studies market, Williams's densely written book concentrates on a limited selection of films, but manages to be relatively inclusive and incisive.

Sex and the Cinema by Tanya Krzywinska (Wallflower Press)

Tanya Krzywinska is concerned with the socio-cultural aspects of sex and how representations in the cinema have altered the erotic expectations of the audience rather than with a consideration of specific films. She addresses issues such as adultery, sadomasochism and incest.

Behind the Scenes of Otto Preminger by Willi Frischauer (William Morrow & Company)

A celebration but by no means a hagiography, Willi Frischauer's detailed guide to the working methods of the director is the work of a writer who knew Preminger for more than 40 years.

The Celluloid Closet: Homosexuality in the Movies by Vito Russo (Harper & Row)

This is the 1981 book about the treatment of homosexuality in the cinema that inspired the influential documentary. It is fascinating and witty in its analysis, but deeply tendentious in its wish to extirpate all negative images of gay characters in films – imagine Hitchcock's *Strangers on a Train* with a non-gay Bruno as the villain, or, still with Hitchcock, *Rebecca* without Judith Anderson's mesmerising lesbian Mrs Danvers.

Filmography

8½, 1963, directed by Federico Fellini
9 Songs, 2004, directed by Michael Winterbottom
9½ Weeks, 1986, directed by Adrian Lyne
10, 1979, directed by Blake Edwards
24 Hour Party People, 2002, directed by Michael Winterbottom
À Ma Souer!, 2001, directed by Catherine Breillat
Advise & Consent, 1962, directed by Otto Preminger
The Agony of Love, 1966, directed by William Rotsler and produced by Harry H. Novak
Aida, 1953, directed by Clemente Fracassi
Alina, 1950, directed by Giorgio Pastina
All About Eve, 1950, directed by Joseph L. Mankiewicz
All Ladies Do It, 1992, directed by Tinto Brass
All the Fine Young Cannibals, 1960, directed by Michael Anderson
Amor Non Ho ... Però ... Però, 1951, directed by Giorgio Bianchi
L'Amore, 1948, directed by Roberto Rossellini
Amour, 2012, directed by Michael Haneke
Anatomy of a Murder, 1959, directed by Otto Preminger
And God Created Woman (Et Dieu Créa la Femme), 1956, directed by Roger Vadim
Andy Warhol's Blood for Dracula, 1974, directed by Andy Warhol and Paul Morrissey
Andy Warhol's Flesh for Frankenstein, 1973, directed by Andy Warhol and Paul Morrissey
Antichrist, 2009, directed by Lars von Trier
Arabesque, 1966, directed by Stanley Donen
The Arabian Nights (Il Fiore delle Mille e Una Notte), 1974, directed by Pier Paolo Pasolini
The Asphalt Jungle, 1950, directed by John Huston
Attack of the 50 Foot Woman, 1958, directed by Nathan Juran (as Nathan Hertz)
Avanti a Lui Tremava Tutta Roma, 1946, directed by Carmine Gallone
L'Avventura, 1960, directed by Michelangelo Antonioni
Baby Doll, 1956, directed by Elia Kazan
Baise-Moi, 2000, directed by Virginie Despentes and Coralie Trinh Thi
The Balcony, 1963, directed by Joseph Strick
The Band Wagon, 1953, directed by Vincente Minnelli
Il Bandito, 1946, directed by Alberto Lattuada
Barbarella, 1968, directed by Roger Vadim
Basic Instinct, 1992, directed by Paul Verhoeven
Basic Instinct 2, 2006, directed by Michael Caton-Jones
The Beast, 1975, directed by Walerian Borowczyk
Le Beau Serge, 1958, directed by Claude Chabrol
Behind Closed Shutters (Persiane Chiuse), 1951, directed by Luigi Comencini
Behind the Candelabra, 2013, directed by Steven Soderbergh

Behind the Green Door, 1972, directed by Jim and Artie Mitchell
Belle du Jour, 1967, directed by Luis Buñuel
La Belle et la Bête, 1946, directed by Jean Cocteau
Belle of the Nineties, 1934, directed by Leo McCarey
Bellissima, 1952, directed by Luchino Visconti
Beyond the Valley of the Dolls, 1970, directed by Russ Meyer
The Big Sleep, 1946, directed by Howard Hawks
Les Bijoutiers du Clair de Lune, 1958, directed by Roger Vadim
Bitter Rice (Riso Amaro), 1949, directed by Giuseppe De Santis
Black Swan, 2010, directed by Darren Aronofsky
Blonde Venus, 1932, directed by Josef von Sternberg
Blood and Roses (Et Mourir de Plaisir), 1960, directed by Roger Vadim
The Blood Rose (La Rose Écorchée aka Ravaged), 1970, directed by Claude Mulot
Blow-Up, 1966, directed by Michelangelo Antonioni
The Blue Angel (Der Blaue Engel), 1930, directed by Josef von Sternberg
Blue is the Warmest Colour, 2013, directed by Abdellatif Kechiche
Blue Jasmine, 2013, directed by Woody Allen
Boccaccio '70, 1962, directed by Federico Fellini, Luchino Visconti and Vittorio De Sica
The Body, 1971, various directors
Body Double, 1984, directed by Brian De Palma
Bombshell, 1933, directed by Victor Fleming
Boogie Nights, 1997, directed by Paul Thomas Anderson
Bound, 1996, directed by Lana (Larry) and Andy Wachowski
Boy on a Dolphin, 1957, directed by Jean Negulesco
The Boys in the Band, 1969, directed by William Friedkin
Brief Crossing (Brève Traversée), 2001, directed by Catherine Breillat
Brief Encounter, 1945, directed by David Lean
Brief Encounter, 1974, directed by Alan Bridges
Brimstone & Treacle, 1982, directed by Richard Loncraine
Bus Stop, 1956, directed by Joshua Logan
Butterfield 8, 1960, directed by Daniel Mann
Cabaret, 1972, directed by Bob Fosse
Café Flesh, 1982, directed by Stephen Sayadian (as Rinse Dream)
Caligula, 1979, directed by Tinto Brass
Camille, 1936, directed by George Cukor
The Canterbury Tales (I Racconti di Canterbury), 1972, directed by Pier Paolo Pasolini
The Canyons, 2013, directed by Paul Schrader
Cape Fear, 1962, directed by J. Lee Thompson
Carmen Jones, 1954, directed by Otto Preminger
Carnal Knowledge, 1971, directed by Mike Nichols
Caroline Chérie, 1951, directed by Richard Pottier
Carry on Camping, 1969, directed by Gerald Thomas
Casablanca, 1942, directed by Michael Curtiz
Casque d'Or, 1952, directed by Jacques Becker
The Cassandra Crossing, 1977, directed by George Pan Cosmatos
Cat on a Hot Tin Roof, 1958, directed by Richard Brooks
Catch-22, 1970, directed by Mike Nichols
Cavalleria, 1936, directed by Goffredo Alessandrini

The Celluloid Closet, 1995, directed by Rob Epstein and Jeffrey Friedman
The Chapman Report, 1962, directed by George Cukor
The Chastity Belt (*La Cintura di Castità*, aka *On My Way to the Crusades, I Met a Girl Who ...*), 1968, directed by Pasquale Festa Campanile
Château en Suède, 1963, directed by Roger Vadim
Cherry, Harry and Raquel, 1970, directed by Russ Meyer
Un Chien Andalou, 1929, directed by Luis Buñuel and Salvador Dalí
The Chronicle of Anna Magdalena Bach, 1968, directed by Jean-Marie Straub
La Cieca di Sorrento, 1934, directed by Goffredo Alessandrini
La Ciociara, 1960, directed by Vittorio De Sica
La Città Si Difende, 1951, directed by Pietro Germi
City of Women (*La Città delle Donne*), 1980, directed by Federico Fellini
Closely Observed Trains, 1966, directed by Jirí Menzel
Common Law Cabin, 1967, directed by Russ Meyer
Confessions of a Window Cleaner, 1974, directed by Val Guest
A Countess from Hong Kong, 1967, directed by Charlie Chaplin
Country Hooker, 1974, directed by Lew Guinn and produced by Harry H. Novak
Les Cousins, 1959, directed by Claude Chabrol
Crash, 1996, directed by David Cronenberg
Creature from the Black Lagoon, 1954, directed by Jack Arnold
The Creature Walks Among Us, 1956, directed by John Sherwood
Cries and Whispers, 1972, directed by Ingmar Bergman
Crimes of Passion, 1984, directed by Ken Russell
The Crimson Petal and the White (TV series), 2011, directed by Marc Munden
Cruising, 1980, directed by William Friedkin
The Damned, 1969, directed by Luchino Visconti
A Dangerous Method, 2011, directed by David Cronenberg
A Daughter of the Gods, 1916, directed by Herbert Brenon
Dead Ringers, 1988, directed by David Cronenberg
Death by Hanging, 1968, directed by Nagisa Oshima
Death in Venice (*Morte a Venezia*), 1971, directed by Luchino Visconti
Debbie Does Dallas, 1978, directed by Jim Clark
The Decameron, 1971, directed by Pier Paolo Pasolini
Deep End, 1970, directed by Jerzy Skolimowski
Deep Throat, 1972, directed by Gerard Damiano
Dementia 13 (aka *The Haunted and the Hunted*), 1963, directed by Francis Ford Coppola
Desire Under the Elms, 1958, directed by Delbert Mann
Destry Rides Again, 1939, directed by George Marshall
The Detective, 1968, directed by Gordon Douglas
The Devil in Miss Jones, 1973, directed by Gerard Damiano
Devil in the Flesh (*Le Malizie di Venere*), 1973, directed by Massimo Dallamano
The Devil is a Woman, 1935, directed by Josef von Sternberg
The Devils, 1971, directed by Ken Russell
Diamond Lil, 1933, directed by Lowell Sherman
Diary of a Chambermaid (*Le Journal d'une Femme de Chambre*), 1964, directed by Luis Buñuel
Diary of a Lost Girl, 1929, directed by G. W. Pabst
Diary of a Shinjuku Thief, 1969, directed by Nagisa Oshima
Different from the Others (*Anders als die Andern*), 1919, directed by Richard Oswald

Dinner at Eight, 1933, directed by George Cukor
Dishonoured, 1931, directed by Josef von Sternberg
Divorce Italian Style (*Divorzio all'Italiana*), 1961, directed by Pietro Germi
Doctor at Sea, 1955, directed by Ralph Thomas
La Dolce Vita, 1960, directed by Federico Fellini
La Donna del Fiume, 1954, directed by Mario Soldati
Double Indemnity, 1944, directed by Billy Wilder
Dr Breedlove (aka *Kiss Me Quick!*), 1964, directed by Peter Perry Jr (as Seymour Tuchus) and produced by Harry H. Novak
Dramma della Gelosia – Tutti i Particolari in Cronaca, 1970, directed by Ettore Scola
The Dreamers, 2003, directed by Bernardo Bertolucci
Dressed to Kill, 1980, directed by Brian De Palma
Duel in the Sun, 1946, directed by King Vidor
The Eclipse (*L'Eclisse*), 1962, directed by Michelangelo Antonioni
Eden and After, 1970, directed by Alain Robbe-Grillet
Ekstase, 1933, directed by Gustav Machaty
El Cid, 1961, directed by Anthony Mann
Emmanuelle, 1974, directed by Just Jaeckin
Empire, 1964, directed by Andy Warhol
Empire of the Senses (*Ai No Corrida*, aka *In the Realm of the Senses*), 1976, directed by Nagisa Oshima
En Cas de Malheur (*Love is My Profession*), 1958, directed by Claude Autant-Lara
Enrico Caruso: Leggenda di una Voce, 1951, directed by Giacomo Gentilomo
Erotikon, 1920, directed by Mauritz Stiller
Eskimo Nell, 1975, directed by Martin Campbell
Europe in the Raw, 1963, directed by Russ Meyer
Every Home Should Have One, 1970, directed by Jim Clark
Exodus, 1960, directed by Otto Preminger
The Exorcist, 1973, directed by William Friedkin
A Face in the Crowd, 1957, directed by Elia Kazan
Fanfan la Tulipe, 1952, directed by Christian-Jaque
Fantastic Voyage, 1966, directed by Richard Fleischer
Faster Pussycat! Kill! Kill!, 1966, directed by Russ Meyer
Fatal Attraction, 1987, directed by Adrian Lyne
Fellini Satyricon, 1969, directed by Federico Fellini
La Femme Infidèle, 1969, directed by Claude Chabrol
Fifty Shades of Grey, 2015, directed by Sam Taylor-Johnson
Fire Maidens from Outer Space, 1956, directed by Cy Roth
Flash Gordon, 1980, directed by Mike Hodges
The Flea, 1905 (short film)
Flesh, 1968, directed by Andy Warhol and Paul Morrissey
Flesh Gordon, 1974, directed by Michael Benveniste and Howard Ziehm
Folia per l'Opera, 1948, directed by Mario Costa
A Fool There Was, 1915, directed by Frank Powell
Forever Amber, 1947, directed by Otto Preminger
Four Kinds of Love (*Le Bambole*), 1965, directed by Mauro Bolignini
The Fourth Man (*De Vierde Man*), 1983, directed by Paul Verhoeven
The Fox, 1967, directed by Mark Rydell
A Free Ride, 1915, anonymous director
Frenzy, 1972, directed by Alfred Hitchcock

Freud (aka *Freud: The Secret Passion*), 1962, directed by John Huston
From Here to Eternity, 1953, directed by Fred Zinnemann
La Frusta e il Corpo (*The Whip and the Body aka Night is the Phantom/What!*), 1963,
 directed by Mario Bava
Fuck (aka *Blue Movie*), 1969, directed by Andy Warhol
La Fuggitiva, 1941, directed by Piero Ballerini
The Fugitive Kind, 1960, directed by Sidney Lumet
The Garden of Allah, 1936, directed by Richard Boleslawski
Garden of Eden, 1954, directed by Max Nosseck
Gentlemen Prefer Blondes, 1953, directed by Howard Hawks
Gilda, 1946, directed by Charles Vidor
Un Giorno in Pretura, 1954, directed by Stefano Vanzini (as 'Steno')
The Girl Can't Help It, 1956, directed by Frank Tashlin
The Girl with the Dragon Tattoo, 2009, directed by Niels Arden Oplev
The Girl with the Dragon Tattoo, 2011, directed by David Fincher
Girls (TV series), 2012, created by Lena Dunham
Girls Without Rooms (*Flamman*), 1956, directed by Arne Ragneborn
The Glass Menagerie, 1950, directed by Irving Rapper
The Golden Coach (*Le Carrosse d'Or*), 1953, directed by Jean Renoir
GoldenEye, 1995, directed by Martin Campbell
Goto, Island of Love, 1969, directed by Walerian Borowczyk
Grande École, 2004, directed by Robert Salis
Green Lantern, 2011, directed by Martin Campbell
Gwendoline, 1984, directed by Just Jaeckin
Hardcore (aka *The Hardcore Life*), 1979, directed by Paul Schrader
The Harem (aka *Her Harem*), 1967, directed by Marco Ferreri
Helen of Troy, 1956, directed by Robert Wise
Hell's Angels, 1930, directed by Howard Hughes
The Hellfire Club, 1961, directed by Robert Baker and Monty Berman
Henry & June, 1990, directed by Philip Kaufman
Her Private Hell, 1967, directed by Norman J. Warren
The Hidden Fortress, 1958, directed by Akira Kurosawa
Hiroshima Mon Amour, 1959, directed by Alain Resnais
Hour of the Wolf, 1968, directed by Ingmar Bergman
How to Marry a Millionaire, 1953, directed by Jean Negulesco
The Human Centipede, 2009, directed by Tom Six
The Hunt, 2012, directed by Thomas Vinterberg
Husbands and Wives, 1992, directed by Woody Allen
I Am Curious (Blue), 1968, directed by Vilgot Sjöman
I Am Curious (Yellow), 1967, directed by Vilgot Sjöman
I'm No Angel, 1933, directed by Wesley Ruggles
I'm Not Feeling Myself Tonight, 1976, directed by Joseph McGrath
Identification of a Woman (*Identificazione di una Donna*), 1982, directed by
 Michelangelo Antonioni
If, 1968, directed by Lindsay Anderson
The Immoral Mr Teas, 1959, directed by Russ Meyer
L'Immortelle, 1963, directed by Alain Robbe-Grillet
In My Skin (*Dans Ma Peau*), 2002, directed by Marina de Van
Insatiable, 1980, directed by Stu Segall (as Godfrey Daniels)
The Inside of the White Slave Traffic, 1913, directed by Frank Beal

Interior. Leather Bar., 2013, directed by James Franco and Travis Mathews
Intimacy, 2001, directed by Patrice Chéreau
Intolerance, 1916, directed by D. W. Griffith
Irreversible, 2002, directed by Gaspar Noé
Joanna, 1968, directed by Mike Sarne
Judith, 1966, directed by Daniel Mann
Juliet of the Spirits (*Giulietta degli Spiriti*), 1965, directed by Federico Fellini
Katie Tippel (*Keetje Tippel*), 1975, directed by Paul Verhoeven
The Key (*La Chiave*), 1983, directed by Tinto Brass
Kill Your Darlings, 2013, directed by John Krokidas
The Killing of Sister George, 1968, directed by Robert Aldrich
A Kind of Loving, 1962, directed by John Schlesinger
Kinsey, 2004, directed by Bill Condon
The Kiss (aka *The Widow Jones*), 1896, directed by William Heise
Knight Without Armour, 1937, directed by Jacques Feyder
Lady Chatterley's Lover, 1981, directed by Just Jaeckin
Lady Undressing, 1905 (short film)
The Landlord, 1970, directed by Hal Ashby
Language of Love, 1969, directed by Torgny Wickman
The Last House on the Left, 1972, directed by Wes Craven
Last of the Mobile Hot Shots, 1970, directed by Sidney Lumet
Last Tango in Paris, 1972, directed by Bernardo Bertolucci
Last Year in Marienbad, 1961, directed by Alain Resnais
Laura, 1944, directed by Otto Preminger
The Liberation of L. B. Jones, 1970, directed by William Wyler
The List of Adrian Messenger, 1963, directed by John Huston
Lolita, 1962, directed by Stanley Kubrick
Lolita, 1997, directed by Adrian Lyne
The Look of Love, 2013, directed by Michael Winterbottom
Looking for Mr Goodbar, 1977, directed by Richard Brooks
Lorna, 1964, directed by Russ Meyer
Love Happy, 1949, directed by David Miller
Love on a Pillow (*Le Repos du Guerrier*), 1962, directed by Roger Vadim
Lovelace, 2013, directed by Rob Epstein and Jeffrey Friedman
The Lovers (*Les Amants*), 1958, directed by Louis Malle
Mädchen in Uniform, 1931, directed by Leontine Sagan and Carl Froelich
Made in Italy (TV series), 1965, directed by Nanni Loy
Maison Close (TV series), 2010, directed by Mabrouk El Mechri
Maîtresse, 1975, directed by Barbet Schroeder
Male and Female, 1919, directed by Cecil B. DeMille
Mam'selle Striptease (*En Effeuillant la Marguerite*), 1956, directed by Marc Allégret
Mamma Roma, 1962, directed by Pier Paolo Pasolini
Man of La Mancha, 1972, directed by Arthur Hiller
Man of Steel, 2013, directed by Zack Snyder
The Man with the Golden Arm, 1955, directed by Otto Preminger
Mandingo, 1975, directed by Richard Fleischer
Medium Cool, 1969, directed by Haskell Wexler
Merci la Vie, 1991, directed by Bertrand Blier
The Merry Widow, 1925, directed by Erich von Stroheim

Midnight Cowboy, 1969, directed by John Schlesinger
Modesty Blaise, 1966, directed by Joseph Losey
Mona: The Virgin Nymph (aka *Mona*), 1970, directed by Michael Benveniste
(as Mike Light) and Howard Ziehm
Mondo Topless, 1966, directed by Russ Meyer
The Moon is Blue, 1953, directed by Otto Preminger
Morocco, 1930, directed by Josef von Sternberg
Mudhoney, 1965, directed by Russ Meyer
The Music Lovers, 1970, directed by Ken Russell
Myra Breckinridge, 1970, directed by Mike Sarne
Naked as Nature Intended, 1961, directed by George Harrison Marks
Naked Came the Stranger, 1975, directed by Radley Metzger
Naked City, 1948, directed by Jules Dassin
Naked Killer, 1992, directed by Clarence Fok Yiu-leung
Naked Youth, 1960, directed by Nagisa Oshima
Never So Few, 1959, directed by John Sturges
Niagara, 1953, directed by Henry Hathaway
The Night of the Iguana, 1964, directed by John Huston
Ninotchka, 1939, directed by Ernst Lubitsch
Not Tonight Henry, 1960, directed by W. Merle Connell
Notorious, 1946, directed by Alfred Hitchcock
La Notte, 1961, directed by Michelangelo Antonioni
Nudes of the World, 1962, directed by Arnold L. Miller
Nudist Paradise, 1958, directed by Nat Miller
The Nudist Story, 1960, directed by Ramsey Herrington
Nymphomaniac, 2013, directed by Lars von Trier
Obsession (*Ossessione*), 1943, directed by Luchino Visconti
Occupe-toi d'Amélie...!, 1949, directed by Claude Autant-Lara
Los Olvidados, 1950, directed by Luis Buñuel
On the Road, 2012, directed by Walter Salles
L'Onorevole Angelina, 1947, directed by Luigi Zampa
The Opening of Misty Beethoven, 1976, directed by Radley Metzger (as Henry Paris)
Orchestral Rehearsal (*Prova d'Orchestra*), 1978, directed by Federico Fellini
Oscar Wilde, 1960, directed by Gregory Ratoff
The Outlaw, 1943, directed by Howard Hughes
La Pacifista, 1970, directed by Miklós Jancsó
I Pagliacci, 1948, directed by Mario Costa
Pandora's Box (aka *Lulu*), 1929, directed by G. W. Pabst
Une Parisienne, 1957, directed by Michel Boisrond
The Party's Over, 1965, directed by Guy Hamilton
The Passenger (*Professione: Reporter*), 1975, directed by Michelangelo Antonioni
The Pawnbroker, 1964, directed by Sidney Lumet
Peeping Tom, 1960, directed by Michael Powell
Penny Dreadful (TV series), 2014, created by John Logan
Persona, 1966, directed by Ingmar Bergman
Peyton Place, 1957, directed by Mark Robson
The Piano Teacher, 2001, directed by Michael Haneke
Picnic, 1955, directed by Joshua Logan
The Picture of Dorian Gray, 1945, directed by Albert Lewin

Pillow Talk, 1959, directed by Michael Gordon
The Pleasure Girls, 1965, directed by Gerry O'Hara
Pornography: Copenhagen 1970, 1970, directed by Jorgen Lyhne
Pornography in Denmark, 1970, directed by Michael Miller
Portnoy's Complaint, 1972, directed by Ernest Lehman
The Postman Always Rings Twice, 1946, directed by Tay Garnett
The Postman Always Rings Twice, 1981, directed by Bob Rafelson
Pretty Baby, 1978, directed by Louis Malle
Pride and Prejudice, 1940, directed by Robert Z. Leonard
The Pride and the Passion, 1957, directed by Stanley Kramer
Primitive London, 1965, directed by Stanley Long
Princess, 2006, directed by Anders Morgenthaler
The Private Afternoons of Pamela Mann, 1974, directed by Radley Metzger
Prostitute, 1980, directed by Tony Garnett
Psycho, 1960, directed by Alfred Hitchcock
Psycho, 1998, directed by Gus Van Sant
Les Quatre Vérités, 1962, directed by Alessandro Blasetti
Queen Christina, 1933, directed by Rouben Mamoulian
Queen Kelly, 1929, directed by Erich von Stroheim
Quiet Days in Clichy, 1970, directed by Jens Jørgen Thorsen
Rabid, 1977, directed by David Cronenberg
Red Desert (Il Deserto Rosso), 1964, directed by Michelangelo Antonioni
Red Dust, 1932, directed by Victor Fleming
Revenge of the Creature, 1955, directed by Jack Arnold
Rocco and his Brothers (Rocco e i Suoi Fratelli), 1960, directed by Luchino Visconti
Roma, 1972, directed by Federico Fellini
Roma, Città Aperta, 1945, directed by Roberto Rossellini
La Romana (TV series), 1988, directed by Giuseppe Patroni Griffi
Romance, 1999, directed by Catherine Breillat
Room at the Top, 1959, directed by Jack Clayton
The Rose Tattoo, 1955, directed by Daniel Mann
Salò, or the 120 Days of Sodom, 1975, directed by Pier Paolo Pasolini
Salon Kitty, 1976, directed by Tinto Brass
Samson and Delilah, 1949, directed by Cecil B. DeMille
Saturday Night and Sunday Morning, 1960, directed by Karel Reisz
The Scarlet Empress, 1934, directed by Josef von Sternberg
Lo Sconosciuto di San Marino, 1948, directed by Michal Waszynski
The Secret of Santa Vittoria, 1969, directed by Stanley Kramer
Seduced and Abandoned (Sedotta e Abbandonata), 1964, directed by Pietro Germi
I Sequestrati di Altona, 1962, directed by Vittorio De Sica
Serafino, 1968, directed by Pietro Germi
The Servant, 1963, directed by Joseph Losey
The Seven Year Itch, 1955, directed by Billy Wilder
The Seventh Seal, 1957, directed by Ingmar Bergman
Sex, Lies, and Videotape, 1989, directed by Steven Soderbergh
The Sex Lure, 1916, directed by Ivan Abramson
Shalako, 1968, directed by Edward Dmytryk
Shame, 2011, directed by Steve McQueen
She Done Him Wrong, 1933, directed by Lowell Sherman

She Got What She Asked For (*La Bellezza di Ippolita*), 1962, directed by Giancarlo Zagni
The Sheik, 1921, directed by George Melford
Shivers, 1975, directed by David Cronenberg
The Silence, 1963, directed by Ingmar Bergman
Silk Stockings, 1957, directed by Rouben Mamoulian
The Singer Not the Song, 1961, directed by Roy Ward Baker
Skidoo, 1968, directed by Otto Preminger
The Snake Pit, 1948, directed by Anatole Litvak
Sodom and Gomorrah, 1962, directed by Robert Aldrich
Solomon and Sheba, 1959, directed by King Vidor
Some Like It Cool, 1962, directed by Michael Winner
Some Like It Hot, 1959, directed by Billy Wilder
Sophia Loren: Her Own Story, 1980, directed by Mel Stuart
Spellbound, 1945, directed by Alfred Hitchcock
Spetters, 1980, directed by Paul Verhoeven
Splendor in the Grass, 1961, directed by Elia Kazan
La Sposa Non Può Attendere, 1949, directed by Gianni Franciolini
The Strawberry Statement, 1970, directed by Stuart Hagmann
A Streetcar Named Desire, 1951, directed by Elia Kazan
Suburban Pagans, 1968, directed by William Rotsler (as Shannon Carse) and produced by Harry H. Novak
Suddenly, Last Summer, 1959, directed by Joseph L. Mankiewicz
Summer and Smoke, 1961, directed by Peter Glenville
Summer with Monika, 1953, directed by Ingmar Bergman
The Sun's Burial, 1960, directed by Nagisa Oshima
Superman: The Movie, 1978, directed by Richard Donner
Supervixens, 1975, directed by Russ Meyer
The Surrogate, 1984, directed by Don Carmody
Sweet Bird of Youth, 1962, directed by Richard Brooks
Taking Off, 1971, directed by Milos Forman
A Tale of Five Cities, 1951, directed by Romolo Marcellini and Emil E. Reinert
Tales of Ordinary Madness (*Storie di Ordinaria Follia*), 1981, directed by Marco Ferreri
Tarzan the Ape Man, 1932, directed by W. S. Van Dyke
Taxi Driver, 1976, directed by Martin Scorsese
Teaserama, 1955, directed by Irving Klaw
Teresa Venerdì, 1941, directed by Vittorio De Sica
That Kind of Girl, 1963, directed by Robert Hartford-Davis
Theorem (*Teorema*), 1968, directed by Pier Paolo Pasolini
Thérèse Raquin, 1953, directed by Marcel Carné
They're Playing with Fire, 1984, directed by Howard Avedis
This Property is Condemned, 1966, directed by Sydney Pollack
This Sporting Life, 1963, directed by Lindsay Anderson
The Three Musketeers, 1948, directed by George Sidney
Tonight for Sure, 1962, directed by Francis Ford Coppola
Too Hot to Handle (aka *Playgirl After Dark*), 1960, directed by Terence Young
Traffic in Souls, 1913, directed by George Loane Tucker
Tragic Pursuit (*Caccia Tragica*), 1947, directed by Giuseppe De Santis
Trans-Europ-Express, 1967, directed by Alain Robbe-Grillet

Trapeze, 1956, directed by Carol Reed
Trash, 1970, directed by Andy Warhol and Paul Morrissey
The Trials of Oscar Wilde, 1960, directed by Ken Hughes
Tropic of Cancer, 1970, directed by Joseph Strick
Two-Faced Woman, 1941, directed by George Cukor
Ulysses, 1967, directed by Joseph Strick
Valley of the Dolls, 1967, directed by Mark Robson
Varietease, 1954, directed by Irving Klaw
Venere Imperiale, 1962, directed by Jean Delannoy
La Vérité, 1960, directed by Henri-Georges Clouzot
Victim, 1961, directed by Basil Dearden
Videodrome, 1983, directed by David Cronenberg
The Virgin Spring, 1960, directed by Ingmar Bergman
Viridiana, 1961, directed by Luis Buñuel
Viva Maria!, 1965, directed by Louis Malle
Vixen! (aka *Russ Meyer's Vixen!*), 1968, directed by Russ Meyer
Walk on the Wild Side, 1962, directed by Edward Dmytryk
Watchmen, 2009, directed by Zack Snyder
West End Jungle, 1961, directed by Stanley Long
The Wicked Lady, 1945, directed by Leslie Arliss
The Wife Swappers, 1969, directed by Derek Ford and produced by Stanley Long
Wild is the Wind, 1957, directed by George Cukor
Wild Strawberries, 1957, directed by Ingmar Bergman
Winter Light, 1963, directed by Ingmar Bergman
Witchcraft Through the Ages (*Häxan*), 1922, directed by Benjamin Christensen
Woman of Straw, 1964, directed by Basil Dearden
Woman of Summer (aka *The Stripper*), 1963, directed by Franklin Schaffner
Women in Love, 1969, directed by Ken Russell
The Wonderful World of Sex, 2003, various directors
Woodstock, 1970, directed by Michael Wadleigh
WR: Mysteries of the Organism, 1971, directed by Dušan Makavejev
Wuthering Heights, 1939, directed by William Wyler
Yesterday, Today and Tomorrow, 1963, directed by Vittorio De Sica
Zabriskie Point, 1970, directed by Michelangelo Antonioni

Index

Foreign films are listed under the title by which they are/were best known in the UK (e.g. La Dolce Vita, but Bitter Rice)

227

Printed and bound by CPI Group (UK) Ltd, Croydon, CR0 4YY